100 ICONIC
GANGSTER MOVIES

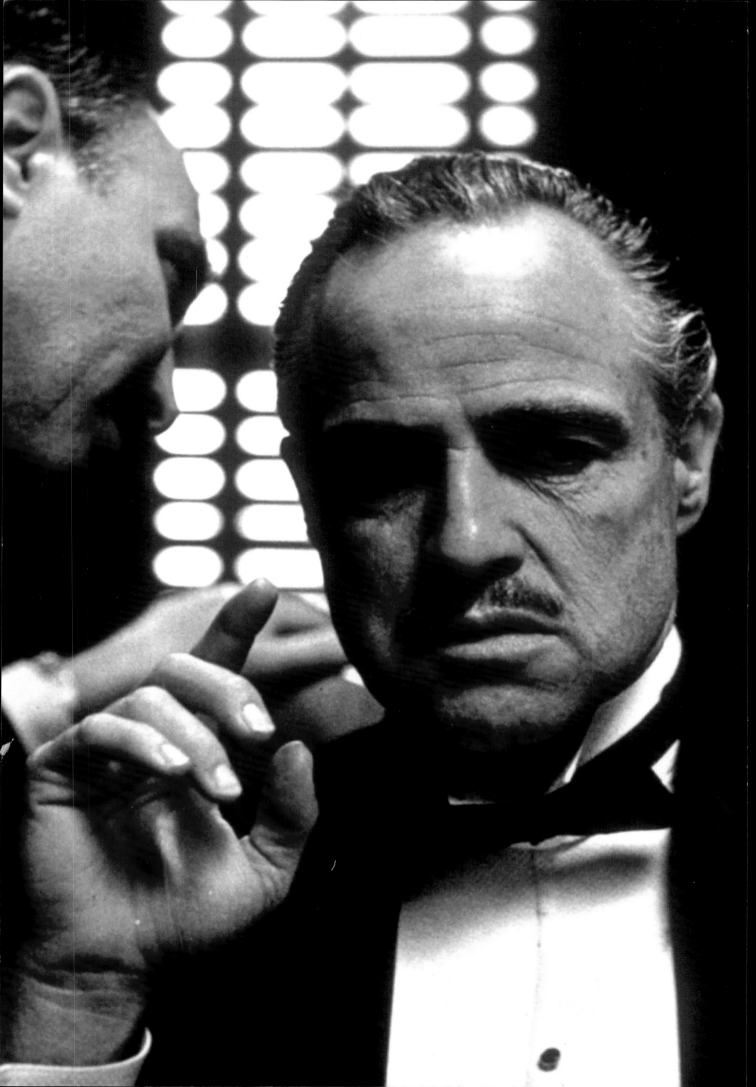

Pierre Toromanoff

100 ICONIC
GANGSTER MOVIES

GINGKO PRESS

TABLE OF CONTENTS

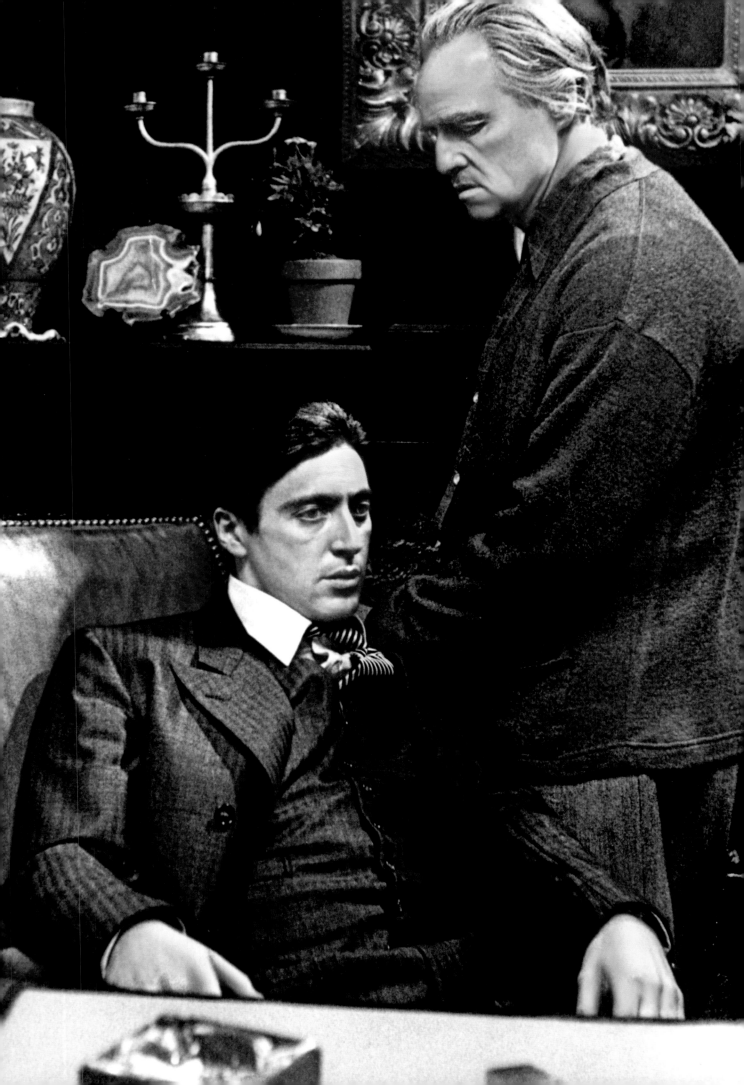

INTRODUCTION

The popular myth of the clever outlaw who always managed to escape the authorities hot on his heels is ubiquitous among cultures around the world, and older than the hills. The gallant bandit who stole from the rich and distributed some of his booty to the poor became an endearing character, an image of resistance to oppression by the powerful that restored some justice to the world. While no one pitied an outlaw if he was caught and punished, the list of his misdeeds – or his exploits – made a perfect theme for folk tales and stories. Figures, such as Robin Hood in England or Song Jiang in China, became true epic heroes.

In the 19th century, the American tradition of the Old West outlaw took off and legendary figures emerged. Billy the Kid, Jesse James, Butch Cassidy and the Wild Bunch made the headlines as far as the East Coast, and dime novels deliberately exaggerated the exploits of these somewhat romantic heroes. Not only did the Wild West gunfighters ignore the law, but they also lived in untamed and hostile territories, far from the world in which their admirers lived. The cinema paid tribute to them in numerous films such as *The Good, the Bad and the Ugly* (1966) or *Butch Cassidy and the Sundance Kid* (1969).

The gangster of the 1920s, which serves as an archetype for gangster films, is of a completely different type. He is a city-dweller who you might meet in a bar or a nightclub, a man often dressed with care, aiming to project respectability. This anti-hero enables his customers to drink alcohol in the Prohibition era, to indulge in gambling or to frequent brothels. He is a man whose ascendant quality is audacity, and although it is obvious that he has a shadowy side, he nevertheless arouses a certain sympathy that Hollywood directors knew perfectly how to exploit. The everyday life of gangsters during the Prohibition era would soon inspire the film studios: true gangster stories exceeded what the most inventive of screenwriters could imagine. All they had to do was draw on the facts to create the plot of a film. The biggest godfathers of the mafia and organized crime became celebrities just like millionaires, movie stars and sports champions.

The Hays Code, which was enforced on all film studios in the 1930s and forbade the portrayal of gangsters in a positive light, had a paradoxically beneficial effect – even if it imposed serious constraints that bordered on the absurd. It forced filmmakers to portray gangsters in an unvarnished way and not to conceal their cruelty and cynicism. Actors like James Cagney put all their talent into portraying villains in roles that impressed audiences and still drew admiration. In the 1950s, with the gradual relaxation of censorship, filmmakers were able to retrace the sagas of the great criminal figures of the Prohibition era, from Al Capone to "Machine Gun" Kelly, while renewing the genre with masterpieces such as *The Killing* by Stanley Kubrick or *The Brothers Rico* by Phil Karlson. The French New Wave, in the 1960s, brought a touch of psychology and humanity to the characters; the gangster became a hero rebelling against the social order, a theme in tune with the times. The 1960s also saw the emergence of quasi-parodies of gangster films, such as *The Biggest Bundle of Them All* and *The Italian Job*. The first installment of *The Godfather* by Francis Ford Coppola, which was released in 1972, arguably marked the birth of the contemporary gangster film. The spectacular action scenes blended harmoniously with more intimate moments where the main protagonists revealed their feelings and doubts. Martin Scorsese's masterpieces form, in the same spirit, a vast historical panorama of the underworld in the United States from the 1860s to the present day. Under the influence of young directors such as Quentin Tarantino or Steven Soderbergh, gangster films have conquered a new generation of spectators who will find here a selection of the best films since the 1930s, films that can be seen and seen again without losing their punchy spirit.

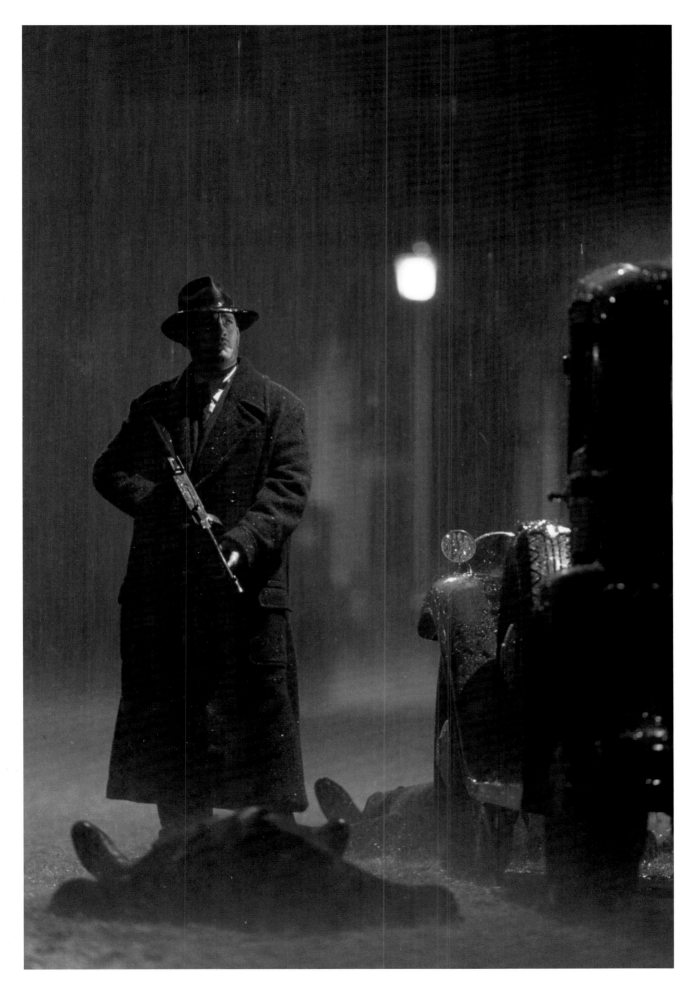

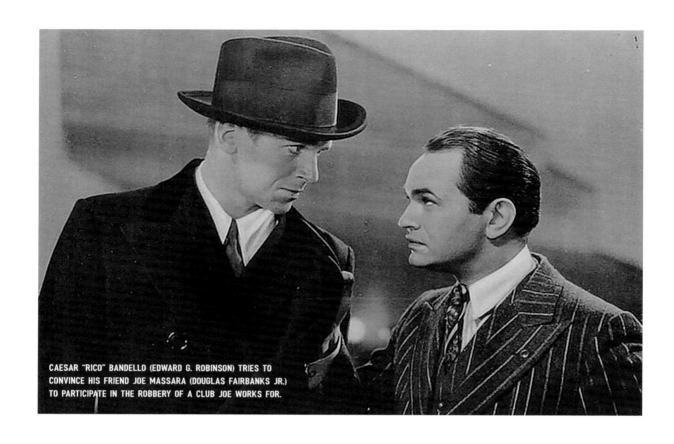

CAESAR "RICO" BANDELLO (EDWARD G. ROBINSON) TRIES TO
CONVINCE HIS FRIEND JOE MASSARA (DOUGLAS FAIRBANKS JR.)
TO PARTICIPATE IN THE ROBBERY OF A CLUB JOE WORKS FOR.

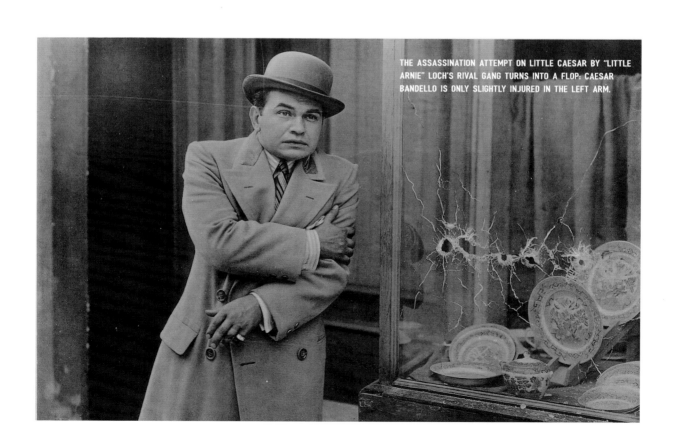

THE ASSASSINATION ATTEMPT ON LITTLE CAESAR BY "LITTLE
ARNIE" LOCH'S RIVAL GANG TURNS INTO A FLOP: CAESAR
BANDELLO IS ONLY SLIGHTLY INJURED IN THE LEFT ARM.

LITTLE CAESAR

UNITED STATES, 1931
DIRECTOR: MERVYN LEROY

After a bloody attack on a gas station, small-time thug Caesar "Rico" Bandello (Edward G. Robinson) convinces his friend and accomplice Joe Massara (Douglas Fairbanks Jr.) to move to Chicago and try their luck in organized crime. Caesar, the more ambitious of the two, is rapidly hired by Sam Vettori (Stanley Fields), whose gang controls parts of the city's North Side, while Joe finds a job as a dancer in a night club run by rival gang boss "Little Arnie" Lorch (Maurice Black). Joe falls in love with his dance partner, Olga (Glenda Farrell) and wants to break with his gangster past. However, under Caesar's influence, he is forced to act as lookout for his friend during the hold-up of Little Arnie Lorch's club that takes place on New Year's eve. Caesar, who leads the heist, kills a crime commissioner who was trying to intervene and has to liquidate one of his accomplices, Tony Passa (William Collier Jr.) who is overcome with remorse and tries to confess to a priest. After this successful coup, Caesar takes over the leadership of his gang and gradually replaces an aging Sam Vettori. However, he has to withstand the surveillance of Sergeant Flaherty (Thomas E. Jackson), a tenacious policeman, and the growing animosity of Lorch who tries to have him shot. Slightly injured during an assassination attempt, Caesar goes to Lorch's house and forces him to flee the city to avoid being murdered. Now the master of the North Side district, Caesar has only one ambition: to make his old friend Joe his right-hand man. But Joe refuses and his fiancée Olga calls Sergeant Flaherty for help, telling him that Joe is ready to testify against Caesar. The latter arrives at the couple's apartment. He tries to kill Joe but doesn't succeed and has to flee with his faithful second Otero (George E. Stone), who gets shot by the police. Wanted by the police, Caesar sinks into misfortune and alcoholism. He is eventually shot by Flaherty in an ambush.

LEAD ACTORS: EDWARD G. ROBINSON (CAESAR ENRICO BANDELLO, ALIAS "LITTLE CAESAR" AND "RICO"), DOUGLAS FAIRBANK JR. (JOE MASSARA), GLENDA FARRELL (OLGA STASSOFF), GEORGE E. STONE (OTERO), STANLEY FIELDS (SAM VETTORI), THOMAS E. JACKSON (SERGEANT FLAHERTY), MAURICE BLACK ("LITTLE ARNIE" LORCH), SIDNEY BLACKMER ("BIG BOY"), RALPH INCE (PETER MONTANA), WILLIAM COLLIER JR. (TONY PASSA) / DIALOGUE: FRANCIS EDWARD FARAGOH, ROBERT N. LEE, AFTER WILLIAM R BURNETT'S NOVEL OF THE SAME NAME / MUSIC: DAVID MENDOZA / CATEGORIES: LIFE AND DEATH OF A GANGSTER / DURATION: 98 MINUTES / AWARD: NOMINATED FOR THE OSCAR FOR THE BEST SCREENPLAY / TRIVIA: ALTHOUGH THE FILM FEATURES ITALIAN GANGSTERS IN CHICAGO, NONE OF THE ACTORS WERE OF ITALIAN ORIGIN.

THE PUBLIC ENEMY

UNITED STATES, 1931
DIRECTOR: WILLIAM A. WELLMAN

From an early age, Tom Powers (James Cagney) and Matt Doyle (Edward Woods) have been an inseparable pair of petty criminals. They are recruited by a fence, Putty Nose (Murray Kinnell), who persuades them to rob a fur warehouse. But the job goes badly wrong, when a third accomplice, who is on lookout, is shot by a policeman on patrol. Tom and Matt have no choice but to kill the cop to escape his pursuit. To make matters worse, Putty Nose, who had promised to help, had left town to give himself an alibi. Although Mike (Donald Cook), Tom's very earnest brother and Molly (Rita Flynn), Matt's pretty sister, urge them to get back on the right track, the friends will not give up their dream of becoming high-profile criminals. The beginning of Prohibition, which finds them on the brink of manhood, gives them an unexpected opportunity. Tom and Matt are recruited by one of Chicago's underworld bosses, Paddy Ryan (Robert Emmett O'Connor), to monitor beer deliveries and punish uncooperative bartenders. As the bootlegging business flourishes, Tom and Matt become figures in the Chicago mob and hang out with Samuel "Nails" Nathan (Leslie Fenton), one of the city's

barons, with whom Paddy Ryan has allied himself against the gang of Schemer Burns. While Matt finds perfect love with his girlfriend Mamie (Joan Blondell), a far less romantic Tom falls out with his girlfriend Kitty (Mae Clarke) to the point of crushing half a grapefruit on her face. Soon after, he meets Gwen Allen (Jean Harlow), with whom he falls madly in love. But the accidental death of their godfather Nails Nathan, killed during a horse ride, breaks the precarious balance between the rival gangs. Paddy Ryan, weakened by the death of his ally, abandons his henchmen and flees the city. Spotted by Schemer Burns' gang, the friends are ambushed, and Matt is shot during the ensuing gunfight. Tom, desperate and lonely, manages to track down Schemer Burns. He kills his rival and part of his gang, but he is seriously injured. Even his admission to the hospital will not save him from his attackers.

This pre-code gangster film, filmed with uncompromising realism, is credited as being the one that revealed James Cagney's immense talent.

LEAD ACTORS: JAMES CAGNEY (TOM POWERS), EDWARD WOODS (MATT DOYLE), JEAN HARLOW (GWEN ALLEN), LESLIE FENTON (SAMUEL "NAILS" NATHAN), ROBERT EMMETT O'CONNOR (PADDY RYAN), DONALD COOK (MIKE POWERS), RITA FLYNN (MOLLY DOYLE), MURRAY KINNELL (PUTTY NOSE) / DIALOGUE: HARVEY F. THEW, BASED ON THE NOVEL BEER AND BLOOD BY JOHN BRIGHT AND KUBEC GLASMON / MUSIC: DAVID MENDOZA / CATEGORIES: LIFE AND DEATH OF A GANGSTER, PROHIBITION, BOOTLEGGING, RIVAL GANG WARFARE / DURATION: 83 MINUTES / AWARD: AN OSCAR NOMINATION / TRIVIA: DESPITE THE LIBERAL SPIRIT THAT PREVAILED IN FILM STUDIOS BEFORE THE HAYES CODE, THE SCENE WHERE A FLAMBOYANTLY GAY TAILOR TAKES TOM POWERS' MEASUREMENTS WAS CUT DURING THE ORIGINAL EDITING.

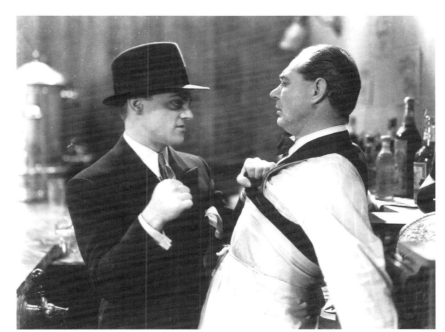

TOM POWERS (JAMES CAGNEY) FORCES A BARTENDER
TO ACCEPT BEER DELIVERED AT PADDY RYAN'S BEHEST.

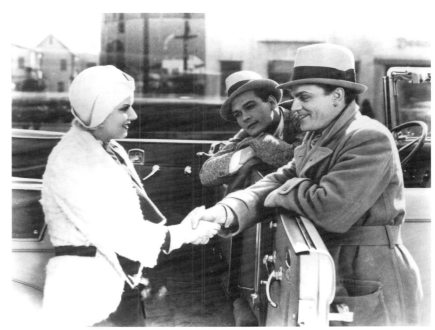

TOM MEETS GWEN ALLEN (JEAN HARLOW) UNDER
THE APPROVING GAZE OF MATT (EDWARD WOODS).

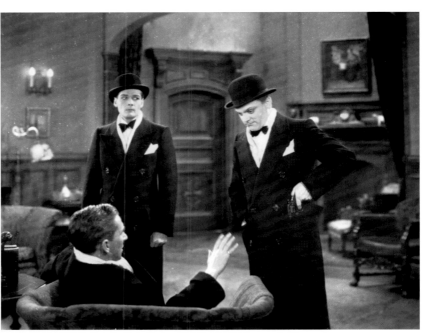

TOM AND MATT SETTLE SCORES WITH THEIR
FORMER PATRON PUTTY NOSE (MURRAY KINNELL).

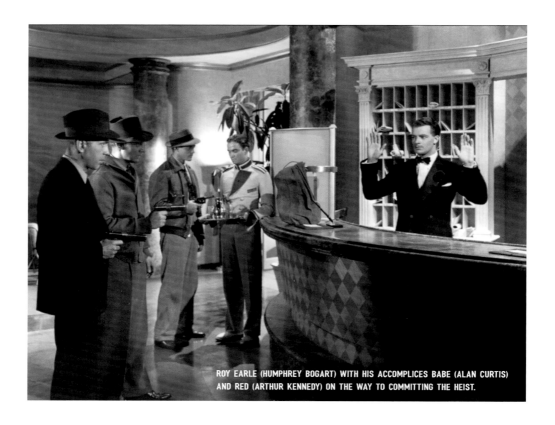

ROY EARLE (HUMPHREY BOGART) WITH HIS ACCOMPLICES BABE (ALAN CURTIS)
AND RED (ARTHUR KENNEDY) ON THE WAY TO COMMITTING THE HEIST.

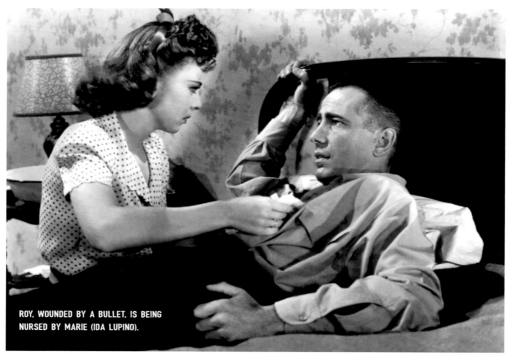

ROY, WOUNDED BY A BULLET, IS BEING
NURSED BY MARIE (IDA LUPINO).

LEAD ACTORS: HUMPHREY BOGART (ROY EARLE), IDA LUPINO (MARIE GARSON), JOAN LESLIE (VELMA), ALAN CURTIS (BABE), ARTHUR KENNEDY (RED), HENRY TRAVERS (PA), DONALD MACBRIDE (BIG MAC), HENRY HULL (DOC BANTON), CORNEL WILDE (LOUIS MENDOZA), BARTON MACLANE (JAKE KRANMER) / DIALOGUE: JOHN HUSTON AND WILLIAM R. BURNETT, AFTER WILLIAM R BURNETT'S NOVEL OF THE SAME NAME / MUSIC: ADOLPH DEUTSCH / CATEGORIES: LIFE AND DEATH OF A GANGSTER, HEIST, MANHUNT / DURATION: 100 MINUTES

HIGH SIERRA

UNITED STATES, 1941
DIRECTOR: JOHN HUSTON, W.R. BURNETT

Bank robber Roy Earle (Humphrey Bogart) is serving a long-term sentence in an eastern prison when he receives a Governor's pardon with the help of an aging gangster boss, Big Mac (Donald MacBride) who needs him to organize a safe deposit box robbery at a luxury hotel resort somewhere in California's Sierra Nevada mountains. While lodging in a cabin near the luxury hotel to prepare the heist, Roy gets to know his two accomplices, Babe (Alan Curtis) and Red (Arthur Kennedy), two rather inexperienced and unpredictable little thugs. Babe has brought his girlfriend, Marie (Ida Lupino), whom Roy wants to send back to Los Angeles before deciding to let her stay because she seems wiser than the men. He also adopts the camp's dog, Pard, although the cabin caretaker warns him that the dog brings bad luck. As he travels to Los Angeles to receive Big Mac's final instructions, Roy stumbles upon Velma and her family and discovers that the girl has a clubbed foot. Roy falls in love with her and, at his own expense, pays for an operation that will allow her to walk normally. The surgery is a success, and Roy proposes to Velma, but she refuses because she is involved with someone else. A heart-broken Roy goes back to the mountains as the night of the robbery approaches. Although Roy has doubts about the accomplice within the hotel, the receptionist Louis Mendoza (Cornel Wilde), the heist begins normally thanks to Marie who acts as a lookout in one of the cars. When an armed watchman, intrigued by the noise, enters the lobby, Roy shoots him before fleeing. During the escape, Babe and Red are killed in a car accident.

Roy tries to deliver the stolen jewels to Big Mac, but the latter, who was very ill, has just died. His assistant, Jake Kranmer (Barton MacLane), a former cop, tries to grab the loot, but Roy resists and ends up killing Kranmer. Wounded in the shooting, Roy owes his salvation to Marie for whom he now has feelings, but the romance is short-lived: denounced by Mendoza, the couple is wanted by the police. Roy arranges Marie's escape and takes refuge in the mountains where he stands up to the police. Marie, who wants to save him, arrives on the scene with the dog Pard, who runs towards his master and accidentally causes his death.

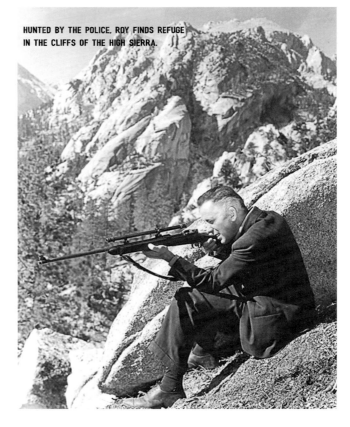

HUNTED BY THE POLICE, ROY FINDS REFUGE IN THE CLIFFS OF THE HIGH SIERRA.

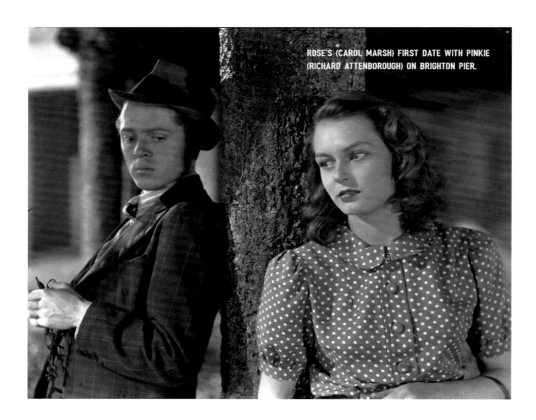

ROSE'S (CAROL MARSH) FIRST DATE WITH PINKIE (RICHARD ATTENBOROUGH) ON BRIGHTON PIER.

BRIGHTON ROCK

UNITED KINGDOM, 1948
DIRECTOR: JOHN BOULTING

This classic film based on a Graham Green novel is set in 1930s Brighton. Fred Hale (Alan Wheatley), a journalist who had investigated organized crime at the resort, thus indirectly contributing to the murder of one of the gang leaders, Kite, returns under a cover name for a promotional operation: he is supposed to leave cards all over the city, entitling whoever finds them to monetary prizes. Recognized by a gang of mobsters, he is pursued and murdered by their leader, Pinkie Brown, (Richard Attenborough), a young psychopath. To give himself an alibi, Pinkie sends one of his men, Spicer (Wylie Watson), to spread the cards all over Brighton as Hale would have done. But Spicer makes an unforgivable mistake: he leaves one of the cards in a cafe where he had had a beer, risking being identified by the staff. Pinkie, who goes there immediately, meets Rose (Carol Marsh), a naive young waitress who remembers Spicer's face perfectly. Instead of eliminating the young woman on the spot, Pinkie decides to seduce her as a way to buy her silence. At the same time, Ida Arnold (Hermione Baddeley), a variety actress who had met Fred Hale just before his death, conducts her own investigation using her divination powers. She traces Rose who is now married to Pinkie. To make matters worse, Colleoni (Charles Goldner), a much more powerful gang leader, decides to take control of the horse races, which are Pinkie's main financial resource. A desperate and increasingly violent Pinkie pushes Rose to commit suicide with him, but the intervention of Ida Arnold and the police, helped by one of the gang members, Dallow (William Hartnell), change his diabolical plan.

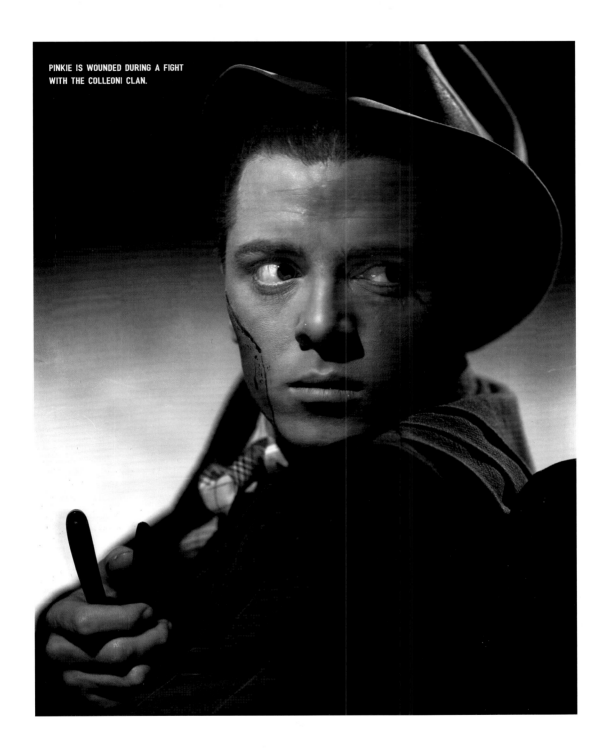

PINKIE IS WOUNDED DURING A FIGHT WITH THE COLLEONI CLAN.

LEAD ACTORS: RICHARD ATTENBOROUGH (PINKIE BROWN), CAROL MARSH (ROSE), HERMIONE BADDELEY (IDA ARNOLD), ALAN WHEATLEY (FRED HALE), WILLIAM HARTNELL (DALLOW), HARCOURT WILLIAMS (PREWITT), WYLIE WATSON (SPICER), NIGEL STOCK (CUBITT), VIRGINIA WINTER (JUDY), CHARLES GOLDNER (COLLEONI), GEORGE CARNEY (PHIL CORKERY) / DIALOGUE: GRAHAM GREENE, TERENCE RATTIGAN, BASED ON GRAHAM GREEN'S NOVEL OF THE SAME NAME. / MUSIC: HANS MAY / CATEGORIES: MANHUNT, HORSERACE RACKET, GANG WARFARE / DURATION: 92 MINUTES

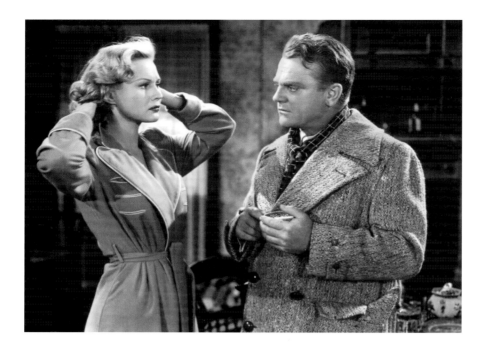

CODY JARETT (JAMES CAGNEY) AND HIS LOVELY WIFE VERNA (VIRGINIA MAYO).

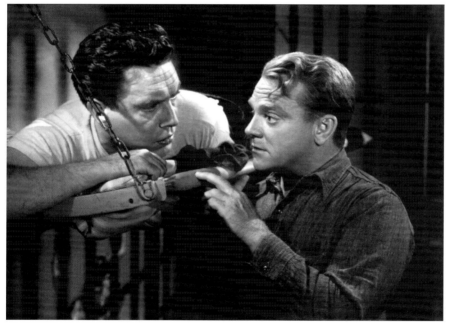

AFTER SAVING CODY JARETT'S LIFE, UNDERCOVER COP AND FAKE INMATE VIC PARDO (EDMOND O'BRIEN) BECOMES THE GANGSTER'S CONFIDANT.

18

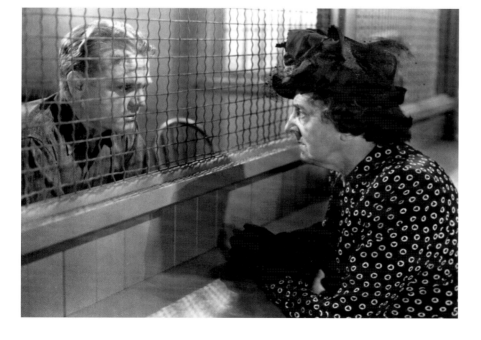

CODY JARETT LEARNS FROM HIS MOTHER (MARGARET WYCHERLY) THAT HIS WIFE AND HIS ACCOMPLICE BIG ED ARE CHEATING ON HIM.

WHITE HEAT

UNITED STATES, 1949
DIRECTOR: RAOUL WALSH

A psychopathic gangster, Cody Jarett (James Cagney), sets up an attack on a postal coach with a small crew of thugs. In the course of the operation, Jarett and his accomplices shoot in cold blood two of the train's crew who had tried to resist them, as well as the driver and his assistant. The ensuing long stakeout in a mountain cabin strains relations between Cody and his gang: one of his lieutenants, "Big Ed" (Steve Cochran), falls in love with Cody's beautiful wife Verna (Virginia Mayo) while Ma Jarett (Margaret Wycherly), Cody's mother, to whom Cody is pathologically bound, looks on in disapproval. When the gangsters finally make their way to California, one of them, badly injured during the train attack, is left behind. Fingerprints on a cigarette pack found after his death point the police to Cody. Soon afterwards, his mother is spotted by the police while shopping, and followed by Inspector Philip Evans' (John Archer) men who fail to arrest her. Cody decides to surrender to the authorities and to confess to a minor crime committed in Illinois to divert suspicion. Sentenced to a short prison term, Cody believes he is out of danger. But his wife Verna cheats on him with Big Ed and murders Ma Jarett with his help. In addition, Inspector Evans has placed one of his men in Jarett's cell to learn his secrets. Hank Fallon (Edmond O'Brien), under the false identity of inmate Vic Pardo, gains Cody's trust and accompanies him on an escape. The gangster, increasingly furious, seeks to settle scores with Big Ed and sets up a plan to get back at him. Deprived of contact with Evans, Vic Pardo displays particular ingenuity in order to sabotage Jarett's plans.

LEAD ACTORS: JAMES CAGNEY (CODY JARETT), EDMOND O'BRIEN (HANK FALLON/VIC PARDO), MARGARET WYCHERLY (MA JARETT), VIRGINIA MAYO (VERNA JARETT), STEVE COCHRAN ("BIG ED" SOMERS), JOHN ARCHER (PHILIP EVANS) / DIALOGUE: IVAN GOFF, BEN ROBERTS, BASED ON AN IDEA BY VIRGINIA KELLOGG / MUSIC: MAX STEINER / CATEGORIES: PSYCHOPATHIC GANGSTER, UNDERCOVER COP, POSTAL TRAIN ATTACK / DURATION: 114 MINUTES / AWARD: AN OSCAR NOMINATION / TRIVIA: A FORMER ICON OF AMERICAN SPORT PLAYS A SUPPORTING ROLE IN THE PRISON SCENES: JIM THORPE, ALSO KNOWN BY HIS NATIVE AMERICAN SAC AND FOX TRIBAL NAME: WA-THO-HUK (BRIGHT PATH) WAS THE FIRST NATIVE AMERICAN TO WIN TWO GOLD MEDALS AT THE 1912 OLYMPIC GAMES, IN THE PENTATHLON AND DECATHLON.HE WAS UNFAIRLY STRIPPED OF HIS MEDALS ON A TECHNICALITY, BUT NEVERTHELESS PURSUED A MULTI-FACETED ATHLETIC CAREER IN BASEBALL, BASKETBALL AND AMERICAN FOOTBALL. A FILM WAS EVEN DEDICATED TO HIM DURING HIS LIFETIME: "JIM THORPE: ALL AMERICAN" RELEASED IN 1951 WITH BURT LANCASTER IN THE LEAD ROLE.

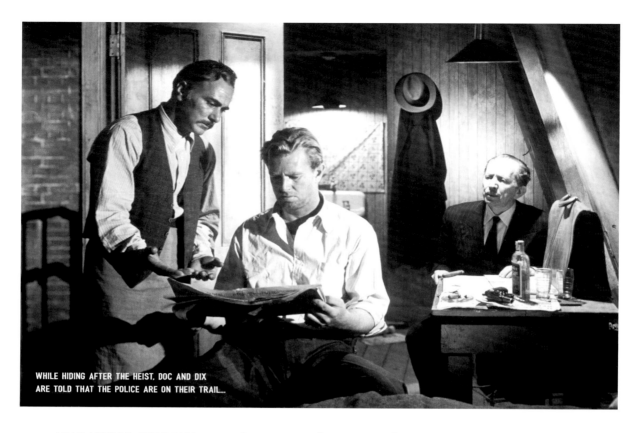

WHILE HIDING AFTER THE HEIST, DOC AND DIX ARE TOLD THAT THE POLICE ARE ON THEIR TRAIL...

LEAD ACTORS: STERLING HAYDEN (DIX HANDLEY), SAM JAFFE ("DOC" ERWIN RIEDENSCHNEIDER), LOUIS CALHERN (ALONZO EMMERICH), JEAN HAGEN (DOLL CONOVAN), MARILYN MONROE (ANGELA PHINLAY), JAMES WHITMORE (GUS MINISSI), MARC LAWRENCE (COBBY), BRAD DEXTER (BOB BRANNOM), JOHN MCINTIRE (POLICE COMMISSIONER HARDY), ANTHONY CARUSO (LOUIE CIAVELLI) /DIALOGUE: JOHN HUSTON, BEN MADDOW, AFTER WILLIAM R. BURNETT'S NOVEL OF THE SAME NAME / MUSIC: MIKLÓS RÓZSA / CATEGORIES: JEWEL ROBBERY, MANHUNT, CORRUPTED POLICEMEN / DURATION: 112 MINUTES / AWARDS: NOMINATED FOR FOUR OSCARS AND FOR THREE GOLDEN GLOBE AWARDS / TRIVIA: MARILYN MONROE'S ROLE AS ANGELA, EMMERICH'S YOUNG MISTRESS, MARKED THE START OF HER HOLLYWOOD CAREER. / FAMOUS QUOTATION: "CRIME IS ONLY A LEFTHANDED FORM OF HUMAN ENDEAVOR" ALONZO EMMERICH, PLAYED BY LOUIS CALHERN

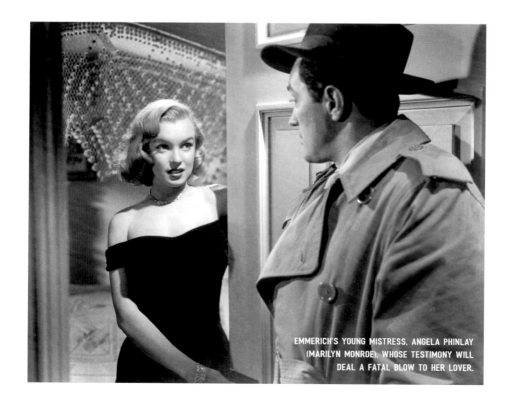

EMMERICH'S YOUNG MISTRESS, ANGELA PHINLAY (MARILYN MONROE), WHOSE TESTIMONY WILL DEAL A FATAL BLOW TO HER LOVER.

THE ASPHALT JUNGLE

UNITED STATES, 1950
DIRECTOR: JOHN HUSTON

While serving a prison sentence, criminal mastermind "Doc" Erwin Riedenschneider (Sam Jaffe) devised the perfect plan to rob a diamond dealer's shop and steal gemstones worth a million dollars. On his release, Doc Riedenschneider gets in touch with a bookie, Cobby (Marc Lawrence), who acts as an intermediary for a shady lawyer, Alonzo Emmerich (Louis Calhern). Emmerich promises to finance the heist and even offers to dispose of the loot. While talking to Cobby, Doc meets Dix Handley (Sterling Hayden), a small-time hoodlum who remains proud and determined despite being addicted to booze and gambling. Handley, the son of a Kentucky farmer, dreams of buying the family farm back and raising horses on it. He gladly accepts the offer to join Doc's team, as he knows he can count on the support of Gus (James Whitmore), a hunchbacked barkeeper who

protects him, and of his ex-girlfriend, Doll (Jean Hagen). Meanwhile, Emmerich, who is actually broke due to the lifestyle of his young mistress Angela (Marilyn Monroe), devises a plan to grab the loot and flee abroad. The burglary begins as planned, but an alarm goes off as the safecracker, Louie Ciavelli (Anthony Caruso) blows the door. The safecracker is seriously injured in the escape, while Doc, Dix and Gus manage to evade the police. When they arrive at Emmerich's house, they find him in the company of an accomplice, Bob Brannom (Brad Dexter) who forces them to hand over the loot. But Dix succeeds in killing Brannom and forces Emmerich to cooperate. The gangsters hope they can get away with it, however Commissioner Hardy's men are on their trail and won't give them that chance.

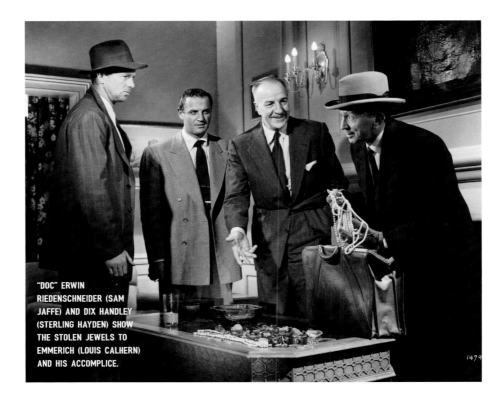

"DOC" ERWIN RIEDENSCHNEIDER (SAM JAFFE) AND DIX HANDLEY (STERLING HAYDEN) SHOW THE STOLEN JEWELS TO EMMERICH (LOUIS CALHERN) AND HIS ACCOMPLICE.

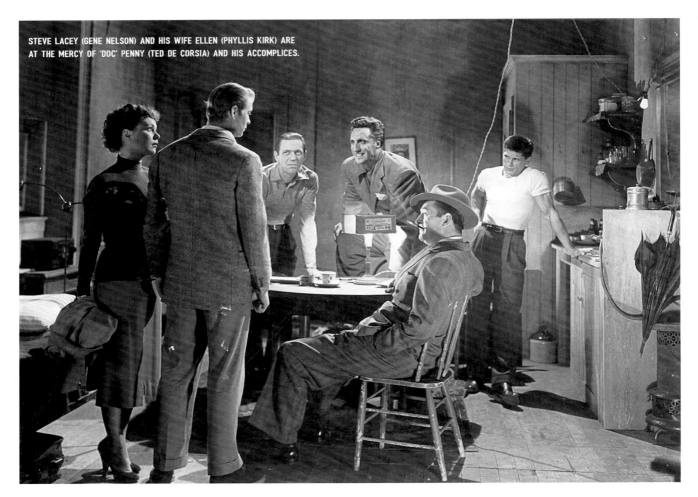

STEVE LACEY (GENE NELSON) AND HIS WIFE ELLEN (PHYLLIS KIRK) ARE
AT THE MERCY OF 'DOC' PENNY (TED DE CORSIA) AND HIS ACCOMPLICES.

LEAD ACTORS: GENE NELSON (STEVE LACEY), PHYLLIS KIRK (ELLEN LACEY), STERLING HAYDEN (DETECTIVE SIMS),
TED DE CORSIA (PENNY), CHARLES BRONSON (HASTINGS), JAY NOVELLO (DR. OTTO HESSLER), NEDRICK YOUNG
(GAT MORGAN), TIMOTHY CAREY (JOHNNY HASLETT) / DIALOGUE: CRANE WILBUR, BERNARD GORDON,
RICHARD WORMSER, BASED ON JOHN AND WARD HAWKINS' SHORT STORY CRIMINAL'S MARK PUBLISHED IN THE
SATURDAY EVENING POST / MUSIC: DAVID BUTTOLPH / CATEGORIES: MANHUNT, BANK HEIST / DURATION: 74 MINUTES /
TRIVIA: A YOUNG ACTOR, UNKNOWN TO THE PUBLIC, GOT THE ROLE OF HASTINGS AND WAS CREDITED FOR THE FIRST
TIME IN HIS CAREER: CHARLES BUCHINSKY, BETTER KNOWN UNDER THE PSEUDONYM CHARLES BRONSON.

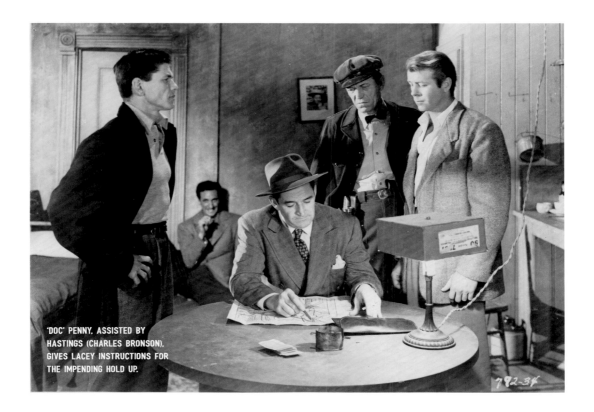

'DOC' PENNY, ASSISTED BY
HASTINGS (CHARLES BRONSON),
GIVES LACEY INSTRUCTIONS FOR
THE IMPENDING HOLD UP.

CRIME WAVE

UNITED STATES, 1954
DIRECTOR: ANDRE DeTOTH

Three escapees from San Quentin prison attack a small gas station at night. While the ringleader, 'Doc' Penny (Ted de Corsia), picks up the banknotes, a policeman on a motorcycle shows up and injures one of the criminals before being shot. The wounded gangster, Morgan (Nedrick Young), tries to reach the home of a former cellmate who has broken with his criminal past, Steve Lacey (Gene Nelson), where an alcoholic doctor turned veterinarian, Dr. Otto Hessler (Jay Novello), will extract the bullet. But Lacey and his wife Ellen (Phyllis Kirk) refuse to help him so as not to jeopardize Lacey's parole. Morgan dies before Hessler arrives, and Lacey forces the veterinarian to take care of the corpse. At the same time, an investigation is being conducted by an unconventional police officer, Detective Sims (Sterling Hayden). After questioning Steve, Sims traces the three thugs and suspects Lacey of helping Morgan. Taken to the police station, Lacey denies any involvement and Sims must release him after three days. Upon his return home, Lacey and his wife are taken hostage by Doc Penny and his accomplice Hasting (Charles Bronson) who try to force Lacey to take part in a bank hold up and organize their escape to Mexico. Lacey has no other choice but to collaborate, his only goal is to free his wife and to return to a normal life.

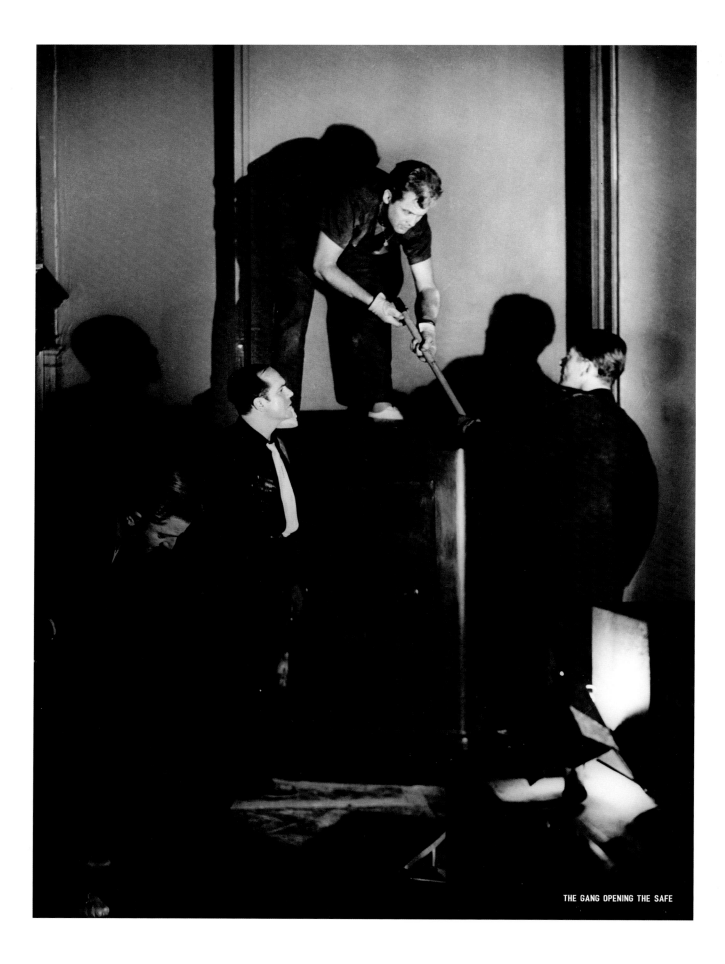

THE GANG OPENING THE SAFE

RIFIFI

FRANCE, 1955
DIRECTOR: JULES DASSIN

Tony le Stéphanois (Jean Servais) spent five years in prison for a burglary and came out with tuberculosis. He reconnects with his friends Jo le Suédois (Carl Möhner) and Mario Ferrati, (Robert Manuel) but refuses to join in on the robbery of a jewelry store that his friends are planning. His only concern is to find his former girlfriend, Mado (Marie Sabouret), with whom he has lost touch. When he discovers that she lives with the owner of a cabaret in Pigalle, Pierre Grutter (Marcel Lupovici), Tony goes there alone, determined to see her again. His old flame is ready to leave Grutter and follow him, but Tony is so furious at her betrayal that he beats Mado in retaliation. Disillusionment motivates a change of mind and the decision to take the lead in the proposed burglary after all. The team is reinforced by an Italian safecracker, Cesar the Milanese, who is just as gifted at female conquests as he is at safecracking. The robbery of the jeweler's is a success, but a dizzying move by Cesar puts Pierre Grutter's men on the trail of Tony and his friends. The two gangs will brutally kill each other to get their hands on the loot...

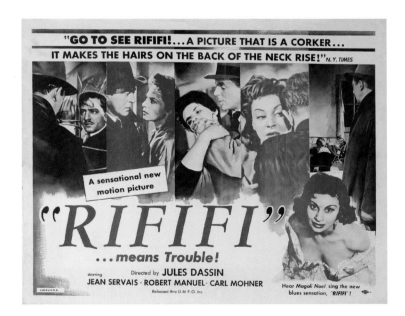

LEAD ACTORS: JEAN SERVAIS (TONY LE STÉPHANOIS), CARL MÖHNER (JO LE SUÉDOIS), ROBERT MANUEL (MARIO FERRATI), MARIE SABOURET (MADO), JANINE DARCEY (LOUISE), MARCEL LUPOVICI (PIERRE GRUTTER), ROBERT HOSSEIN (RÉMI GRUTTER), JULES DASSIN (CESAR) / DIALOGUE: JULES DASSIN, RENÉ WHEELER, AUGUSTE LE BRETON AFTER LE BRETON'S NOVEL OF THE SAME NAME / MUSIC: GEORGES AURIC / CATEGORIES: HEIST OF THE CENTURY, RIVAL GANGS / DURATION: 118 MINUTES / TRIVIA: FOR THE ROBBERY SCENE, JULES DASSIN OPTED TO SHOOT FOR MORE THAN THIRTY MINUTES IN ABSOLUTE SILENCE: NO DIALOGUE OR MUSIC ACCOMPANIES THE GANGSTERS' PROGRESSION TOWARDS THE SAFE. IN THIS WAY, THE DIRECTOR CAPTURED ALL THE TENSION THAT ANIMATED TONY LE STÉPHANOIS' TEAM AT THE FATEFUL MOMENT. / AWARDS: ONE AWARD (BEST DIRECTOR) AND A NOMINATION FOR PALME D'OR AT THE CANNES FILM FESTIVAL 1955

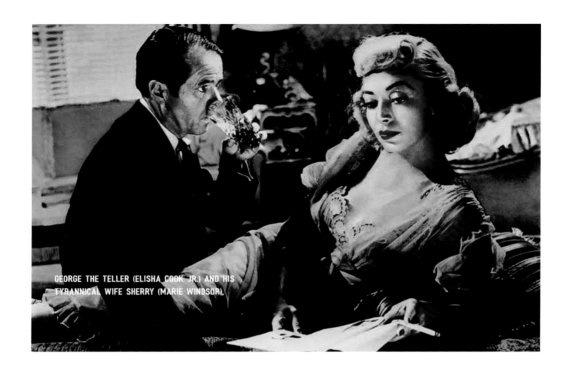

GEORGE THE TELLER (ELISHA COOK JR.) AND HIS
TYRANNICAL WIFE SHERRY (MARIE WINDSOR).

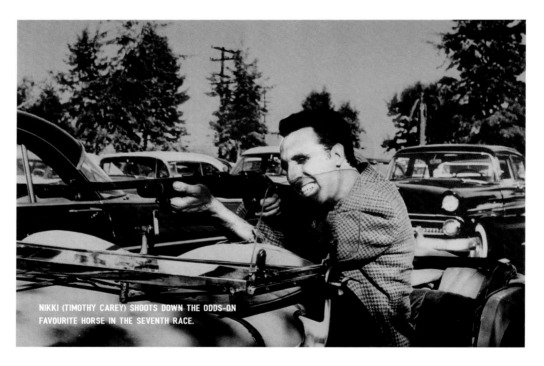

NIKKI (TIMOTHY CAREY) SHOOTS DOWN THE ODDS-ON
FAVOURITE HORSE IN THE SEVENTH RACE.

LEAD ACTORS: STERLING HAYDEN (JOHNNY CLAY), ELISHA COOK JR. (GEORGE PEATTY), MARIE WINDSOR
(SHERRY PEATTY), JAY C. FLIPPEN (MARVIN UNGER), TED DE CORSIA (PATROLMAN RANDY KENNAN), JOE SAWYER (MIKE),
VINCE EDWARDS (VAL CANNON), KOLA KWARIANI (MAURICE OBOUKHOFF), TIMOTHY CAREY (NIKKI ARCANE),
COLEEN GRAY (FAY) / DIALOGUE: STANLEY KUBRICK, JIM THOMPSON, BASED ON THE NOVEL CLEAN BREAK
BY LIONEL WHITE / MUSIC: GERALD FRIED / CATEGORIES: HEIST, PERFECT CRIME / DURATION: 84 MINUTES /
TRIVIA: MAURICE, THE WRESTLER PASSIONATE ABOUT CHESS, WAS PLAYED BY A PROFESSIONAL WRESTLER AND ACTIVE
CHESS PLAYER, KOLA KWARIANI. HE USES THE RUSSIAN WORD "PATSAN" (BOY, LAD) TO ADDRESS OTHER CHESS PLAYERS.

THE KILLING

UNITED STATES, 1956
DIRECTOR: STANLEY KUBRICK

Ex-convict Johnny Clay (Sterling Hayden) masterminds the ultimate, spectacular heist to put a glorious end to his criminal career: the robbery of a racetrack on a crowded day, which is expected to bring him and his gang two million dollars in cash. To accomplish his plan, he has recruited an unusual team that includes a dirty cop, Patrolman Randy Kennan (Ted de Corsia), one of the racetrack tellers, George (Elisha Cook Jr.), a bartender at the site, Mike (Joe Sawyer), a wrestler who must start a fight to create a diversion, Maurice (Kola Kwariani), and a sniper, Nikki (Timothy Carey) to shoot down the favourite horse in the seventh race to add to the confusion. Everything seems to be set like clockwork, however, one of the accomplices, George the teller, breaks his promise and tells his wife Sherry (Marie Windsor) about the plan. Sherry, who

wants to get rid of her husband, tells her lover Val (Vince Edwards) about the heist and prompts him to steal the loot from the gang. The heist goes through as planned, although Nikki is killed while on the run. The accomplices meet in an apartment to wait for Johnny who is transporting the loot but is delayed by traffic jams. To the gang's surprise, Val and a henchman are the first to arrive, and they are determined to get their hands on the money. In the ensuing gunfight, everyone is killed except George who, seriously wounded, manages to escape as Johnny pulls up in front of the building. While George returns home to shoot his unfaithful wife, Johnny heads for the airport with the two million to join his girlfriend, Fay (Coleen Gray), and start a new life. But bad luck is hanging over him...

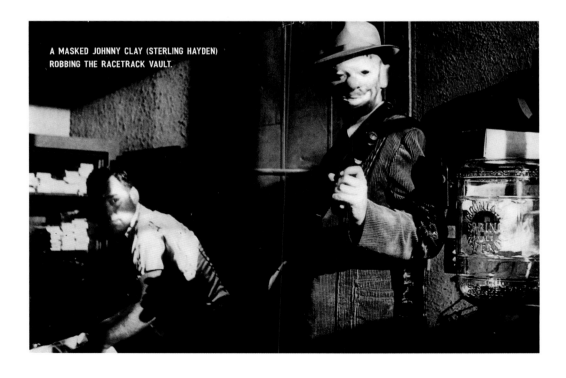

A MASKED JOHNNY CLAY (STERLING HAYDEN) ROBBING THE RACETRACK VAULT.

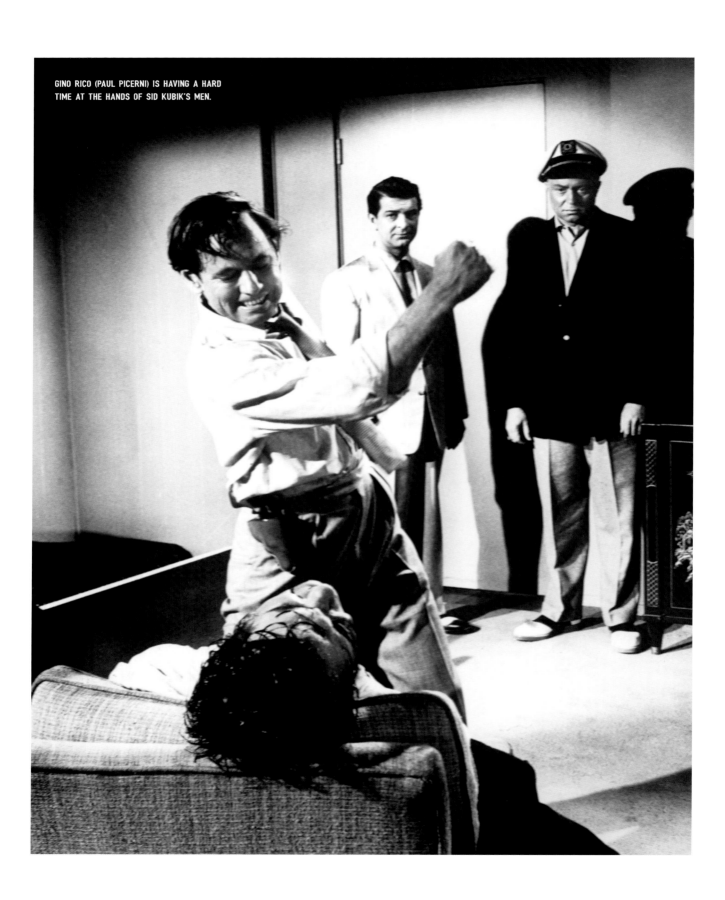

GINO RICO (PAUL PICERNI) IS HAVING A HARD
TIME AT THE HANDS OF SID KUBIK'S MEN.

THE BROTHERS RICO

UNITED STATES, 1957
DIRECTOR: PHIL KARLSON

Eddie Rico (Richard Conte), a former mob accountant, lives a contented life with his young wife Alice (Dianne Foster) in Florida, and runs a prosperous laundry business. But one day, an envoy of his former boss asks him to help and provide a job for a member of the syndicate who has to lay low for a while. This is the beginning of a series of events that will force Eddie to confront his past: Shortly afterwards, he meets his brother Gino (Paul Picerni), who confesses to him that he is on the run after taking part in a gang killing, a murder in which their third brother, Johnny (James Darren), is also involved.

Eddie, who believes in the magnanimity of his former boss Sid Kubik (Larry Gates), tries to plead the cause of his brothers, but quickly realises that Kubik has only one idea in mind: to liquidate the Rico family. A nail-biting manhunt ensues, and Eddie's old instincts return, even if he cannot rescue his younger brothers.

LEAD ACTORS: RICHARD CONTE (EDDIE RICO), DIANNE FOSTER (ALICE RICO), JAMES DARREN (JOHNNY RICO), KATHRYN GRANT CROSBY (NORAH RICO-MALAKS), LARRY GATES (SID KUBIK), HARRY BELLAVER (LAMOTTA), PAUL PICERNI (GINO RICO), RUDY BOND (CHARLIE GONZALES) / DIALOGUE: LEWIS MELTZER, BEN PERRY, BASED ON THE NOVEL OF THE SAME NAME BY GEORGES SIMENON / MUSIC: GEORGE DUNING / CATEGORIES: MANHUNT, REPENTANT GANGSTER / DURATION: 92 MINUTES

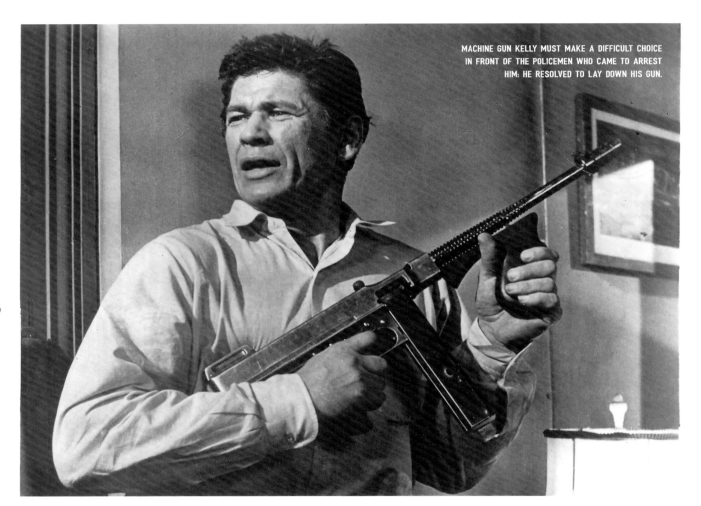

MACHINE GUN KELLY MUST MAKE A DIFFICULT CHOICE IN FRONT OF THE POLICEMEN WHO CAME TO ARREST HIM: HE RESOLVED TO LAY DOWN HIS GUN.

LEAD ACTORS: CHARLES BRONSON (GEORGE "MACHINE GUN" KELLY), SUSAN CABOT (FLORENCE "FLO" BECKER), MOREY AMSTERDAM (MICHAEL FANDANGO) / DIALOGUE: ROBERT WRIGHT CAMPBELL / MUSIC: GERALD FRIED / CATEGORIES: TRUE CRIME, PUBLIC ENEMY / DURATION: 80 MINUTES

MACHINE GUN KELLY

UNITED STATES, 1958
DIRECTOR: ROGER CORMAN

With Charles Bronson as George "Machine Gun" Kelly, one of the first criminals to top the FBI's most wanted list, one would expect a fast-paced biopic tracing the gangster's most notorious crimes. Director Roger Corman, however, decides to unveil the paradoxes of a strangely superstitious and cowardly character who is so afraid of death that he suspends the attack on a bank with accomplices after seeing a coffin cross his path. This man, obsessed by machine-guns and who seldom parts from his own, was also under the influence of his lover, "Flo" Becker (Susan Cabot), a determined woman who does not hesitate to provoke Kelly in his moments of doubt. Charles Bronson brilliantly plays the role of Machine Gun Kelly, an anti-hero switching from the greatest cold-bloodedness to a surprising cowardice in the blink of an eye, as in the final scene where he decides to surrender rather than to fight the policemen surrounding the safe house where he was hiding after conducting a kidnapping.

31

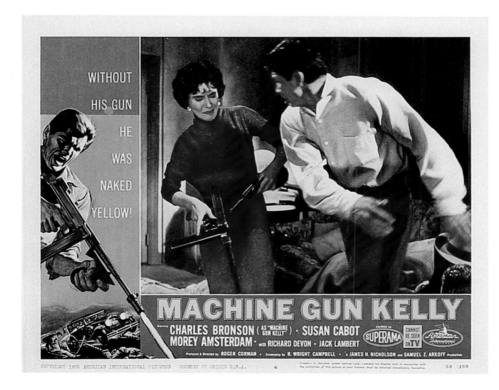

GEORGE "MACHINE GUN" KELLY
(CHARLES BRONSON) AND HIS PARTNER
FLORENCE BECKER (SUSAN CABOT)
FORM AN EXPLOSIVE COUPLE.

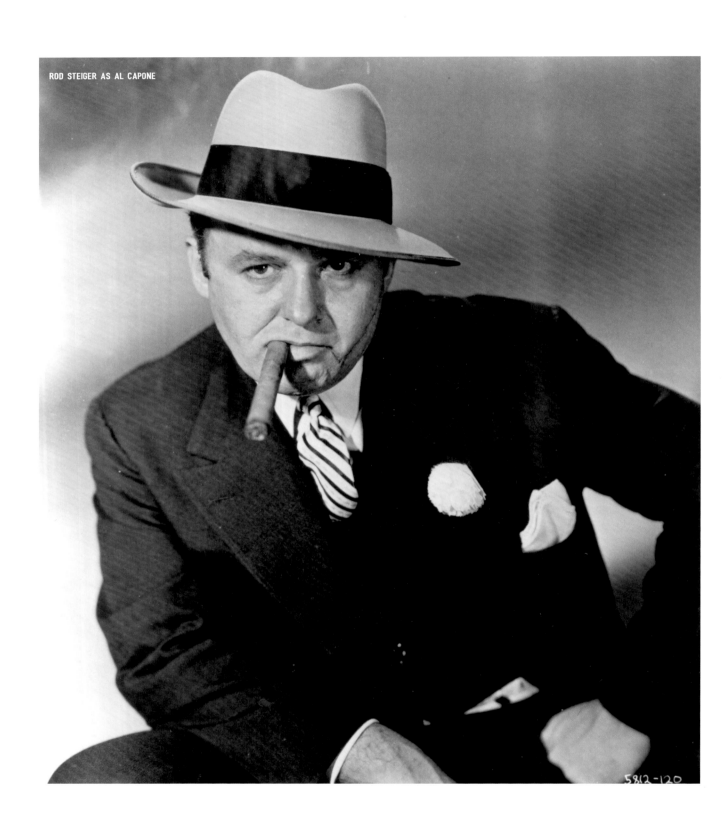

ROD STEIGER AS AL CAPONE

5812-120

LEAD ACTORS: ROD STEIGER (AL CAPONE), NEHEMIAH PERSOFF (JOHNNY TORRIO), JAMES GREGORY (SCHAEFER), FAY SPAIN (MAUREEN FLANNERY), JOE DE SANTIS (BIG JIM COLOSIMO), MURVYN VYE (GEORGE "BUGS" MORAN), ROBERT GIST (DEAN O'BANION), MARTIN BALSAM (MAC KEELY) / DIALOGUE: MALVIN WALD, HENRY F. GREENBERG / MUSIC: DAVID RASKIN / CATEGORIES: LIFE AND DEATH OF A GANGSTER / DURATION: 104 MINUTES

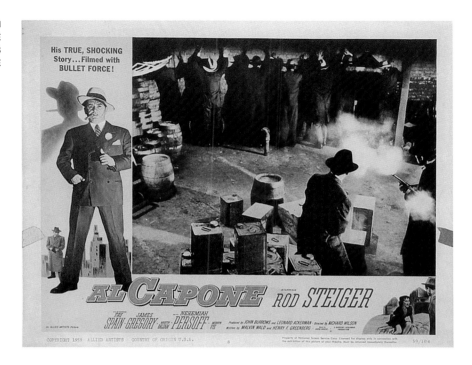

AL CAPONE

UNITED STATES, 1959
DIRECTOR: RICHARD WILSON

It took the talents of the actor Rod Steiger to play an authentic and complex Al Capone. Richard Wilson's film avoids the pitfall of romanticizing the legendary criminal and shows an ambitious, cynical, angry and brutal Al Capone, who is also capable of humanity and blessed with remarkable business acumen. From his debut in Chicago as Johnny Torrio's (Nehemiah Persoff) bodyguard to his fall from grace that led him to Alcatraz, all of the most famous gangster's deeds are recounted with a sense of historical accuracy: the elimination of "Big Jim" Colosimo (Joe De Santis), the godfather who had become a nuisance, the assassination of Dean O'Banion (Robert Gist), the golden age of Prohibition and bootlegging, the rivalry with the North Side gangs that led to the Saint Valentine's Day massacre. As if by contrast, the loneliness faced by police officer Schaefer (James Gregory), one of the few honest cops in the city, further accentuates the impression of total impunity that Al Capone and the members of the Outfit enjoyed. The final scene at Alcatraz, where Al Capone, aging and ill, is beaten by his fellow inmates with the tacit complicity of the guards, is all the more striking.

MA BARKER'S KILLER BROOD

UNITED STATES, 1960
DIRECTOR: BILL KARN

Kate "Ma" Barker was probably the first woman to be considered the mastermind of a criminal gang. A gang whose core was made up of Ma Barker's four sons, whom she had trained from a very young age to commit crimes. The only rule she instilled in them was "Never get caught!". Her ability to plan holdups down to the last detail, her manipulative skills, and the discipline she brought to the gang earned her a particular esteem among the greatest criminals of her time, such as John Dillinger and Baby Face Nelson. She joined forces with some of them to pull off some of the most spectacular heists of the early 1930s. Bill Karn's film offers a romanticized vision of Ma Barker's career, from the poor mother who encouraged her children's thieving instincts to the gang's undisputed matriarch.

Bank robberies, kidnappings, and murders were her signature: Ma Barker excelled at violent crime. She didn't hesitate to have one of her sons undergo extremely painful plastic surgery to shield him from FBI scrutiny. Ma Barker's peerless epic ended abruptly when her hideout in Florida was surrounded by FBI agents who had patiently tracked her down. She died with a Tommy gun in her hand at the side of her son Fred, true to her only principle "Never get caught!"

LEAD ACTORS: LURENE TUTTLE (MA BARKER), DON SPRUANCE (HERMAN BARKER), RON FOSTER (DOC BARKER), REX HOLMAN (LLOYD BARKER), ERIC MORRIS (FRED BARKER), PAUL DUBOV (ALVIN KARPIS), VICTOR LUNDIN (MACHINE GUN KELLY), MYRNA DELL (LOU) / DIALOGUE: F. PAUL HALL / MUSIC: GENE KAUER / CATEGORIES: LIFE AND DEATH OF A GANGSTER, CRIMINAL GANG, WOMAN GANGSTER / DURATION: 89 MINUTES

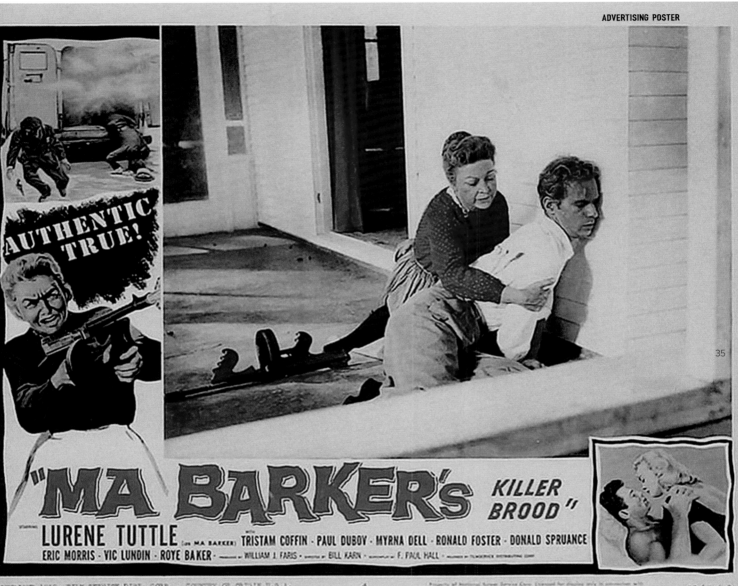

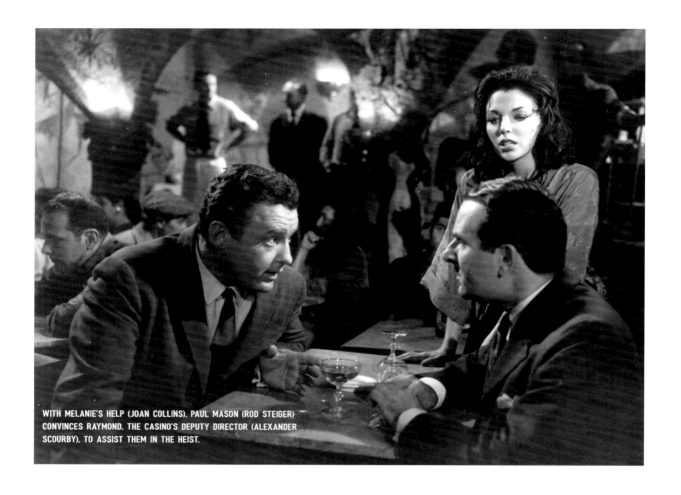

WITH MELANIE'S HELP (JOAN COLLINS), PAUL MASON (ROD STEIGER) CONVINCES RAYMOND, THE CASINO'S DEPUTY DIRECTOR (ALEXANDER SCOURBY), TO ASSIST THEM IN THE HEIST.

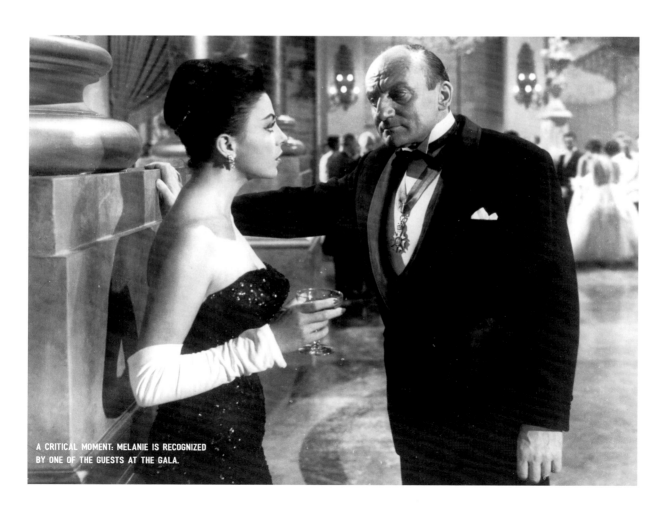

A CRITICAL MOMENT: MELANIE IS RECOGNIZED BY ONE OF THE GUESTS AT THE GALA.

PAUL MASON HELPS LOUIS THE
SAFECRACKER (MICHAEL DANTE)
TO OVERCOME HIS VERTIGO.

SEVEN THIEVES

UNITED STATES, 1960
DIRECTOR: HENRY HATHAWAY

Theo Wilkins (Edward G. Robinson) is a disgraced American professor who fell into disrepute and served time in prison. In revenge for a world that has robbed him of his fame and banished him, he sets up the perfect crime: the robbery of a Monte Carlo casino on a gala day. He has recruited a small team, but he lacks a fearless man to lead them. An opportunity arises when his friend Paul Mason (Rod Steiger), an experienced thief, is released from a three-year sentence. Wilkins gets Mason to fly from New York to Cannes and head up the operations. Mason, who is reluctant at the beginning, ends up accepting the professor's offer after meeting the only female accomplice, Melanie (Joan Collins), an exotic dancer who seduced the deputy director of the casino.

While Mason is falling under Melanie's spell, preparations for the heist move forward. Wilkins' plan is simple: with the help of the assistant director, the team is to blend in with the guests. While one of the accomplices, Poncho (Eli Wallach), accompanied by Wilkins, will play an angry and capricious billionaire in a wheelchair to divert attention, Mason and a safecracker, Louis (Michael Dante), assisted by Melanie, will enter the underground vault by sneaking into the director's apartment. Another accomplice acts as the ambulance driver to cover their escape. But nothing happens as planned. Only the cold-bloodedness and inventiveness of the gangsters allows them to reach their goal, although more surprises lay ahead.

LEAD ACTORS: ROD STEIGER (PAUL MASON), JOAN COLLINS (MELANIE), EDWARD G. ROBINSON (THEO WILKINS), ELI WALLACH (PONCHO), MICHAEL DANTE (LOUIS), ALEXANDER SCOURBY (RAYMOND LE MAY, THE CASINO'S DEPUTY DIRECTOR) / DIALOGUE: SYDNEY BOEHM, BASED ON MAX CATTO'S NOVEL THE LIONS AT THE KILL / MUSIC: DOMINIC FRONTIERE / CATEGORIES: PERFECT CRIME / DURATION: 102 MINUTES / AWARD: NOMINATED FOR THE OSCAR FOR THE BEST COSTUME DESIGN

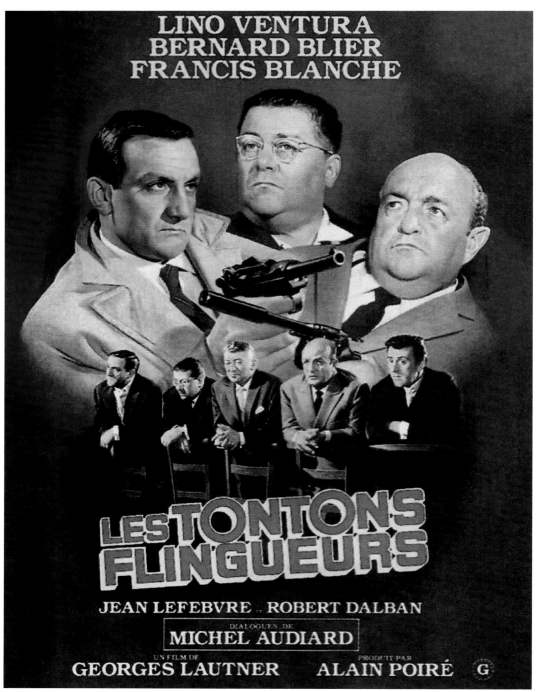

THE MOVIE POSTER

LEAD ACTORS: LINO VENTURA (FERNAND NAUDIN), BERNARD BLIER (RAOUL VOLFONI), JEAN LEFEBVRE (PAUL VOLFONI),
FRANCIS BLANCHE (MAÎTRE FOLACE), ROBERT DALBAN (JEAN THE BUTLER), VENANTINO VENANTINI (PASCAL),
HORST FRANK (THÉO), SABINE SINJEN (PATRICIA), CLAUDE RICH (ANTOINE DELAFOY) / DIALOGUE: MICHEL AUDIARD,
GEORGES LAUTNER, ALBERT SIMONIN / MUSIC: MICHEL MAGNE / CATEGORY: PARODY, PARISIAN MAFIA /
DURATION: 105 MINUTES

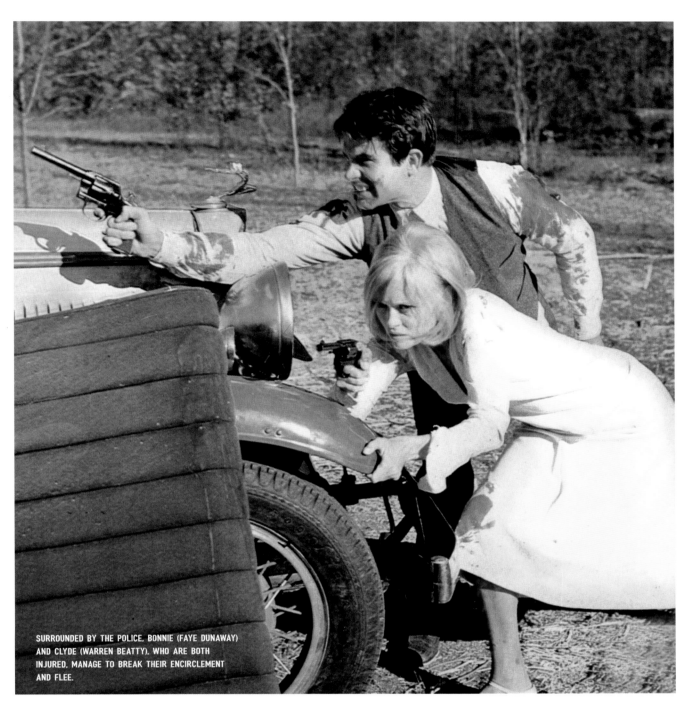

SURROUNDED BY THE POLICE, BONNIE (FAYE DUNAWAY) AND CLYDE (WARREN BEATTY), WHO ARE BOTH INJURED, MANAGE TO BREAK THEIR ENCIRCLEMENT AND FLEE.

LEAD ACTORS: WARREN BEATTY (CLYDE BARROW), FAYE DUNAWAY (BONNIE PARKER), MICHAEL J. POLLARD (C.W. MOSS), GENE HACKMAN (BUCK BARROW), ESTELLE PARSONS (BLANCHE BARROW), DENVER PYLE (FRANK HAMER), GENE WILDER (EUGENE GRIZZARD) / DIALOGUE: DAVID NEWMAN, ROBERT BENTON / MUSIC: CHARLES STROUSE / DURATION: 111 MINUTES / CATEGORY: LIFE AND DEATH OF LEGENDARY GANGSTERS / AWARDS: TEN NOMINATIONS AND TWO OSCAR AWARDS (BEST CAMERAMAN FOR BURNETT GUFFEY, BEST SUPPORTING ACTRESS FOR ESTELLE PARSONS), SEVEN GOLDEN GLOBES NOMINATIONS.

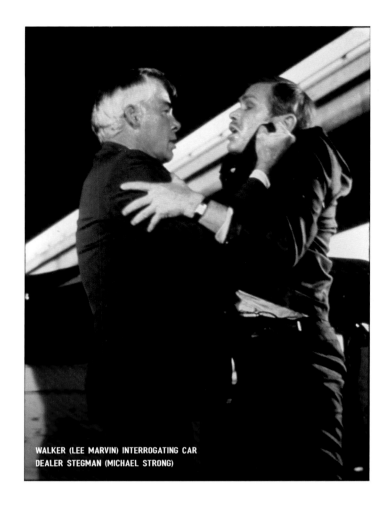

WALKER (LEE MARVIN) INTERROGATING CAR
DEALER STEGMAN (MICHAEL STRONG)

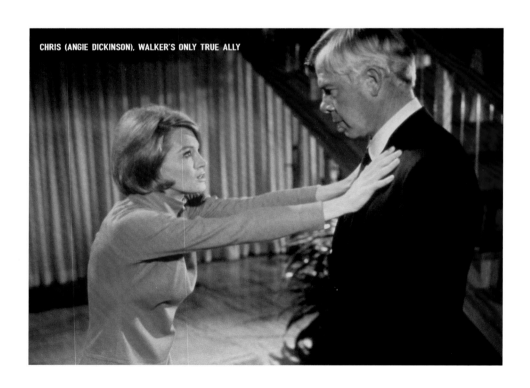

CHRIS (ANGIE DICKINSON), WALKER'S ONLY TRUE ALLY

LEAD ACTORS: LEE MARVIN (WALKER), JOHN VERNON (MAL REESE), SHARON ACKER (LYNNE), ANGIE DICKINSON (CHRIS),
KEENAN WYNN (YOST), MICHAEL STRONG (STEGMAN) LLOYD BOCHNER (CARTER), CARROLL O'CONNOR (BREWSTER) /
DIALOGUE: ALEXANDER JACOBS, DAVID NEWHOUSE, RAFE NEWHOUSE, ADAPTED FROM DONALD E. WESTLAKE'S NOVEL
THE HUNTER / MUSIC: JOHNNY MANDEL / CATEGORIES: GANG WAR, MANHUNT / DURATION: 92 MINUTES

POINT BLANK

UNITED STATES, 1967
DIRECTOR: JOHN BOORMAN

To help his longtime friend Mal Reese (John Vernon) repay a sum of money to "The Organization", a crime syndicate, Walker (Lee Marvin), a rather taciturn man, agrees to assist him in intercepting a money transfer organized by the underworld within the walls of the deserted Alcatraz prison. The two men, supported by Walker's wife Lynne (Sharon Acker), take a considerable amount of loot, but Reese, who is having an affair with Lynne decides to liquidate Walker and keep the money for himself. However, Walker miraculously survives being shot by Reese and swims back to shore. A year later, Walker and a mysterious man who calls himself Yost (Keenan Wynn) agree to eliminate Reese so Walker can get his share of the loot. Yost gives Walker his first lead: Lynne's new address. Walker expects to surprise Reese there, but Reese left Lynne several months ago. Lynne, very disturbed by the arrival of Walker, commits suicide with sleeping pills. A courier bringing cash to Lynne from Reese, puts Walker on the trail of Stegman (Michael Strong), a car dealer connected to The Organization. Violently questioned by Walker, Stegman drops information about Chris (Angie Dickinson), Lynne's sister, who is being courted by Reese. With Chris's help, and by thwarting the traps set in his path, Walker will succeed in eliminating not only Reese, but also the leaders of The Organization, Carter (Lloyd Bochner) and Brewster (Carroll O'Connor) from whom he wants his money back. This quest will take him back to Alcatraz...

45

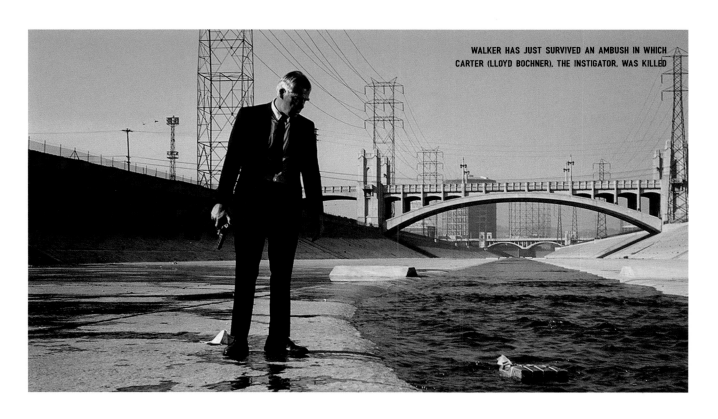

WALKER HAS JUST SURVIVED AN AMBUSH IN WHICH CARTER (LLOYD BOCHNER), THE INSTIGATOR, WAS KILLED

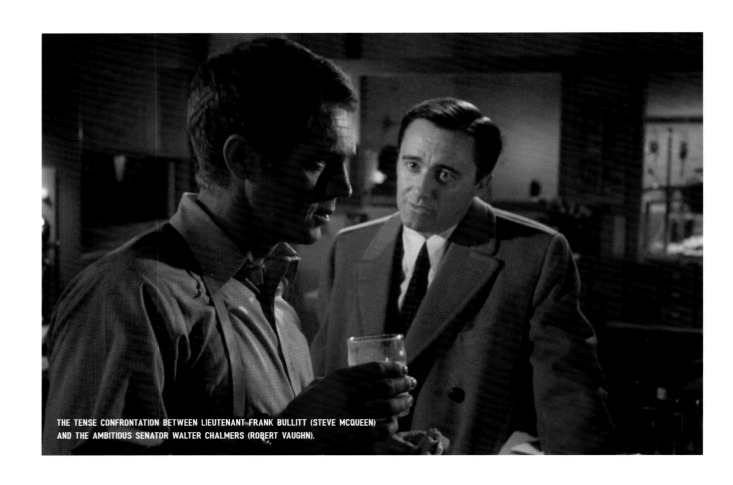

THE TENSE CONFRONTATION BETWEEN LIEUTENANT FRANK BULLITT (STEVE MCQUEEN)
AND THE AMBITIOUS SENATOR WALTER CHALMERS (ROBERT VAUGHN).

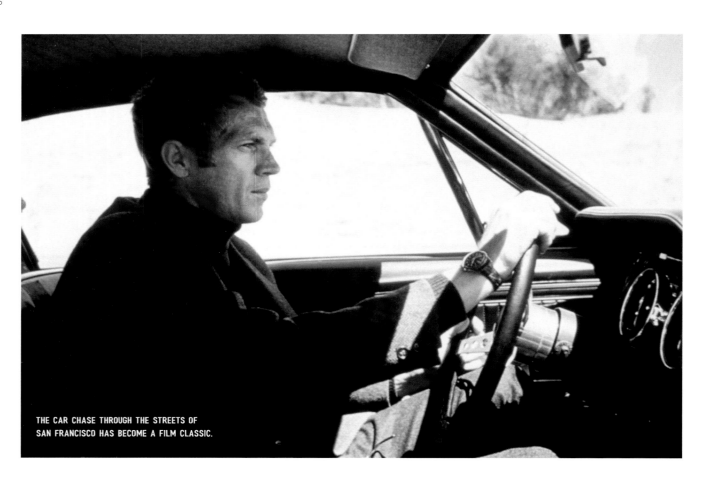

THE CAR CHASE THROUGH THE STREETS OF
SAN FRANCISCO HAS BECOME A FILM CLASSIC.

BULLITT

UNITED STATES, 1968
DIRECTOR: PETER YATES

Walter Chalmers (Robert Vaughn), an ambitious senator, has pledged to bring down Peter Ross, Chicago's mafia strongman. He has a valuable asset for this: Peter's own brother, Johnny (Pat Renella), who is suspected by the crime syndicate of having stolen several million from their coffers. To ensure the protection of his witness before his hearing, Chalmers brings him to San Francisco and asks the police to keep him safe in a hotel room. This mission is entrusted to Lieutenant Frank Bullitt (Steve McQueen) and his team. However, as one of the police officers starts his night shift, two suspicious men posing as his colleagues arrive at the hotel reception desk. Called for backup, Bullitt finds the witness in a coma and the policeman in charge of protecting him shot in the leg. The latter still has the strength to tell Bullitt that the witness himself removed the chain from the door, as if he were expecting a visitor. At the hospital where the wounded were transported, Senator Chalmers threatens Bullitt with administrative reprisals if the witness is not able to speak within the next few days. Shortly afterwards, one of the killers manages to infiltrate the hospital with the intention of finishing off Johnny Ross, but a nurse alerts Frank Bullitt and he chases the killer through the hospital corridors and then, by car, through the streets of San Francisco. The chase ends with the explosion of the car and the death of the killer. Upon Bullitt's return to the hospital, he is informed that Johnny Ross is dead. To prevent the case from being dropped, Bullitt quietly removes the body and spreads the rumor that Ross is still alive, causing Chalmers even more anger. Bullitt owes his salvation to the unwavering support of his superior officer. Information from an informant puts him on a new track: that of a woman whom Johnny Ross called at a hotel. When he arrives at the hotel, he discovers the corpse of a woman registered under the name of Dorothy Renick. Bullitt understands that Johnny Ross paid another man, Albert Renick (Felice Orlandi), to act as a decoy and had him and his wife murdered so that he could flee abroad. But Bullitt does not intend to let him get away that easily.

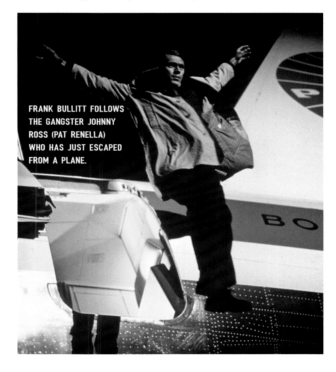

FRANK BULLITT FOLLOWS THE GANGSTER JOHNNY ROSS (PAT RENELLA) WHO HAS JUST ESCAPED FROM A PLANE.

LEAD ACTORS: STEVE MCQUEEN (FRANK BULLITT), ROBERT VAUGHN (SENATOR WALTER CHALMERS), JACQUELINE BISSET (CATHY), DON GORDON (DETECTIVE DELGETTI), SIMON OAKLAND (CAPTAIN BENNET), FELICE ORLANDI (ALBERT RENICK), PAT RENELLA (JOHNNY ROSS) / DIALOGUE: ALAN TRUSTMAN, HARRY KLEINER AFTER THE NOVEL MUTE WITNESS BY ROBERT L. FISH / MUSIC: LALO SCHIFRIN / DURATION: 113 MINUTES / CATEGORIES: MAFIA, WITNESS PROTECTION, GANGSTER ON THE RUN

MAFIA (THE DAY OF THE OWL)

FRANCE, ITALY, 1968
DIRECTOR: DAMIANO DAMIANI

A public works contractor, Salvatore Colasberna, is shot dead while driving his truck. The man was known for his persistent refusal to cooperate with the Mafia. The investigation looks like a difficult case for Captain Bellodi (Franco Nero), a police officer from Parma who has just been appointed to the small Sicilian town where the murder took place. Worryingly, a potential witness, who lived near where Colasberna was killed, has disappeared. His wife Rosa (Claudia Cardinale) refuses to say what she knows for fear of never seeing her husband again. But when she realizes that the local mafia boss, Don Mariano Arena (Lee J. Cobb) will do nothing to help her, she decides to confess that she saw a small-time gangster, Zecchinetta (Gaetano Cimarosa) prowling around the area on the day of the crime. The fact is corroborated by Parrinieddu (Serge Reggiani), an informant who plays a double game. While incarcerated, Zecchinetta spreads a rumor started by Don Mariano: Colasberna was killed by Rosa's husband and the latter is hiding in Palermo. But Captain Bellodi sees this as a mere diversion. He'll do whatever it takes to catch Don Mariano, who believes himself to be untouchable. The confrontation between the two men turns into a scandal when Bellodi has Don Mariano arrested. But the captain fails to find any convincing evidence - the only body he finds is that of Parrinieddu - and the local godfather's supporters manage to get him released. Bellodi is transferred to the mainland and replaced by a new, more compliant captain.

LEAD ACTORS: CLAUDIA CARDINALE (ROSA NICOLOSI), FRANCO NERO (CAPTAIN BELLODI), LEE J. COBB (DON MARIANO ARENA), GAETANO CIMAROSA (ZECCHINETTA), SERGE REGGIANI (PARRINIEDDU) / DIALOGUE: DAMIANO DAMIANI, UGO PIRRO, AFTER LEONARDO SCIASCIA'S EPONYMOUS NOVEL / MUSIC: GIOVANNI FUSCO / DURATION: 108 MINUTES / CATEGORIES: SICILIAN MAFIA, CORRUPTION, LINKS BETWEEN MAFIOSI AND POLITICIANS / REWARD: A NOMINATION AT THE BERLINALE / TRIVIA: ON ITS RELEASE IN ITALY, THE FILM WAS FORBIDDEN TO MINORS FOR ITS CORROSIVE AND UNCOMPROMISING CRITICISM OF PUBLIC INSTITUTIONS.

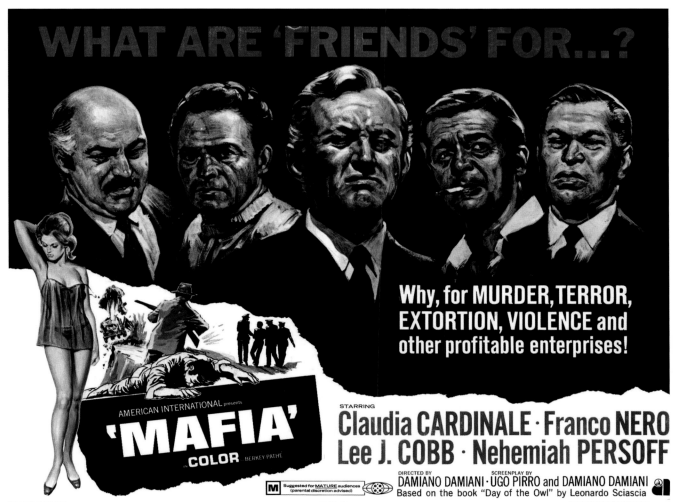

THE MOVIE POSTER

THE BIGGEST BUNDLE OF THEM ALL

UNITED STATES, 1968
DIRECTOR: KEN ANNAKIN

A former Chicago mafia boss, Cesare Celli (Vittorio De Sica), who lives quietly near Naples, is kidnapped by a gang of amateur thugs led by Harry Price (Robert Wagner) and his beautiful girlfriend Juliana (Raquel Welch). However, the kidnappers' hopes to obtain a substantial ransom for his release evaporate very quickly: The old don is penniless and none of his former affiliates wants to pay for his release. Exasperated both by the lack of respect from his former fellow gangsters, and by the ineptitude of his captors, Celli decides to take matters into his own hands. With the help of a mastermind, Professor Samuels (Edward G. Robinson), he sets up the theft of a shipment of $5 million worth of platinum ingots that is to be transported by train. While Celli sees this as a way to restore his wealth and get the gang out of trouble, Harry Price is determined to cross him to secure a bigger share of the take. He believes he can count on Juliana's charm to get crucial information from Celli, but the old man's delicate manners and the charm he exerts on the other accomplices will overpower the petty machinations. Although chased by the police, the gang manages to get their hands on the ingots and escape aboard a former fighter bomber, however bad luck accompanies the apprentice gangsters.

50

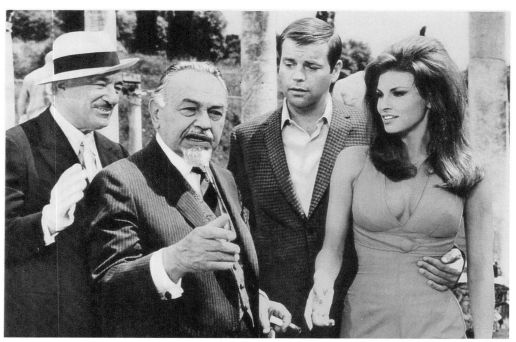

DON CESARE (VITTORIO DE SICA), PROFESSOR SAMUELS (EDWARD G. ROBINSON), HARRY PRICE (ROBERT WAGNER) AND JULIANA (RAQUEL WELCH) DISCUSS THE PROFESSOR'S PLAN TO STEAL PLATINUM INGOTS FROM AN ARMORED TRAIN.

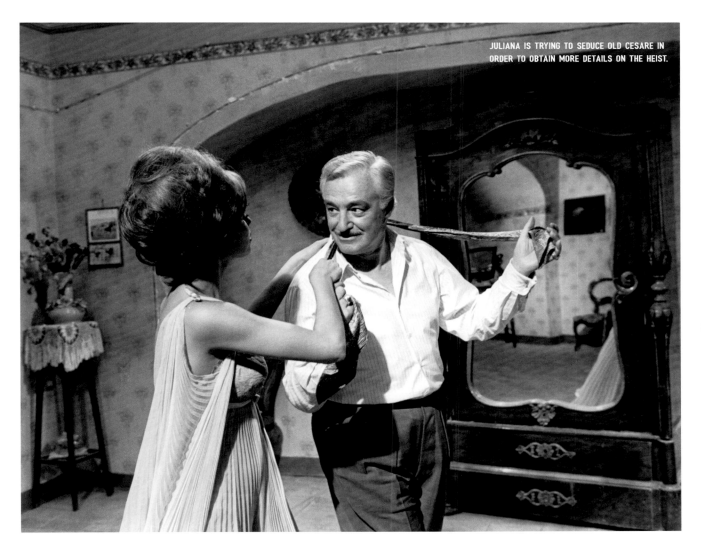

JULIANA IS TRYING TO SEDUCE OLD CESARE IN
ORDER TO OBTAIN MORE DETAILS ON THE HEIST.

51

LEAD ACTORS: VITTORIO DE SICA (CESARE CELLI), RAQUEL WELCH (JULIANA), ROBERT WAGNER (HARRY PRICE),
GODFREY CAMBRIDGE (BENNY BROWNSTEAD), DAVY KAYE (DAVEY COLLINS), FRANCESCO MULÈ (ANTONIO TOZZI),
EDWARD G. ROBINSON (PROFESSOR SAMUELS) / DIALOGUE: SY SALKOWITZ, JOSEF SHAFTEL / MUSIC: RIZ ORTOLANI /
DURATION: 105 MINUTES / CATEGORIES: KIDNAPPING, TRAIN ROBBERY, HEIST OF THE CENTURY

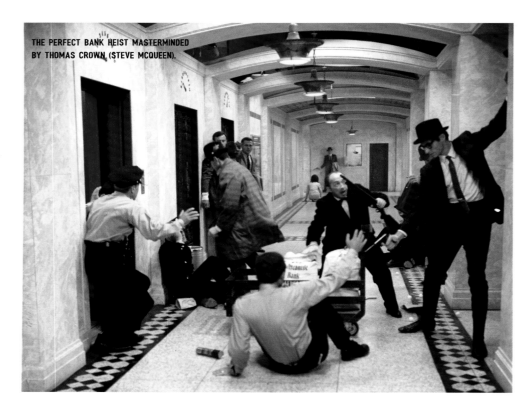

THE PERFECT BANK HEIST MASTERMINDED
BY THOMAS CROWN (STEVE MCQUEEN).

52

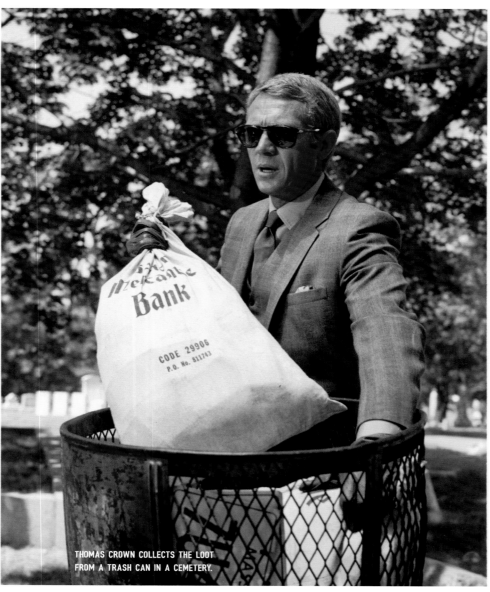

THOMAS CROWN COLLECTS THE LOOT
FROM A TRASH CAN IN A CEMETERY.

THE THOMAS CROWN AFFAIR

UNITED STATES, 1968
DIRECTOR: NORMAN JEWISON

Thomas Crown (Steve McQueen) is a young millionaire who seems to succeed at everything. A talented businessman, he is also an accomplished sportsman and a womanizer. To take on a new challenge in line with his intelligence, Crown decides to organize the robbery of a highly protected Boston bank. He hires five henchmen who do not know each other and to whom he never shows his face. The heist of the bank is a success, and one of the accomplices, Erwin Weaver (Jack Weston), brings the loot to the agreed location where Crown collects it. All he has to do is to carry his share of two million dollars to a numbered account in Switzerland. Meanwhile, Detective Eddy Malone (Paul Burke), who is in charge of the investigation, is struggling to find even the slightest clue. The bank's insurance company decides to send its most brilliant investigator, Vicki Anderson (Faye Dunaway), as backup. Her experience in similar cases prompts her to direct the search towards people who have travelled frequently to Switzerland in recent months. She identifies Crown as a prime suspect and takes the first opportunity to meet him. Without making a mystery of her purpose, Vicki Anderson leads Crown in a cat-and-mouse game where mutual attraction quickly takes over.

Although Vicki has found Erwin's trail, she is unable to accuse Crown because Erwin does not recognize him during a meeting in the same room, and Crown feigns indifference. The latter, who wants to test how deeply Vicki is in love with him, offers to repeat the same robbery, leaving her free either to stop him or to run away with him. It is a question of who will fall into the other's trap…

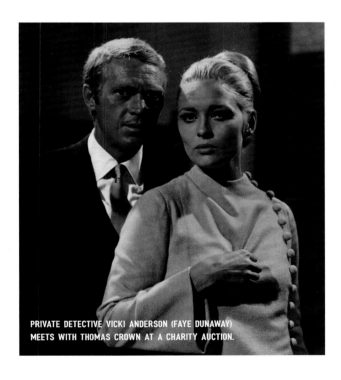

PRIVATE DETECTIVE VICKI ANDERSON (FAYE DUNAWAY) MEETS WITH THOMAS CROWN AT A CHARITY AUCTION.

53

LEAD ACTORS: STEVE MCQUEEN (THOMAS CROWN), FAYE DUNAWAY (VICKI ANDERSON), PAUL BURKE (DETECTIVE EDDY MALONE), JACK WESTON (ERWIN WEAVER) / DIALOGUE: ALAN TRUSTMAN / MUSIC: MICHEL LEGRAND / DURATION: 102 MINUTES / CATEGORIES: BANK HEIST, PERFECT CRIME, CRIMINAL MASTERMIND / AWARD: AN OSCAR AND A GOLDEN GLOBE FOR THE BEST ORIGINAL SONG ("THE WINDMILLS OF YOUR MIND" BY MICHEL LEGRAND) / TRIVIA: THE THOMAS CROWN AFFAIR IS ONE OF THE FIRST HOLLYWOOD MOVIES TO USE THE SPLIT-SCREEN TECHNIQUE TO CREATE A DYNAMIC IMAGE EFFECT.

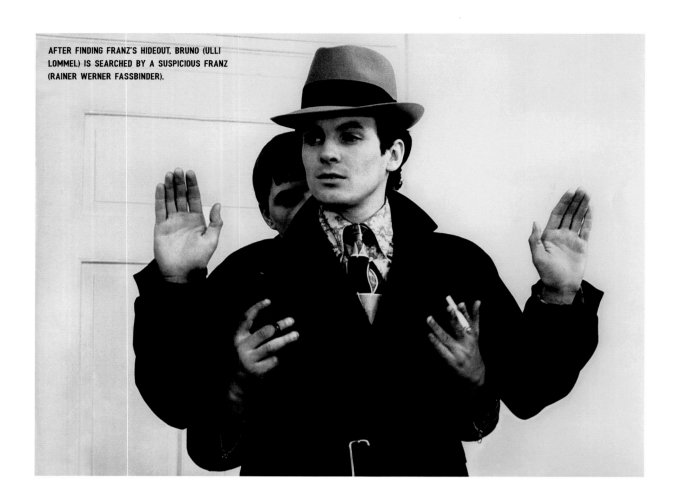

AFTER FINDING FRANZ'S HIDEOUT, BRUNO (ULLI
LOMMEL) IS SEARCHED BY A SUSPICIOUS FRANZ
(RAINER WERNER FASSBINDER).

54

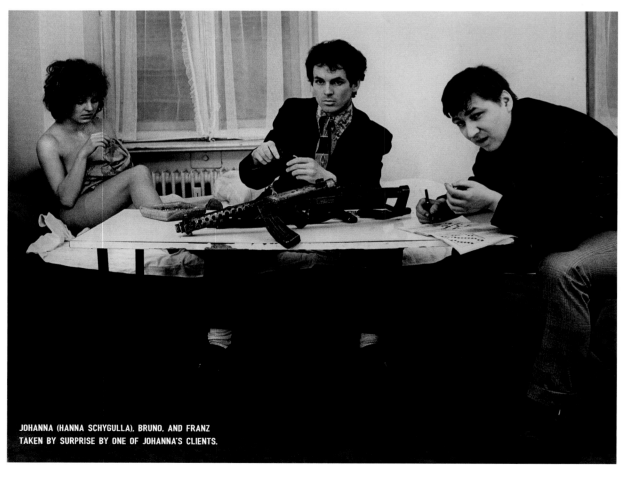

JOHANNA (HANNA SCHYGULLA), BRUNO, AND FRANZ
TAKEN BY SURPRISE BY ONE OF JOHANNA'S CLIENTS.

LOVE IS COLDER THAN DEATH

GERMANY, 1969
DIRECTOR: RAINER WERNER FASSBINDER

In this film made at the age of twenty-four, Rainer Werner Fassbinder deliberately opted for an aesthetic approach close to that of the French New Wave that had emerged in the 1960s. Moreover, he dedicated this early work to three French directors of the time: Claude Chabrol, Éric Rohmer and Jean-Marie Straub. Far from the standards of the genre, Fassbinder sets his actors in a universe that resembles a theater stage with long moments of either silence or music. The plot revolves around the love triangle formed by Franz (Rainer Werner Fassbinder), a small-time pimp, Johanna (Hanna Schygulla) the prostitute he protects, and Bruno (Ulli Lommel), a mysterious gangster whom Franz met when they were both being held by henchmen from a crime syndicate that wanted to recruit them. Bruno, who has agreed to work for the syndicate, is in charge of finding Franz, who refused and has gone underground in Munich. After reconnecting with Franz and meeting Johanna, Bruno helps Franz eliminate a Turkish man whose brother Franz killed.

To eliminate any witnesses, Bruno also shoots the waitress at the café where the murder took place. Franz, suspected by the police, is arrested but released for lack of evidence.

Meanwhile, Bruno and Johanna become lovers. Later on, Franz and Bruno plan an attack on a bank branch, but the police, secretly warned by Johanna, station plainclothes policemen to intercept the thugs. Bruno, equipped with a fake machine gun, is fatally wounded during the attack, while Franz and Johanna manage to escape with the dying body of their friend. When Johanna confesses her betrayal to Franz, he greets the news with a certain degree of indifference.

LEAD ACTORS: RAINER WERNER FASSBINDER (FRANZ), ULLI LOMMEL (BRUNO), HANNA SCHYGULLA (JOHANNA) / DIALOGUE: RAINER WERNER FASSBINDER, KATRIN SCHAAKE / MUSIC: HOLGER MÜNZER, PEER RABEN / DURATION: 88 MINUTES / CATEGORIES: LIFE AND DEATH OF A GANGSTER, BANK ROBBERY, SHOOT-OUT, PROSTITUTION.

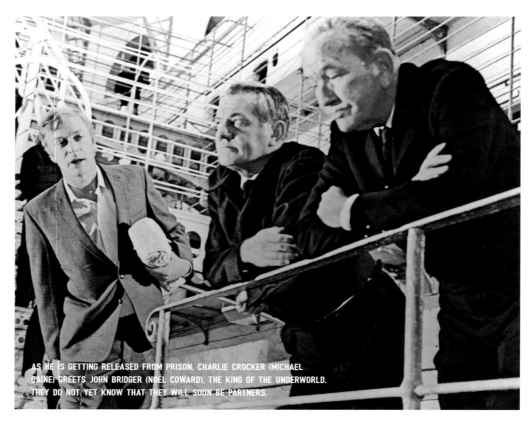

AS HE IS GETTING RELEASED FROM PRISON, CHARLIE CROCKER (MICHAEL
CAINE) GREETS JOHN BRIDGER (NOËL COWARD), THE KING OF THE UNDERWORLD.
THEY DO NOT YET KNOW THAT THEY WILL SOON BE PARTNERS.

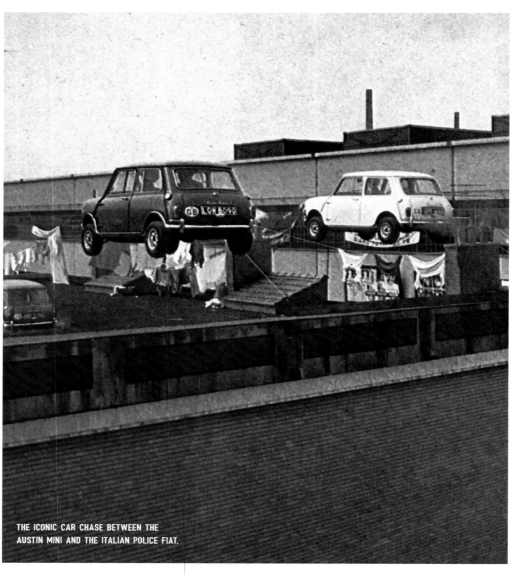

THE ICONIC CAR CHASE BETWEEN THE
AUSTIN MINI AND THE ITALIAN POLICE FIAT.

THE ITALIAN JOB

UNITED KINGDOM, 1969
DIRECTOR: PETER COLLINSON

Freshly released from prison, Charlie Croker (Michael Caine), a young gangster and womanizer, inherits a plan to pull off the heist of the century: his goal is to steal gold bars worth four million dollars in the heart of Turin. As he has neither means nor accomplices, Croker has to team up with Bridger (Noël Coward), an eccentric godfather who controls the British underworld from prison and decorates his cell with portraits of Queen Elizabeth. The team provided by Bridger is as eclectic as it is quirky, and consists of a computer genius (Benny Hill), who is supposed to disrupt the city's traffic control, professional robbers and daredevil drivers to drive three Austin Minis and escape with the gold bars in front of the police and the local mafia. Everything seems to be going according to plan, but in the euphoria of their success, the mobsters will make an irreparable mistake...

While the script's very British humor seems to make a mockery of traditional gangster films, the use of modern technology is a nod to the James Bond series, whose sixth opus, *On Her Majesty's Secret Service*, was released the same year. It is also the first film with a plot partly based on a computer bug.

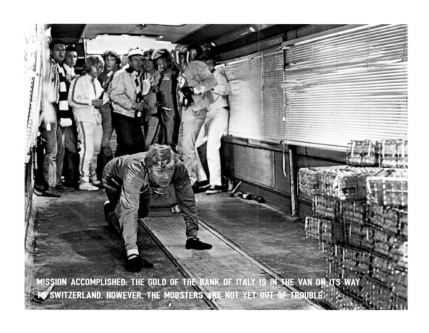

MISSION ACCOMPLISHED: THE GOLD OF THE BANK OF ITALY IS IN THE VAN ON ITS WAY TO SWITZERLAND. HOWEVER, THE MOBSTERS ARE NOT YET OUT OF TROUBLE.

LEAD ACTORS: MICHAEL CAINE (CHARLIE CROKER), NOËL COWARD (JOHN BRIDGER), BENNY HILL (SIMON PEACH), MAGGIE BLYE (LORNA) / DIALOGUE: TROY KENNEDY-MARTIN / MUSIC: QUINCY JONES/ DURATION: 99 MINUTES / CATEGORIES: HEIST OF THE CENTURY, PARODY

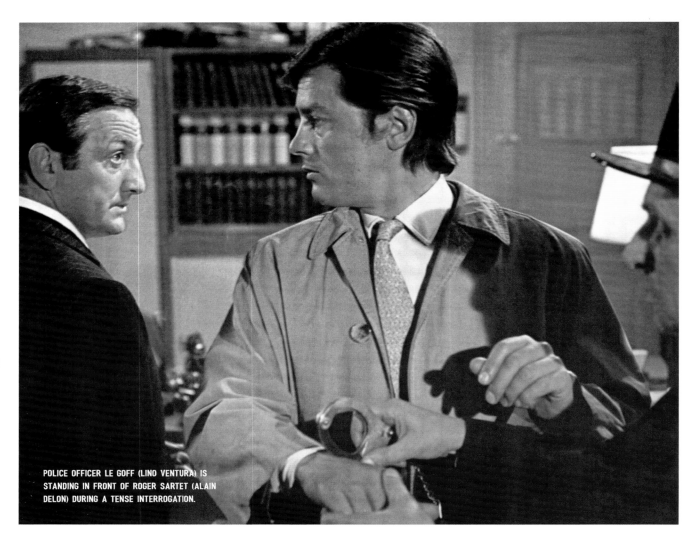

POLICE OFFICER LE GOFF (LINO VENTURA) IS
STANDING IN FRONT OF ROGER SARTET (ALAIN
DELON) DURING A TENSE INTERROGATION.

LEAD ACTORS: JEAN GABIN (VITTORIO MANALESE), LINO VENTURA (POLICE OFFICER LE GOFF), ALAIN DELON
(ROGER SARTET) / DIALOGUE: HENRI VERNEUIL, JOSÉ GIOVANNI, PIERRE PELEGRI / MUSIC: ENNIO MORRICONE /
DURATION: 117 MINUTES / CATEGORY: HEIST OF THE CENTURY / TRIVIA: THROUGH THE PORTHOLES OF THE HIJACKED
PLANE ONE CAN SEE THE MYTHICAL FRENCH LINER "LE FRANCE" DOCKED IN THE PORT OF NEW YORK.

THE SICILIAN CLAN

FRANCE, ITALY, 1969
DIRECTOR: HENRI VERNEUIL

Imprisoned for the murder of two policemen, gangster Roger Sartet (Alain Delon) knows that he is facing the death penalty. He manages to escape from a prison van thanks to the Manalese clan, a Sicilian mafia family based in France. Penniless because he had to pay for the help provided by the Manalese by handing over his complete fortune in the form of rare postage stamps, Sartet offers the clan's patriarch, Vittorio (Jean Gabin), an unlikely heist: to steal jewelry by French jewelers which will be exhibited at a museum in Rome. A test of the security system indicates that the gangsters have no chance, so they devise an alternative plan: the announced transfer of the jewels to New York gives the gangsters an opportunity for a hijacking. This is the plan chosen by Vittorio and his old Italian American friend Tony Nicosia (Amedeo Nazzari) to seize the rare pieces of jewelry.

Meanwhile, in Paris, the Police Officer Le Goff (Lino Ventura), who had arrested Sartet, vows to take him back into custody and send him to the gallows. One thing leading to another, he follows the track that leads him to the Manalese family. Sartet's impulsive character and his attraction for one of the clan wives will not help his relationship with old Vittorio...

59

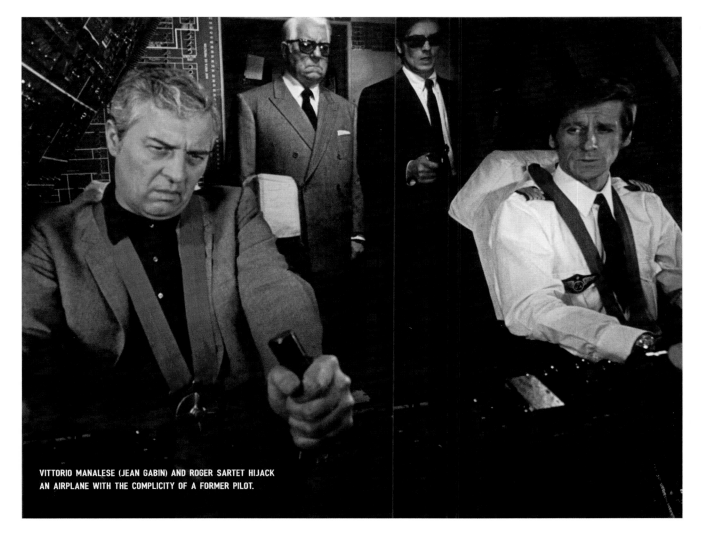

VITTORIO MANALESE (JEAN GABIN) AND ROGER SARTET HIJACK
AN AIRPLANE WITH THE COMPLICITY OF A FORMER PILOT.

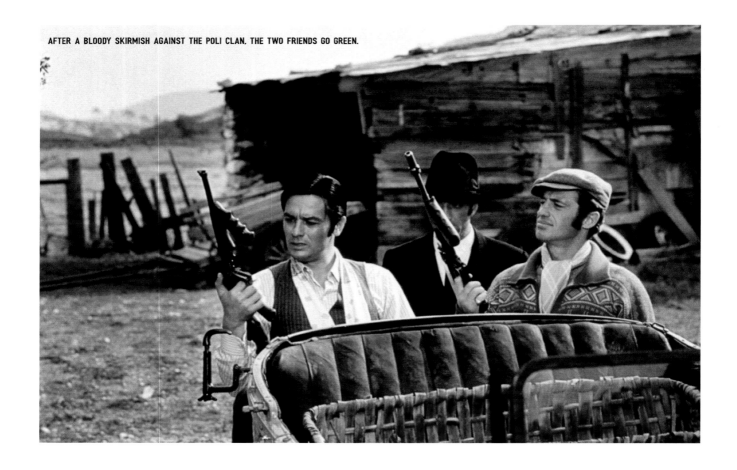

AFTER A BLOODY SKIRMISH AGAINST THE POLI CLAN, THE TWO FRIENDS GO GREEN.

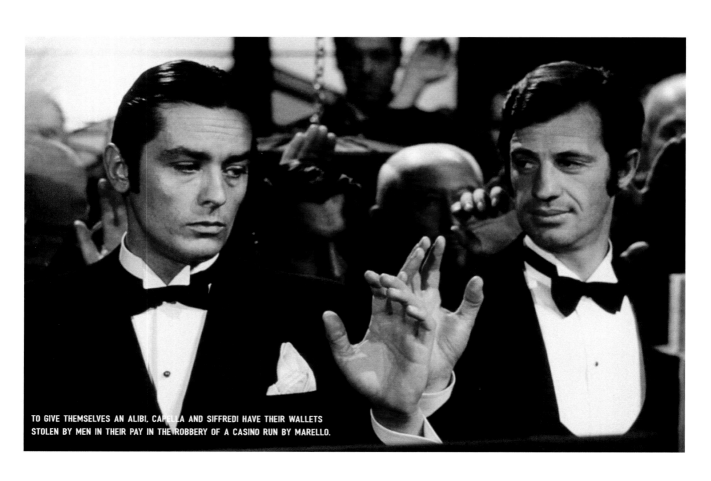

TO GIVE THEMSELVES AN ALIBI, CAPELLA AND SIFFREDI HAVE THEIR WALLETS
STOLEN BY MEN IN THEIR PAY IN THE ROBBERY OF A CASINO RUN BY MARELLO.

BORSALINO

FRANCE, ITALY, 1970
DIRECTOR: JACQUES DERAY

No sooner is young gangster Roch Siffredi (Alain Delon) out of jail than he gets revenge on the "Danseur", a small-time crook who ratted him out (Christian de Tillière), and looks for Lola (Catherine Rouvel). Lola, a prostitute who shared Siffredi's life before he was imprisoned is now the mistress of a ruthless mobster, François Capella (Jean-Paul Belmondo). After a merciless fight in front of Lola, Siffredi and Capella become friends and join forces for better or worse. The two thugs manage to gain a foothold in the Marseilles business world and to eliminate a number of competitors while gaining support from local politicians. When they take on one of the city's two godfathers, Poli (André Bollet), they know the game will be tough and that the other godfather, Marello (Arnoldo Foà), will keep an eye on them.

Following the rhythm of a 1920s comedy, Director Jacques Deray leads us into the Marseilles underworld with his flamboyant bosses who fraternize with the city's political and economic elite. Belmondo and Delon make one of their rare joint films.

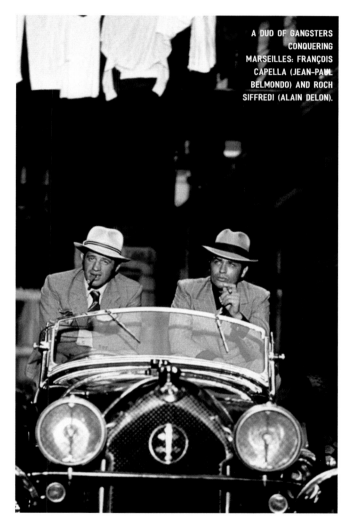

A DUO OF GANGSTERS CONQUERING MARSEILLES: FRANÇOIS CAPELLA (JEAN-PAUL BELMONDO) AND ROCH SIFFREDI (ALAIN DELON).

61

LEAD ACTORS : ALAIN DELON (ROCH SIFFREDI), JEAN-PAUL BELMONDO (FRANÇOIS CAPELLA), CATHERINE ROUVEL (LOLA), MICHEL BOUQUET (MAÎTRE RINALDI), FRANÇOISE CHRISTOPHE (SIMONE ESCARGUEL), MARIO DAVID (MARIO) / DIALOGUE: JEAN-CLAUDE CARRIÈRE, JEAN CAU, JACQUES DERAY AND CLAUDE SAUTET, BASED ON THE BOOK *BANDITS À MARSEILLE* BY EUGÈNE SACCOMANO / MUSIC: CLAUDE BOLLING / DURATION: 125 MINUTES / CATEGORIES: MARSEILLES MAFIA, MAFIA AND POLITICS / REWARD: A NOMINATION FOR THE GOLDEN GLOBES

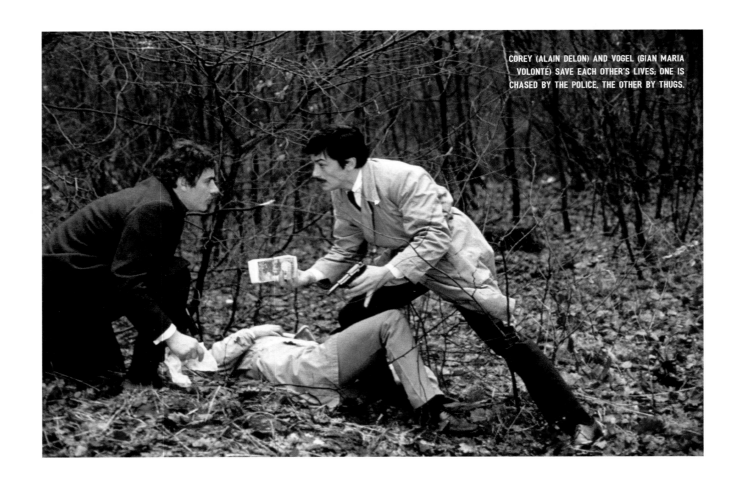

COREY (ALAIN DELON) AND VOGEL (GIAN MARIA VOLONTÉ) SAVE EACH OTHER'S LIVES; ONE IS CHASED BY THE POLICE, THE OTHER BY THUGS.

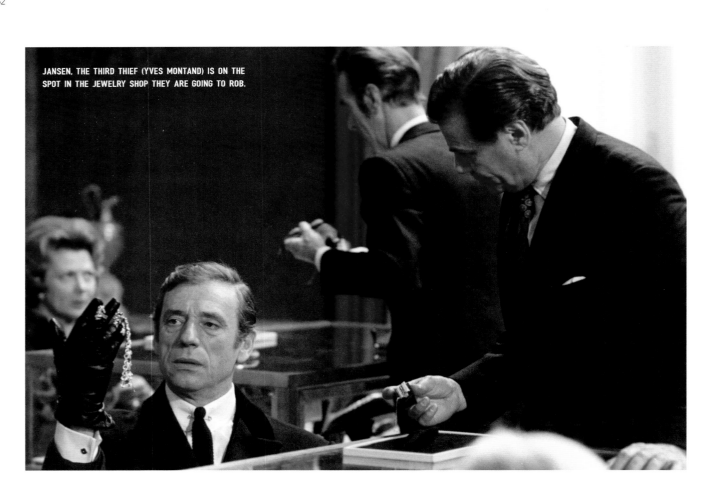

JANSEN, THE THIRD THIEF (YVES MONTAND) IS ON THE SPOT IN THE JEWELRY SHOP THEY ARE GOING TO ROB.

THE RED CIRCLE

FRANCE, ITALY, 1970
DIRECTOR: JEAN-PIERRE MELVILLE

While being transferred from Marseille to Paris on a night train, gangster Vogel (Gian Maria Volonté) manages to escape Police Officer Mattei (André Bourvil) who is escorting him. Although the police are on his heels, they do not succeed in taking him back. At the same time, another mobster, Corey (Alain Delon), who has just served his sentence, returns to Paris by car. Chance brings the two men together and circumstances make them closer: Corey manages to conceal Vogel during a roadside check, and Vogel saves Corey's life as he is being pursued by two former accomplices. Shortly before his release from prison, Corey was informed about a robbery opportunity by a crooked prison guard, and Corey involves Vogel in the preparations. While Police Officer Mattei, still on the trail of Vogel, interrogates his informants, Corey and his accomplice recruit a former disgraced policeman, Jansen (Yves Montand), who is known for his marksmanship. The team sets out to attack a jewelry store at Place Vendôme and pull off a masterstroke. But Police Officer Mattei has not given up yet.

The well-structured plot and the exceptional cast make the film a little masterpiece of French cinema in the 1970s. Just as much as a gangster film, it is a reflection on human destiny, as the quote from the Buddha emphasizes: "When men, even if they ignore each other, must meet one day, everything can happen to each of them, and they can follow divergent paths; on the day, inexorably, they will gather in the red circle."

63

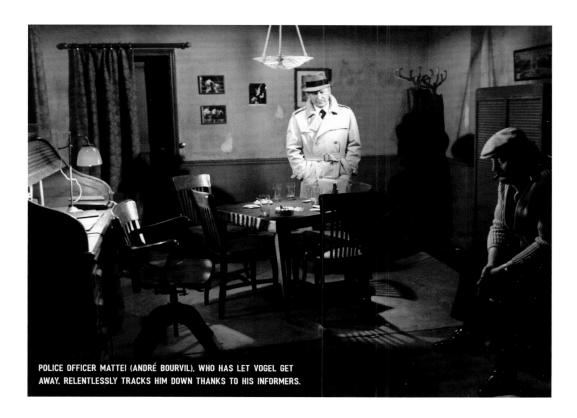

POLICE OFFICER MATTEI (ANDRÉ BOURVIL), WHO HAS LET VOGEL GET AWAY, RELENTLESSLY TRACKS HIM DOWN THANKS TO HIS INFORMERS.

LEAD ACTORS: ANDRÉ BOURVIL (POLICE OFFICER FRANÇOIS MATTEI), ALAIN DELON (COREY), YVES MONTAND (JANSEN), GIAN MARIA VOLONTÉ (VOGEL), WITH THE PARTICIPATION OF MIREILLE DARC / DIALOGUE: JEAN-PIERRE MELVILLE / MUSIC: ÉRIC DEMARSAN / DURATION: 140 MINUTES / CATEGORY: LIFE AND DEATH OF A GANGSTER

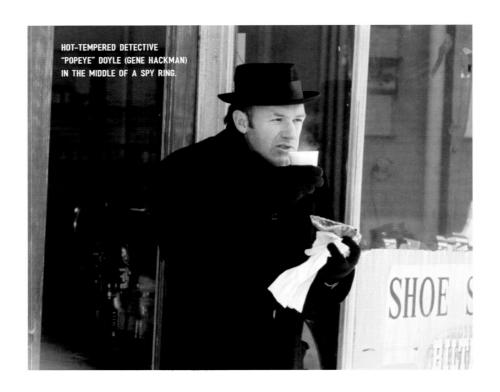

HOT-TEMPERED DETECTIVE "POPEYE" DOYLE (GENE HACKMAN) IN THE MIDDLE OF A SPY RING.

LEAD ACTORS: GENE HACKMAN (DETECTIVE JIMMY "POPEYE" DOYLE), ROY SCHEIDER (DETECTIVE BUDDY "CLOUDY" RUSSO), FERNANDO REY (ALAIN CHARNIER), TONY LO BIANCO (SAL BOCA) / DIALOGUE: ERNEST TIDYMAN, BASED ON ROBIN MOORE'S NON-FICTION BOOK OF THE SAME NAME / MUSIC: DON ELLIS / DURATION: 104 MINUTES / CATEGORY: DRUG TRAFFICKING / AWARDS: FIVE OSCARS (BEST PICTURE, BEST LEADING ACTOR, BEST DIRECTOR, BEST SCREENPLAY AND BEST EDITING)

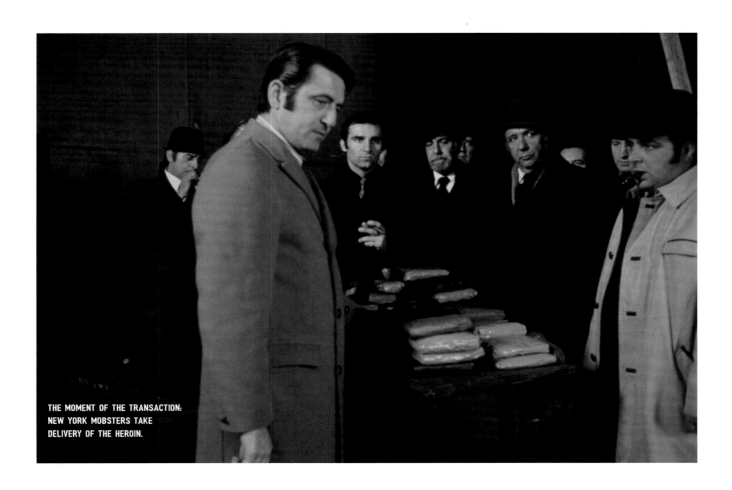

THE MOMENT OF THE TRANSACTION: NEW YORK MOBSTERS TAKE DELIVERY OF THE HEROIN.

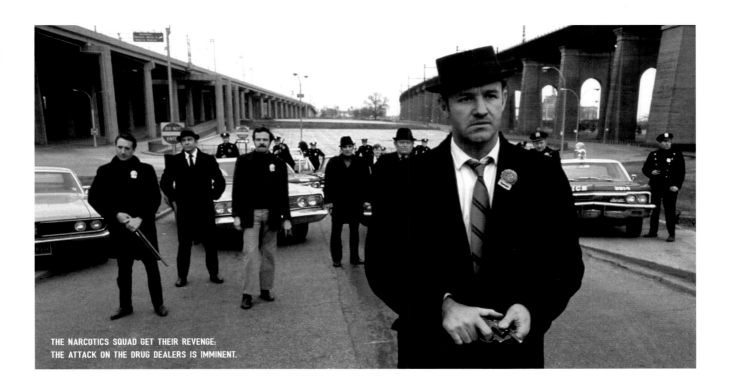

THE NARCOTICS SQUAD GET THEIR REVENGE:
THE ATTACK ON THE DRUG DEALERS IS IMMINENT.

THE FRENCH CONNECTION

UNITED STATES, 1971
DIRECTOR: WILLIAM FRIEDKIN

Two inspectors from the New York narcotics squad, Jimmy "Popeye" Doyle (Gene Hackman) and Buddy "Cloudy" Russo (Roy Scheider) track down drug dealers in Brooklyn bars. Information gathered during the arrest of a suspect puts them on the trail of an international network that supplies the United States from Marseilles. At the same time, in Marseilles, a French policeman is shot dead by one of Alain Charnier's henchmen, the leader of a gang that controls the heroin market (Fernando Rey).

As Charnier prepares to import a large quantity of drugs hidden in a car, New York detectives follow the trail of a suspect, Sal Boca (Tony Lo Bianco), who has links with big mob bosses. An intercepted phone call informs them that a Frenchman is trying to meet Boca: it's Charnier, who came to New York with the intention to sell the heroin. However, Charnier soon realizes that he is being shadowed, and he manages to escape

Detective Doyle in the chaos of the New York subway. Charnier, scalded by the incident, hides in Washington while giving the order to shoot the policeman. The assassination attempt fails, and an unhurt Doyle chases the killer who has taken refuge in a subway train, before shooting him in a brutal duel.

Shortly afterwards, Doyle and his colleagues spot the car they suspect contains the drug load and conduct an unsuccessful search of the car. Only Detective Russo's perspicacity leads them to the safe house. When the car is returned to an accomplice of Charnier's, it is discreetly followed by the police to the site of the transaction, a disused factory that is immediately surrounded.

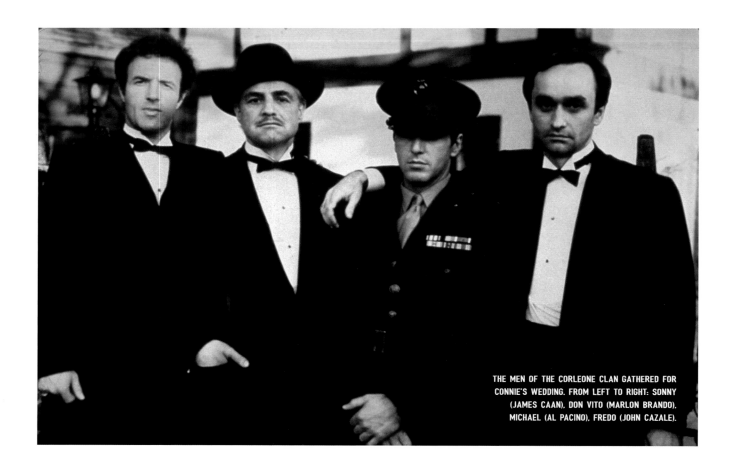

THE MEN OF THE CORLEONE CLAN GATHERED FOR
CONNIE'S WEDDING. FROM LEFT TO RIGHT: SONNY
(JAMES CAAN), DON VITO (MARLON BRANDO),
MICHAEL (AL PACINO), FREDO (JOHN CAZALE).

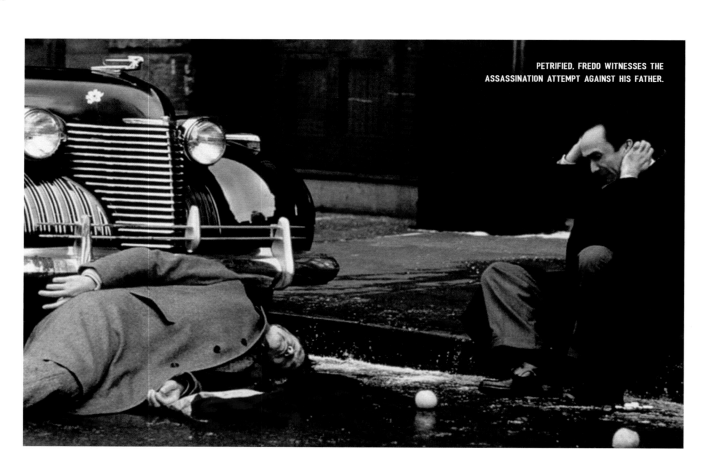

PETRIFIED, FREDO WITNESSES THE
ASSASSINATION ATTEMPT AGAINST HIS FATHER.

THE GODFATHER

UNITED STATES, 1972
DIRECTOR: FRANCIS FORD COPPOLA

The Godfather opens with a joyful scene: the marriage of Connie Corleone (Talia Shire), the daughter of Don Vito Corleone (Marlon Brando), to a clan affiliate. As the Second World War comes to an end, Don Vito, the Godfather, is at the height of his power; his family controls one of New York's five powerful Italian American gangs. Visitors flock to the wedding to ask him a favor that he cannot refuse, according to Sicilian custom, on the day of his daughter's matrimony. The occasion reunites his sons; Sonny, the eldest son with a bubbly character (James Caan); Fredo, the hypersensitive one (John Cazale); Michael (Al Pacino), who has joined the army and keeps his distance from the clan; and Tom Hagen (Robert Duvall), a street child of German-Irish origin adopted by the family, who has become the Godfather's *consigliere*. In spite of the joyful atmosphere, worries are never far away; a drug dealer, Virgil Sollozzo (Al Lettieri), supported by the rival clan Tattaglia, wants to obtain the Corleones' approval to develop his market, but Don Vito refuses to jeopardize the political support he enjoys for a business he disapproves of: a gang war ensues in which the Godfather is almost assassinated; Michael accepts the task of avenging his father by killing Sollozzo and a corrupt police officer working for him, before fleeing to Italy to escape reprisals. When Sonny is killed in an ambush, Michael must get back to New York and take over the family business. In order to impose his authority, he must first liquidate not only all his enemies, but also some of the faithful whose loyalty is no longer absolute.

67

LEAD ACTORS: MARLON BRANDO (DON VITO CORLEONE), AL PACINO (MICHAEL CORLEONE), JAMES CAAN (SONNY CORLEONE), JOHN CAZALE (FREDO CORLEONE), ROBERT DUVALL (TOM HAGEN), DIANE KEATON (KAY ADAMS), SIMONETTA STEFANELLI (APOLLONIA) MORGANA KING (MAMA CORLEONE), AL LETTIERI (SOLLOZZO), RICHARD S. CASTELLANO (CLEMENZA), TALIA SHIRE (CONNIE CORLEONE) / DIALOGUE: FRANCIS FORD COPPOLA, MARIO PUZO, BASED ON PUZO'S NOVEL OF THE SAME NAME / MUSIC: NINO ROTA / DURATION: 175 MINUTES / CATEGORIES: NEW YORK UNDERWORLD, ITALIAN-AMERICAN MAFIA / AWARDS: ELEVEN NOMINATIONS AT THE OSCARS, THREE AWARDS (BEST ACTOR IN A LEADING ROLE FOR MARLON BRANDO, BEST SCREENPLAY FOR MARIO PUZO AND FRANCIS FORD COPPOLA, BEST CINEMATOGRAPHY FOR AL RUDDY). SIX NOMINATIONS AT THE GOLDEN GLOBES, FOUR AWARDS (BEST ACTOR IN A LEADING ROLE FOR MARLON BRANDO, BEST DIRECTOR FOR FRANCIS FORD COPPOLA, BEST SCREENPLAY FOR MARIO PUZO AND FRANCIS FORD COPPOLA, BEST MUSIC FOR NINO ROTA).

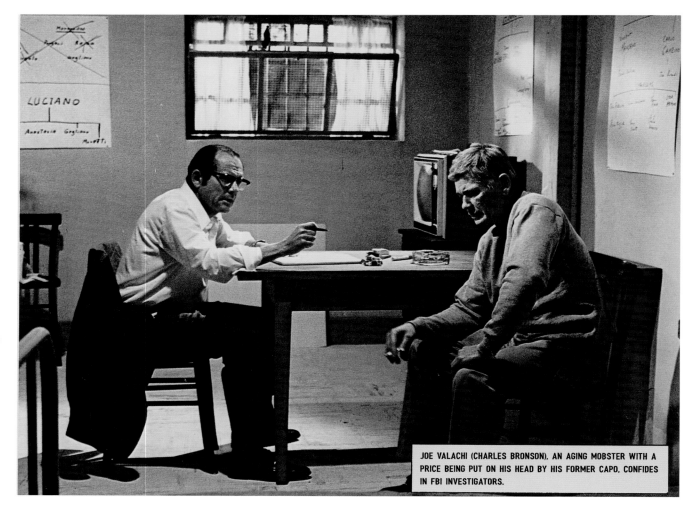

JOE VALACHI (CHARLES BRONSON), AN AGING MOBSTER WITH A PRICE BEING PUT ON HIS HEAD BY HIS FORMER CAPO, CONFIDES IN FBI INVESTIGATORS.

LEAD ACTORS: CHARLES BRONSON (JOE VALACHI), LINO VENTURA (VITO GENOVESE), JILL IRELAND (MARIA REINA-VALACHI), WALTER CHIARI (THE GAP), JOSEPH WISEMAN (SALVATORE MARANZANO) / DIALOGUE: STEPHEN GELLER BASED ON PETER MAAS' BOOK THE VALACHI PAPERS / MUSIC: ORTOLANI RICE / DURATION: 125 MINUTES / CATEGORIES: ITALIAN MAFIA, REPENTANT GANGSTER / TRIVIA: CHARLES BRONSON'S REAL WIFE, BRITISH ACTRESS JILL IRELAND, PLAYED THE ROLE OF MARIA, JOE VALACHI'S WIFE.

THE VALACHI PAPERS

FRANCE, ITALY, USA, 1972
DIRECTOR: TERENCE YOUNG

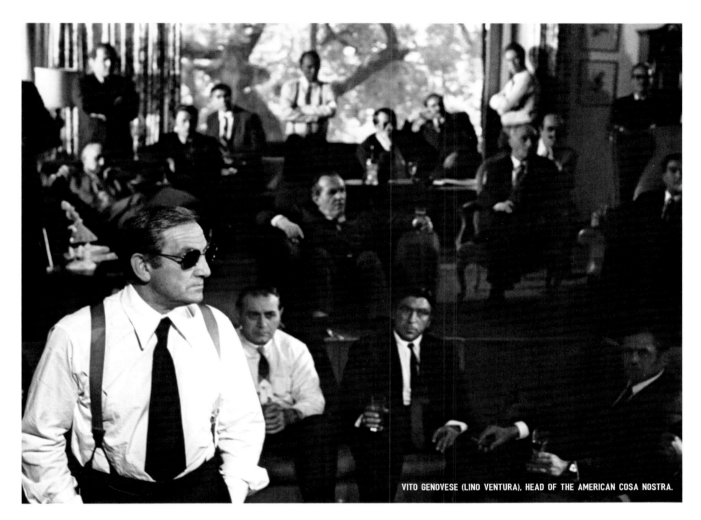

VITO GENOVESE (LINO VENTURA), HEAD OF THE AMERICAN COSA NOSTRA.

Joe Valachi (Charles Bronson), an aging gangster, is imprisoned in an Atlanta penitentiary for heroin trafficking. There he meets his former godfather, Vito Genovese (Lino Ventura), who has been arrested under unknown circumstances. The meeting turns sour when Valachi understands that Genovese suspects him of having ratted him out when Genovese gives Valachi the kiss of death in the presence of other prisoners: Valachi knows he is a dead man, and he agrees to break the code of silence by cooperating with the FBI agents who arrested him. He tells them about his rise in the ranks of the American Cosa Nostra, from his modest beginnings as a driver and gunner for Gaetano Reina (Amedeo Nazzari) to his influential role as Vito Genovese's right-hand in setting up a unified structure bringing together all the Sicilian clans present in the United States under the leadership of Salvatore Maranzano (Joseph Wiseman).

Inspired by the televised confessions of the real Joe Valachi, the first Italian mobster to brave the omertà, the film traces the history of the Italian American mafia over four decades. It reveals a world divided between unbridled brutality and a complex code of honor that leaves little room for emotions.

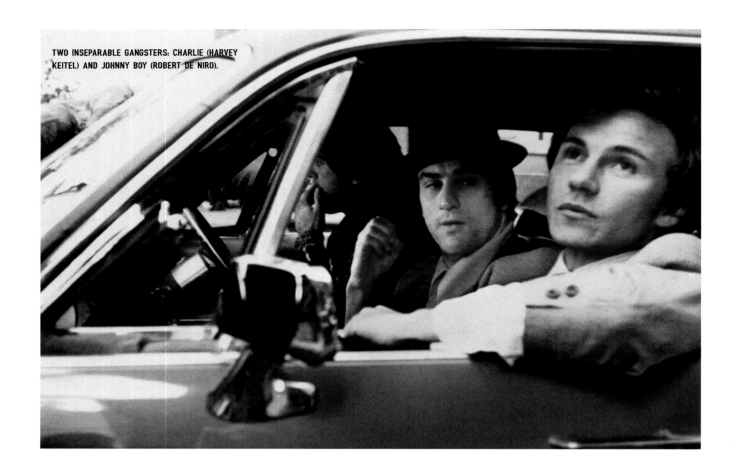

TWO INSEPARABLE GANGSTERS: CHARLIE (HARVEY KEITEL) AND JOHNNY BOY (ROBERT DE NIRO).

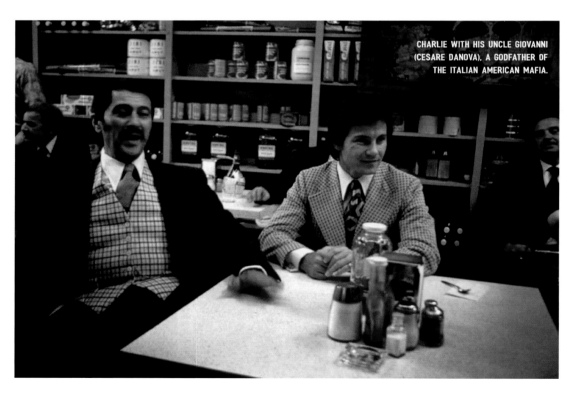

CHARLIE WITH HIS UNCLE GIOVANNI (CESARE DANOVA), A GODFATHER OF THE ITALIAN AMERICAN MAFIA.

LEAD ACTORS: HARVEY KEITEL (CHARLIE CAPPA), ROBERT DE NIRO (JOHNNY BOY), RICHARD ROMANUS (MICHAEL), DAVID PROVAL (TONY), AMY ROBINSON (TERESA), CESARE DANOVA (UNCLE GIOVANNI) / DIALOGUE: MARTIN SCORSESE, MARDIK MARTIN / MUSIC: ERIC CLAPTON / DURATION: 112 MINUTES / CATEGORIES: LIFE AND DEATH OF A MOBSTER, NEW YORK MAFIA / TRIVIA: IN HIS OWN WORDS, MARTIN SCORSESE'S DREAM AS A TEENAGER WAS "TO BECOME A PRIEST OR A GANGSTER"; HE ADMITS TO HAVING FAILED IN BOTH OF THOSE AMBITIONS. THIS AMBIGUITY CAN BE FOUND IN THE CHARACTER OF CHARLIE, TORN BETWEEN GOOD AND EVIL.

MEAN STREETS

UNITED STATES, 1973
DIRECTOR: MARTIN SCORSESE

Charlie Cappa (Harvey Keitel) is a small-time gangster who is looking for his place in the world of Little Italy. Employed by his uncle Giovanni (Cesare Danova), a bigwig in the Italian American mafia, he conscientiously carries out the minor tasks entrusted to him. But his friendship with Johnny Boy (Robert De Niro), a hot-headed thug who is unable to pay his debts, upsets the delicate balance on which Charlie has built his life: his gangster friends Tony (David Proval) and Michael (Richard Romanus) turn away from him as Johnny Boy owes them large sums of money; his affair with Johnny's cousin Teresa (Amy Robinson) is falling apart and is disapproved of by Uncle Giovanni. Johnny Boy, who is sinking deeper and deeper into violence and alcohol, will lead Charlie into a bloody and dead-end flight.

Filmed in a very realistic way, Mean Streets is a film about friendship and forgiveness. Harvey Keitel plays a gangster who carries doubts about his salvation and tries, in vain, to not become a victim of his own cynicism.

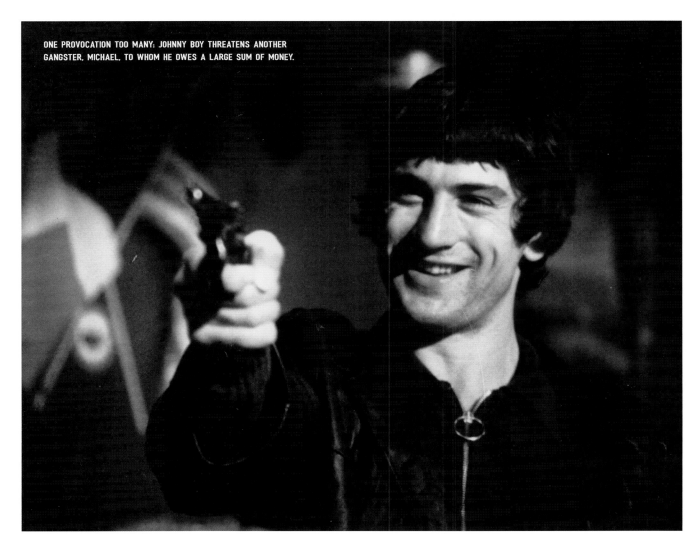

ONE PROVOCATION TOO MANY: JOHNNY BOY THREATENS ANOTHER GANGSTER, MICHAEL, TO WHOM HE OWES A LARGE SUM OF MONEY.

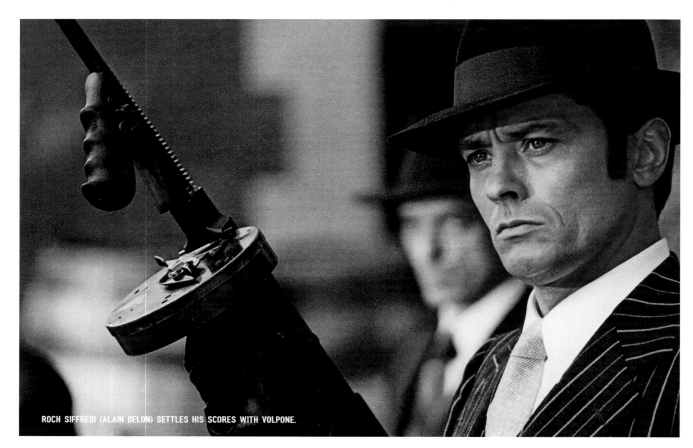

ROCH SIFFREDI (ALAIN DELON) SETTLES HIS SCORES WITH VOLPONE.

LEAD ACTORS: ALAIN DELON (ROCH SIFFREDI), CATHERINE ROUVEL (LOLA), LIONEL VITRANT (FERNAND),
RICCARDO CUCCIOLLA (VOLPONE), DANIEL IVERNEL (INSPECTOR FANTI), ANDRÉ FALCON (INSPECTOR CAZENAVE),
REINHARD KOLLDEHOFF (SAM) / DIALOGUE: PASCAL JARDIN / MUSIC: JEAN LABUSSIÈRE / DURATION: 110 MINUTES /
CATEGORIES: MARSEILLES MAFIA, MAFIA AND POLITICS, REVENGE / TRIVIA: AN AMERICAN SEQUEL TO THIS SECOND PART
WAS PLANNED, AND EVEN ANNOUNCED AT THE END OF THE FILM. UNFORTUNATELY, IT NEVER MATERIALIZED.

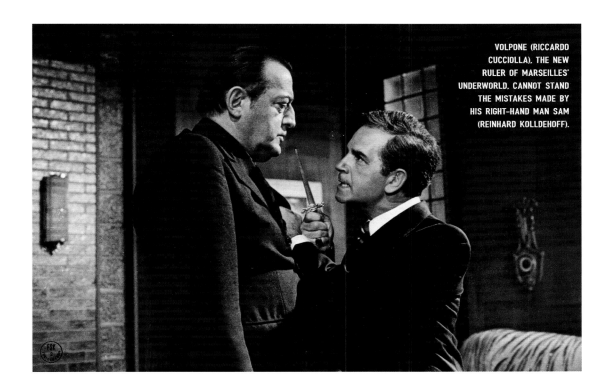

BORSALINO & CO.

FRANCE, ITALY, 1974
DIRECTOR: JACQUES DERAY

After the murder of his partner François Capella, who was assassinated by unknown assailants, Roch Siffredi (Alain Delon) finds himself alone in the face of new challenges. While he has just opened a music hall and his business is doing well, he learns the name of the man who ordered the killing of his friend and accomplice: Volpone (Riccardo Cucciolla), an Italian gangster who operates in several countries and who has his sights set on the Marseilles milieu. Siffredi has Volpone's brother liquidated while Volpone himself is on his way to Marseilles. War between the two gangs is declared. Inspector Fanti (Daniel Ivernel), who feels sympathy for Siffredi, warns him that his new opponent, Volpone, has political support and strong protectionon the extreme right. Reprisals are not long in coming: Siffredi's music

hall is attacked and a girl working in the brothel owned by his partner Lola (Catherine Rouvel) is sprayed with vitriol. One of Volpone's lieutenants, Sam (Reinhard Kolldehoff), manages to take Siffredi prisoner and gives him a treatment that turns him into an inveterate alcoholic. Found dead drunk in a café by his faithful lieutenant Fernand (Lionel Vitrant), Siffredi is ridiculed in the press and committed to a psychiatric hospital. He can no longer count on his former support, Inspector Fanti has been replaced by Cazenave (André Falcon), a man under Volpone's orders. But Fernand, always the loyal man, organizes Siffredi's escape. The hour of vengeance has come and Volpone's men fall one after the other.

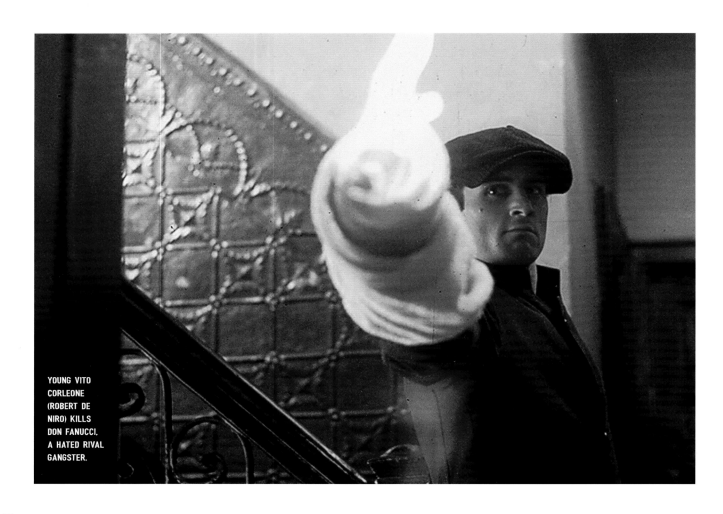

YOUNG VITO CORLEONE (ROBERT DE NIRO) KILLS DON FANUCCI, A HATED RIVAL GANGSTER.

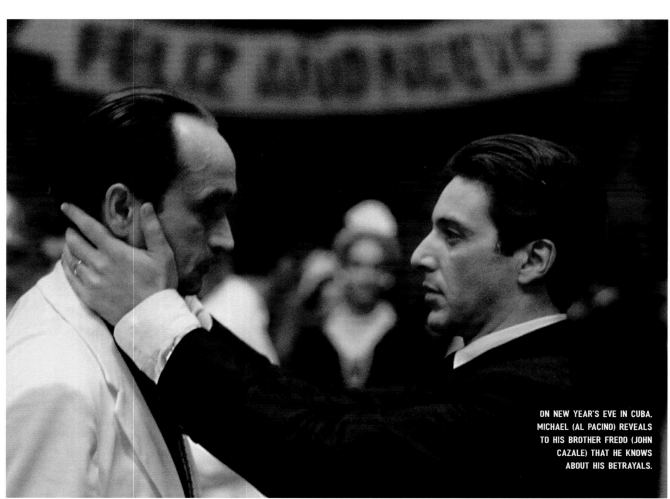

ON NEW YEAR'S EVE IN CUBA, MICHAEL (AL PACINO) REVEALS TO HIS BROTHER FREDO (JOHN CAZALE) THAT HE KNOWS ABOUT HIS BETRAYALS.

THE GODFATHER: PART II

UNITED STATES, 1974
DIRECTOR: FRANCIS FORD COPPOLA

Michael Corleone, who has become one of the big names in the American mafia, now lives in Nevada with his family, although some of the clan's affiliates still have a presence in New York and are fighting against the emergence of the Rosato brothers. He faces the loneliness of power: he must not only fight against the crooked politicians who despise him and drag him before an investigative committee, but also against rival gangs who try to turn some of his allies against him. Michael even has to sacrifice his brother Fredo, who has taken a stand for the godfather of Cuban casinos, Hyman Roth (Lee Strasberg) against the interests of his own family. But it is probably the collapse of his marriage with Kay (Diane Keaton) that affects Michael more than anything else. In parallel, the life of young Vito Corleone (Robert De Niro) is recounted in flashbacks spanning his escape from a Sicilian village in 1901 to his beginnings as a gang leader in New York's Little Italy in the 1920s, his fight with local godfather Don Fanucci (Gastone Moschin) and the vengeance for his parents' murder in Sicily.

LEAD ACTORS: AL PACINO (MICHAEL CORLEONE), JOHN CAZALE (FREDO CORLEONE), ROBERT DUVALL (TOM HAGEN), DIANE KEATON (KAY CORLEONE), ROBERT DE NIRO (YOUNG VITO CORLEONE), LEE STRASBERG (HYMAN ROTH), TALIA SHIRE (CONNIE CORLEONE) / DIALOGUE: FRANCIS FORD COPPOLA, MARIO PUZO, PARTLY BASED ON PUZO'S NOVEL OF THE SAME NAME / MUSIC: NINO ROTA, CARMINE COPPOLA / DURATION: 202 MINUTES / CATEGORIES: MAFIA BOSS, GAMBLING, ITALIAN AMERICAN UNDERWORLD IN NEW YORK / AWARDS: ELEVEN NOMINATIONS AT THE OSCARS, SIX AWARDS (BEST DIRECTOR FOR FRANCIS FORD COPPOLA, BEST SUPPORTING ACTOR FOR ROBERT DE NIRO, BEST SCREENPLAY FOR MARIO PUZO AND FRANCIS FORD COPPOLA, BEST CINEMATOGRAPHY, BEST MUSIC FOR NINO ROTA AND CARMINE COPPOLA, BEST SET DESIGN, SIX NOMINATIONS AT THE GOLDEN GLOBES.

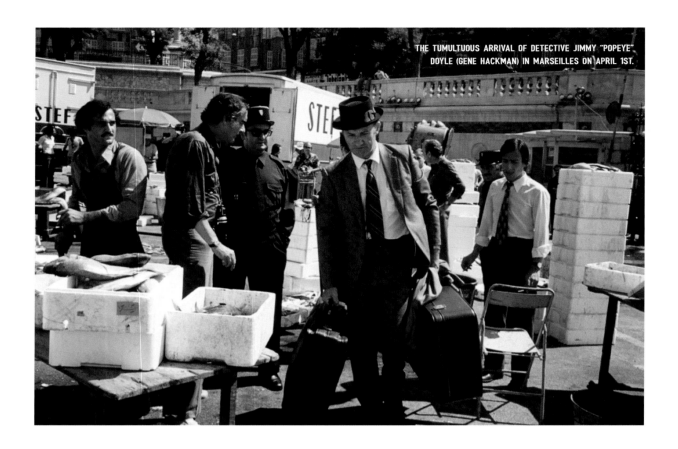

THE TUMULTUOUS ARRIVAL OF DETECTIVE JIMMY "POPEYE" DOYLE (GENE HACKMAN) IN MARSEILLES ON APRIL 1ST.

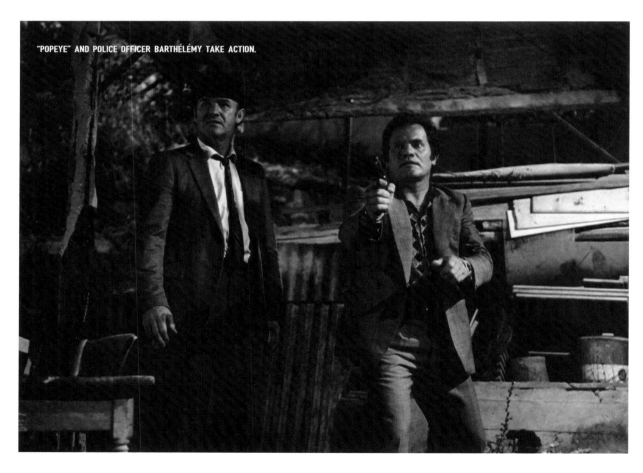

"POPEYE" AND POLICE OFFICER BARTHÉLÉMY TAKE ACTION.

THE FRENCH CONNECTION II

FRANCE, UNITED STATES, 1975
DIRECTOR: JOHN FRANKENHEIMER

Jimmy "Popeye" Doyle (Gene Hackman) is sent to Marseille to find international drug dealer Charnier (Fernando Rey), but he soon runs up against the hostility of the city's police officers, particularly that of Officer Henri Barthélémy (Bernard Fresson), who is visibly opposed to his coming. At a disadvantage from not speaking French, Doyle makes a series of missteps and finds himself ostracized. He wanders around Marseille in search of his enemy, who, to make matters worse, sees him first and sends men after Doyle. Captured by the mafia and interrogated by Charnier, Doyle is forcibly drugged in a brothel for weeks before being sent back to the police, close

to death. Undergoing a detoxification treatment by Officer Barthélémy, Doyle gradually regains his health and memory. He understands that he was used as bait so the police could get their hands on Charnier. He finally befriends Barthélémy, whose life he saves. Doyle is now only a step away from taking his revenge on Charnier.

By filming the sequel to French Connection in Marseilles, John Frankenheimer has avoided the pitfall of repetitive sequels and paints an uncompromising portrait of the French criminal world.

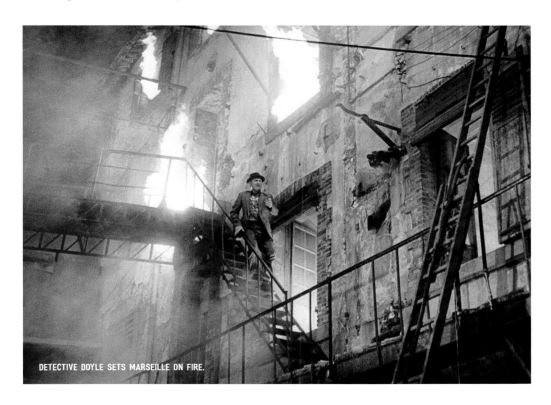

DETECTIVE DOYLE SETS MARSEILLE ON FIRE.

LEAD ACTORS: GENE HACKMAN (JIMMY "POPEYE" DOYLE), FERNANDO REY (ALAIN CHARNIER), BERNARD FRESSON (POLICE OFFICER HENRI BARTHÉLÉMY), PHILIPPE LÉOTARD (JACQUES, CHARNIER'S RIGHT-HAND MAN) / DIALOGUE: ALEXANDER JACOBS, ROBERT DILLON, LAURIE DILLON / MUSIC: DON ELLIS / DURATION: 119 MINUTES / CATEGORIES: MARSEILLES MAFIA, MANHUNT

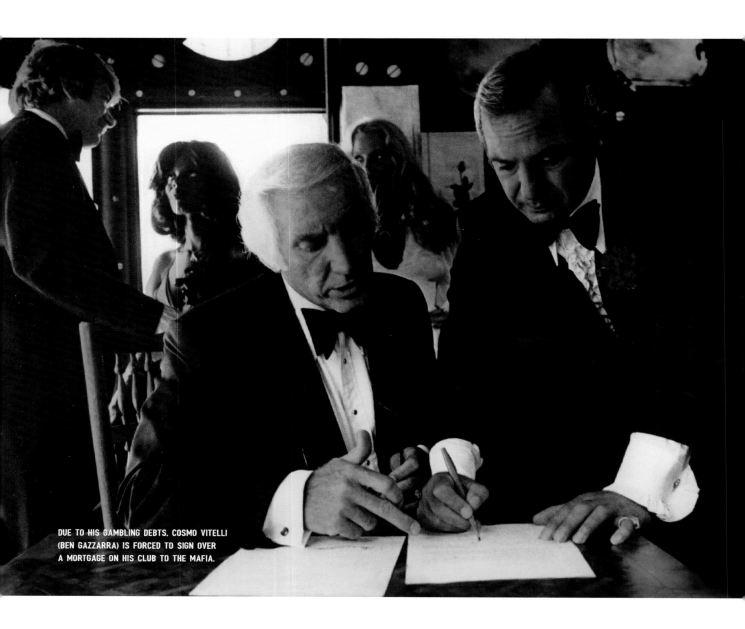

DUE TO HIS GAMBLING DEBTS, COSMO VITELLI
(BEN GAZZARRA) IS FORCED TO SIGN OVER
A MORTGAGE ON HIS CLUB TO THE MAFIA.

THE KILLING OF A CHINESE BOOKIE

UNITED STATES, 1976
DIRECTOR: JOHN CASSAVETES

Cosmo Vitelli (Ben Gazarra) runs a strip club on the outskirts of Los Angeles that aspires to look like a chic cabaret. He's also an inveterate gambler who is easily swept along; he ends up owing $23,000 to Mort Weil (Seymour Cassel), the owner of a poker joint, and his mafia associates. To prevent his mortgaged club from falling into the hands of mobsters, Vitelli has no choice but to accept the offer they put in his hands: he must kill an old Chinese bookmaker who is one of their rivals in order to pay off his debt. Cosmo carries out this mission, but while doing so he shoots several of the bookmaker's bodyguards and gets a bullet in the hip himself. Injured, he finds refuge with the mother of his girlfriend

Rachel (Azizi Johari), one of the dancers in the bar. Meanwhile, the mafia, worried about the bloody turn the assassination has taken, decide to eliminate Cosmo. Weil is in charge of taking him to the chosen place where Flo (Timothy Carey) will discreetly finish him off. But Cosmo thwarts their plans by getting rid of Weil and persuading Flo to let him live. He still manages to escape from a third gangster on his heels. Despite the pain his injury causes, Cosmo finds the strength to return to his bar and instill a sense of optimism in his depressed team. Is this his last will?

LEAD ACTORS: BEN GAZZARA (COSMO VITELLI), SEYMOUR CASSEL (MORT WEIL), AZIZI JOHARI (RACHEL), TIMOTHY CAREY (FLO), SONNY APRILE (SONNY) / DIALOGUE: JOHN CASSAVETES / MUSIC: BO HARWOOD / DURATION: 135 MINUTES / CATEGORIES: CALIFORNIAN MAFIA, GAMBLING, CABARETS

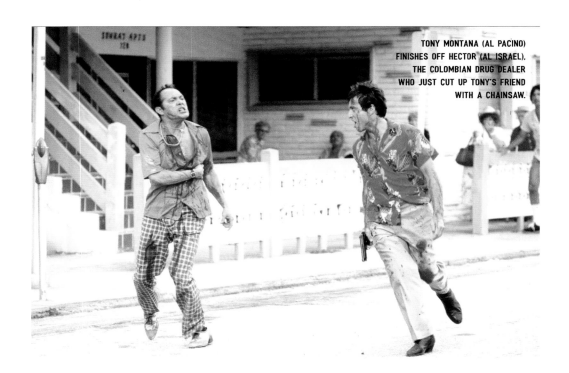

TONY MONTANA (AL PACINO)
FINISHES OFF HECTOR (AL ISRAEL),
THE COLOMBIAN DRUG DEALER
WHO JUST CUT UP TONY'S FRIEND
WITH A CHAINSAW.

80

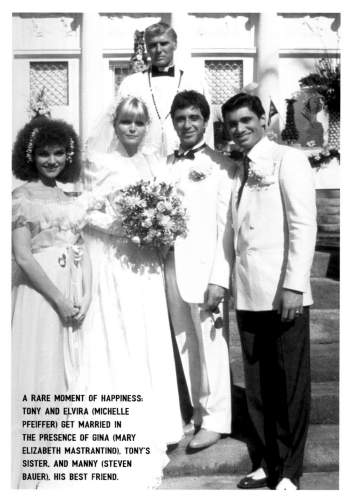

A RARE MOMENT OF HAPPINESS:
TONY AND ELVIRA (MICHELLE
PFEIFFER) GET MARRIED IN
THE PRESENCE OF GINA (MARY
ELIZABETH MASTRANTINO), TONY'S
SISTER, AND MANNY (STEVEN
BAUER), HIS BEST FRIEND.

LEAD ACTORS: AL PACINO (TONY MONTANA, A.K.A "SCARFACE"), MICHELLE PFEIFFER (ELVIRA), STEVEN BAUER (MANNY RIBERA), MARY ELIZABETH MASTRANTONIO (GINA MONTANA), ROBERT LOGGIA (FRANK LOPEZ), PAUL SHENAR (ALEJANDRO SOSA) / DIALOGUE: OLIVER STONE / MUSIC: GIORGIO MORODER / DURATION: 170 MINUTES / CATEGORIES: DRUG TRAFFICKING, LIFE AND DEATH OF A GANGSTER / AWARDS: THREE GOLDEN GLOBES NOMINATIONS. / TRIVIA: "SCARFACE" (THE SCARRED ONE) WAS ALSO THE NICKNAME OF AL CAPONE, TO WHOM THE 1932 FILM SCARFACE WAS DEDICATED.

SCARFACE

UNITED STATES, 1983
DIRECTOR: BRIAN DE PALMA

Tony Montana (Al Pacino), a small-time Cuban criminal, manages to reach Florida thanks to an exodus of opponents organized by the communist regime in 1980. Tony and his friend Manny Ribera (Steven Bauer) are quickly spotted by Frank Lopez (Robert Loggia) who controls the drug trade in Miami and hires them as henchmen. Tony is given risky missions that he carries out successfully. He gains Lopez's trust while nurturing a passion for the latter's girlfriend, Elvira (Michelle Pfeiffer). Nothing can stop Tony's ambition, not even Lopez, who tries to have him murdered and pays a high price for his treason. Allied to the Bolivian drug producer Alejandro Sosa (Paul Shenar), Tony is now a respected godfather; he marries Elvira and showers his own sister Gina (Mary Elizabeth Mastrantonio) with gifts, while jealously watching over her. However, his excessive self-confidence and a tragic addiction to cocaine will precipitate his downfall and those who loved him leave him: Elvira, but also Gina and Manny, his lifelong friend, whom Tony ends up killing for having married Gina in secret.

This updated version of the original 1932 film by Howard Hawks and Ben Hecht, *Scarface* has become a cinema classic thanks to the exceptional performance of Al Pacino and the dialogue by Oliver Stone.

81

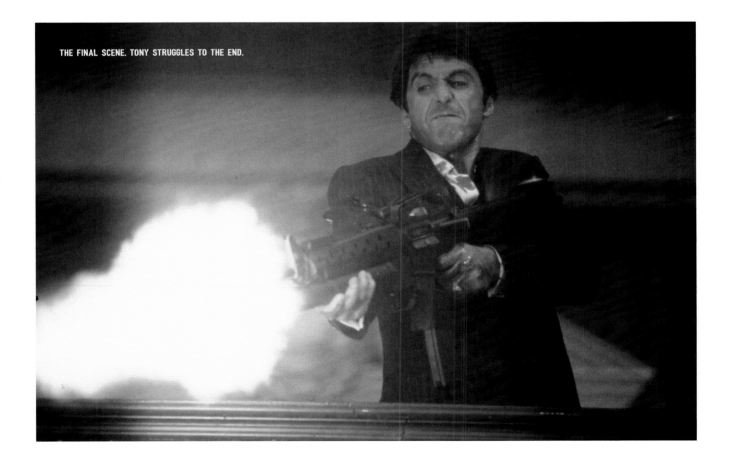

THE FINAL SCENE. TONY STRUGGLES TO THE END.

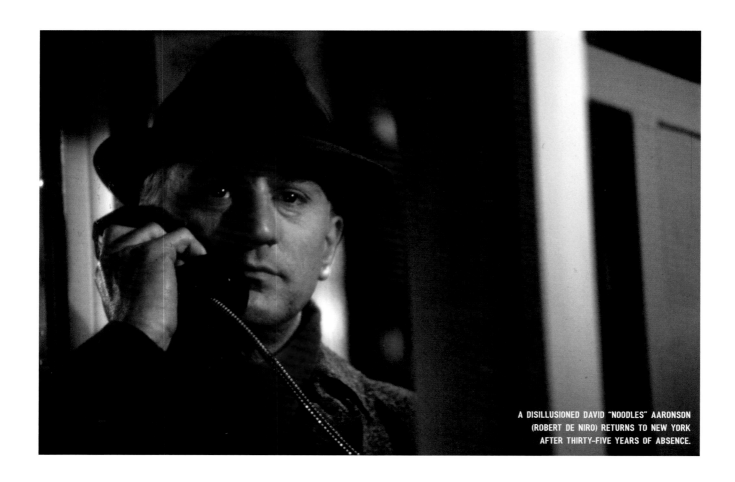

A DISILLUSIONED DAVID "NOODLES" AARONSON
(ROBERT DE NIRO) RETURNS TO NEW YORK
AFTER THIRTY-FIVE YEARS OF ABSENCE.

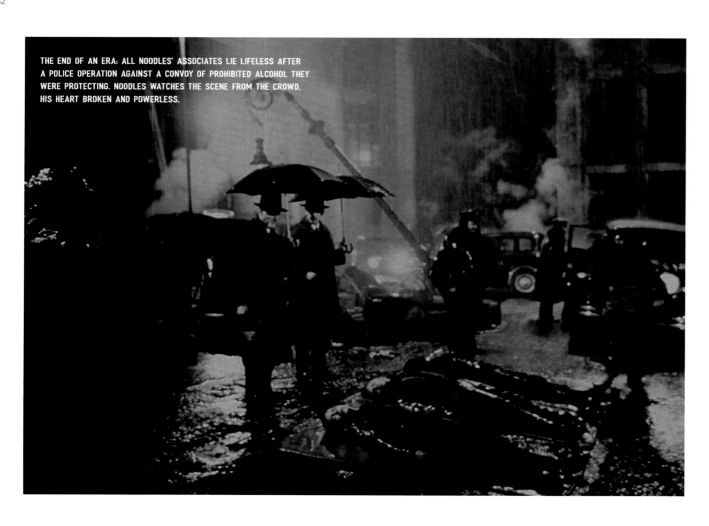

THE END OF AN ERA: ALL NOODLES' ASSOCIATES LIE LIFELESS AFTER
A POLICE OPERATION AGAINST A CONVOY OF PROHIBITED ALCOHOL THEY
WERE PROTECTING. NOODLES WATCHES THE SCENE FROM THE CROWD,
HIS HEART BROKEN AND POWERLESS.

ONCE UPON A TIME IN AMERICA

ITALY, USA, 1984
DIRECTOR: SERGIO LEONE

The glorious and tragic epic tale of a young gang of thugs from Manhattan's Jewish district is seen through the memories of one of its few survivors, David "Noodles" Aaronson, (young: Scott Tiler, adult: Robert De Niro). Thirty-five years after fleeing New York to escape the pursuit of killers, Noodles returns to the city to confront the ghosts of his past. The plot, which intertwines three periods of his life, shows him as a teenager when he first met Max Bercovicz (young: Rustly Jacobs, adult: James Wood), the brain of the gang who leads his friends from petty street crime to alcohol trafficking and organized crime; then to the golden age of Prohibition, where everything seems possible to Max, Noodles, and their associates; and finally to the late 1960s, where Noodles, disillusioned with life, discovers

that he has been deceived and betrayed. Nothing can resist the cruelty of fate, neither Noodles' attraction to beautiful Deborah (young: Jennifer Connelly, adult: Elizabeth McGovern), nor the joyful innocence of Dominic (Noah Moazezi), the youngest of the gang, who dies from the bullets of a rival. Sergio Leone was inspired by Harry Grey's novel, *The Hoods*, an autobiographical story by a repentant mobster, which he transformed into a sublime reflection on life's disillusions, violence, love, and betrayal. The film is punctuated by the music of Ennio Morricone and by the melancholic tune on the pan flute played by Gheorghe Zamfir.

83

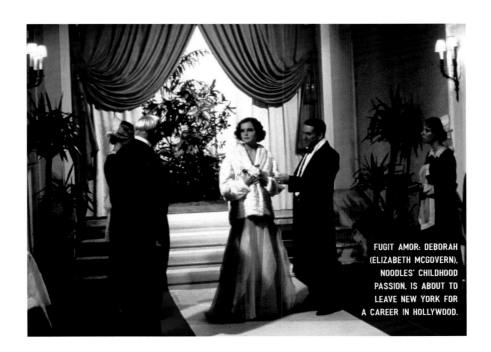

FUGIT AMOR: DEBORAH (ELIZABETH MCGOVERN), NOODLES' CHILDHOOD PASSION, IS ABOUT TO LEAVE NEW YORK FOR A CAREER IN HOLLYWOOD.

LEAD ACTORS: ROBERT DE NIRO (DAVID "NOODLES" AARONSON), JAMES WOOD (MAX BERCOVICZ, THEN SENATOR CHRISTOPHER BAILEY), ELIZABETH MCGOVERN (DEBORAH GELLY), LARRY RAPP ("FAT" MOE GELLY) / DIALOGUE: LÉONARDO BENVENUTI, PIERO DE BERNARDI, ENRICO MEDIOLI, FRANCO ARCALLI, FRANCO FERRINI AND SERGIO LEONE / MUSIC: ENNIO MORRICONE / DURATION: 221 MINUTES (251 MINUTES FOR THE RESTORED VERSION) / CATEGORY: GANG HISTORY / AWARDS: TWO GOLDEN GLOBE NOMINATIONS.

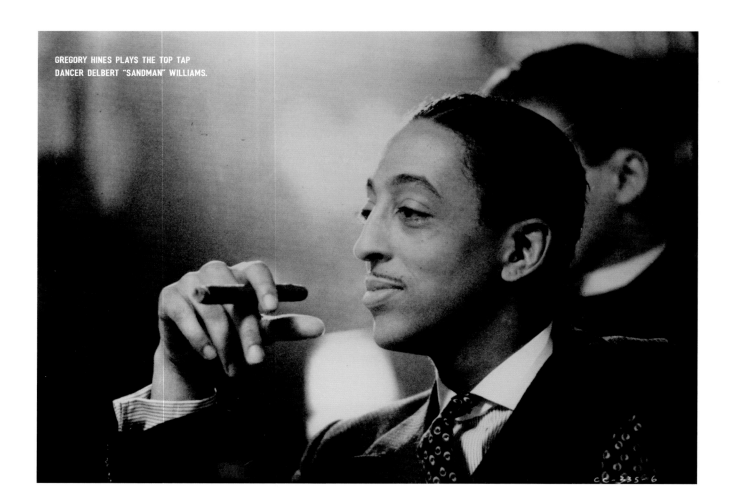

THE COTTON CLUB

UNITED STATES, 1984
DIRECTOR: FRANCIS FORD COPPOLA

After saving the life of gangster boss Dutch Schultz (James Remar), young Jazz trumpeter Dixie Dwyer (Richard Gere) is the musician that all Harlem nightclubs are fighting for. However, a romance unfolding between Schultz's mistress, Vera Cicero (Diane Lane) and Dixie starts to cause tension between the two men. The antagonism grows even more when another gangster, Owney Madden (Bob Hoskins), the boss of the Cotton Club, takes Dixie under his protection and sends him to Hollywood where he becomes a movie star. Destiny will eventually put Vera back on Dixie's path, just as it favors another couple in the film, Delbert "Sandman"

Williams (Gregory Hines), a tap dancer at the Cotton Club, who must fight against segregation to make a name for himself, and Lila Rose Oliver (Lonette McKee), a young bi-racial singer who dreams of glory.

Francis Ford Coppola takes us back us to New York in the era of the 1929 stock market crash, mixing fictional characters with legendary gangsters who ruled jazz clubs and cabarets.

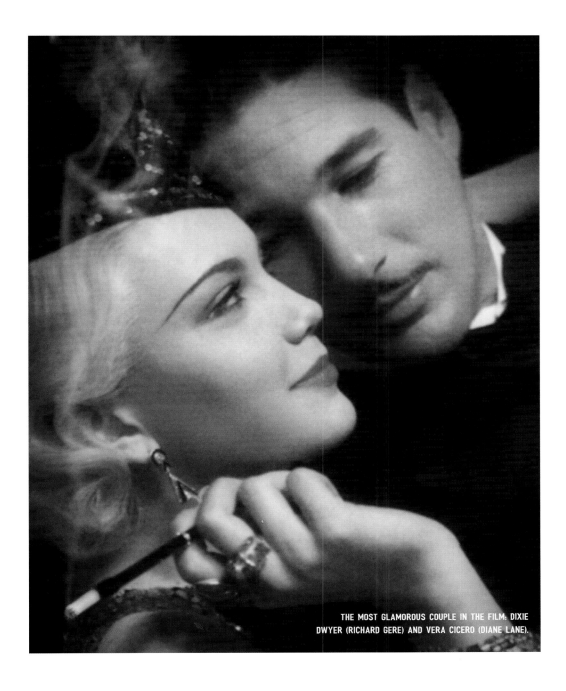

THE MOST GLAMOROUS COUPLE IN THE FILM: DIXIE DWYER (RICHARD GERE) AND VERA CICERO (DIANE LANE).

LEAD ACTORS: RICHARD GERE (DIXIE DWYER), GREGORY HINES (DELBERT "SANDMAN" WILLIAMS), DIANE LANE (VERA CICERO), JAMES REMAR (DUTCH SCHULTZ), BOB HOSKINS (OWNEY MADDEN), NICOLAS CAGE (VINCENT DWYER), LONETTE MCKEE (LILA ROSE OLIVER) / DIALOGUE: WILLIAM KENNEDY, FRANCIS FORD COPPOLA / MUSIC: JOHN BARRY / DURATION: 127 MINUTES / CATEGORIES: CAFÉ SOCIETY, NIGHTLIFE AND UNDERWORLD / AWARDS: TWO OSCAR NOMINATIONS, TWO GOLDEN GLOBES. / TRIVIA: GREGORY HINES' OWN BROTHER, MAURICE HINES, PLAYS CLAYTON "CLAY" WILLIAMS, THE BROTHER AND DANCE PARTNER OF DELBERT "SANDMAN" IN THE FILM.

PRIZZI'S HONOR

UNITED STATES, 1985
DIRECTOR: JOHN HUSTON

Charley Partanna (Jack Nicholson) is a hitman working for the powerful Prizzi family. His godfather is none other than Don Corrado Prizzi (William Hickey), to whom he has solemnly sworn to put the interests of the family before his own. At a wedding in Brooklyn, Charley meets a beautiful stranger with whom he falls madly in love. He does everything he can to find her after she disappears in the middle of the festivities; he even flies to Los Angeles as soon as she invites him to join her. But the beautiful one is not who he thinks she is: Irene (Kathleen Turner) is also a hired killer, and Charley actually shot her husband to avenge the robbery of a Las Vegas casino controlled by the Prizzi. Charley and Irene decide nevertheless, to get married, though they will soon run into Maerose Prizzi (Anjelica Huston) on their way: the Don's granddaughter, is a former lover of Charley's, and Maerose has a grudge against Irene. In an attempt to help his granddaughter, the godfather, who loves Charley like a son, puts a deal in his hand: if he gets rid of his wife, he will take over the organization and dethrone Dominic Prizzi (Lee Richardson), the Don's own son. But Irene hasn't had her last word yet...

While the plot is in line with the standards of gangster films, Prizzi's Honor is more of a satire than a classic mafia movie: It seems that Huston is mocking Coppola's *Godfather*, or that the script has been reworked by the Coen brothers. William Hickey plays an amazing mafia godfather, as senile as he is bloodthirsty.

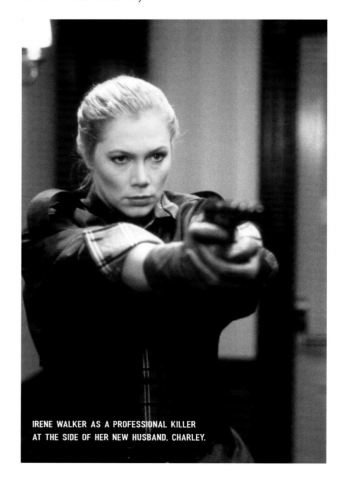

IRENE WALKER AS A PROFESSIONAL KILLER
AT THE SIDE OF HER NEW HUSBAND, CHARLEY.

LEAD ACTORS: JACK NICHOLSON (CHARLEY PARTANNA), KATHLEEN TURNER (IRENE WALKER), ANJELICA HUSTON (MAEROSE PRIZZI), WILLIAM HICKEY (DON CORRADO PRIZZI), ROBERT LOGGIA (EDUARDO PRIZZI), LEE RICHARDSON (DOMINIC PRIZZI), JOHN RANDOLPH (ANGELO PARTANNA, CHARLEY'S FATHER) / DIALOGUE: RICHARD CONDON, JANET ROACH, BASED ON THE NOVEL OF THE SAME NAME BY RICHARD CONDON / MUSIC: ALEX NORTH / DURATION: 130 MINUTES / CATEGORY: LIFE AND DEATH OF A GANGSTER / AWARDS: EIGHT OSCAR NOMINATIONS, ONE AWARD (BEST SUPPORTING ACTRESS FOR ANJELICA HUSTON). SIX GOLDEN GLOBES NOMINATIONS, FOUR AWARDS (BEST PICTURE, BEST DIRECTOR, BEST ACTORS FOR KATHLEEN TURNER AND JACK NICHOLSON).

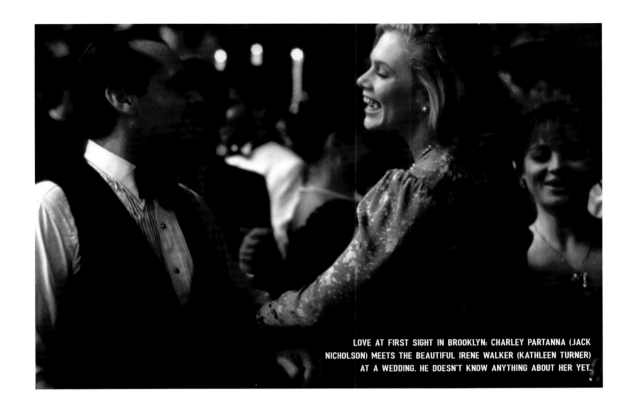

LOVE AT FIRST SIGHT IN BROOKLYN: CHARLEY PARTANNA (JACK NICHOLSON) MEETS THE BEAUTIFUL IRENE WALKER (KATHLEEN TURNER) AT A WEDDING. HE DOESN'T KNOW ANYTHING ABOUT HER YET.

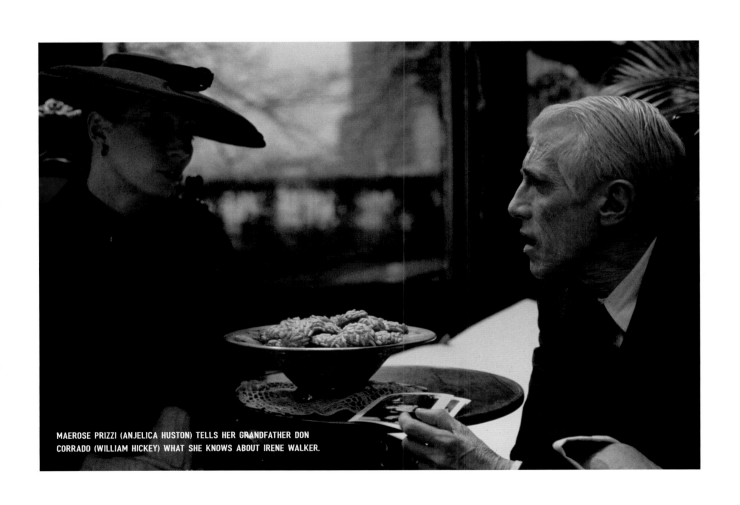

MAEROSE PRIZZI (ANJELICA HUSTON) TELLS HER GRANDFATHER DON CORRADO (WILLIAM HICKEY) WHAT SHE KNOWS ABOUT IRENE WALKER.

YEAR OF THE DRAGON

UNITED STATES, 1985
DIRECTOR: MICHAEL CIMINO

Just as a Chinatown godfather is murdered in the midst of a gang war, a policeman with rather disconcerting methods is tasked with bringing order to this New York district: Stanley White (Mickey Rourke), a Vietnam veteran, has a strong racist prejudice against the Chinese community and wants to break the prevailing law of silence. He is challenged not only by Joey Tai (John Lone), the new leader of the triads, but also by a part of the NYPD hierarchy who prefers the status quo and the bribes they can take from the triads. However, White can rely on the support of a star journalist, Tracy Tzu (Ariane Koizumi), even though his affair with her exacerbates his difficult relationship with his wife Connie. Without real support from his department and abandoned by all his friends, White will multiply the violence to bring down Joey Tai, even if it means taking some liberties with the rules.

Although strongly criticized for the prejudices about the Chinese community and the sexism it carries, this action film in which Mickey Rourke gives a brilliant performance has the merit of lifting the veil on the Hong Kong triads and their American counterparts.

LEAD ACTORS MICKEY ROURKE (STANLEY WHITE), JOHN LONE (JOEY TAI), ARIANE KOIZUMI (TRACY TZU), RAYMOND J. BARRY (LOUIS BUKOWSKI), CAROLINE KAVA (CONNIE WHITE) / DIALOGUE: MICHAEL CIMINO, OLIVER STONE BASED ON THE NOVEL OF THE SAME NAME BY ROBERT DALEY / MUSIC: DAVID MANSFIELD / DURATION: 134 MINUTES / CATEGORIES: TRIADS, CHINESE MAFIA IN THE UNITED STATES / AWARDS: TWO NOMINATIONS FOR THE GOLDEN GLOBES, ONE AT THE CANNES FILM FESTIVAL.

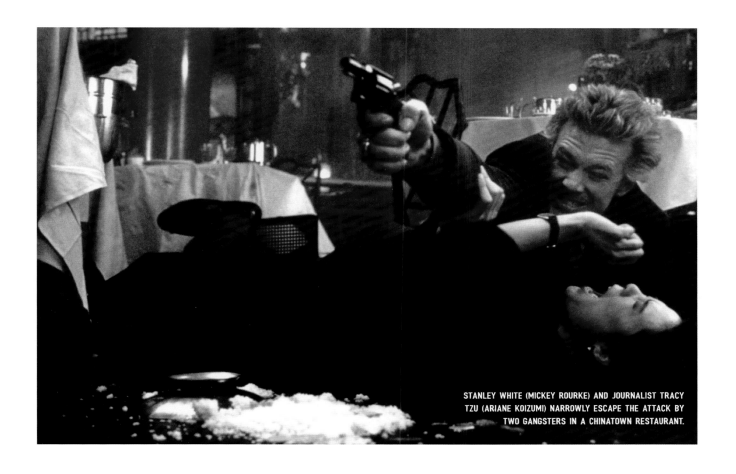

STANLEY WHITE (MICKEY ROURKE) AND JOURNALIST TRACY
TZU (ARIANE KOIZUMI) NARROWLY ESCAPE THE ATTACK BY
TWO GANGSTERS IN A CHINATOWN RESTAURANT.

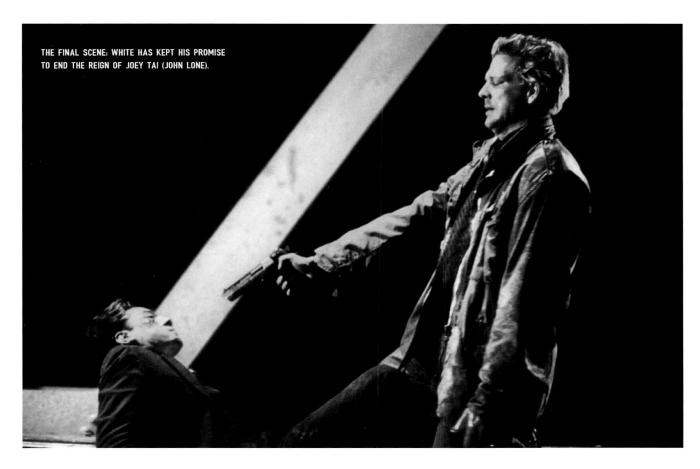

THE FINAL SCENE: WHITE HAS KEPT HIS PROMISE
TO END THE REIGN OF JOEY TAI (JOHN LONE).

THE UNTOUCHABLES

UNITED STATES, 1987
DIRECTOR: BRIAN DE PALMA

At the end of the 1920s, Chicago was a city entirely controlled by Al Capone and his men; the most glorious of the mafia godfathers took advantage of Prohibition to make a fortune in all kinds of traffic: alcohol, prostitution, illegal betting. The police and the justice department, corrupt and powerless, were at Capone's command, as were many politicians who knew they had no chance of being elected without his support. The arrival of a young inspector from the financial squad, Eliot Ness (Kevin Costner), who was determined to bring down Capone, became a turning point in Capone's fate: with a small team of honest policemen, "The Untouchables", Ness delivered blow after blow to an overconfident Al Capone (Robert De Niro). But Eliot Ness and his men knew that the boss of the underworld would stop at nothing to bring them down. Eliot Ness's "Three Musketeers" were ready to pay a heavy price in order for justice to triumph.

The film brings together exceptional actors who play their roles masterfully; Kevin Costner as a man of principles; Sean Connery as Jim Malone, a disillusioned old policeman ready to give good advice; Andy García as George Stone, a fiery young recruit; Charles Martin Smith as a tough tax inspector; Robert De Niro as a versatile and impulsive Al Capone. The music, by Ennio Morricone, perfectly accompanies the rhythm of the film. The narrative is inspired by Eliot Ness's real story, albeit slightly romanticized.

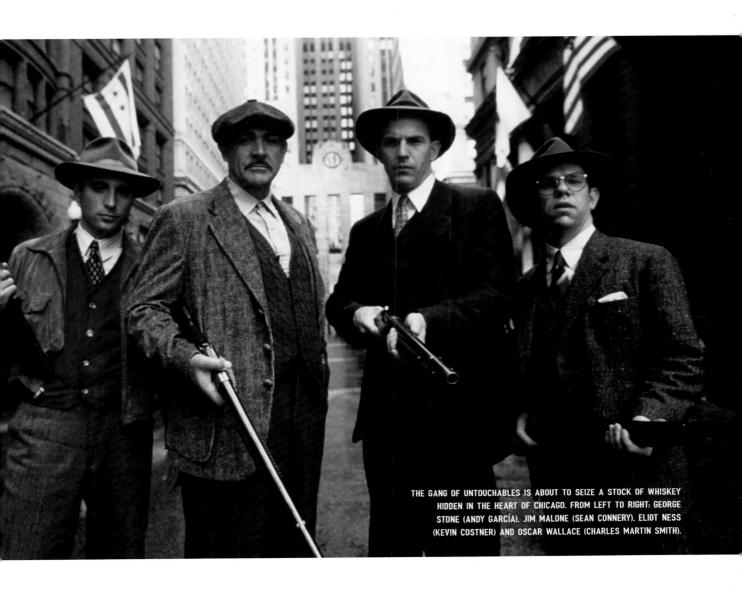

THE GANG OF UNTOUCHABLES IS ABOUT TO SEIZE A STOCK OF WHISKEY HIDDEN IN THE HEART OF CHICAGO. FROM LEFT TO RIGHT: GEORGE STONE (ANDY GARCÍA), JIM MALONE (SEAN CONNERY), ELIOT NESS (KEVIN COSTNER) AND OSCAR WALLACE (CHARLES MARTIN SMITH).

LEAD ACTORS: KEVIN COSTNER (ELIOT NESS), SEAN CONNERY (JIM MALONE), ROBERT DE NIRO (AL CAPONE), ANDY GARCÍA (GEORGE "GIUSEPPE" STONE), CHARLES MARTIN SMITH (OSCAR WALLACE) / DIALOGUE: DAVID MAMET / MUSIC: ENNIO MORRICONE / DURATION: 119 MINUTES / CATEGORIES: DOWNFALL OF A GODFATHER, HISTORICAL NARRATIVE / AWARDS: FOUR OSCAR NOMINATIONS, ONE AWARD (BEST SUPPORTING ACTOR FOR SEAN CONNERY). TWO GOLDEN GLOBES NOMINATIONS.

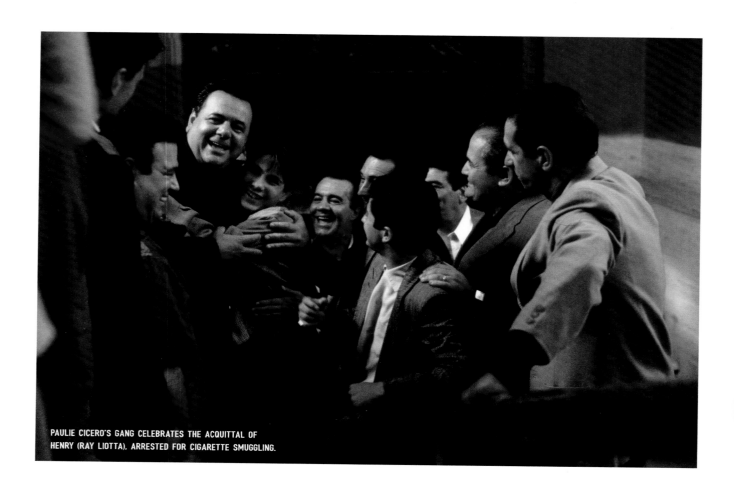

PAULIE CICERO'S GANG CELEBRATES THE ACQUITTAL OF
HENRY (RAY LIOTTA), ARRESTED FOR CIGARETTE SMUGGLING.

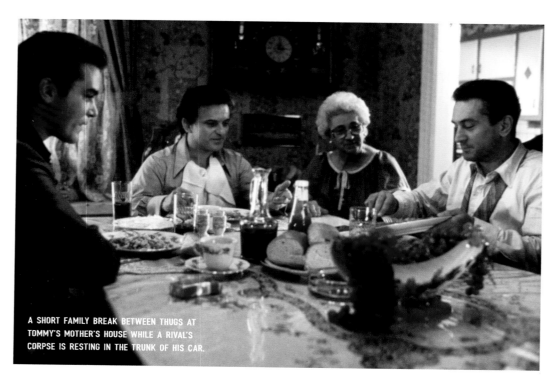

A SHORT FAMILY BREAK BETWEEN THUGS AT
TOMMY'S MOTHER'S HOUSE WHILE A RIVAL'S
CORPSE IS RESTING IN THE TRUNK OF HIS CAR.

LEAD ACTORS: RAY LIOTTA (HENRY HILL), ROBERT DE NIRO (JIMMY CONWAY), LORRAINE BRACCO (KAREN HILL),
JOE PESCI (TOMMY DEVITO), PAUL SORVINO (PAULIE CICERO) / DIALOGUE: NICHOLAS PILEGGI, MARTIN SCORSESE /
MUSIC: HARRY NILSSON / DURATION: 146 MINUTES / CATEGORY: GANG HISTORY / AWARDS: SIX OSCAR NOMINATIONS,
ONE AWARD (BEST MALE SUPPORTING ACTRESS). FIVE GOLDEN GLOBE NOMINATIONS.

GOODFELLAS

UNITED STATES, 1990
DIRECTOR: MARTIN SCORSESE

Henry Hill (Ray Liotta), the eldest son of an Irish Italian family, grows up in a poor Brooklyn neighborhood controlled by the Lucchese clan. As a teenager, he is recruited by the mafia for occasional small jobs that he accomplishes with great commitment. This earns him the recognition of one of the godfathers, Paulie Cicero (Paul Sorvino), and the affection of Jimmy Conway, a young legendary thug who, like him, is of Irish Italian descent. When Henry is arrested by the police for cigarette smuggling, the gang provides him with a lawyer and celebrates his acquittal.

When Henry successfully steals $420,000 in cash from an Air France flight, he suddenly becomes one of the rising stars of the New York mob. It is at this time that he meets Karen, a young woman from the Brooklyn Jewish bourgeoisie, and marries her. He has now become a seasoned gangster, and he associates with impulsive, and utterly talkative Tommy DeVito (Joe Pesci). When Tommy murders the godfather of another family, Henry and Jimmy help him hide the body.

In the early 1970s, Henry and Jimmy are imprisoned for an extortion case. With their boss Paulie, who is serving six months for another case, they organize trafficking within the prison. There, for the first time, Henry becomes involved in cocaine trafficking and starts distancing himself from Paulie. When Henry is released, he reconnects with Jimmy, who set up the Lufthansa heist, and together they collect $6 million in loot. But Jimmy is consumed by paranoia and Paulie is more and more addicted to white powder. The downfall is inevitable…

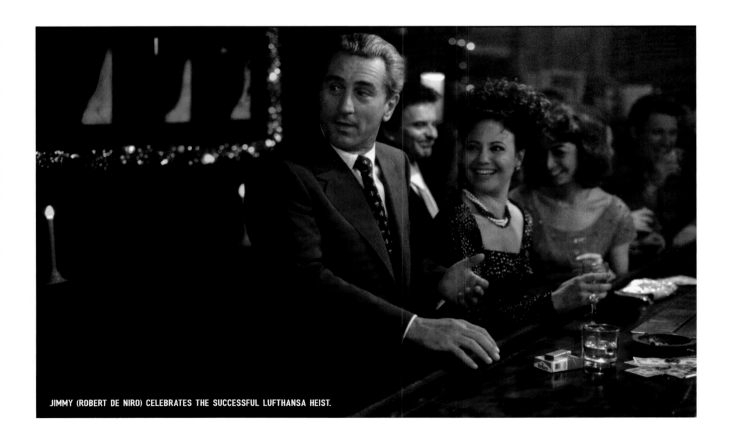

JIMMY (ROBERT DE NIRO) CELEBRATES THE SUCCESSFUL LUFTHANSA HEIST.

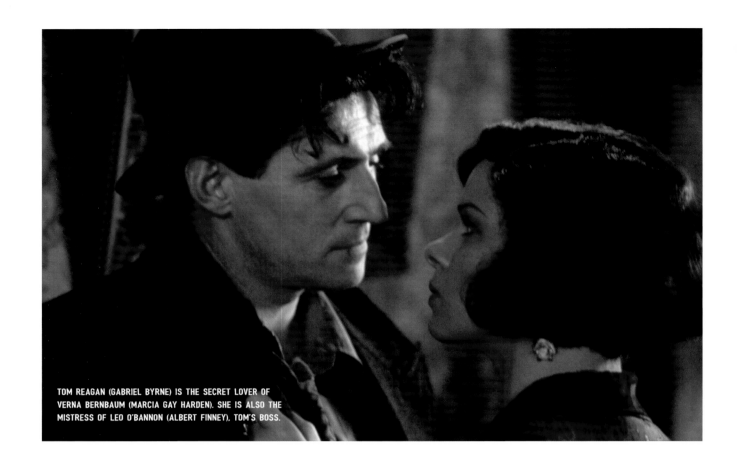

TOM REAGAN (GABRIEL BYRNE) IS THE SECRET LOVER OF
VERNA BERNBAUM (MARCIA GAY HARDEN). SHE IS ALSO THE
MISTRESS OF LEO O'BANNON (ALBERT FINNEY), TOM'S BOSS.

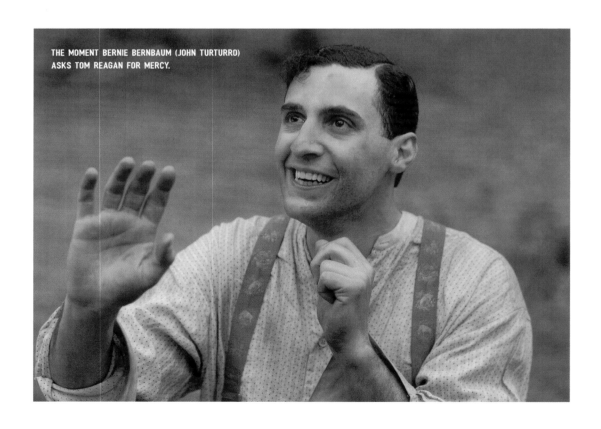

THE MOMENT BERNIE BERNBAUM (JOHN TURTURRO)
ASKS TOM REAGAN FOR MERCY.

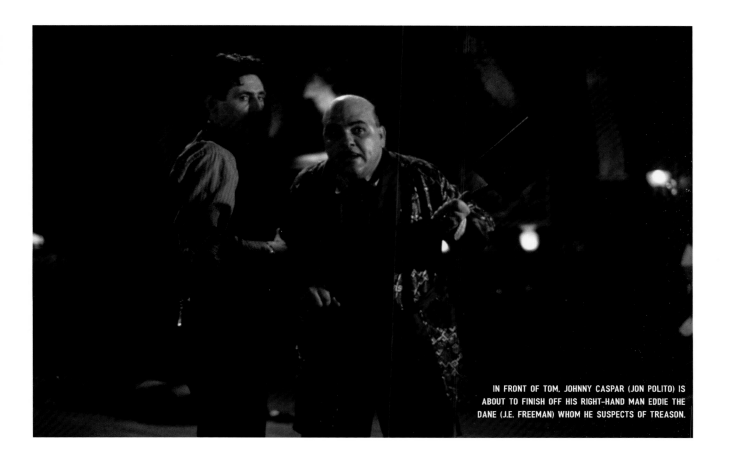

IN FRONT OF TOM, JOHNNY CASPAR (JON POLITO) IS
ABOUT TO FINISH OFF HIS RIGHT-HAND MAN EDDIE THE
DANE (J.E. FREEMAN) WHOM HE SUSPECTS OF TREASON.

MILLER'S CROSSING

UNITED STATES, 1990
DIRECTOR: JOEL & ETHAN COEN

In the 1920s, Leo O'Bannon (Albert Finney) is the undisputed master of a city somewhere in the Midwest. At the head of the Irish mafia, he controls the activities of the mayor and the police. No gang can operate without his endorsement and that of his loyal right-hand man Tom Reagan (Gabriel Byrne). But Leo's mind is partly blinded by his passion for the beautiful Verna (Marcia Gay Harden). He protects her brother Bernie (John Turturro), a small-time crook, from the fury of an angry Italian mob boss, Johnny Caspar (Jon Polito), who is always followed by his right-hand, the ruthless Eddie the Dane (J.E. Freeman). Tom Reagan, who is Verna's secret lover, gets into trouble when he is solicited by Johnny Caspar who wants to seize power and replace Leo. While the latter's clout in the city begins to waver, Tom must skillfully maneuver to thwart the traps set by his opponents: Johnny Caspar, Eddie the Dane and even Bernie, Verna's brother, a troubled character totally devoid of scruples.

The Coen brothers create here a small masterpiece of *film noir* where tragic moves succeed one another like a flurry of punches.

LEAD ACTORS: GABRIEL BYRNE (TOM REAGAN), JON POLITO (JOHNNY CASPAR), MARCIA GAY HARDEN (VERNA BERNBAUM), ALBERT FINNEY (LEO O'BANNON), J.E. FREEMAN (EDDIE THE DANE), JOHN TURTURRO (BERNIE BERNBAUM) / DIALOGUE: JOEL AND ETHAN COEN / MUSIC: CARTER BURWELL / DURATION: 115 MINUTES / CATEGORIES: GANG WARFARE, PROHIBITION, BETRAYAL

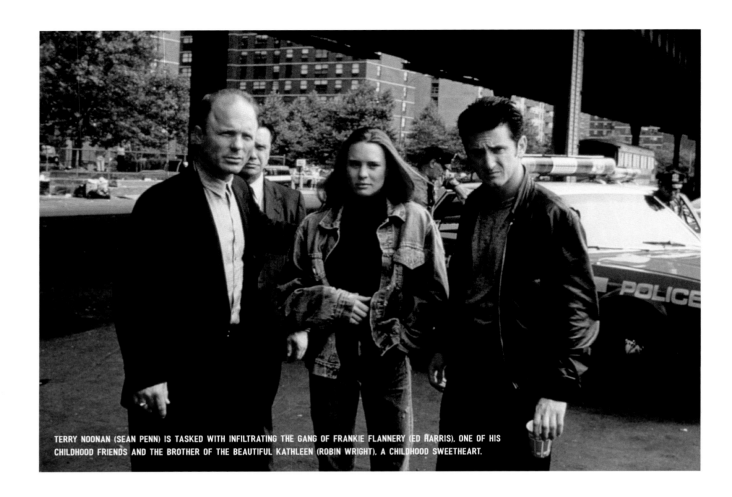

TERRY NOONAN (SEAN PENN) IS TASKED WITH INFILTRATING THE GANG OF FRANKIE FLANNERY (ED HARRIS), ONE OF HIS CHILDHOOD FRIENDS AND THE BROTHER OF THE BEAUTIFUL KATHLEEN (ROBIN WRIGHT), A CHILDHOOD SWEETHEART.

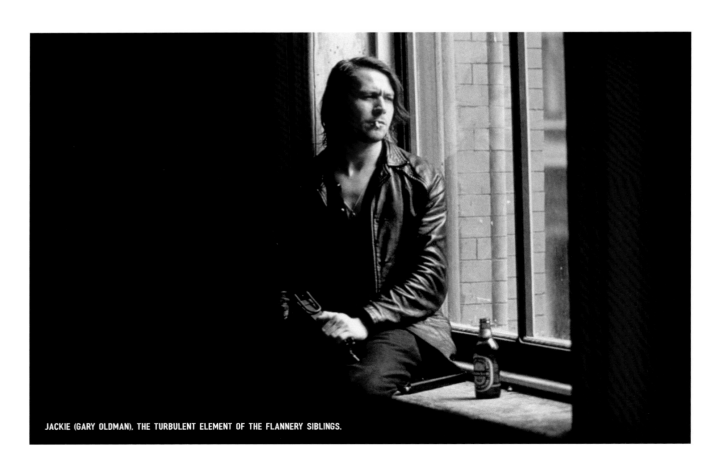

JACKIE (GARY OLDMAN), THE TURBULENT ELEMENT OF THE FLANNERY SIBLINGS.

STATE OF GRACE

UNITED STATES, 1990
DIRECTOR: PHIL JOANOU

After a ten-year absence, Terry Noonan (Sean Penn) returns to New York City and Hell's Kitchen, the Irish neighborhood where he grew up. He quickly reconnects with his old friend Jackie Flannery (Gary Oldman), whose brother Frankie (Ed Harris) became a local mob boss, but also with Kathleen (Robin Wright), Frankie and Jackie's sister, his first love. Despite Frankie's mistrust, Terry is quickly put in charge of settling delicate matters with Jackie. He is on the front line in an ongoing war between the Irish mafia and Italian gangsters led by Borelli (Joe Viterelli). When a friend of Jackie and Terry, Stevie McGuire (John C. Reilly) is found with his throat cut after an argument with the Italians, the suspicions lead to a lieutenant of Borelli's, but Terry learns that Stevie was liquidated by Frankie himself to preserve the peace between the gangs. Plagued by doubt about what to do, Terry confides to Kathleen his true identity: he has become a policeman in Boston and has been given the mission to infiltrate Frankie's gang. While being closely watched by Pat Nicholson (R. D. Call), Frankie's right-hand man, Terry now accompanies Jackie on all his missions. As such he witnesses, hidden behind a hut, the assassination of Jackie by his own brother. Terry decides to avenge the death of his friend.

97

TERRY WITH NICK (JOHN TURTURRO), HIS LIAISON OFFICER.

LEAD ACTORS: SEAN PENN (TERRY NOONAN), GARY OLDMAN (JACKIE FLANNERY), ED HARRIS (FRANKIE FLANNERY), ROBIN WRIGHT (KATHLEEN FLANNERY), R.D. CALL (PAT NICHOLSON), JOHN TURTURRO (NICK), JOHN C. REILLY (STEVIE MCGUIRE), JOE VITERELLI (BORELLI) / DIALOGUE: DENNIS MCINTYRE / MUSIC: ENNIO MORRICONE / DURATION: 134 MINUTES / CATEGORIES: NEW YORK MAFIA, UNDERCOVER COPS

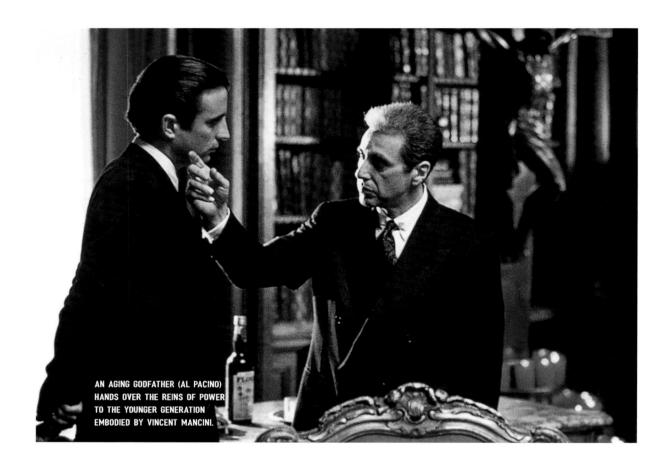

AN AGING GODFATHER (AL PACINO)
HANDS OVER THE REINS OF POWER
TO THE YOUNGER GENERATION
EMBODIED BY VINCENT MANCINI.

LEAD ACTORS: AL PACINO (MICHAEL CORLEONE), ANDY GARCIA (VINCENT MANCINI), SOFIA COPPOLA (MARY CORLEONE), DIANE KEATON (KAY ADAMS MICHELSON), TALIA SHIRE (CONNIE CORLEONE), JOE MANTEGNA (JOEY ZASA), RAF VALLONE (CARDINAL LAMBERTO) / DIALOGUE: FRANCIS FORD COPPOLA, MARIO PUZO / MUSIC: NINO ROTA, CARMINE COPPOLA / DURATION: 163 MINUTES / CATEGORIES: CHRONICLE OF A MAFIA FAMILY, VENGEANCE / AWARDS: SEVEN NOMINATIONS AT THE OSCARS, SEVEN NOMINATIONS AT THE GOLDEN GLOBES

THE GODFATHER: PART III

UNITED STATES, 1990
DIRECTOR: FRANCIS FORD COPPOLA

The plot of *The Godfather: Part III*, shot fifteen years after the previous film, takes place in the late 1970s. An ageing Michael Corleone is torn by remorse and aims to redeem himself through charitable contributions. At a party, the illegitimate son of Sonny Corleone, Vincent Mancini (Andy Garcia), meets with the rest of the family. He has inherited his father's bloodline and impresses Michael with his determination. Vincent also meets his cousin Mary, Michael's daughter (Sofia Coppola) who falls in love with him. Vincent carries on the family business by eliminating Joey Zasa (Joe Mantegna), a disloyal affiliate, while starting an affair with Mary. For his part, Michael realizes that he has been cheated by Italian politicians and financiers close to the Vatican. Increasingly bitter and disillusioned, Michael ends up handing over the reins of power to Vincent. But fate, ruthlessly, will take away the one that matters most to him: his daughter Mary.

VINCENT MANCINI (ANDY GARCIA) MUST RENOUNCE HIS LOVE AFFAIR WITH HIS COUSIN MARY CORLEONE (SOFIA COPPOLA) TO BECOME THE GODFATHER OF THE CORLEONE CLAN.

SCOTTY APPLETON (ICE-T) HOLDS NINO BROWN AT GUNPOINT IN FRONT OF NICK PERETTI (JUDD NELSON).

LEAD ACTORS: WESLEY SNIPES (NINO BROWN), CHRIS ROCK (POOKIE), ALLEN PAYNE (GEE MONEY), ICE-T (SCOTTY APPLETON), JUDD NELSON (NICK PERETTI), MARIO VAN PEEBLES (STONE), RUSSELL WONG (PARK), BILL NUNN (DUH DUH DUH MAN), JOHN APREA (DON ARMATEO) / DIALOGUE: THOMAS LEE WRIGHT, BARRY MICHAEL COOPER / MUSIC: VASSAL BENFORD, MICHEL COLOMBIER / DURATION: 97 MINUTES / CATEGORIES: DRUG TRAFFICKING, UNDERCOVER POLICEMAN

NEW JACK CITY

UNITED STATES, 1991
DIRECTOR: MARIO VAN PEEBLES

In the mid-1980s, crack cocaine made a major breakthrough into the drug market. In the Bronx, Nino Brown (Wesley Snipes) and his accomplices took control of the traffic. They set up the headquarters of their gang, the Cash Money Brothers, in an apartment building, the Carter, and terrorize its inhabitants. The two police inspectors in charge of taking down Nino Brown, Stone (Mario Van Peebles) and Park (Russel Wong), recruit two former police officers with unusual methods and controversial characters: Scotty Appleton (Ice-T), whose mother was killed by a drug trafficker, and Nick Peretti (Judd Nelson) who has a history of drug addiction. After a failed undercover attempt by a former drug dealer, Pookie (Chris Rock), the two cops overcome their differences and try to play on the dissension within the gang to confront Nino Brown. The resentment of one of his lieutenants, Gee Money (Allen Payne) and tensions with the Italian mafia led by Don Armateo (John Aprea) will facilitate their plans.

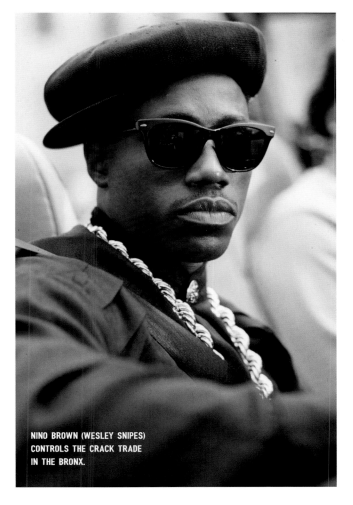

NINO BROWN (WESLEY SNIPES)
CONTROLS THE CRACK TRADE
IN THE BRONX.

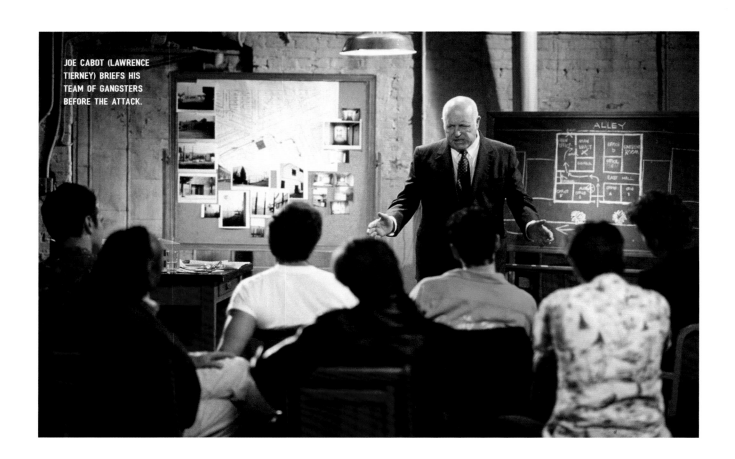

JOE CABOT (LAWRENCE TIERNEY) BRIEFS HIS TEAM OF GANGSTERS BEFORE THE ATTACK.

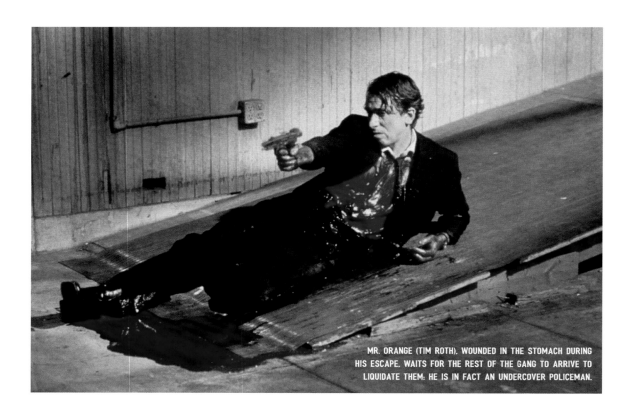

MR. ORANGE (TIM ROTH), WOUNDED IN THE STOMACH DURING HIS ESCAPE, WAITS FOR THE REST OF THE GANG TO ARRIVE TO LIQUIDATE THEM: HE IS IN FACT AN UNDERCOVER POLICEMAN.

LEAD ACTORS: TIM ROTH (MR. ORANGE / FREDDY), HARVEY KEITEL (MR. WHITE / LARRY), STEVE BUSCEMI (MR. PINK), MICHAEL MADSEN (MR. BLONDE / VIC VEGA), EDWARD BUNKER (MR. BLUE), QUENTIN TARANTINO (MR. BROWN), LAWRENCE TIERNEY (JOE CABOT), CHRIS PENN ("NICE GUY" EDDIE CABOT), KIRK BALTZ (MARVIN NASH) / DIALOGUE : QUENTIN TARANTINO / MUSIC: KARYN RACHTMAN / DURATION: 99 MINUTES / CATEGORIES : GANG ROBBERY, INFILTRATED POLICEMAN

RESERVOIR DOGS

UNITED STATES, 1992
DIRECTOR: QUENTIN TARANTINO

A Los Angeles mobster, Joe Cabot (Lawrence Tierney), recruited six gangsters from various backgrounds to rob a diamond dealer. The six men, who do not know each other, have code names to preserve their anonymity: Mr. White (Harvey Keitel), Mr. Orange (Tim Roth), Mr. Blonde (Michael Madsen), Mr. Pink (Steve Buscemi), Mr. Brown (Quentin Tarantino) and Mr. Blue (Edward Bunker). The gang members look very relaxed and their meeting seems to be more focused on discussing music. However the action soon turns to the heist, but the very quick arrival of the police on the scene thwarts Cabot's plans: Mr. White and Mr. Orange flee, Mr. Brown is killed, Mr. Blonde has shot several people and Mr. Blue has disappeared. When they arrive at the warehouse that serves as a rallying point, Mr. White and Mr. Orange have become friendly enough to use their real first names. Then Mr. Pink, who put the diamonds in a safe place, appears, followed by Mr. Blonde, whom everyone suspects to be a psychopath - he took a policeman hostage - and finally Eddie Cabot (Chris Penn) Joe's son. While Eddie, Mr. White and Mr. Pink leave the place to get the diamonds, Mr. Blonde tortures the policeman to the point that Mr. Orange, who is lying in his own blood, shoots Mr. Blonde with his gun. Mr. Orange explains to the policeman that he himself is an undercover agent and that he is waiting for Joe Cabot to come and kill all the members of the gang. When the latter arrives, he sees Mr. Blonde dead and murders the policeman while affirming that Mr. Orange has betrayed them. In the confusion that ensues, the protagonists kill each other, except for Mr. Pink, who flees with the diamonds before the police attack.

Quentin Tarantino thus transforms a perfect robbery story into a resounding fiasco with incredible twists and turns.

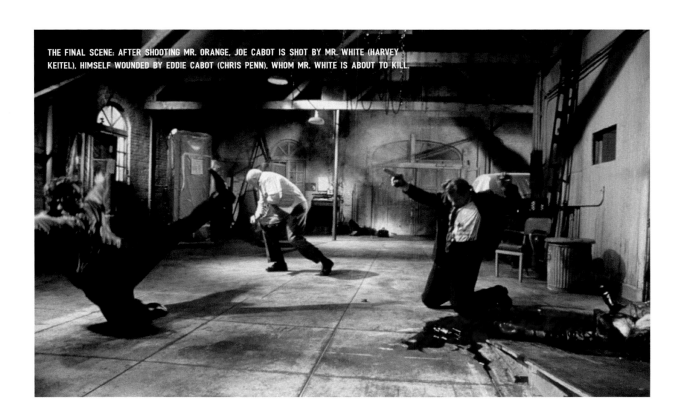

THE FINAL SCENE: AFTER SHOOTING MR. ORANGE, JOE CABOT IS SHOT BY MR. WHITE (HARVEY KEITEL), HIMSELF WOUNDED BY EDDIE CABOT (CHRIS PENN), WHOM MR. WHITE IS ABOUT TO KILL.

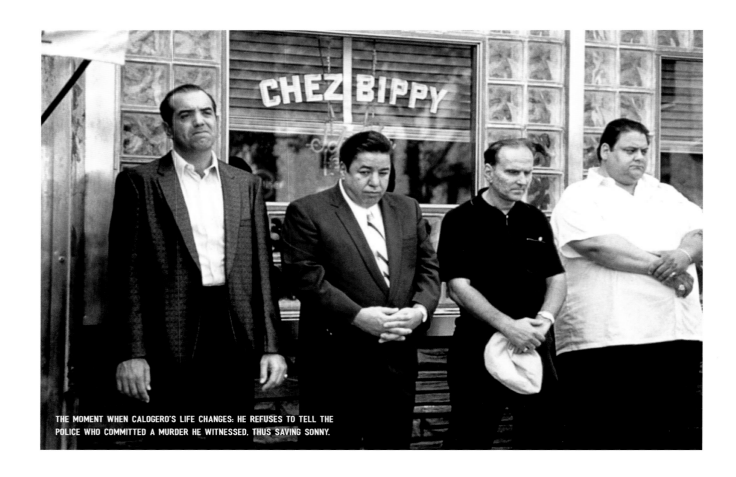

THE MOMENT WHEN CALOGERO'S LIFE CHANGES: HE REFUSES TO TELL THE POLICE WHO COMMITTED A MURDER HE WITNESSED, THUS SAVING SONNY.

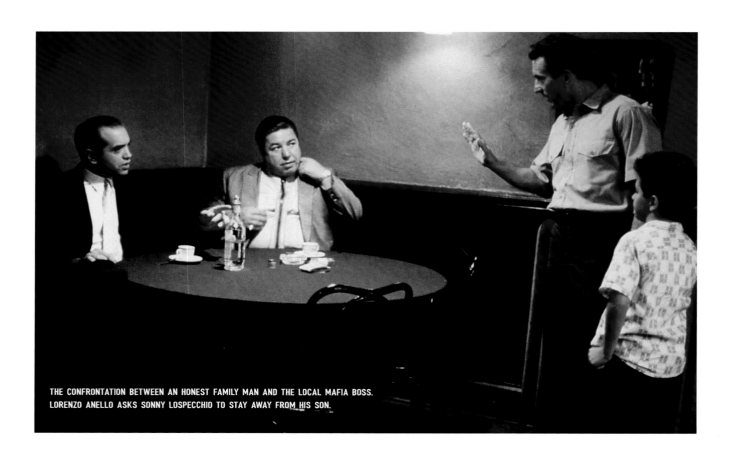

THE CONFRONTATION BETWEEN AN HONEST FAMILY MAN AND THE LOCAL MAFIA BOSS. LORENZO ANELLO ASKS SONNY LOSPECCHIO TO STAY AWAY FROM HIS SON.

A BRONX TALE

UNITED STATES, 1993
DIRECTOR: ROBERT DE NIRO

Born into the family of a bus driver with strict principles, Calogero Anello is a young Italian American boy growing up in the Bronx in the early 1960s. The boy is fascinated by Sonny LoSpecchio (Chazz Palminteri), the local mob boss, whom he watches all day long on the street. After witnessing Sonny kill a rival in broad daylight, Calogero refuses to identify him to the police. The gangster then becomes fond of this brave boy who is quickly adopted as the gang's mascot. However, Calogero's father does not see this friendship in a positive light. As the years go by, Calogero is increasingly torn between the respect he feels for his father and the admiration he has for Sonny. Everything gets even more complicated when Calogero falls in love with Jane, a beautiful African American high school friend, in a poor district marked by racial hatred.

A surprising Robert De Niro plays a man of integrity, while Chazz Palminteri brilliantly portrays an old-fashioned Italian American gangster, who is both unscrupulous and generous. Palminteri, who also wrote the screenplay, drew on his childhood memories to recreate the atmosphere of the Bronx where he situates this funny and tragic story that confronts reason and emotions. While the film is dedicated to the memory of Robert De Niro Sr., who died shortly before its release, it was Chazz Palminteri's father who was actually a bus driver.

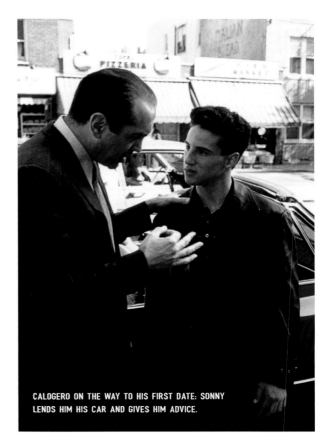

CALOGERO ON THE WAY TO HIS FIRST DATE: SONNY LENDS HIM HIS CAR AND GIVES HIM ADVICE.

LEAD ACTORS: ROBERT DE NIRO (LORENZO ANELLO), CHAZZ PALMINTERI (SONNY LOSPECCHIO), LILLO BRANCATO (CALOGERO ANELLO AS A TEENAGER), FRANCIS CAPRA (CALOGERO AS A 9-YEAR-OLD CHILD), TARAL HICKS (JANE WILLIAMS) / DIALOGUE: CHAZZ PALMINTERI / MUSIC: BUTCH BARBELLA / DURATION: 121 MINUTES / CATEGORY: LIFE AND DEATH OF A MOBSTER / AWARD: NOMINATED AT THE VENICE FILM FESTIVAL / TRIVIA: ROBERT DE NIRO HAD TO PASS A BUS DRIVER'S LICENSE TEST TO BE ABLE TO PLAY HIS PART IN THE FILM.

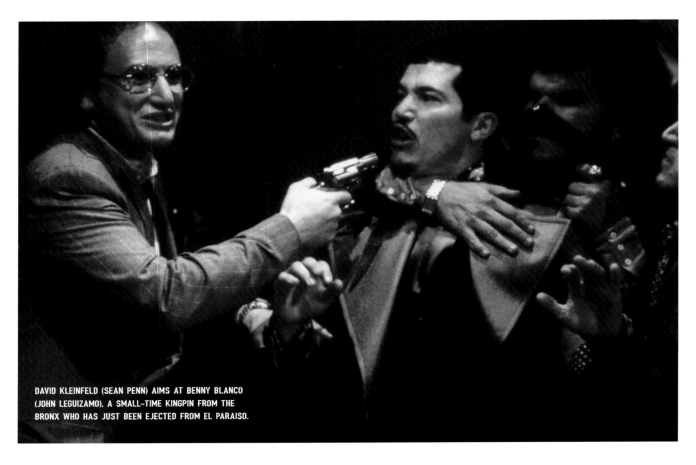

DAVID KLEINFELD (SEAN PENN) AIMS AT BENNY BLANCO
(JOHN LEGUIZAMO), A SMALL-TIME KINGPIN FROM THE
BRONX WHO HAS JUST BEEN EJECTED FROM EL PARAISO.

LEAD ACTORS: AL PACINO (CARLITO BRIGANTE), SEAN PENN (DAVID KLEINFELD), PENELOPE ANN MILLER (GAIL),
JOHN LEGUIZAMO (BENNY BLANCO), LUIZ GUZMÁN (PACHANGA) / DIALOGUE: DAVID KOEPP, BASED ON THE NOVEL
OF THE SAME NAME BY EDWIN TORRES / MUSIC: PATRICK DOYLE / DURATION: 144 MINUTES /
CATEGORY: LIFE AND DEATH OF A GANGSTER / AWARDS: TWO NOMINATIONS FOR THE GOLDEN GLOBES

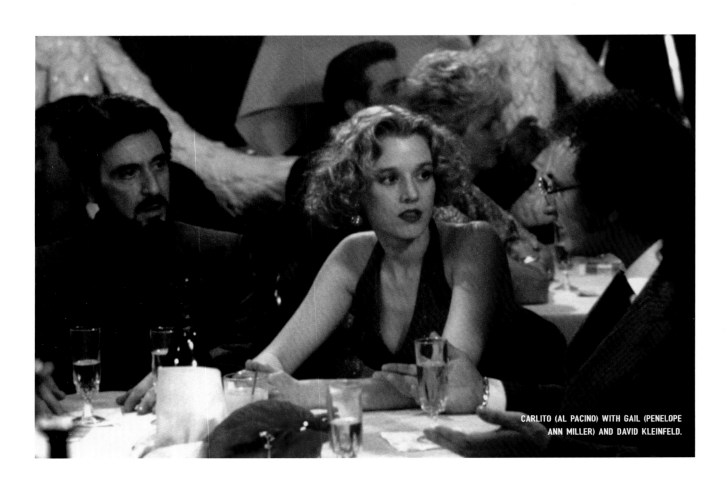

CARLITO (AL PACINO) WITH GAIL (PENELOPE
ANN MILLER) AND DAVID KLEINFELD.

CARLITO'S WAY

UNITED STATES, 1993
DIRECTOR: BRIAN DE PALMA

Carlito Brigante (Al Pacino) had just spent five years in prison when he was released due to a mistrial thanks to his best friend and lawyer, David Kleinfeld (Sean Penn). He wants to change his life at all costs and dreams of joining forces with one of his former fellow inmates who runs a rental car business in the Bahamas. To achieve his goal, he needs to raise $75,000. A combination of circumstances leads him to take over the management of a nightclub, El Paraiso, which brings him substantial income. In spite of urgent calls from his former accomplices, Carlito stays out of drug trafficing and reconnects with Gail

(Penelope Ann Miller), his love from the past. But his loyalty to David Kleinfeld, who increasingly sinks into violence and cocaine addiction, will undermine the fragile balance on which Carlito's new life is based. When Kleinfeld assassinates an Italian mob boss, from whom the lawyer has stolen a million dollars, Carlito knows that his life is hanging by a thread.

Brian De Palma's film is a modern version of the Greek tragedies: the hero already knows he is condemned but is constantly trying to escape his fate.

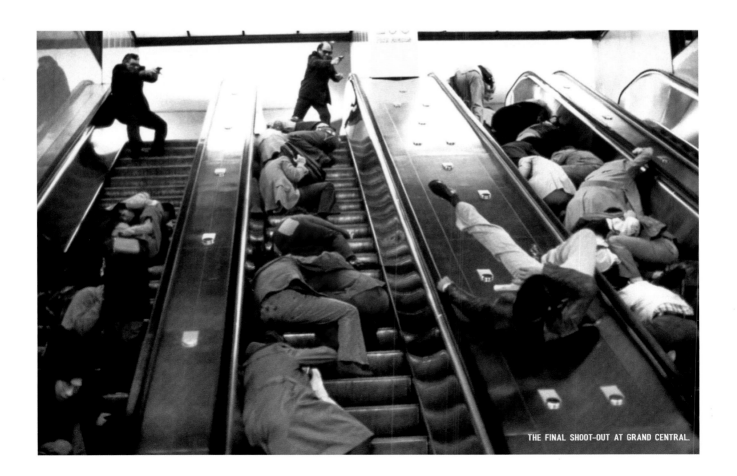

THE FINAL SHOOT-OUT AT GRAND CENTRAL.

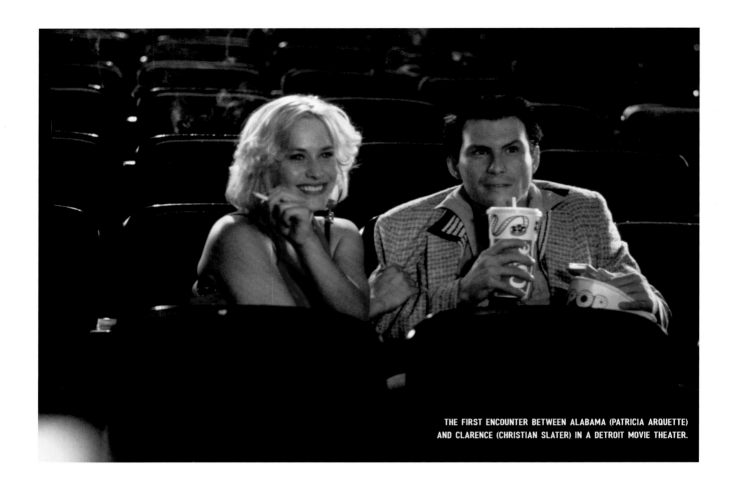

THE FIRST ENCOUNTER BETWEEN ALABAMA (PATRICIA ARQUETTE)
AND CLARENCE (CHRISTIAN SLATER) IN A DETROIT MOVIE THEATER.

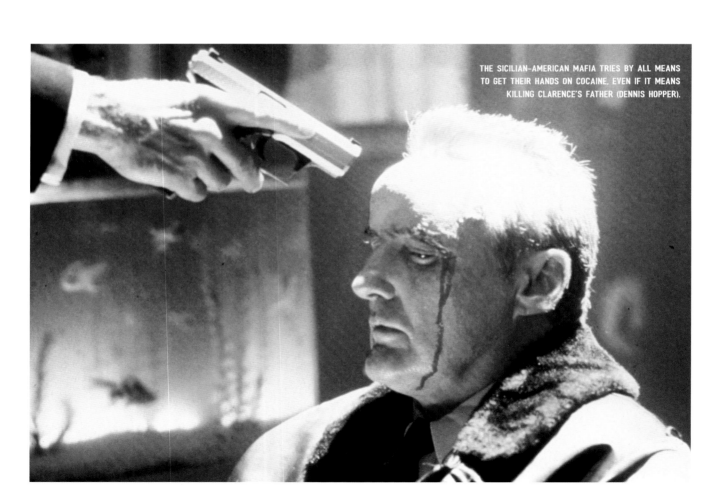

THE SICILIAN-AMERICAN MAFIA TRIES BY ALL MEANS
TO GET THEIR HANDS ON COCAINE, EVEN IF IT MEANS
KILLING CLARENCE'S FATHER (DENNIS HOPPER).

TRUE ROMANCE

UNITED STATES, 1993
DIRECTOR: TONY SCOTT

On his birthday, Clarence Worley (Christian Slater), a comic book salesman, goes to see an Asian martial arts movie in a Detroit movie theater. A gorgeous blonde, Alabama (Patricia Arquette), appears and sits next to him. It's love at first sight for both of them. Just before getting married the next morning, Alabama confesses to Clarence that she is a newly-minted call girl who had been ordered by Clarence's boss as a birthday present. Not deterred by Alabama's confession, Clarence proposes to pick up her belongings from Drexl, her former pimp. But the meeting between Clarence and Drexl turns sour: Clarence ends up shooting Drexl and his bodyguard at the end of a legendary fight. He grabs a suitcase that he believes to be Alabama's, but is instead packed full of Drexl's cocaine. Back at his place, where Alabama is waiting for him, Clarence realizes his mistake and decides to flee to Los Angeles to sell the dope. Unfortunately, he has left his driver's license at Drexl's house and the Sicilian mafia, for whom the drugs were intended, comes after him. While the mafia consigliere Vincenzo Cocotti (Christopher Walken) kills Clarence's father, Clifford (Dennis Hopper), to get information, the two newlyweds contact a Hollywood producer, Lee Donowitz (Saul Rubinek) to sell him the merchandise. But nothing happens as planned.

109

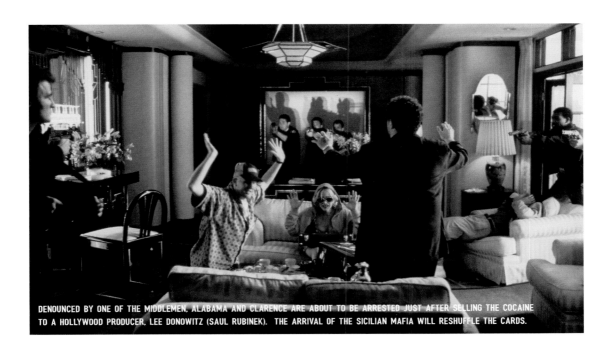

DENOUNCED BY ONE OF THE MIDDLEMEN, ALABAMA AND CLARENCE ARE ABOUT TO BE ARRESTED JUST AFTER SELLING THE COCAINE TO A HOLLYWOOD PRODUCER, LEE DONOWITZ (SAUL RUBINEK). THE ARRIVAL OF THE SICILIAN MAFIA WILL RESHUFFLE THE CARDS.

LEAD ACTORS: CHRISTIAN SLATER (CLARENCE WORLEY), PATRICIA ARQUETTE (ALABAMA WHITMAN-WORLEY), MICHAEL RAPAPORT (DICK RITCHIE), DENNIS HOPPER (CLIFFORD WORLEY), CHRISTOPHER WALKEN (VINCENZO COCOTTI), GARY OLDMAN (DREXL SPIVEY), BRAD PITT (FLOYD), BRONSON PINCHOT (ELLIOT), SAUL RUBINEK (LEE DONOWITZ) / DIALOGUE: QUENTIN TARANTINO / MUSIC: HANS ZIMMER / DURATION: 119 MINUTES / CATEGORIES: DRUG TRAFFICKING, PROSTITUTION, ITALIAN MAFIA

LÉON: THE PROFESSIONAL

FRANCE, 1994
DIRECTOR: LUC BESSON

110

Léon (Jean Reno) is a hitman with an austere lifestyle: he lives alone in a modest apartment in Little Italy, New York, drinks a lot of milk, takes devoted care of a green houseplant, exercises and watches old romantic comedies. His only work is to liquidate the targets designated by his mentor Tony (Danny Aiello), a small-time Italian American mobster who exploits Léon's humble and modest character. One day he comes across a young neighbor smoking on the stairs, he asks the girl why she's not at school and realizes that she has been beaten up. Mathilda (Nathalie Portman) has a rather complicated family situation: she lives in a patchwork family, with an abusive and drug-addicted father, a stepmother and a sister she hates. Her her only emotional bond is with her four-year-old little brother. Her father has been involved in drug trafficking with corrupt police officers led by a psychopath, Norman Stansfield (Gary Oldman). Stansfield, furious that the father has diverted some of the cocaine to himself, executes the entire family, except for Mathilda, who was out shopping. Seeing the killers still at the scene, she takes refuge at Léon's apartment down the hall, where he reluctantly opens his door to her. Mathilda asks Léon to teach her his trade so that she can one day avenge her family. The hitman, hesitant at first, gradually warms to his mentorship role and helps the young girl to achieve her goal.

LEAD ACTORS: JEAN RENO (LÉON), NATHALIE PORTMAN (MATHILDA), GARY OLDMAN (NORMAN STANSFIELD), DANNY AIELLO (TONY) / DIALOGUE: LUC BESSON / MUSIC: ÉRIC SERRA / DURATION: 110 MINUTES (UNCUT VERSION: 136 MINUTES) / CATEGORIES: HITMAN, DRUG TRAFFICKING, ITALIAN AMERICAN MAFIA, CORRUPT POLICEMEN

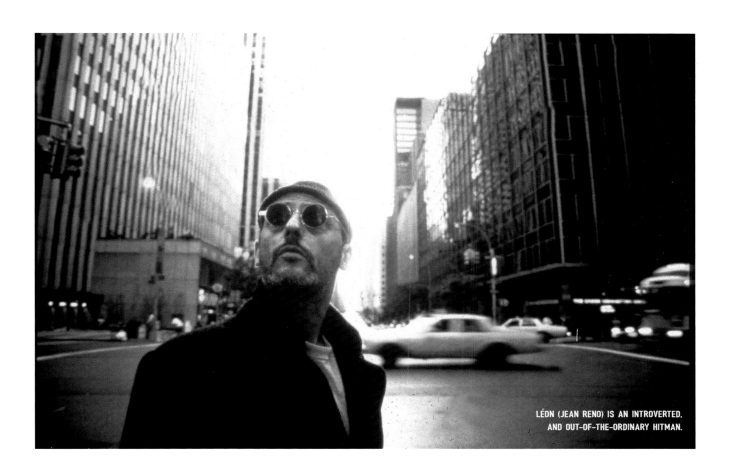

LÉON (JEAN RENO) IS AN INTROVERTED,
AND OUT-OF-THE-ORDINARY HITMAN.

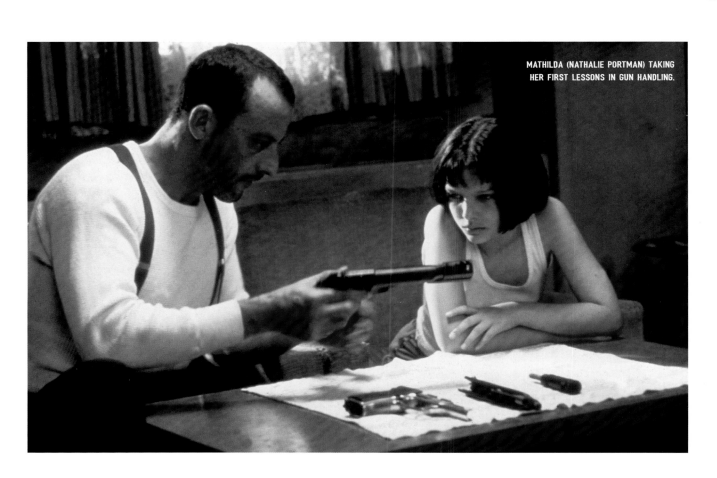

MATHILDA (NATHALIE PORTMAN) TAKING
HER FIRST LESSONS IN GUN HANDLING.

PULP FICTION

UNITED STATES, 1994
DIRECTOR: QUENTIN TARANTINO

This cult movie has marked an entire generation and Quentin Tarantino seems to have followed the advice of his fellow director, Jean-Luc Godard: "Every story must have a beginning, a middle and an end, but not necessarily in that order". The two main stories that make up the plot are interspersed with zany episodes. The narration doesn't even bother with chronology, as we see Vincent Vega (John Travolta) appear alongside his sidekick Jules Winnfield (Samuel L. Jackson), although in a previous scene he was killed by Butch Coolidge (Bruce Willis). The violence of some scenes counterbalances the banality of other situations that are deliberately comic.

The whole story revolves around Marsellus Wallace (Ving Rhames), a big shot from Los Angeles who entrusts two henchmen, Jules Winnfield and Vincent Vega, with the task of recovering a briefcase stolen by a group of amateurs. The two killers easily liquidate two of the thieves, but a third one, who had gone to the lavatory before their arrival, shoots without warning, but misses them. Vincent suspects their informant, Marvin (Phil LaMarr), of having arranged the third thief's hideout to get rid of them. On the way home, while Jules is driving the car, Vincent inadvertently kills Marvin with a bullet to the head. They then have to go to a friend of Marsellus' who makes all traces of the crime disappear. Jules and Vincent, who have swapped their bloody suits for beach wear, find Marsellus as he is arranging for Butch Coolidge, a boxer, to throw an upcoming fight. But Butch decides to double cross them and wins the match in order to pocket the bets. As he flees after retrieving a watch from his father and killing Vincent Vega, who was about to shoot him, Butch crashes his car into Marsellus. Marsellus chases Butch into a store run by a sadistic psychopath who takes them prisoner and intends to subject them to physical outrages before eliminating them. Butch manages to free himself and saves Marsellus, who forgives him on the condition that he leaves town and never talks about the incident. Other side stories, such as the dance between Vincent and Mia Wallace (Uma Thurman), Marsellus' wife, or the monologue of a former soldier who knew Butch's father, who died in Vietnam, inject novelty into the story.

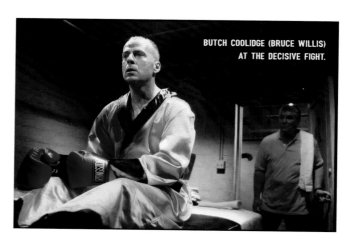

BUTCH COOLIDGE (BRUCE WILLIS) AT THE DECISIVE FIGHT.

LEAD ACTORS: JOHN TRAVOLTA (VINCENT VEGA), SAMUEL L. JACKSON (JULES WINNFIELD), BRUCE WILLIS (BUTCH COOLIDGE), UMA THURMAN (MIA WALLACE), VING RHAMES (MARSELLUS WALLACE), CHRISTOPHER WALKEN (CAPTAIN KOONS), MARIA DE MEDEIROS (FABIENNE, BUTCH'S GIRLFRIEND) / DIALOGUE: QUENTIN TARANTINO, ROGER AVARY / MUSIC: KARYN RACHTMAN, LAURA LOVELACE / DURATION: 154 MINUTES / CATEGORIES: CONTRACT KILLERS, FIXED FIGHTS, GANG LEADER / AWARDS: PALME D'OR AT THE CANNES FILM FESTIVAL. SEVEN OSCAR NOMINATIONS, ONE AWARD (BEST ORIGINAL SCREENPLAY FOR QUENTIN TARANTINO AND ROGER AVARY), SIX GOLDEN GLOBES NOMINATIONS, ONE AWARD (BEST SCREENPLAY).

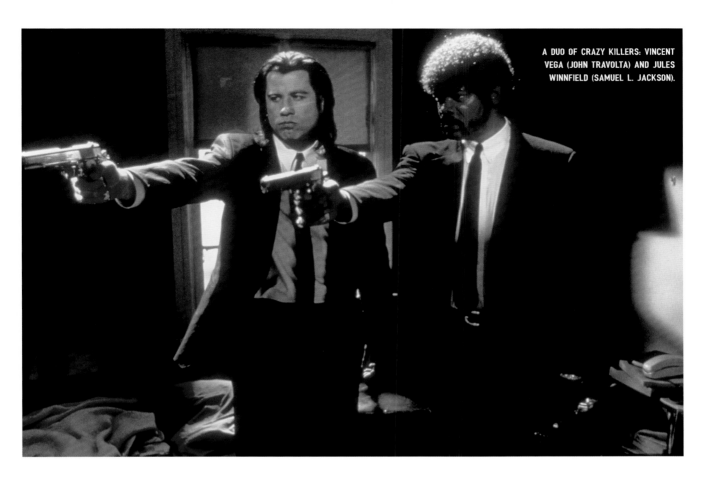

A DUO OF CRAZY KILLERS: VINCENT VEGA (JOHN TRAVOLTA) AND JULES WINNFIELD (SAMUEL L. JACKSON).

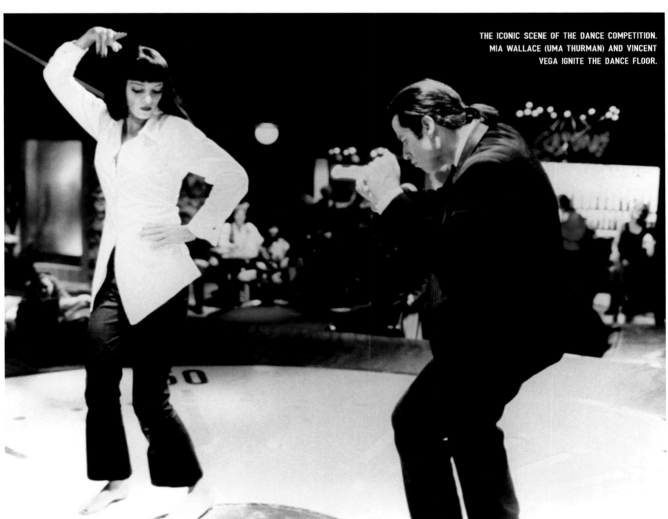

THE ICONIC SCENE OF THE DANCE COMPETITION. MIA WALLACE (UMA THURMAN) AND VINCENT VEGA IGNITE THE DANCE FLOOR.

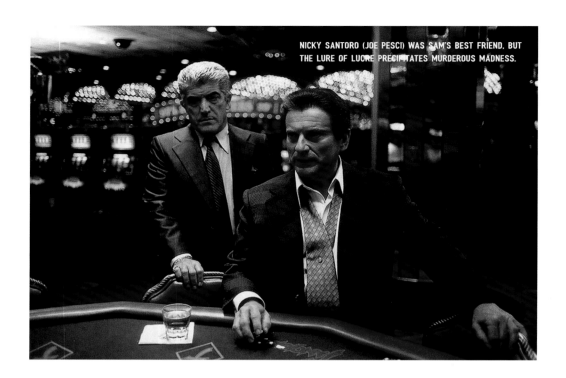

NICKY SANTORO (JOE PESCI) WAS SAM'S BEST FRIEND. BUT THE LURE OF LUCRE PRECIPITATES MURDEROUS MADNESS.

114

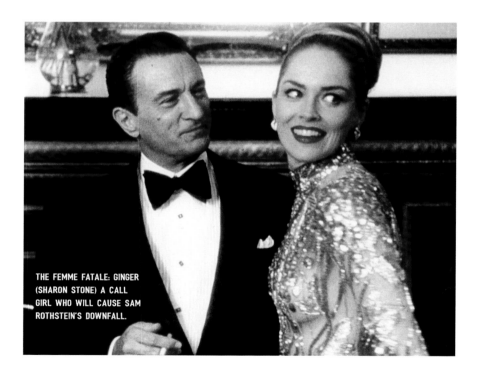

THE FEMME FATALE: GINGER (SHARON STONE) A CALL GIRL WHO WILL CAUSE SAM ROTHSTEIN'S DOWNFALL.

LEAD ACTORS: ROBERT DE NIRO (SAM "ACE" ROTHSTEIN), SHARON STONE (GINGER MCKENNA ROTHSTEIN), JOE PESCI (NICKY SANTORO), JAMES WOOD (LESTER DIAMOND) / DIALOGUE: MARTIN SCORSESE, NICHOLAS PILEGGI / MUSIC: BOBBY MACKSTON / DURATION: 178 MINUTES / CATEGORIES: BIOPIC, TRUE STORY / TRIVIA: TO BEST EMBODY HIS CHARACTER, ROBERT DE NIRO HAD THE COSTUMES HE WEARS, MADE BY FRANK ROSENTHAL'S TAILOR, THE "REAL" SAM ROTHSTEIN.

CASINO

UNITED STATES, 1995
DIRECTOR: MARTIN SCORSESE

Sent by the Chicago underworld to run the Tangiers, a giant casino in Las Vegas, Sam "Ace" Rothstein does wonders there: money flows in large sums, the house is held with an iron fist and woe to any cheaters who cross Rothstein's path. But the arrival of childhood friend Nicky Santoro (Joe Pesci), whose mission is to protect him, will gradually transform the dream into a nightmare. Santoro is obsessed with gain and will stop at nothing to build a fortune at the expense of others. The sudden intrusion of Ginger (Sharon Stone), a high-flying call girl into Rothstein's life doesn't make it any easier. Rothstein decides to marry her and start a family, but Ginger falls into drug addiction under the influence of her former pimp, Lester Diamond (James Wood). Dreams of success and happiness fade away. As always in Las Vegas, no one wins. And the king of Vegas will end his life in exile...

Based on Nicholas Pileggi's novel *Love and Honor in Las Vegas*, the film tells the true story of Frank "Lefty" Rosenthal, a former gangster who ended up running several casinos in the city, and of Anthony Spilotro, one of the most violent Italian-American mafia enforcers. As in the film, the real Rosenthal survived a car bomb thanks to a heavy metal plate under the driver's seat.

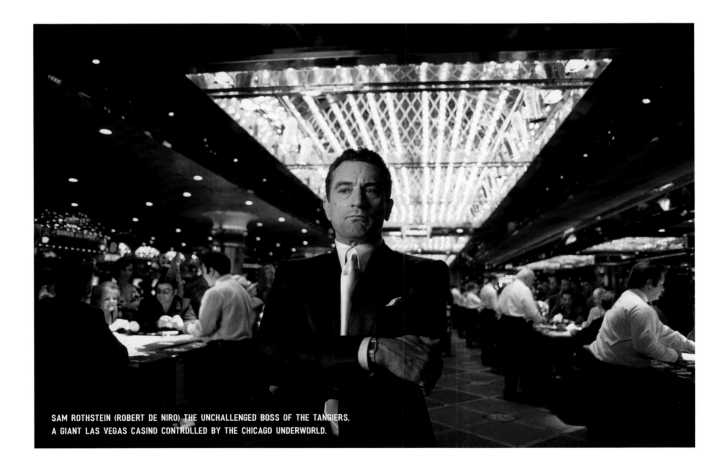

SAM ROTHSTEIN (ROBERT DE NIRO) THE UNCHALLENGED BOSS OF THE TANGIERS, A GIANT LAS VEGAS CASINO CONTROLLED BY THE CHICAGO UNDERWORLD.

HEAT

UNITED STATES, 1995
DIRECTOR: MICHAEL MANN

Neil McCauley (Robert De Niro), a high-flying bank robber, is about to attack an armored truck with his gang: Chris Shiherlis (Val Kilmer), Michael Cheritto (Tom Sizemore) and Trejo (Danny Trejo). The meticulously planned attack turns into carnage when a new recruit, Waingro (Kevin Gage), shoots down several guards for no reason. Once in safety, McCauley, furious at Waingro, decides to liquidate him. But Waingro manages to flee right from under McCauley's nose. The goal of the robbery was to steal bonds owned by a shady financier, Roger Van Zant (William Fichtner), McCauley then makes contact with Van Zant in the hope of selling him back the stolen shares, which the businessman will resell discreetly after pocketing the insurance premium for the robbery.

Meanwhile, Lieutenant Vincent Hanna (Al Pacino) is in charge of the investigation. His flair, determination and experience in the field quickly put him on the trail of McCauley and his men. His tireless pursuit is not the only pitfall that awaits the crooks: Van Zant, who had accepted the deal proposed by McCauley, sends killers to recover the bonds and liquidate the perpetrators. His plan fails, and he is threatened with death by McCauley. The only solution for Van Zant is to call on Waingro to decimate the gang.

Driven by necessity, McCauley's men plan the robbery of a precious metal deposit. Inspector Hanna hears about the attack and sets up an ambush, but the noise made by a SWAT member puts McCauley on alert and the team flees.

McCauley has meanwhile met Eady, a young bookseller, and is thinking of withdrawing from the scene. Vincent Hanna, ever more intrigued by this unusual gangster, arranges a meeting over a cup of coffee, where McCauley explains that he would rather die than go back to prison. Pushed by his friends, McCauley agrees to one last robbery, in a bank, but the exit turns into a drama: only McCauley and Chris Shiherlis survive, hunted by the police. Hanna will eventually defeat McCauley at the end of an epic chase, but his victory has a bitter taste.

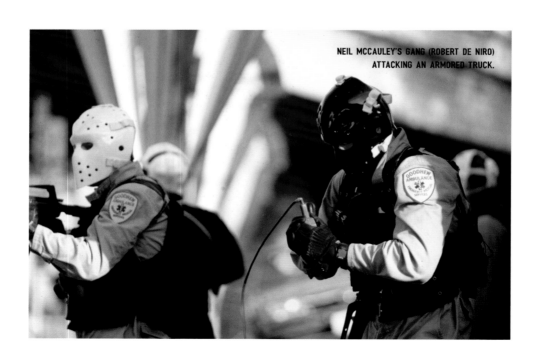

NEIL MCCAULEY'S GANG (ROBERT DE NIRO) ATTACKING AN ARMORED TRUCK.

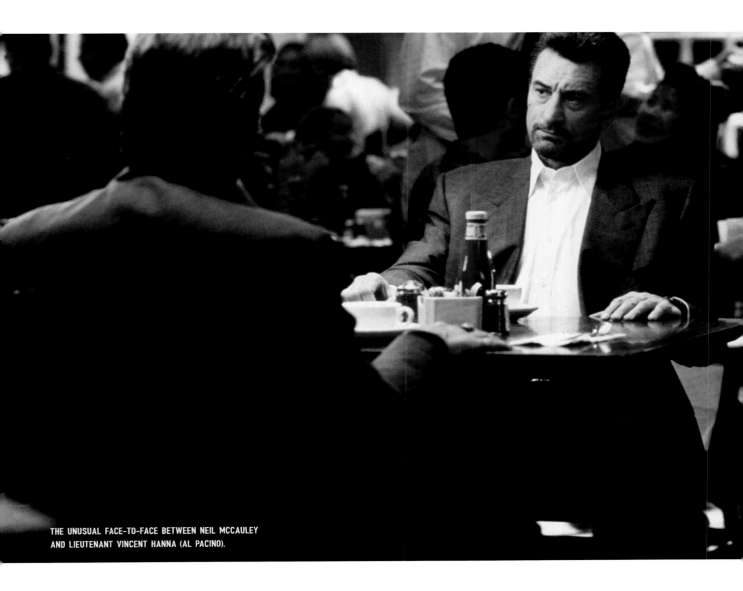

THE UNUSUAL FACE-TO-FACE BETWEEN NEIL MCCAULEY
AND LIEUTENANT VINCENT HANNA (AL PACINO).

LEAD ACTORS: ROBERT DE NIRO (NEIL MCCAULEY), AL PACINO (VINCENT HANNA), VAL KILMER (CHRIS SHIHERLIS), TOM SIZEMORE (MICHAEL CHERITTO), DANNY TREJO (TREJO), AMY BRENNEMAN (EADY), ASHLEY JUDD (CHARLENE SHIHERLIS), DIANE VENORA (JUSTINE HANNA), KEVIN GAGE (WAINGRO) WILLIAM FICHTNER (ROGER VAN ZANT) / DIALOGUE: MICHAEL MANN / MUSIC: MICHAEL BROOK, BRIAN ENO, ELLIOT GOLDENTHAL, MOBY & TERJE RYPDAL / DURATION: 170 MINUTES / CATEGORY: GANG DISMANTLING / TRIVIA: THE SCENE WHERE LIEUTENANT HANNA AND NEIL MCCAULEY ARE HAVING COFFEE WAS SHOT SEVERAL TIMES. AL PACINO AND ROBERT DE NIRO SHOWED TOO MUCH COMPLICITY BUT THEIR FACE-TO-FACE MEETING WAS SUPPOSED TO BE MARKED BY MISTRUST.

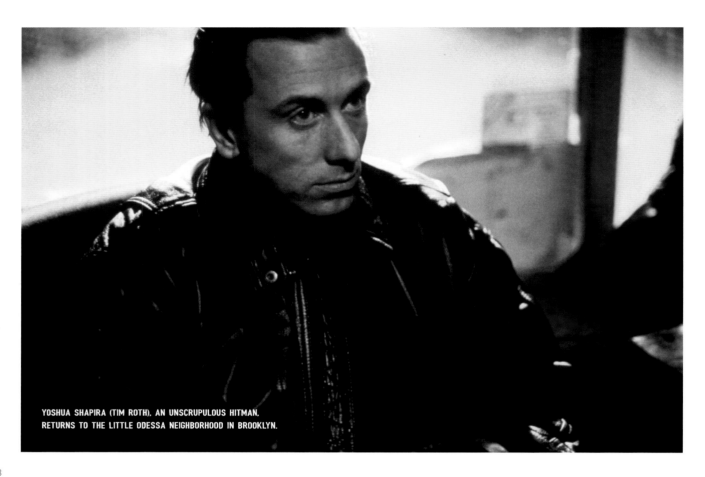

YOSHUA SHAPIRA (TIM ROTH), AN UNSCRUPULOUS HITMAN,
RETURNS TO THE LITTLE ODESSA NEIGHBORHOOD IN BROOKLYN.

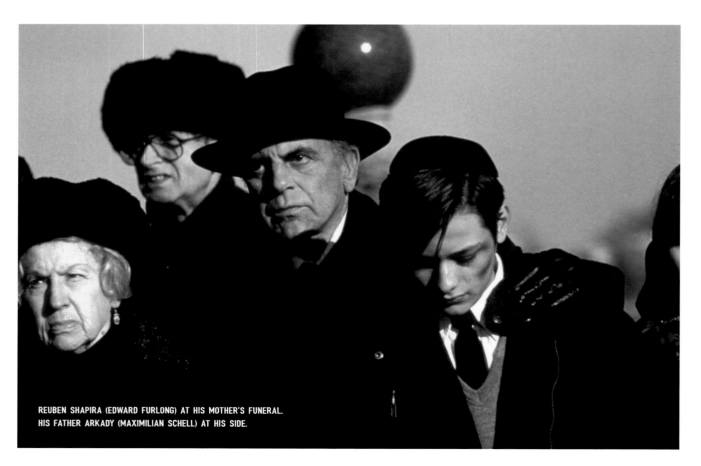

REUBEN SHAPIRA (EDWARD FURLONG) AT HIS MOTHER'S FUNERAL.
HIS FATHER ARKADY (MAXIMILIAN SCHELL) AT HIS SIDE.

LITTLE ODESSA

UNITED STATES, 1995
DIRECTOR: JAMES GRAY

Yoshua Shapira (Tim Roth), a professional killer, flees his neighborhood in Little Odessa after shooting the son of local godfather Boris Volkoff (Paul Guilfoyle). His job brings him back to Brooklyn where he has to eliminate an Iranian jeweler. He discreetly resumes contact with his younger brother Reuben (Edward Furlong) and with Alla, a youthful love never forgotten (Moira Kelly). In spite of the dangers that hang over him, Yoshua decides to visit his very sick mother (Vanessa Redgrave), even though he has to face his father (Maximilian Schell) who considers him lost. Yoshua and Reuben, both suffering from loneliness, try to renew the bond that united them in their childhood. But Volkoff's gang watches them and urges the father to reveal where his eldest son is hiding. The sudden death of the mother will not be the only misfortune that will affect Yoshua.

This first film by James Gray, made when he was 24 years old, treats subjects dear to the director: family conflicts, paternal authority and the relationship between brothers. In some respects, Yoshua Shapira recalls the character of Michael Corleone in *The Godfather*: like him, Yoshua seems drawn against his will into a spiral of violence.

LEAD ACTORS: TIM ROTH (JOSHUA SHAPIRA), EDWARD FURLONG (REUBEN SHAPIRA), VANESSA REDGRAVE (IRINA SHAPIRA), MAXIMILIAN SCHELL (ARKADY SHAPIRA), MOIRA KELLY (ALLA SHUSTERVICH), PAUL GUILFOYLE (BORIS VOLKOFF) / DIALOGUE: JAMES GRAY / MUSIC: DANA SANO / DURATION: 98 MINUTES / CATEGORIES: CONTRACT KILLER, FAMILY CONFLICTS, REVENGE

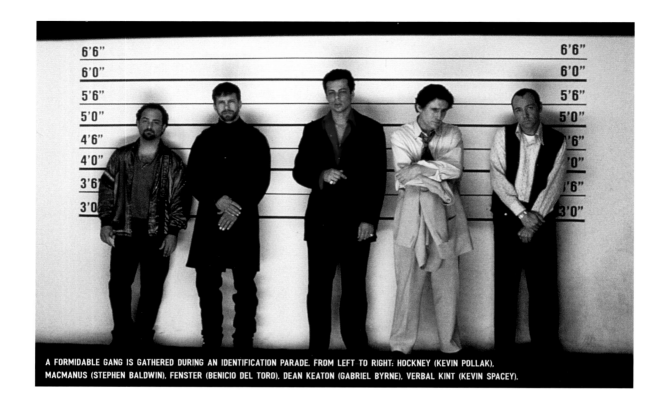

A FORMIDABLE GANG IS GATHERED DURING AN IDENTIFICATION PARADE. FROM LEFT TO RIGHT: HOCKNEY (KEVIN POLLAK), MACMANUS (STEPHEN BALDWIN), FENSTER (BENICIO DEL TORO), DEAN KEATON (GABRIEL BYRNE), VERBAL KINT (KEVIN SPACEY).

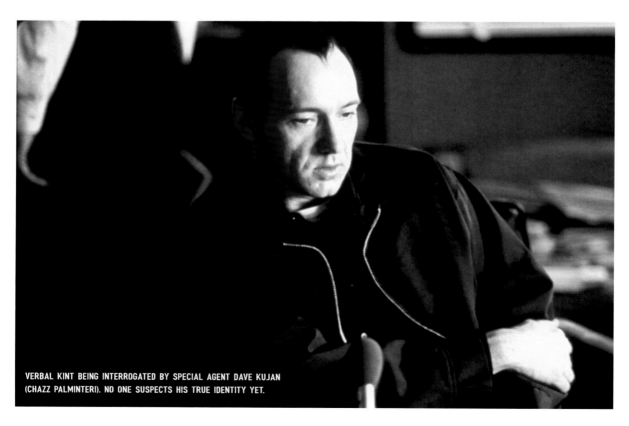

VERBAL KINT BEING INTERROGATED BY SPECIAL AGENT DAVE KUJAN (CHAZZ PALMINTERI). NO ONE SUSPECTS HIS TRUE IDENTITY YET.

LEAD ACTORS: KEVIN SPACEY (VERBAL KINT), GABRIEL BYRNE (DEAN KEATON), STEPHEN BALDWIN (MICHAEL MACMANUS), BENICIO DEL TORO (FRED FENSTER), KEVIN POLLAK (TODD HOCKNEY), CHAZZ PALMINTERI (SPECIAL AGENT DAVE KUJAN), GIANCARLO ESPOSITO (INSPECTOR JACK BAER), PETE POSTLETHWAITE (KOBAYASHI), SUZY AMIS (EDIE FINNERAN), DAN HEDAYA (INSPECTOR JEFF RABIN) / DIALOGUE: CHRISTOPHER MCQUARRIE / MUSIC: JOHN OTTMAN / DURATION: 106 MINUTES / CATEGORIES: ROBBERIES, DRUG TRAFFICKING, SETTLING OF SCORES / AWARDS: TWO ACADEMY AWARDS (BEST SUPPORTING ACTOR FOR KEVIN SPACEY, BEST ORIGINAL SCREENPLAY FOR CHRISTOPHER MCQUARRIE), A GOLDEN GLOBES NOMINATION.

THE USUAL SUSPECTS

UNITED STATES, 1995
DIRECTOR: BRYAN SINGER

Five high-flying gangsters are randomly brought together by the New York police for a lineup: There's Dean Keaton (Gabriel Byrne), a former cop turned gangster who wants to distance himself from the world of crime; Michael MacManus (Stephen Baldwin), a sniper who uses every twisted trick in the book, along with his companion, Fred Fenster (Benicio del Toro); Todd Hockney (Kevin Pollak), an explosives specialist with a strong personality, and Verbal Kint (Kevin Spacey), a crippled crook protected by Keaton. They take advantage of their police custody to plan the robbery of a gem trafficker escorted by crooked police officers. Keaton, who is reluctant to dive back in, finally accepts at Kint's insistence. The operation is a success, and the gang takes off to Los Angeles where a contact of MacManus', Redfoot (Peter Greene) puts them on a case. But instead of diamonds, the loot turns out to contain packets of heroin. The thugs learn that a lawyer, Kobayashi (Pete Postlethwaite), has set up the scheme: he contacts them in the name of a mysterious trafficker, Keyser Söze, whose reputation for cruelty is legendary. Kobayashi explains to the initially incredulous gang members that in the past they have stolen goods that belonged to Söze's gang. In exchange for forgiving their debts, Kobayashi demands that the five men

seize a drug shipment from a rival gang that is due to arrive at the port. Only Fenster refuses; he is found dead on a beach the next day. In a heavy atmosphere, the gangsters storm an Argentinian cargo ship carrying 91 tons of drugs. But the holds are empty; the operation was just a trap imagined by Keyser Söze himself to get rid of an old Hungarian enemy on board and make Keaton's gang disappear by blowing up the ship. The only survivor, Verbal Kint - who had stayed on the dock to watch the action - tells the story to Special Customs Agent Dave Kujan. Kujan suspects that Keaton staged the whole thing to disappear. But Söze's sketch, based on the description of one of the crew members who was badly burned, is going to cause an unbelievable twist...

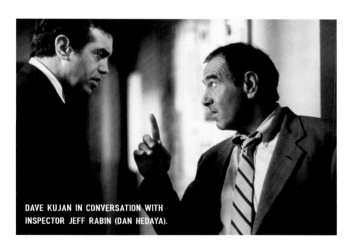

DAVE KUJAN IN CONVERSATION WITH
INSPECTOR JEFF RABIN (DAN HEDAYA).

TRIVIA: ACCORDING TO BRYAN SINGER, THE TITLE OF THE FILM IS DIRECTLY INSPIRED BY CASABLANCA; THE EXPRESSION "THE USUAL SUSPECTS" IS UTTERED REGULARLY BY CAPTAIN RENAULT. ONE OF THE FRENCHMEN WITH WHOM KEATON HAS LUNCH AT THE BEGINNING OF THE FILM IS NAMED RENAULT. / THE MOST FAMOUS SENTENCE OF THE FILM, "THE GREATEST TRICK THE DEVIL EVER PULLED WAS CONVINCING THE WORLD HE DIDN'T EXIST" IS TAKEN FROM CHARLES BAUDELAIRE'S SPLEEN DE PARIS.

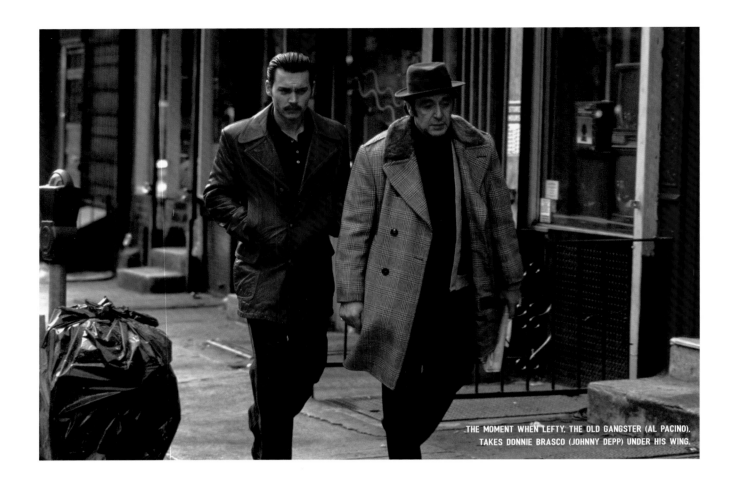

THE MOMENT WHEN LEFTY, THE OLD GANGSTER (AL PACINO), TAKES DONNIE BRASCO (JOHNNY DEPP) UNDER HIS WING.

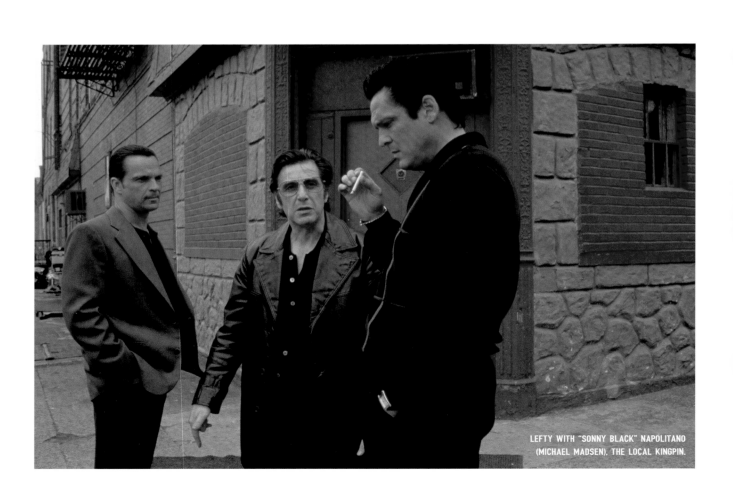

LEFTY WITH "SONNY BLACK" NAPOLITANO (MICHAEL MADSEN), THE LOCAL KINGPIN.

DONNIE BRASCO

UNITED STATES, 1997
DIRECTOR: MIKE NEWELL

Joseph Pistone, an FBI agent claiming to be a diamond fence, infiltrates a Brooklyn mafia family under the protection of an aging gangster, Benjamin "Lefty" Ruggiero (Al Pacino) who works for an expeditious boss, "Sonny Black" Napolitano (Michael Madsen). The fake fence and real cop, whom the gang only knows as Donnie Brasco (Johnny Depp), lives in constant fear of being uncovered and executed by the gangsters. He also faces the misunderstanding of his wife and children, to whom he cannot reveal anything about the operation he is carrying out. In this tense context, the earnest friendship he forges with Lefty is his only comfort. An FBI move to bring the gang to Florida and compromise a local clan turns into a fiasco, but it brings Sonny Black closer to Donnie. The undercover agent is now part of the inner circle, until the day he is given the task of shooting down the son of a rival mobster...

Inspired by a true story, the film recounts the lives of New York's street gangsters in the late 1970s and the feelings of a cop who seems ready to move to the other side. Al Pacino masterfully plays the role of an old, embittered gangster.

123

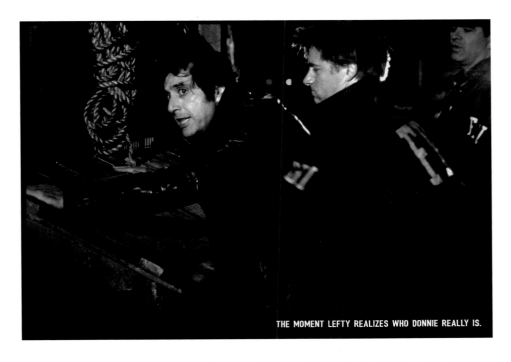

THE MOMENT LEFTY REALIZES WHO DONNIE REALLY IS.

LEAD ACTORS: JOHNNY DEPP (JOSEPH PISTONE/DONNIE BRASCO), AL PACINO (BENJAMIN "LEFTY" RUGGIERO), MICHAEL MADSEN ("SONNY BLACK" NAPOLITANO), ANNE HECHE (MAGGIE PISTONE) / DIALOGUE: JOSEPH D. PISTONE, RICHARD WOODLEY / MUSIC: PATRICK DOYLE / DURATION: 127 MINUTES (147 MINUTES IN THE FULL VERSION) / CATEGORY: INFILTRATED COP / TRIVIA: A $500,000 "CONTRACT" FOR ANYONE WHO FINDS AND SHOOTS THE REAL JOSEPH D. PISTONE – WHO STILL LIVES UNDER AN ASSUMED IDENTITY – IS STILL IN FORCE.

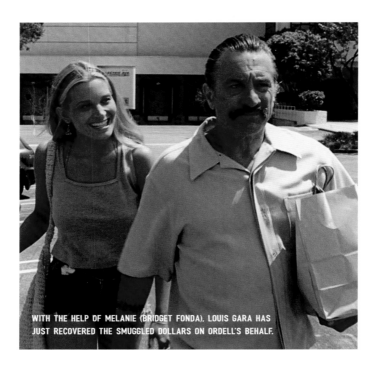

WITH THE HELP OF MELANIE (BRIDGET FONDA), LOUIS GARA HAS
JUST RECOVERED THE SMUGGLED DOLLARS ON ORDELL'S BEHALF.

JACKIE BROWN

UNITED STATES, 1997
DIRECTOR: QUENTIN TARANTINO

Jackie Brown (Pam Grier), a stewardess on a low-end airline, improves her income by transporting cash between Mexico and the United States on behalf of a gun dealer, Ordell Robbie (Samuel L. Jackson). The day she is caught red-handed with an envelope of dollars and a bag of cocaine, Jackie knows the stakes are high: she fears prison as much as she fears reprisals from Ordell and his accomplices. She is released on bail after agreeing to cooperate with the police, but at the same time she must show her loyalty to Ordell who is ready to eliminate her. Thanks to Max Cherry (Robert Forster), the man who paid her bail, Jackie sets up a diabolical plan to fool the police and Ordell: she promises to pass $550,000 to him at once while

making the inspectors believe that it is only $50,000. Jackie, who plans to flee with the difference, easily deceives Ordell's emissaries, Louis (Robert De Niro) and Melanie (Bridget Fonda). All she needs to do is to get rid of the gangster without attracting the suspicion of the police.

Adapted from a novel by Elmore Leonard, this thriller in the pure Tarantinoesque style happily alternates between absurd situations and close-up killings. Robert De Niro plays a convincing loser and Robert Forster a good guy who is smarter than we think.

LEAD ACTORS: PAM GRIER (JACKIE BROWN), SAMUEL L. JACKSON (ORDELL ROBBIE), ROBERT FORSTER (MAX CHERRY),
ROBERT DE NIRO (LOUIS GARA), BRIDGET FONDA (MELANIE RALSTON), MICHAEL KEATON (INSPECTOR RAY NICOLETTE) /
DIALOGUE: QUENTIN TARANTINO BASED ON THE DETECTIVE NOVEL *RUM PUNCH* BY ELMORE LEONARD /
MUSIC: JAMES NEWTON HOWARD / DURATION: 154 MINUTES / CATEGORIES: DRUG SMUGGLING, MONEY LAUNDERING

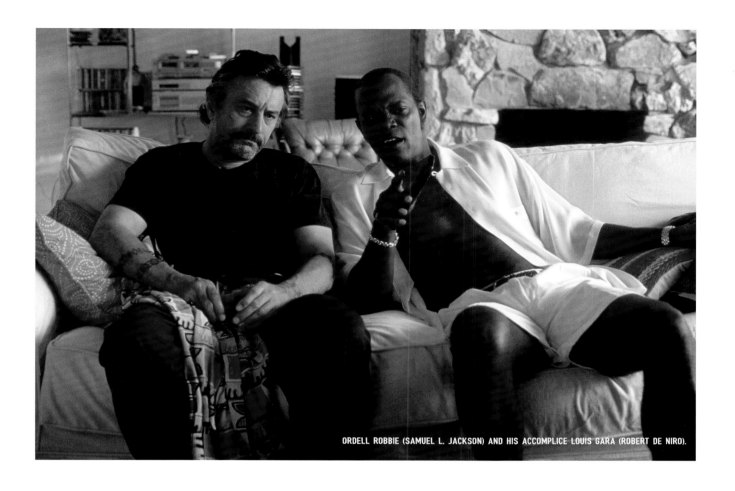

ORDELL ROBBIE (SAMUEL L. JACKSON) AND HIS ACCOMPLICE LOUIS GARA (ROBERT DE NIRO).

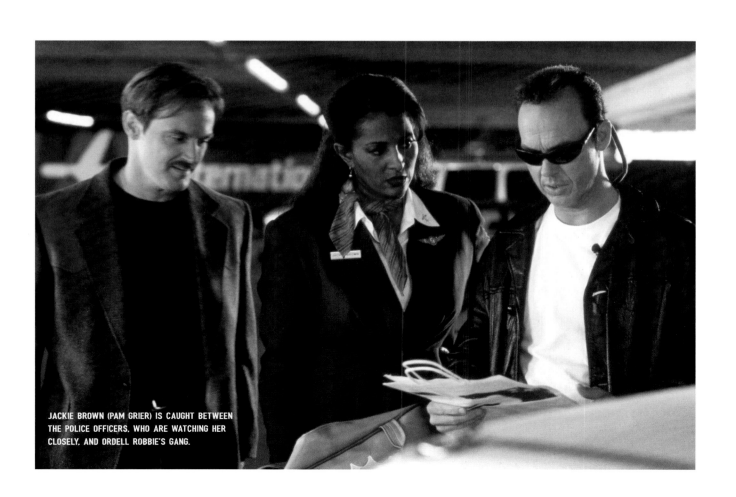

JACKIE BROWN (PAM GRIER) IS CAUGHT BETWEEN
THE POLICE OFFICERS, WHO ARE WATCHING HER
CLOSELY, AND ORDELL ROBBIE'S GANG.

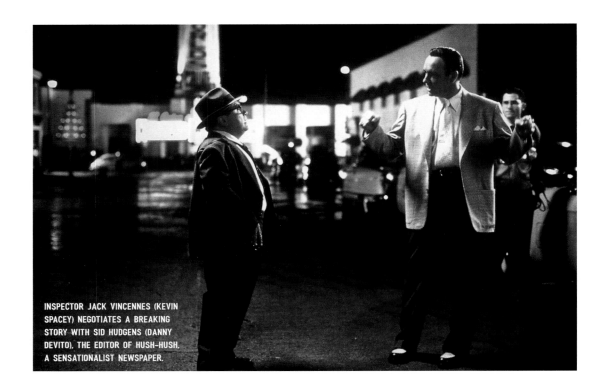

INSPECTOR JACK VINCENNES (KEVIN SPACEY) NEGOTIATES A BREAKING STORY WITH SID HUDGENS (DANNY DEVITO), THE EDITOR OF HUSH-HUSH, A SENSATIONALIST NEWSPAPER.

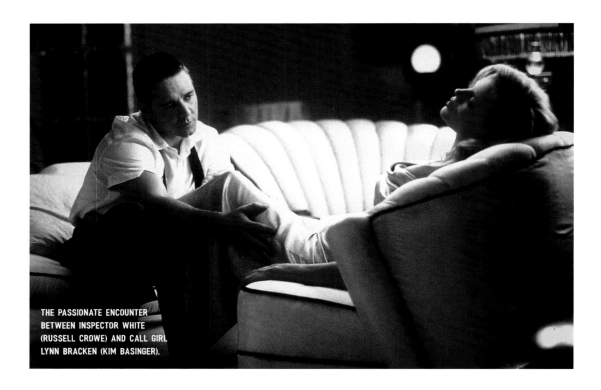

THE PASSIONATE ENCOUNTER BETWEEN INSPECTOR WHITE (RUSSELL CROWE) AND CALL GIRL LYNN BRACKEN (KIM BASINGER).

LEAD ACTORS: GUY PEARCE (ED EXLEY), RUSSELL CROWE (BUD WHITE), KEVIN SPACEY (JACK VINCENNES), KIM BASINGER (LYNN BRACKEN), JAMES CROMWELL (DUDLEY SMITH), DANNY DEVITO (SID HUDGENS) / DIALOGUE: CURTIS HANSON, BRIAN HELGELAND BASED ON THE EPONYMOUS NOVEL BY JAMES ELLROY / MUSIC: JERRY GOLDSMITH / DURATION: 138 MINUTES / CATEGORIES: CORRUPT POLICE OFFICERS, LUXURY PROSTITUTION, DRUG TRAFFICKING / AWARDS: NINE OSCAR NOMINATIONS, TWO AWARDS (BEST SUPPORTING ACTRESS FOR KIM BASINGER, BEST SCREENPLAY FOR CURTIS HANSON AND BRIAN HELGELAND), FIVE GOLDEN GLOBES NOMINATIONS, ONE AWARD (BEST SUPPORTING ACTRESS FOR KIM BASINGER), ONE PALME D'OR NOMINATION AT THE CANNES FILM FESTIVAL.

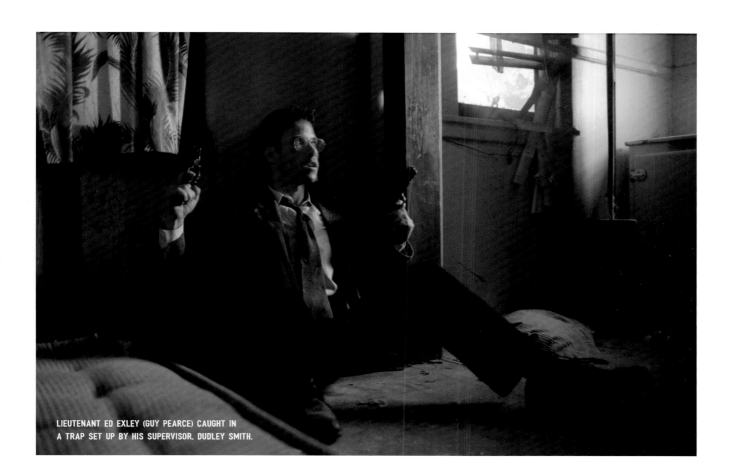

LIEUTENANT ED EXLEY (GUY PEARCE) CAUGHT IN
A TRAP SET UP BY HIS SUPERVISOR, DUDLEY SMITH.

L.A. CONFIDENTIAL

UNITED STATES, 1997
DIRECTOR: CURTIS HANSON

Los Angeles in the early 1950s is a battleground for gangs fighting over the legacy of Mickey Cohen, the city's recently jailed godfather. The police are a perfect mirror of the city's character: rotten with intrigues and petty schemes. In this explosive context, three policemen with very different temperaments are brought to work on the same investigation after a former colleague has been murdered in a night-time café: Ed Exley (Guy Pearce) is a young officer who has a strong sense of integrity and dreams of a great career; Bud White (Russell Crowe), mostly uses his fists, but proves to be more perceptive than he seems; Jack Vincennes (Kevin Spacey) is a disillusioned cop who plays an ambiguous role in Hollywood studios and sells gossip to the director of a tabloid. What starts out as a villainous crime gradually turns into a complex case; it sends White on the trail of a call-girl ring while his colleagues investigate the murdered cop's ties to the underworld. Along the way, they will find the troubling Lynn Bracken (Kim Basinger), and their hierarchical boss, Captain Dudley Smith (James Cromwell), an inflexible prosecutor who likes young actors, and many corpses.

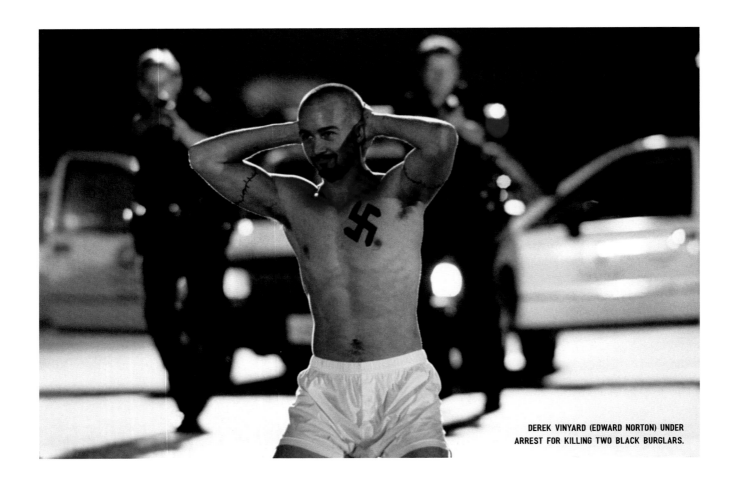

DEREK VINYARD (EDWARD NORTON) UNDER
ARREST FOR KILLING TWO BLACK BURGLARS.

AMERICAN HISTORY X

UNITED STATES, 1998
DIRECTOR: TONY KAYE

Danny Vinyard (Edward Furlong) is a brilliant pupil at Venice Beach High School, although he is under the intellectual spell of his older brother Derek (Edward Norton), a charismatic skinhead who is serving a prison sentence for the murder of two black burglars. Summoned by the principal of his school for writing an essay extolling the merits of *Mein Kampf*, Danny is given a homework assignment about his brother Derek's journey as a reflection on contemporary history. The same day, Derek is released from prison on parole. The years spent behind bars have changed him: he has befriended a black prisoner, Lamont (Guy Torry), and has distanced himself from his neo-Nazi fellow prisoners who made him pay dearly for this betrayal. Invited by a group of skinheads to a party to celebrate his release, Derek decides to settle scores with his former supremacist mentor, Cameron Alexander (Stacy Keach), who continues to manipulate frustrated white youths. His new state of mind leads him to openly contradict his ex-girlfriend Stacey (Fairuza Balk) and his childhood friend Seth (Ethan Suplee). Confronted with Danny's misunderstanding, Derek tells him about his experiences in prison and his rejection of racism. The younger brother accepts Derek's new philosophy and composes his assignment accordingly. But the past is not so easy to erase.

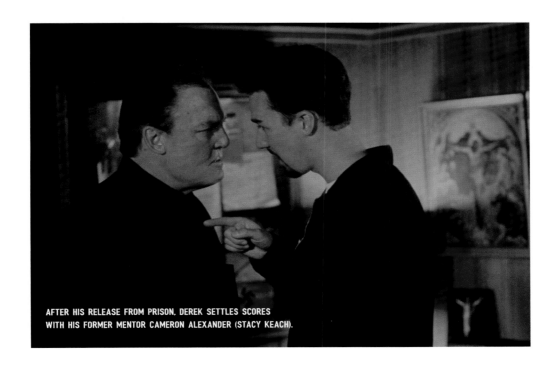

AFTER HIS RELEASE FROM PRISON, DEREK SETTLES SCORES
WITH HIS FORMER MENTOR CAMERON ALEXANDER (STACY KEACH).

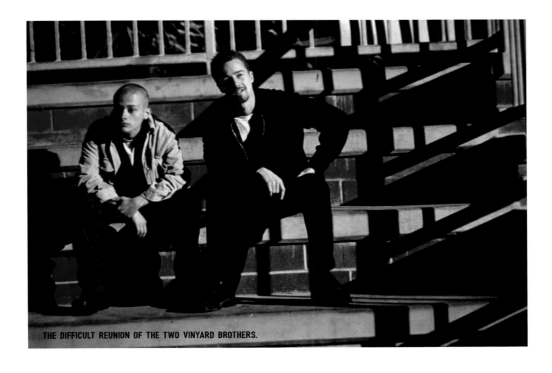

THE DIFFICULT REUNION OF THE TWO VINYARD BROTHERS.

LEAD ACTORS: EDWARD NORTON (DEREK VINYARD), EDWARD FURLONG (DANNY VINYARD), AVERY BROOKS
(DR. BOB SWEENEY), BEVERLY D'ANGELO (DORIS VINYARD), JENNIFER LIEN (DAVINA VINYARD), ETHAN SUPLEE (SETH),
FAIRUZA BALK (STACEY), GUY TORRY (LAMONT), STACY KEACH (CAMERON ALEXANDER) / DIALOGUE: DAVID MCKENNA /
MUSIC: ANNE DUDLEY / DURATION: 119 MINUTES / CATEGORIES: SKINHEAD GANGS, RACIAL VIOLENCE /
AWARD: AN OSCAR NOMINATION.

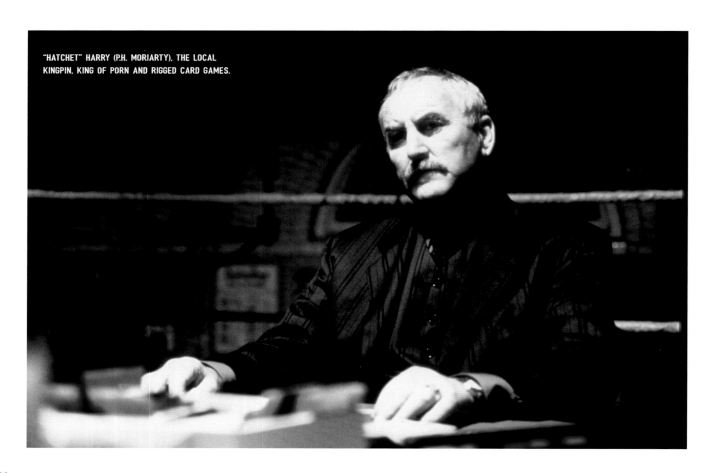

"HATCHET" HARRY (P.H. MORIARTY), THE LOCAL
KINGPIN, KING OF PORN AND RIGGED CARD GAMES.

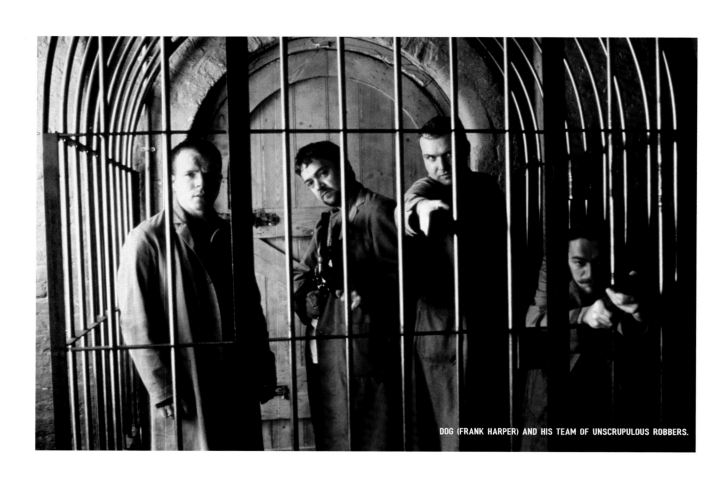

DOG (FRANK HARPER) AND HIS TEAM OF UNSCRUPULOUS ROBBERS.

LOCK, STOCK & TWO SMOKING BARRELS

UNITED KINGDOM, USA, 1998
DIRECTOR: GUY RITCHIE

Eddy (Nick Moran) and three of his friends have managed to raise the sum of £100,000 to sit at the gaming table of "Hatchet" Harry (P.H. Moriarty), a local big shot. But the latter manages to fleece Eddy, who is reputed to be lucky; the four friends must pay off a debt of £500,000 within seven days or see their fingers cut off one after the other. In a panic, they come up with the most unlikely plans until Eddy overhears a conversation with his neighbors, a group of violent gangsters led by Dog (Frank Harper) who plan to rob a bunch of high-living, high-paying cannabis growers. Eddy and his buddies make a deal with Nick the Greek (Stephen Marcus), a fence who will smuggle the drugs and provide them with two antique shotguns. Except that these two shotguns have been stolen from an aristocrat by order of "Hatchet" Harry, and that the latter is moving heaven and earth to find them.

This satirical thriller features a bunch of small-time hoodlums even more pathetic than those in *A Fish Named Wanda.*

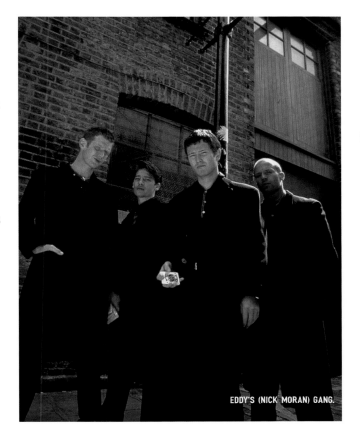

EDDY'S (NICK MORAN) GANG.

LEAD ACTORS: NICK MORAN (EDDY), JASON FLEMYNG (TOM), DEXTER FLETCHER (SOAP), JASON STATHAM (BACON), P.H. MORIARTY ("HATCHET" HARRY), VINNIE JONES (BIG CHRIS), LENNY MCLEAN (BARRY THE BAPTIST), STEPHEN MARCUS (NICK THE GREEK), FRANK HARPER (DOG) / DIALOGUE: GUY RITCHIE / MUSIC: DAVID A. HUGHES, JOHN MURPHY / DURATION: 107 MINUTES / CATEGORIES: RIGGED CARD GAMES, DRUG TRAFFICKING, AMATEUR GANGSTERS / TRIVIA: JASON STATHAM (BACON), WHO PLAYED THE ROLE OF A FENCE AT THE BEGINNING OF THE FILM, PRACTICED THIS RISKY PROFESSION TO FINANCE HIS DIVING TRAINING WHILE HE WAS PART OF THE BRITISH OLYMPIC SELECTION IN THIS SPORT.

TWO GODFATHERS READY TO DO ANYTHING TO MAKE GHOST DOG DISAPPEAR:
SONNY VALERIO (CLIFF GORMAN) AND RAY VARGO (HENRY SILVA).

132

GHOST DOG ALONE AGAINST THE VARGO CLAN.

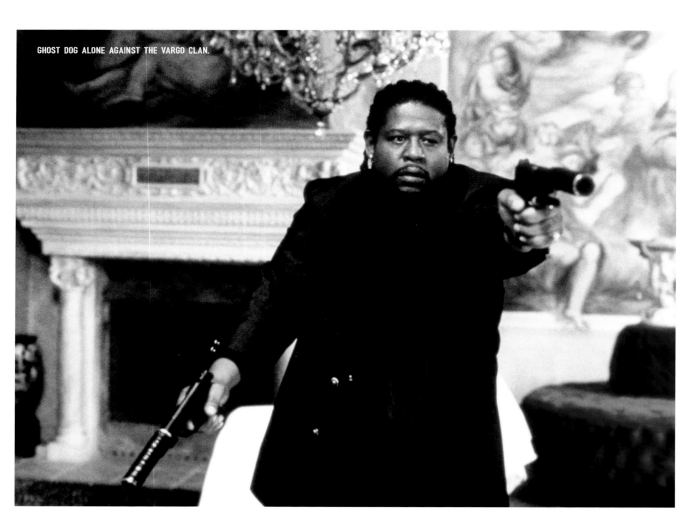

GHOST DOG: THE WAY OF THE SAMURAI

FRANCE, GERMANY, JAPAN, USA, 1999
DIRECTOR: JIM JARMUSCH

Ghost Dog (Forest Whitaker) is a mysterious professional killer who lives according to the 18th century samurai code. He considers himself to be indebted to Louie (John Tormey), a gangster affiliated with the Vargo clan, since Louie saved his life. Louie instructs Ghost Dog to liquidate a clan associate who committed the crime of sleeping with Louise (Tricia Vessey), Ray Vargo's daughter. Concerned that the murder will be attributed to them, Ray Vargo (Henry Silva) and his right-hand man Sonny Valerio (Cliff Gorman) ask Louie to eliminate Ghost Dog to erase all the tracks. But Louie knows next to nothing about his hitman's lifestyle, and Sonny's henchmen organize the manhunt. Warned in secret by Louie - whom he hurts to provide him with an alibi - the samurai understands that he must wipe out the entire clan if he wants to stay alive. He succeeds in breaking into the Vargo's villa and getting rid of all the gangsters present. But on his return to town, Louie shoots him down on the orders of Louise Vargo, who is now the head of the clan: Ghost Dog does not try to resist. The only two friends of the samurai, ice cream merchant Raymond and little Pearline, an avid book reader, helplessly watch the scene.

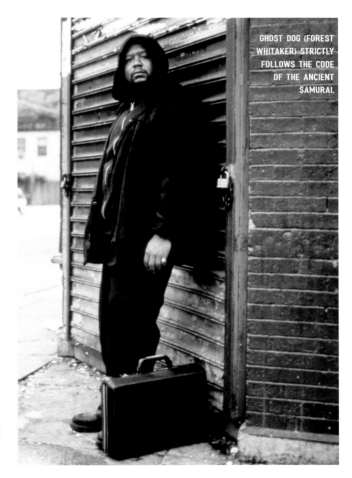

GHOST DOG (FOREST WHITAKER) STRICTLY FOLLOWS THE CODE OF THE ANCIENT SAMURAI.

133

LEAD ACTORS: FOREST WHITAKER (GHOST DOG), JOHN TORMEY (LOUIE), CLIFF GORMAN (SONNY VALERIO), TRICIA VESSEY (LOUISE VARGO), HENRY SILVA (RAY VARGO), CAMILLE WINBUSH (PEARLINE), ISAACH DE BANKOLÉ (RAYMOND, THE HAITIAN ICE CREAM MERCHANT) / DIALOGUE: JIM JARMUSCH / MUSIC: ROBERT FITZGERALD DIGGS (RZA) / DURATION: 116 MINUTES / CATEGORY: LIFE AND DEATH OF A GANGSTER / AWARDS: A NOMINATION AT THE PALME D'OR AT THE CANNES FILM FESTIVAL.

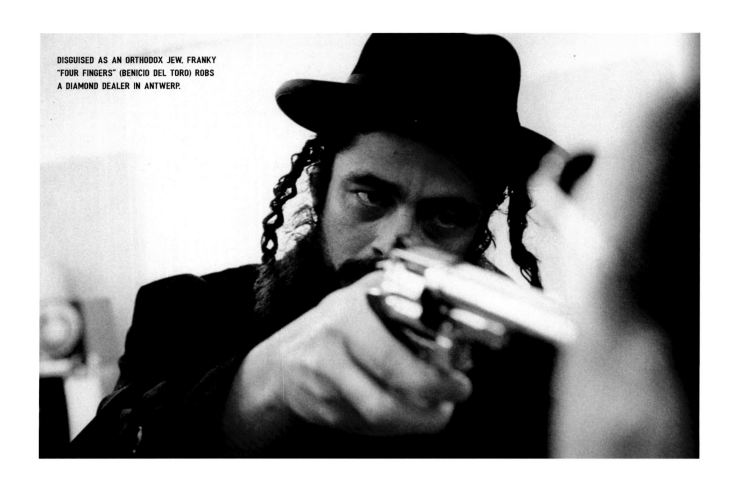

DISGUISED AS AN ORTHODOX JEW, FRANKY
"FOUR FINGERS" (BENICIO DEL TORO) ROBS
A DIAMOND DEALER IN ANTWERP.

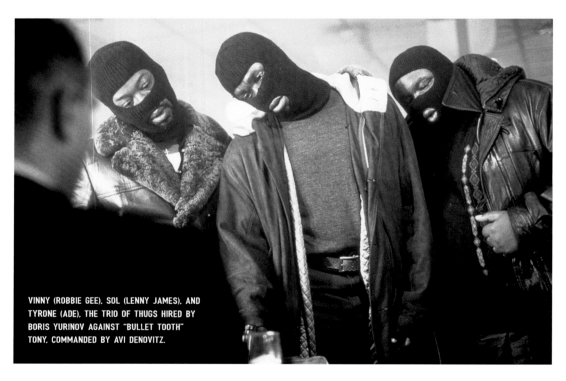

VINNY (ROBBIE GEE), SOL (LENNY JAMES), AND
TYRONE (ADE), THE TRIO OF THUGS HIRED BY
BORIS YURINOV AGAINST "BULLET TOOTH"
TONY, COMMANDED BY AVI DENOVITZ.

LEAD ACTORS: JASON STATHAM (TURKISH), STEPHEN GRAHAM (TOMMY), BRAD PITT (MICKEY O'NEIL), BENICIO DEL TORO
(FRANKY FOUR FINGERS), DENNIS FARINA (COUSIN "AVI" DENOVITZ), MIKE REID (DOUG "THE HEAD"),
VINNIE JONES ("BULLET TOOTH" TONY), RADE ŠERBEDŽIJA (BORIS "THE BLADE" YURINOV), ROBBIE GEE (VINNY),
LENNIE JAMES (SOL), ADE (TYRONE) / DIALOGUE: GUY RITCHIE / MUSIC: JOHN MURPHY / DURATION: 104 MINUTES /
CATEGORIES: DIAMOND ROBBERY, RIGGED BOXING FIGHTS /
TRIVIA: NOBODY UNDERSTANDS WHAT MICKEY THE GYPSY (BRAD PITT) SAYS WHEN HE SWALLOWS ONE SYLLABLE OUT
OF THREE! A LITTLE WINK FROM THE DIRECTOR WHO SUFFERS HIMSELF FROM DYSLEXIA.

OCEAN'S ELEVEN

UNITED STATES, 2001
DIRECTOR: STEVEN SODERBERGH

As soon as he gets out of prison, Danny Ocean (George Clooney) thinks of only one thing: pull off the heist of the century in Las Vegas. He takes advantage of his parole to reconnect with his old friends and gather the team that will seize the cash reserves stored in the vault of the Bellagio, one of the most opulent Las Vegas casinos. Unbeknownst to his accomplices, Danny Ocean has set himself a second goal: to win back the love of his ex-wife, Tess (Julia Roberts), who left him for Terry Benedict (Andy Garcia), the owner of the Bellagio and two other casinos. As his team of wacky experts prepare for this impossible mission, Danny Ocean meets with Tess. But the beautiful girl's heart seems even more unbreakable than the casino's vaults. Will he be able to show enough ingenuity and nerve to achieve his goal?

A successful remake of eponymous movie shot in 1960 with Frank Sinatra's gang, *Ocean's Eleven* gathers exceptional actors for a breathtaking and funny film.

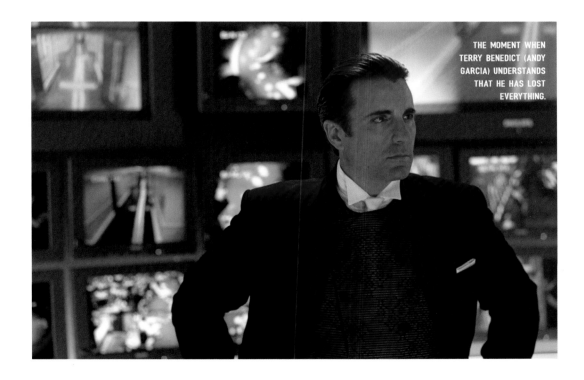

THE MOMENT WHEN TERRY BENEDICT (ANDY GARCIA) UNDERSTANDS THAT HE HAS LOST EVERYTHING.

LEAD ACTORS: GEORGE CLOONEY (DANNY OCEAN), BRAD PITT (RUSTY RYAN), MATT DAMON (LINUS CALDWELL), JULIA ROBERTS (TESS OCEAN), BERNIE MAC (FRANK "RÁMON" CATTON), ELLIOTT GOULD (REUBEN TISHKOFF), ANDY GARCÍA (TERRY BENEDICT) / DIALOGUE: TED GRIFFIN / MUSIC: DAVID HOLMES / DURATION: 116 MINUTES / CATEGORY: THE HEIST OF THE CENTURY

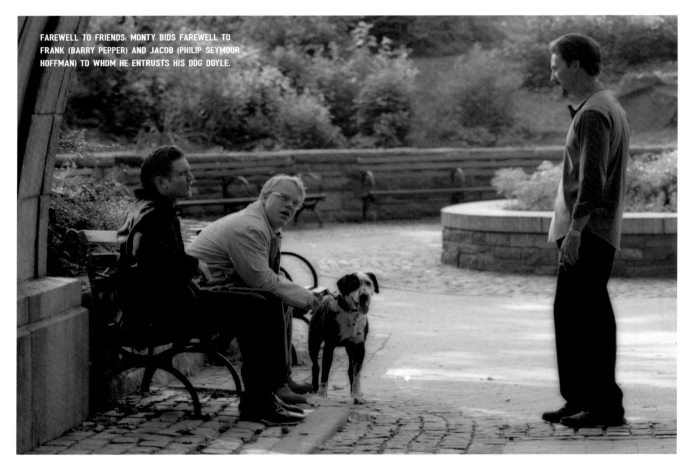

FAREWELL TO FRIENDS: MONTY BIDS FAREWELL TO FRANK (BARRY PEPPER) AND JACOB (PHILIP SEYMOUR HOFFMAN) TO WHOM HE ENTRUSTS HIS DOG DOYLE.

140

LEAD ACTORS: EDWARD NORTON (MONTGOMERY "MONTY" BROGAN), ROSARIO DAWSON (NATURELLE RIVIERA), PHILIP SEYMOUR HOFFMAN (JACOB ELINSKY), BARRY PEPPER (FRANK SLAUGHTERY), ANNA PAQUIN (MARY D'ANNUNZIO), BRIAN COX (JAMES BROGAN) / DIALOGUE: DAVID BENIOFF, BASED ON HIS NOVEL OF THE SAME NAME / MUSIC: TERENCE BLANCHARD, BRUCE SPRINGSTEEN / DURATION: 135 MINUTES / CATEGORIES: DRUG TRAFFICKING, UKRAINIAN MAFIA

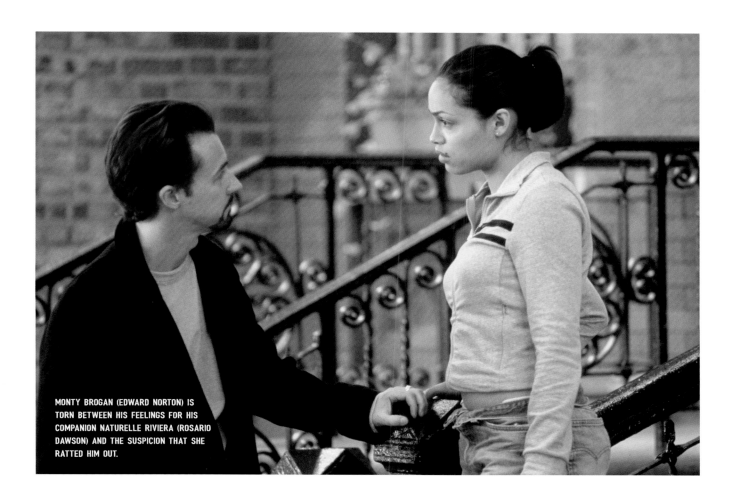

MONTY BROGAN (EDWARD NORTON) IS
TORN BETWEEN HIS FEELINGS FOR HIS
COMPANION NATURELLE RIVIERA (ROSARIO
DAWSON) AND THE SUSPICION THAT SHE
RATTED HIM OUT.

25TH HOUR

UNITED STATES, 2002
DIRECTOR: SPIKE LEE

Sentenced to seven years in prison for drug trafficking, Monty Brogan (Edward Norton) spends his last day of freedom before heading to the penitentiary where he will serve his term. This is his last chance to see his childhood friends Jacob (Philip Seymour Hoffman) and Frank (Barry Pepper), but also to reconnect with his father, and to learn who betrayed him. As the day goes by, Monty is confronted with his memories and a terrible fact: he should never have become a drug dealer. He got caught up in a chain of events in which, not only his Ukrainian mafia suppliers, but also his beautiful girlfriend,

Naturelle Riviera (Rosario Dawson), played a harmful role. Anxious at the idea of confronting the prison world, Monty tries to cut off ties with all those who care about him. Nothing improves when he finds out who ratted him out.

Spike Lee successfully films, with gravity and humor, the emotions of a gangster in a state of doubt and anguish: a man who seems to succeed in everything finds himself alone in front of the uncertainty of an overcrowded and hostile prison, even if the final scene remains ambiguous and suggests another way out.

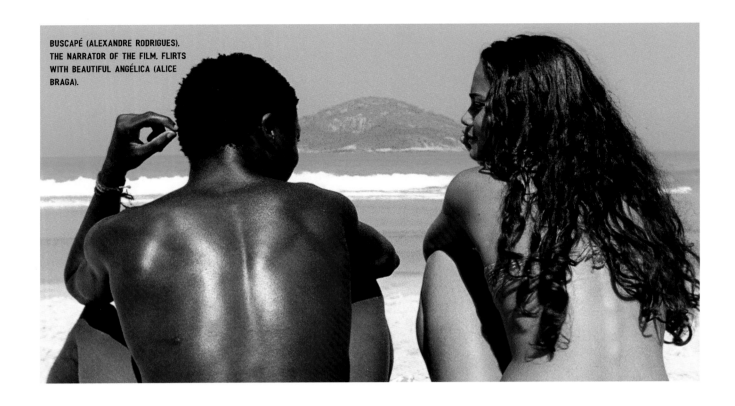

BUSCAPÉ (ALEXANDRE RODRIGUES),
THE NARRATOR OF THE FILM, FLIRTS
WITH BEAUTIFUL ANGÉLICA (ALICE
BRAGA).

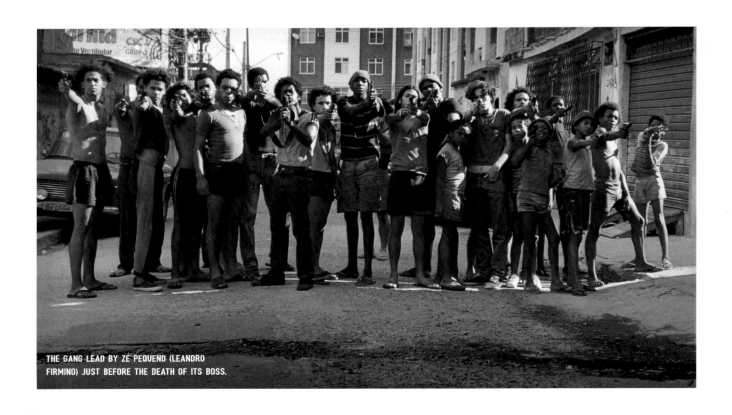

THE GANG LEAD BY ZÉ PEQUENO (LEANDRO
FIRMINO) JUST BEFORE THE DEATH OF ITS BOSS.

CITY OF GOD

BRAZIL, FRANCE, SPAIN, 2002
DIRECTOR: FERNANDO MEREILLES, KÁTIA LUND

In the "City of God", a Rio de Janeiro favela built at the beginning of the 1960s, the destinies of several children cross paths before they diverge; Buscapé "the Rocket" (child: Luis Otávio, teenager: Alexandre Rodrigues) who is too gentle to become a gangster and dreams of becoming a photographer; Cabeleira "Shaggy" (Jonathan Haagensen), a little tough guy in love with the beautiful Berenice (Roberta Rodrigues) who will end up shot by the police; Dadinho "Li'l Dice" (Douglas Silva), a mischievous kid who admires Shaggy, and who already sees himself as the godfather of the city.

We find the characters again in the mid-1970s and early 1980s, when "Li'l Dice" has turned into a psychopathic gangster: renamed Zé Pequeno "Li'l Zé", he confronts Sandro "Carrot" Cenoura's (Matheus Nachtergaele) opposing clan to gain control drug trafficking in the favela, even if it means arming all the children in the neighborhood. Meanwhile, Buscapé, who has become a photographer, experiences his first sentimental disappointments with the beautiful Angélica (Alice Braga) while hanging out with his childhood friends who have fallen into violence. More than the criminal chronicle of a poor neighborhood in Rio, the film shows the banality of evil in a dream landscape, with children growing up too fast and young adults dying too soon.

143

LEAD ACTORS: ALEXANDRE RODRIGUES (BUSCAPÉ "THE ROCKET"), JONATHAN HAAGENSEN (CABELEIRA "SHAGGY"), ROBERTA RODRIGUES (BERNICE), DOUGLAS SILVA (DADINHO "LI'L DICE"), LEANDRO FIRMINO (ZÉ PEQUENO "LI'L ZÉ"), MATHEUS NACHTERGAELE (SANDRO CENOURA "CARROT"), ALICE BRAGA (ANGÉLICA) / DIALOGUE: BRÁULIO MANTOVANI, BASED ON THE EPONYMOUS NOVEL BY PAULO LINS / MUSIC: ED CORTÊS, ANTÔNIO PINTO / DURATION: 130 MINUTES / CATEGORIES: DRUG TRAFFICKING, CHILD CRIMINALITY / AWARDS: FOUR OSCAR NOMINATIONS, ONE AT THE GOLDEN GLOBES.

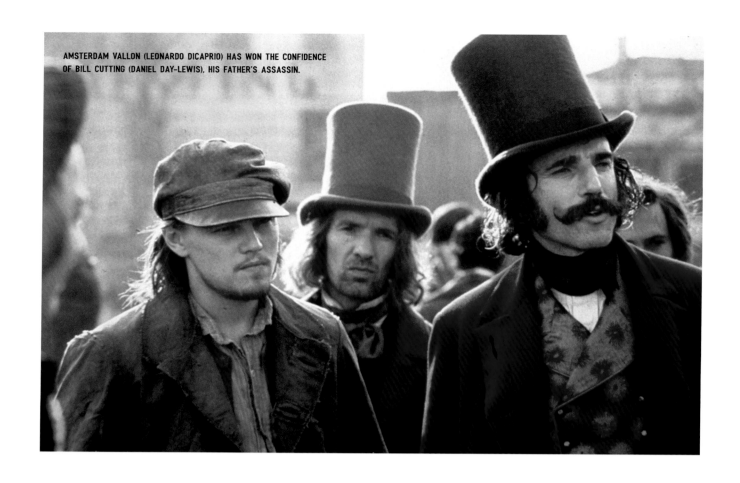

AMSTERDAM VALLON (LEONARDO DICAPRIO) HAS WON THE CONFIDENCE OF BILL CUTTING (DANIEL DAY-LEWIS), HIS FATHER'S ASSASSIN.

144

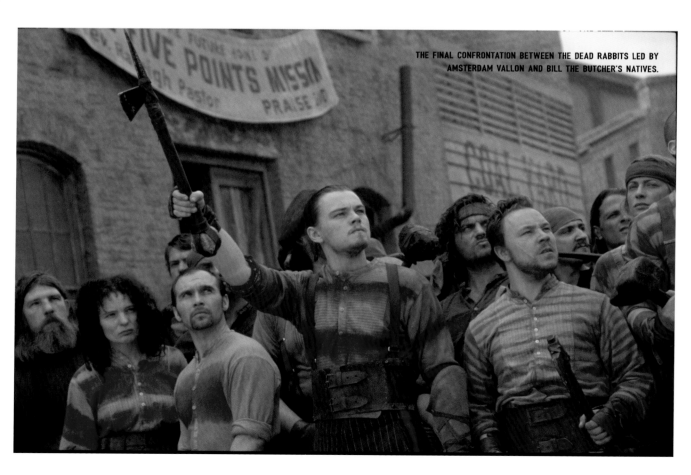

THE FINAL CONFRONTATION BETWEEN THE DEAD RABBITS LED BY AMSTERDAM VALLON AND BILL THE BUTCHER'S NATIVES.

GANGS OF NEW YORK

UNITED STATES, 2002
DIRECTOR: MARTIN SCORSESE

Manhattan, winter 1846, in the poor neighborhood of Five Points, two rival gangs are about to engage in a decisive battle: the Natives, a group of Protestant Englishmen led by Bill Cutting, nicknamed "The Butcher" (Daniel Day-Lewis), confronts the Dead Rabbits, a group of Irish Catholics led by the mysterious "Priest" Vallon (Liam Neeson). The stakes are clear: the gang that wins the fight will ensure its domination of the neighborhood. In the ensuing battle, the Natives take the advantage. The chief of the Dead Rabbits, seriously wounded, is shot in front of his young son. The little boy naively tries to avenge his father, but he is captured and sent to a reformatory.

Seventeen years have passed. While the Civil War is just beginning, the young Amsterdam Vallon (Leonardo DiCaprio) is released from the reformatory and decides to return to Five Points. The neighborhood is now under the undivided control of Bill the Butcher with the complicity of crooked politicians and veterans of the Dead Rabbits who have rallied to him. Amsterdam wanders incognito around the streets of his youth. Only a childhood friend, Johnny Sirocco (Henry Thomas), recognizes him and introduces him, without betraying him, to Bill the Butcher. The latter, unaware of Amsterdam's true identity, takes him under his wing and makes him his trusted man. The young man also meets Jenny Everdeane

(Cameron Diaz), a fearless pickpocket who knows all of Bill the Butcher's secrets from being his mistress. But the favors she grants to Amsterdam make Johnny Sirocco jealous and he reveals his friend's true identity to Bill. When Amsterdam tries to murder his mentor, Bill doesn't kill him, but beats him up and brands him with a red-hot iron. Saved by Jenny, Amsterdam prepares his revenge in hiding. The Dead Rabbits rise from the ashes. As riots against compulsory conscription break out throughout the city, a new and decisive battle takes place.

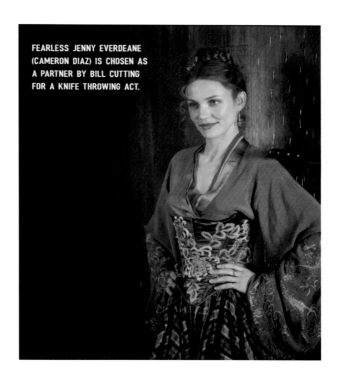

FEARLESS JENNY EVERDEANE (CAMERON DIAZ) IS CHOSEN AS A PARTNER BY BILL CUTTING FOR A KNIFE THROWING ACT.

145

LEAD ACTORS: LEONARDO DICAPRIO (AMSTERDAM VALLON), DANIEL DAY-LEWIS (BILL "THE BUTCHER" CUTTING), CAMERON DIAZ (JENNY EVERDEANE), LIAM NEESON ("PRIEST" VALLON, AMSTERDAM'S FATHER), BRENDAN GLEESON (MONK MCGINN), GARY LEWIS (MCGLOIN), JIM BROADBENT (BOSS TWEED) / DIALOGUE: JAY COCKS, STEVEN ZAILLIAN, KENNETH LONERGAN / MUSIC: HOWARD SHORE / DURATION: 167 MINUTES / CATEGORIES: NEW YORK MAFIA, IRISH GANGS, REVENGE

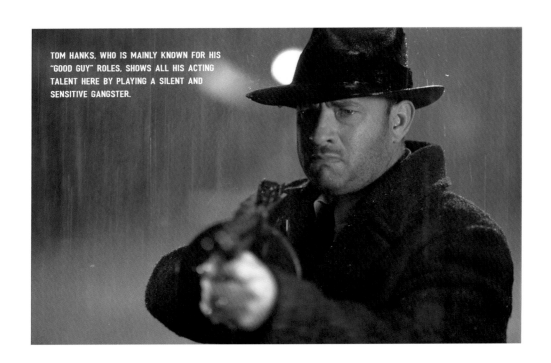

TOM HANKS, WHO IS MAINLY KNOWN FOR HIS "GOOD GUY" ROLES, SHOWS ALL HIS ACTING TALENT HERE BY PLAYING A SILENT AND SENSITIVE GANGSTER.

LEAD ACTORS: TOM HANKS (MICHAEL SULLIVAN), PAUL NEWMAN (JOHN ROONEY), DANIEL CRAIG (CONNOR ROONEY), JUDE LAW (HARLEN MAGUIRE) / DIALOGUE: DAVID SELF / MUSIC: THOMAS NEWMAN / DURATION: 117 MINUTES / CATEGORY: AMERICAN UNDERWORLD IN THE 1930S, REVENGE / AWARDS: SIX OSCAR NOMINATIONS, ONE AWARD (BEST CINEMATOGRAPHER).

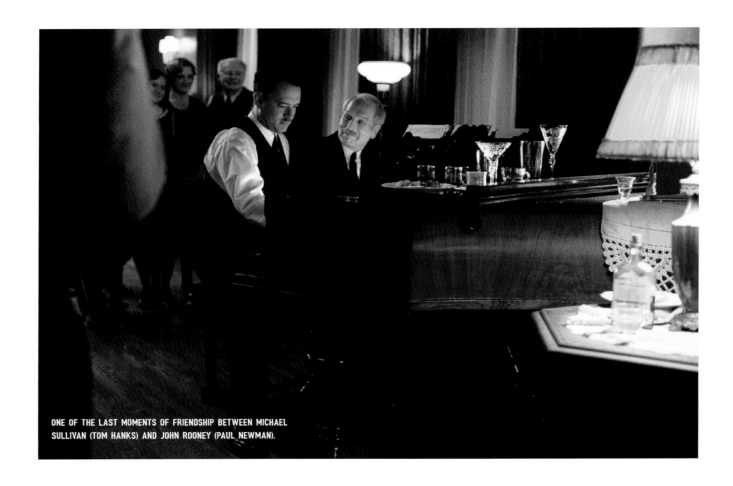

ONE OF THE LAST MOMENTS OF FRIENDSHIP BETWEEN MICHAEL SULLIVAN (TOM HANKS) AND JOHN ROONEY (PAUL NEWMAN).

ROAD TO PERDITION

UNITED STATES, 2002
DIRECTOR: SAM MENDES

Michael Sullivan (Tom Hanks) has all the characteristics of an ordinary man. He leads a quiet life with his wife and two sons in a Midwest town in the early 1930s. However, underneath his taciturn character lies one of John Rooney's (Paul Newman) lieutenants, a godfather of the Irish mafia. When Sullivan's elder son inadvertently witnesses the murder of a man by Connor Rooney (Daniel Craig), John's son, Sullivan soon realizes that his family is in danger. He intervenes too late to prevent the execution of his wife and younger son, but manages to flee to Chicago with his elder son to seek revenge. With no support, and with a psychopathic hitman on his tail, Michael Sullivan gradually devises a plan while discovering the complexity of his feelings for his son.

Sam Mendes creates a film where the theme of just revenge crosses that of father-son relations, with an exceptional cast. It is Paul Newman's last film.

147

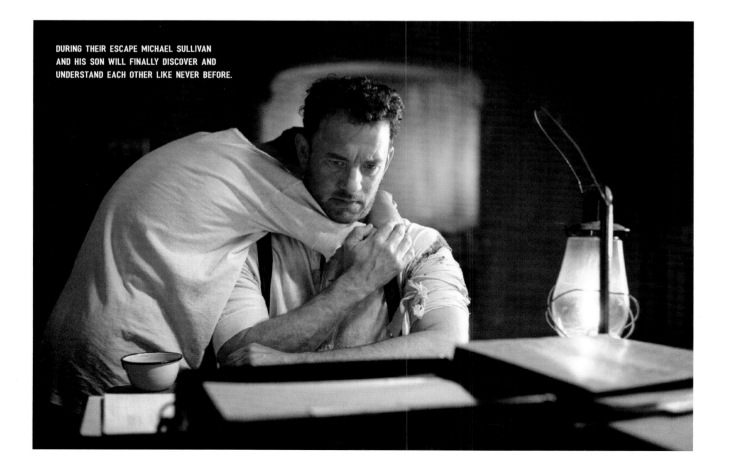

DURING THEIR ESCAPE MICHAEL SULLIVAN AND HIS SON WILL FINALLY DISCOVER AND UNDERSTAND EACH OTHER LIKE NEVER BEFORE.

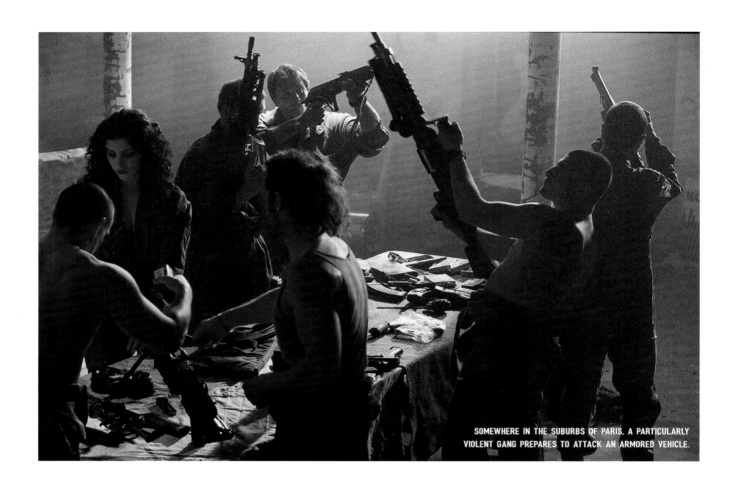

SOMEWHERE IN THE SUBURBS OF PARIS, A PARTICULARLY VIOLENT GANG PREPARES TO ATTACK AN ARMORED VEHICLE.

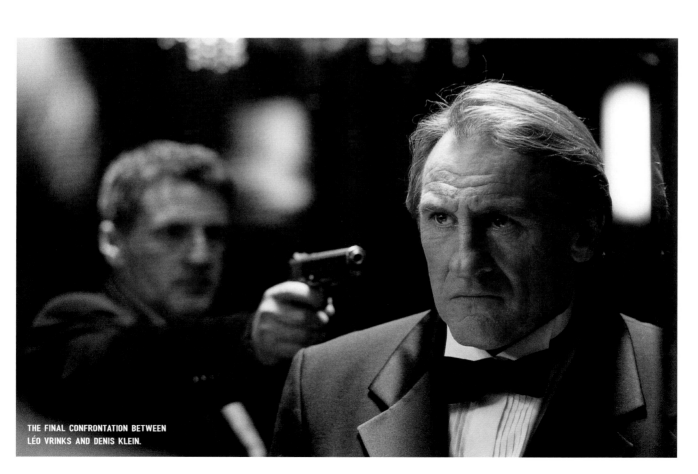

THE FINAL CONFRONTATION BETWEEN LÉO VRINKS AND DENIS KLEIN.

36TH PRECINCT

FRANCE, 2004
DIRECTOR: OLIVIER MARCHAL

In the mid-1980s, cash transport trucks are attacked by an elusive gang using methods of unprecedented violence. As the list of victims grows longer and the public opinion is growing ever more worried, the latent rivalry between Léo Vrinks (Daniel Auteuil), the head of the BRI (Brigade de recherche et d'intervention), and the head of the BRB (Brigade de répression du banditisme), Denis Klein (Gérard Depardieu), does not help matters. When Robert Mancini (André Dussollier), the head of Police, announces that he will give up his position to whichever of the two manage to dismantle the gang, the former friends end up in an open struggle, even if it means covering up the names of their informers beyond reason. But beware of the one who stumbles...

The intrigue imagined by Olivier Marchal, inspired by several miscellaneous true incidents (the Dominique Loiseau affair, the death of inspector Jean Vrindts, among many others) is breathtaking and subtle. It explores the complex relations between the mob and the police, the role of informers in investigations, and the obscure motivations of some policemen: personal ambitions and old grudges sometimes take precedence over ethics.

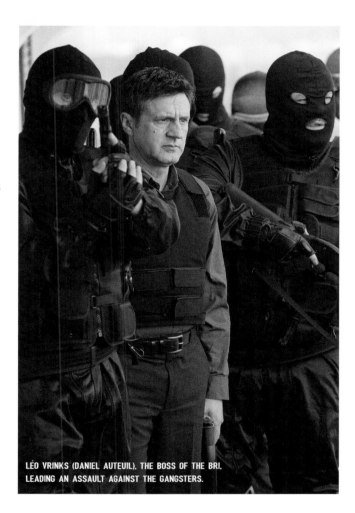

LÉO VRINKS (DANIEL AUTEUIL), THE BOSS OF THE BRI, LEADING AN ASSAULT AGAINST THE GANGSTERS.

149

LEAD ACTORS: DANIEL AUTEUIL (LÉO VRINKS), GÉRARD DEPARDIEU (DENIS KLEIN), ANDRÉ DUSSOLLIER (ROBERT MANCINI), ROSCHDY ZEM (HUGO SILIEN), VALERIA GOLINO (CAMILLE VRINKS), DANIEL DUVAL (EDDY VALENCE), FRANCIS RENAUD (TITI BRASSEUR) / DIALOGUE: OLIVIER MARCHAL, FRANK MANCUSO, JULIEN RAPPENEAU, IN COLLABORATION WITH DOMINIQUE LOISEAU / MUSIC: ERWANN KERMORVANT, AXELLE RENOIR / DURATION: 111 MINUTES / CATEGORY: POLICE AND MAFIA

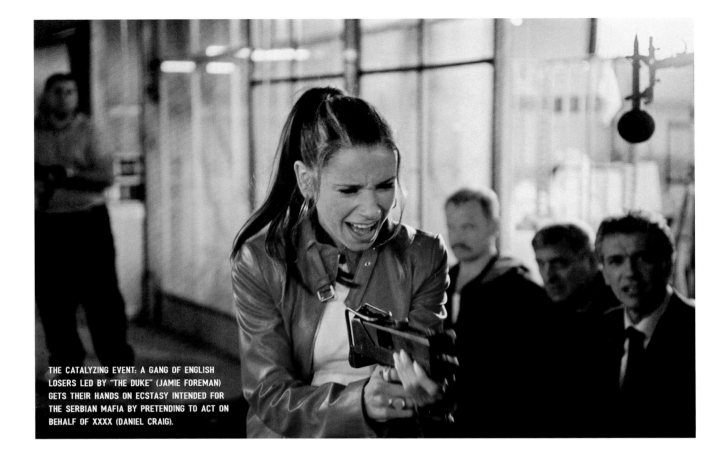

THE CATALYZING EVENT: A GANG OF ENGLISH
LOSERS LED BY "THE DUKE" (JAMIE FOREMAN)
GETS THEIR HANDS ON ECSTASY INTENDED FOR
THE SERBIAN MAFIA BY PRETENDING TO ACT ON
BEHALF OF XXXX (DANIEL CRAIG).

LAYER CAKE

UNITED KINGDOM, 2004
DIRECTOR: MATTHEW VAUGHN

XXXX (Daniel Craig) is a clever dealer - his name is never revealed in the film, highly organized and professional in business. With the help of two gangsters, Morty and Gene, he has made a fortune in drugs and plans to retire from the narcotics business to lead a new life above suspicion. But two events force him to reconsider his plans: a private mission entrusted to him by Jimmy Price (Kenneth Cranham), the godfather who protects him; and the arrival of a shipment of ecstasy pills stolen by a rival gang from Serbian criminals.

Against his will, XXXX is dragged into the heart of these intrigues. Pursued by a Serbian hitman who believes he is responsible for the ecstasy theft, and thrown out by his protector, XXXX sees the world vacillating around him, but he does not give up on his original plan.

The spectacular twists and turns that punctuate the film along with an unexpected ending make it an exceptional thriller.

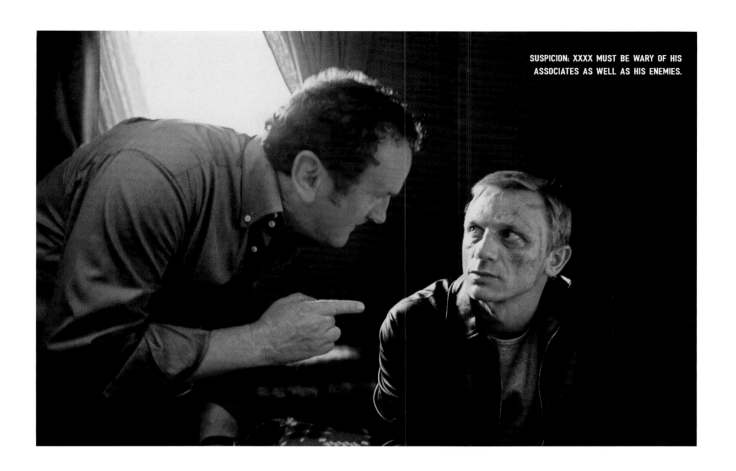

SUSPICION: XXXX MUST BE WARY OF HIS ASSOCIATES AS WELL AS HIS ENEMIES.

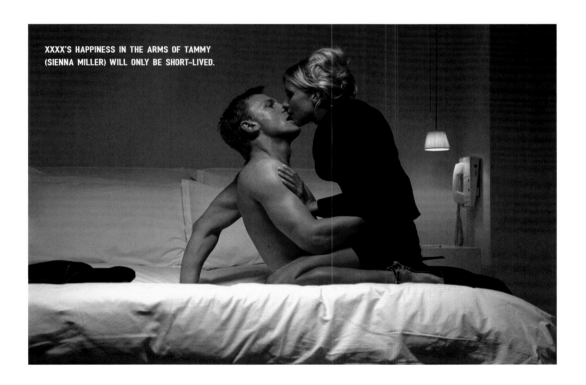

XXXX'S HAPPINESS IN THE ARMS OF TAMMY (SIENNA MILLER) WILL ONLY BE SHORT-LIVED.

LEAD ACTORS: DANIEL CRAIG (XXXX), SIENNA MILLER (TAMMY), GEORGE HARRIS (MORTY), COLM MEANEY (GENE), JAMIE FOREMAN (THE DUKE), MICHAEL GAMBON (EDDIE TEMPLE), SALLY HAWKINS (SLASHER), KENNETH CRANHAM (JIMMY PRICE) / DIALOGUE: J. J. CONNOLLY / MUSIC: LISA GERRARD, ILAN ESHKERI / DURATION: 105 MINUTES / CATEGORY: DRUGS, LIFE AND DEATH OF A DEALER.

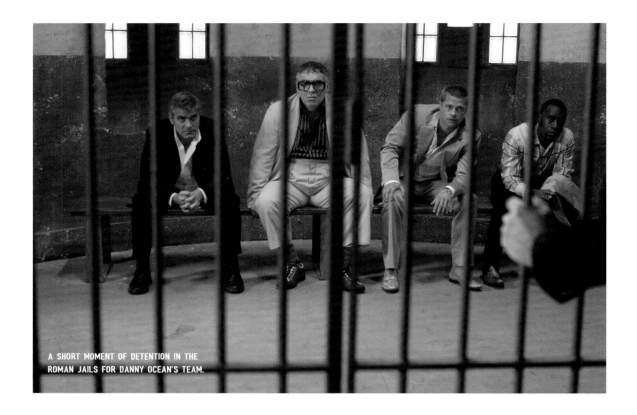

A SHORT MOMENT OF DETENTION IN THE
ROMAN JAILS FOR DANNY OCEAN'S TEAM.

OCEAN'S TWELVE

UNITED STATES, 2004
DIRECTOR: STEVEN SODERBERGH

Danny Ocean (George Clooney) and his accomplices have been enjoying a peaceful life since their Bellagio robbery in Las Vegas, but Terry Benedict (Andy Garcia) promised he would avenge the affront he suffered. He ends up finding them, with the help of François Toulour (Vincent Cassel), a mysterious French burglar who has taken umbrage at their fame. Terry Benedict gives Danny Ocean and his team fifteen days to refund the stolen sum with exorbitant interest. They decide to leave for Europe, with Amsterdam as a first stop, in search of a lucrative heist. Their case gets even more complicated when one of Rusty's (Brad Pitt) ex-girlfriends, beautiful Interpol inspector Isabel Lahiri (Catherine Zeta-Jones) tracks down the gang. Worse still, François Toulour, the "Night Fox" seems determined to keep them in check. All attempts to steal a Fabergé egg on display in Rome in broad daylight turn into a fiasco. Luckily, the gang's humor and astuteness help them overcome every setback.

LEAD ACTORS: GEORGE CLOONEY (DANNY OCEAN), BRAD PITT (RUSTY RYAN), CATHERINE ZETA-JONES (ISABEL LAHIRI), MATT DAMON (LINUS CALDWELL), JULIA ROBERTS (TESS OCEAN), ANDY GARCÍA (TERRY BENEDICT), VINCENT CASSEL (FRANÇOIS TOULOUR). / DIALOGUE: GEORGE NOLFI / MUSIC: DAVID HOLMES / DURATION: 125 MINUTES / CATEGORIES: GANGSTER RIVALRY, MUSEUM BREAK-IN

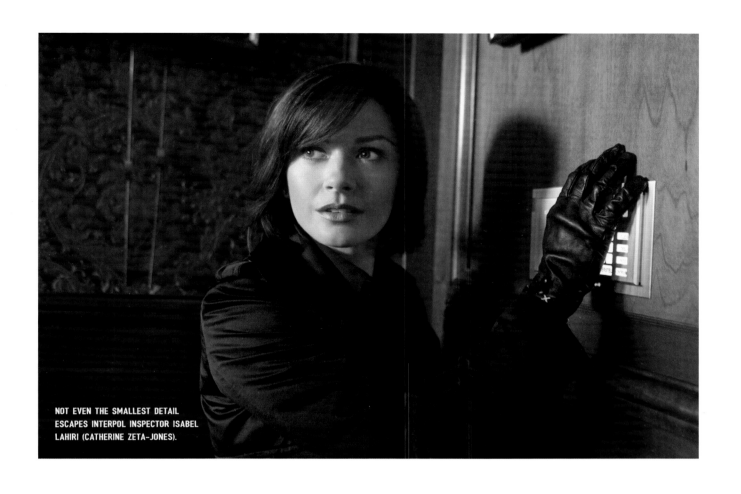

NOT EVEN THE SMALLEST DETAIL
ESCAPES INTERPOL INSPECTOR ISABEL
LAHIRI (CATHERINE ZETA-JONES).

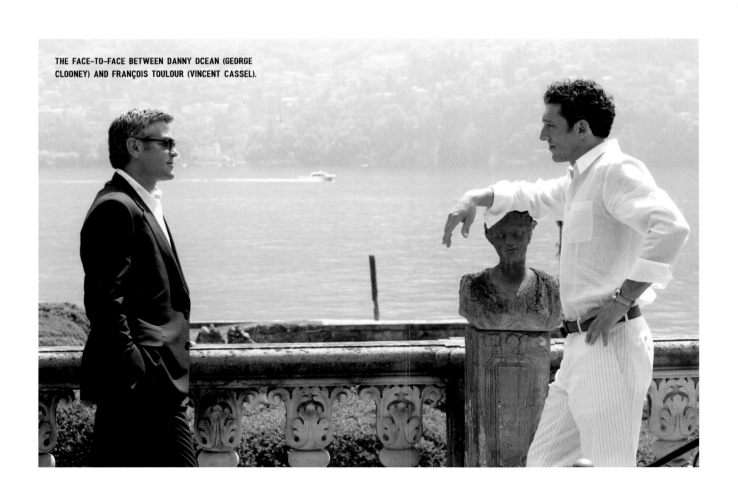

THE FACE-TO-FACE BETWEEN DANNY OCEAN (GEORGE
CLOONEY) AND FRANÇOIS TOULOUR (VINCENT CASSEL).

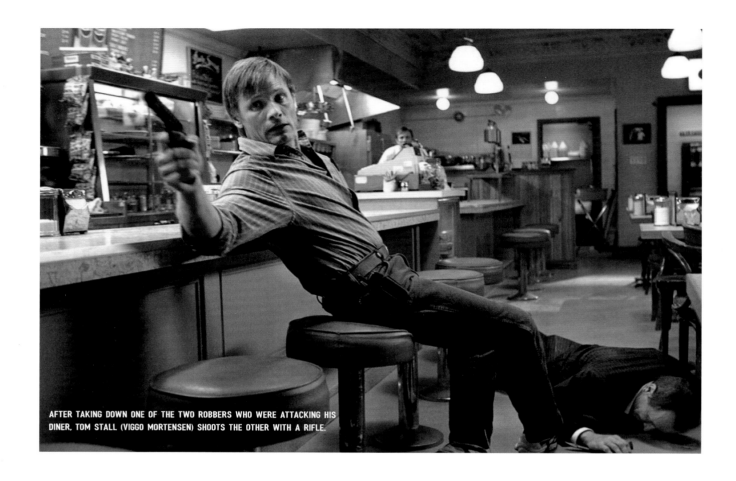

AFTER TAKING DOWN ONE OF THE TWO ROBBERS WHO WERE ATTACKING HIS DINER, TOM STALL (VIGGO MORTENSEN) SHOOTS THE OTHER WITH A RIFLE.

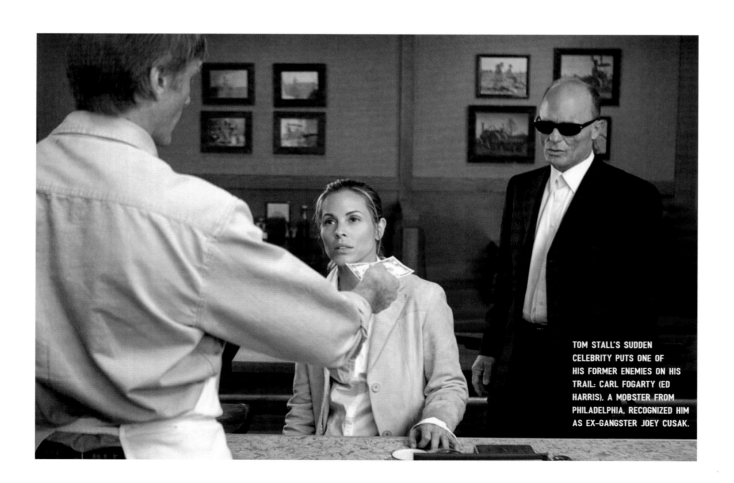

TOM STALL'S SUDDEN CELEBRITY PUTS ONE OF HIS FORMER ENEMIES ON HIS TRAIL: CARL FOGARTY (ED HARRIS), A MOBSTER FROM PHILADELPHIA, RECOGNIZED HIM AS EX-GANGSTER JOEY CUSAK.

A HISTORY OF VIOLENCE

CANADA, GERMANY, USA, 2005
DIRECTOR: DAVID CRONENBERG

Tom Stall (Viggo Mortensen), the owner of a coffee shop in a small town in Indiana, leads an unremarkable and rather happy life. He loves his wife Edie (Maria Bello), a lawyer, and their two children Jack and Sarah. Everything changes when two petty thieves try to rob his diner by threatening to kill a waitress. Tom sends one of the two men to the floor before shooting the second one. But the first assailant, who is still alive, stabs him in the foot with a knife before Tom kills him. Although he is celebrated as a hero, Tom seems eager not to attract attention. His sudden notoriety brings to the surface a past he thought he had erased: that of Joey Cusack, his real name, and his life as a gangster in Philadelphia. One of his former enemies, Carl Fogarty (Ed Harris), whom Tom had disfigured with barbed wire, has tracked him down and starts harassing him. When Fogarty takes Tom's son Jack hostage, Tom regains his killer instincts. He liquidates two of Fogarty's accomplices before being put at gunpoint by Fogarty. Tom owes his life only to the swift action of his son Jack, who grabs a rifle abandoned by his father and kills Fogarty. Violence has taken over Tom's life. His brother Richie, a godfather of the underworld, wants to see him again …

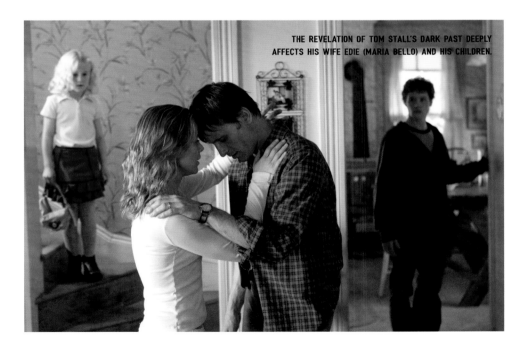

THE REVELATION OF TOM STALL'S DARK PAST DEEPLY AFFECTS HIS WIFE EDIE (MARIA BELLO) AND HIS CHILDREN.

LEAD ACTORS: VIGGO MORTENSEN (TOM STALL/JOEY CUSACK), MARIA BELLO (EDIE STALL), ASHTON HOLMES (JACK STALL), ED HARRIS (CARL FOGARTY), PETER MACNEILL (SAM THE SHERIFF), WILLIAM HURT (RICHIE CUSACK) / DIALOGUE: JOSH OLSON, BASED ON THE GRAPHIC NOVEL BY JOHN WAGNER AND VINCE LOCKE / MUSIC: HOWARD SHORE / DURATION: 96 MINUTES / CATEGORIES: SETTLING SCORES, REPENTANT GANGSTER / AWARDS: TWO OSCAR NOMINATIONS, TWO GOLDEN GLOBES, ONE AT THE CANNES FILM FESTIVAL AND ONE AT THE FRENCH CÉSAR AWARDS.

ROMANZO CRIMINALE

UNITED STATES, 2005
DIRECTOR: MICHELE PLACIDO

On the outskirts of Rome, in the early 1970s, a gang of four teenagers joyride in a stolen car when they come face to face with a police roadblock which they pass by force. Hidden in their safehouse after their escape, they promise to set out to conquer Rome and give themselves code names: they become the "Lebanese", "Freddo" (Cold), "Dandy" and "Grand". Their conversation is quickly interrupted by a police raid during which the Lebanese is wounded in the leg and Grand, who was mortally wounded when their stolen car crashed through the roadblock, eventually passes away.

In 1977, we find the Lebanese (Pierfrancesco Favino) and Dandy (Claudio Santamaria) who come looking for Freddo (Kim Rossi Stuart) when he is released from prison. The Lebanese, who asserts himself as the mastermind of the gang, proposes to organize the kidnapping of Baron Rosellini (Franco Interlenghi). The operation succeeds despite the Baron's accidental death. The friends decide to reinvest part of the ransom in drug trafficking and prostitution, two areas they intend to control, even if it means brutally eliminating their competitors. Incidentally, the gangsters enjoy the silent support of both the Sicilian mafia and of the secret services.

As the gang expands its influence, the team spirit that animated the young gangsters fades away, giving way to mutual distrust. The hunt led by Inspector Scialoja, a young police officer with a sense of integrity, uncovers Dandy's relationship with a call girl, Patrizia (Anna Mouglalis), who becomes the inspector's mistress. When the Lebanese is killed by a rival, Freddo, who was planning to retire from business to live a simple life with his girlfriend Roberta (Jasmine Trinca), decides to avenge his friend. His bloodthirsty madness will lead to his fall.

Adapted from the novel of the same name by Giancarlo De Cataldo, the film tells the story of the Magliana Gang, one of the most violent criminal organizations in Italy.

LEAD ACTORS: KIM ROSSI STUART (FREDDO), PIERFRANCESCO FAVINO (THE LEBANESE), CLAUDIO SANTAMARIA (DANDY), ANNA MOUGLALIS (PATRIZIA), STEFANO ACCORSI (INSPECTOR SCIALOJA), JASMINE TRINCA (ROBERTA) / DIALOGUE: STEFANO RULLI, SANDRO PETRAGLIA, MICHELE PLACIDO, WITH THE PARTICIPATION OF GIANCARLO DE CATALDO / MUSIC: PAOLO BUONVINO / DURATION: 174 MINUTES / CATEGORIES: ITALIAN MAFIA, DRUG TRAFFICKING, COLLUSION BETWEEN SECRET SERVICES AND ORGANIZED CRIME

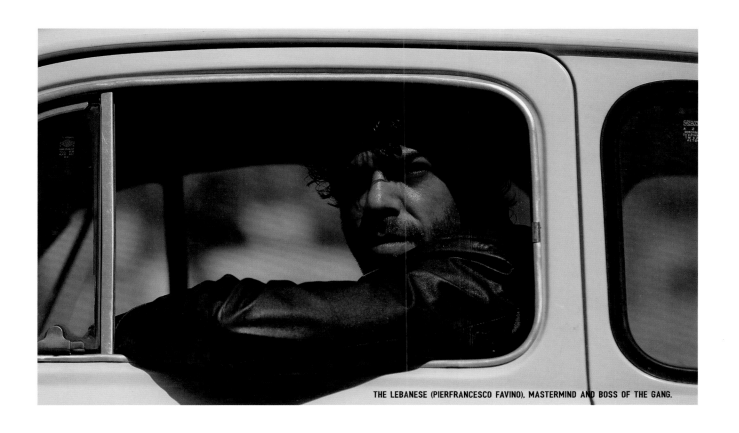

THE LEBANESE (PIERFRANCESCO FAVINO), MASTERMIND AND BOSS OF THE GANG.

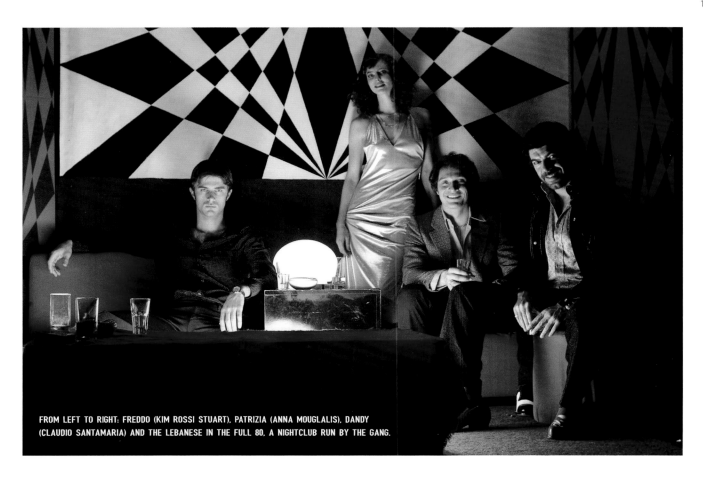

FROM LEFT TO RIGHT: FREDDO (KIM ROSSI STUART), PATRIZIA (ANNA MOUGLALIS), DANDY (CLAUDIO SANTAMARIA) AND THE LEBANESE IN THE FULL 80, A NIGHTCLUB RUN BY THE GANG.

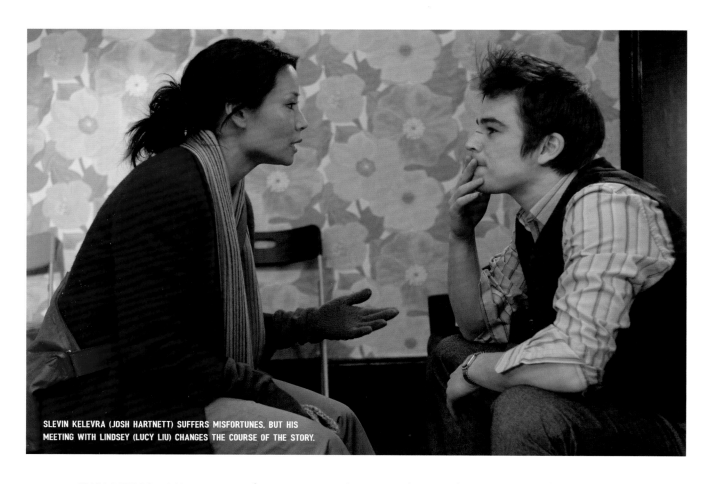

SLEVIN KELEVRA (JOSH HARTNETT) SUFFERS MISFORTUNES, BUT HIS MEETING WITH LINDSEY (LUCY LIU) CHANGES THE COURSE OF THE STORY.

MAIN ACTORS: JOSH HARTNETT (SLEVIN KELEVRA), LUCY LIU (LINDSEY), BRUCE WILLIS (MR. GOODKAT), MORGAN FREEMAN (THE BOSS), BEN KINGSLEY (THE RABBI), STANLEY TUCCI (LIEUTENANT BRIKOWSKI)/ DIALOGUE: JASON SMILOVIC/ MUSIC: JOSHUA RALPH/ DURATION: 110 MINUTES/CATEGORY: SETTLING SCORES

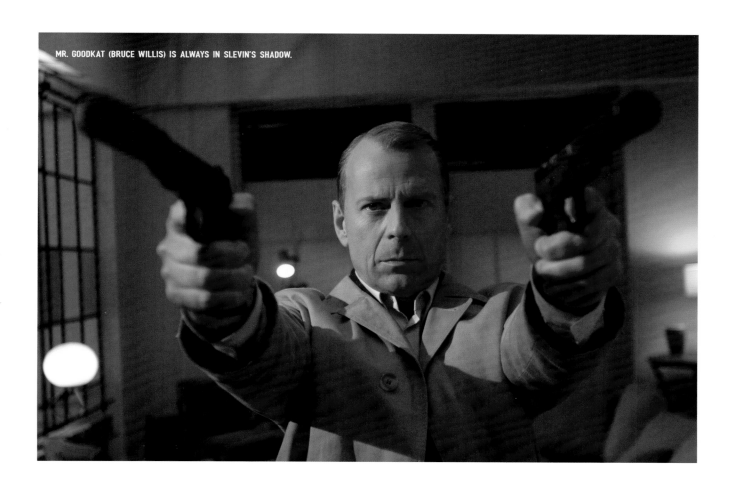

MR. GOODKAT (BRUCE WILLIS) IS ALWAYS IN SLEVIN'S SHADOW.

LUCKY NUMBER SLEVIN

CANADA, GERMANY, UNITED KINGDOM, USA, 2006
DIRECTOR: PAUL McGUIGAN

Young Slevin Kelevra (Josh Hartnett) takes some hard knocks: fired from his job, he finds his girlfriend in bed with a stranger. To take his mind off his troubles, he goes to New York to see his friend Nick Fischer (Sam Jaeger). But before he even arrives at his destination, he gets robbed in the street. It is with a bloody nose that he enters Fisher's house after the latter has mysteriously vanished. The next morning, after finally recovering his equilibrium and settling in at Nick's place, Slevin meets Lindsey (Lucy Liu), a pretty neighbor who worries about Nick's absence. No sooner has Lindsey left, than Slevin is picked up by two black gangsters who take him to The Boss, an African-American godfather, who thinks Slevin is Nick Fisher and asks him to pay back a colossal sum. Penniless and unable to prove that he is not who they think he is, Slevin accepts a proposal from the gangster: he must kill Yitzchok, the gay son of The Rabbi, a former friend of The Boss who has become his archenemy. The task is particularly difficult because Yitzchok is under constant surveillance by trained bodyguards. Back at Nick Fisher's apartment, Slevin sees two orthodox Jews knock at the door: this time he is brought to The Rabbi who, like The Boss, demands immediate repayment of a debt. The situation seems desperate, all the more so since a hired killer, Mr. Goodkat (Bruce Willis), who was seen at the very beginning of the film, appears in The Boss's and The Rabbi's offices as soon as Slevin leaves them. Meanwhile, Lindsey, who has grown fond of Slevin, has been investigating and tracking Mr. Goodkat's whereabouts. They leave for dinner in town and by chance they run into Yitzchok, with whom Slevin is able to talk one-on-one. Back home, Lindsey and Slevin fall into each other's arms and spend the night together - a small moment of respite from the nightmare the young man is living.

159

The next day, Slevin manages to liquidate Yitzchok with the help of Mr. Goodkat, then they neutralize The Boss and The Rabbi together. Shackled next to each other awaiting death, the two criminals - and the spectators - finally learn what binds Goodkat and Slevin...

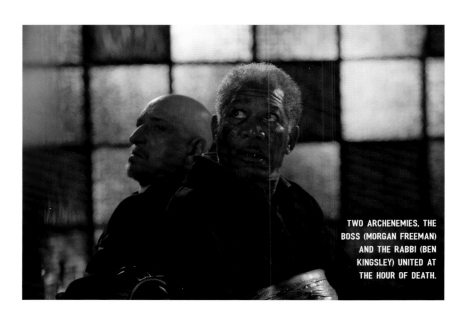

TWO ARCHENEMIES, THE BOSS (MORGAN FREEMAN) AND THE RABBI (BEN KINGSLEY) UNITED AT THE HOUR OF DEATH.

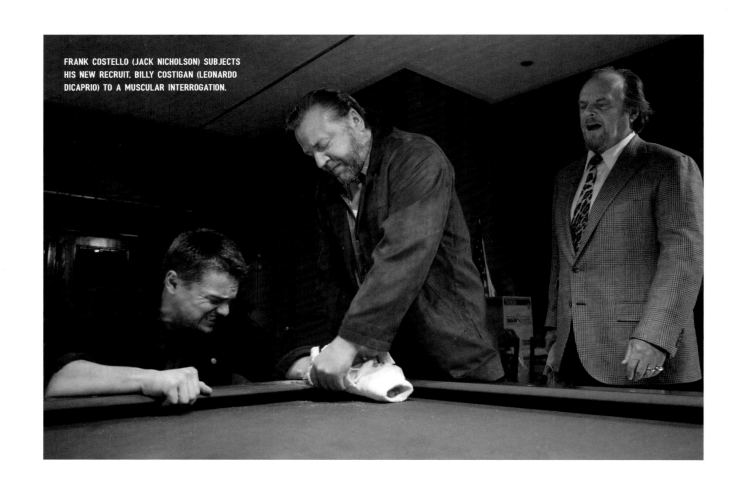

FRANK COSTELLO (JACK NICHOLSON) SUBJECTS
HIS NEW RECRUIT, BILLY COSTIGAN (LEONARDO
DICAPRIO) TO A MUSCULAR INTERROGATION.

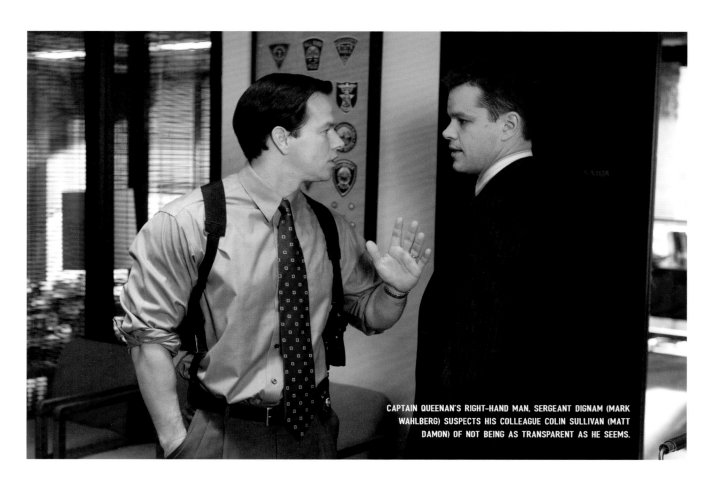

CAPTAIN QUEENAN'S RIGHT-HAND MAN, SERGEANT DIGNAM (MARK
WAHLBERG) SUSPECTS HIS COLLEAGUE COLIN SULLIVAN (MATT
DAMON) OF NOT BEING AS TRANSPARENT AS HE SEEMS.

THE DEPARTED

UNITED STATES, 2006
DIRECTOR: MARTIN SCORSESE

Billy Costigan (Leonardo DiCaprio) spent his childhood surrounded by characters from the Irish Mafia in Boston. When the young man enters the police academy, Captain Queenan (Martin Sheen), who leads the undercover operations, recruits him to infiltrate the gang led by Frank Costello (Jack Nicholson), the local godfather. In order not to attract suspicion, Billy must abandon his training and agree to spend several years in prison under fake charges. Upon his release, he is quickly spotted by Costello who engages him in his gang. He then begins to inform Captain Queenan and his assistant, Sergeant Dignam (Mark Wahlberg) of Costello's activities.

At the same time, another trainee, Colin Sullivan (Matt Damon) joins the anti-gang unit, a rival agency to Captain Queenan's. Sullivan has known Costello since childhood and starts warning him about police actions. While playing the mole for the godfather, Sullivan pursues a career as a model police officer and maintains a relationship with a psychologist, one of whose patients is

none other than Billy Costigan, who is finding it increasingly difficult to come to terms with his dual identity.

When Costello tries to resell stolen micro-processors to a Chinese triad, the warehouse where deal takes place is surrounded by police. Sullivan manages to warn Costello, and Costello escapes his pursuers. It is now clear that there is a mole on each side, and Costello urges Sullivan to find out who has infiltrated his gang.

The manhunt will be merciless, especially since Sullivan is charged by his unsuspecting superiors with flushing out Costello's mole in the police force.

161

MADOLYN, THE PSYCHOLOGIST CAUGHT BETWEEN COLIN SULLIVAN AND BILLY COSTIGAN.

LEAD ACTORS: LEONARDO DI CAPRIO (WILLIAM "BILLY" COSTIGAN JR.), MATT DAMON (SERGEANT COLIN SULLIVAN), JACK NICHOLSON (FRANK COSTELLO), MARK WAHLBERG (SERGEANT SEAN DIGNAM), MARTIN SHEEN (CAPTAIN OLIVER QUEENAN), VERA FARMIGA (MADOLYN) / DIALOGUE: WILLIAM MONAHAN / MUSIC: HOWARD SHORE / DURATION: 151 MINUTES/CATEGORIES: DIRTY COPS, UNDERCOVER COPS, IRISH-AMERICAN MAFIA

AMERICAN GANGSTER

UNITED STATES, 2007
DIRECTOR: RIDLEY SCOTT

In the late 1960s, as the Vietnam War is raging, drug consumption is in full swing in New York City. Very few police officers and judges are not corrupted by the powerful mafia bosses. Richie Roberts (Russell Crowe) is one of the few honest agents who has made himself famous by turning in a travel bag full of cash amounting to $1 million. He is then chosen by his higher-ups to create a police unit that specializes in hunting for drug traffickers.

At the same time, one of Harlem's historical godparents, the African American "Bumpy" Johnson (Clarence Williams III) has died of a heart attack. His driver and right-hand man, Frank Lucas (Denzel Washington), decides to set up his own business: a methodical and daring gangster, he manages to have pure heroin from Thailand smuggled aboard American military aircraft. Lucas' high-quality dope, sold under the name "Blue Magic", is quickly becoming the star attraction of New York City nightlife. Despite starting as an outsider, Frank Lucas rises to be a mafia boss respected by the biggest families. However, agent Richie Roberts and his team are onto him. The struggle is bound to be merciless.

Inspired by real events, the plot recreates the atmosphere of the Nixon years and the troubled relationship between the police and the mob. The film pays tribute to the first great African American drug dealer, Frank Lucas, an outstanding and complex personality who eventually collaborated with Richie Roberts to bring down corrupt police officers.

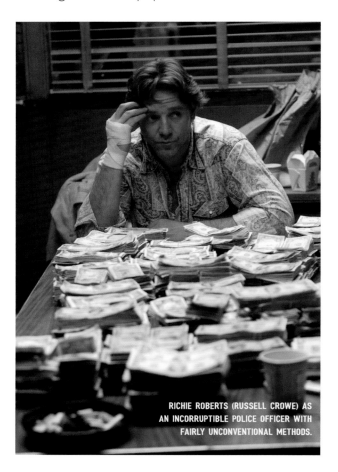

RICHIE ROBERTS (RUSSELL CROWE) AS AN INCORRUPTIBLE POLICE OFFICER WITH FAIRLY UNCONVENTIONAL METHODS.

LEAD ACTORS: DENZEL WASHINGTON (FRANK LUCAS), RUSSELL CROWE (RICHIE ROBERTS), LYMARI NADAL (EVA LUCAS), JOSH BROLIN (DETECTIVE TRUPO) / DIALOGUE: STEVEN ZAILLIAN / MUSIC: MARC STREITENFELD / DURATION: 157 MINUTES / CATEGORY: DRUG TRAFFICKING / AWARDS: TWO OSCAR NOMINATIONS, THREE GOLDEN GLOBES NOMINATIONS. / TRIVIA: AFTER RESIGNING FROM THE POLICE, RICHIE ROBERTS BECAME A LAWYER AND DEFENDED...FRANK LUCAS! HE OBTAINED A REDUCTION OF LUCAS' SENTENCE FROM SEVENTY TO FIFTEEN YEARS IN PRISON. THE TWO MEN BECAME FRIENDS.

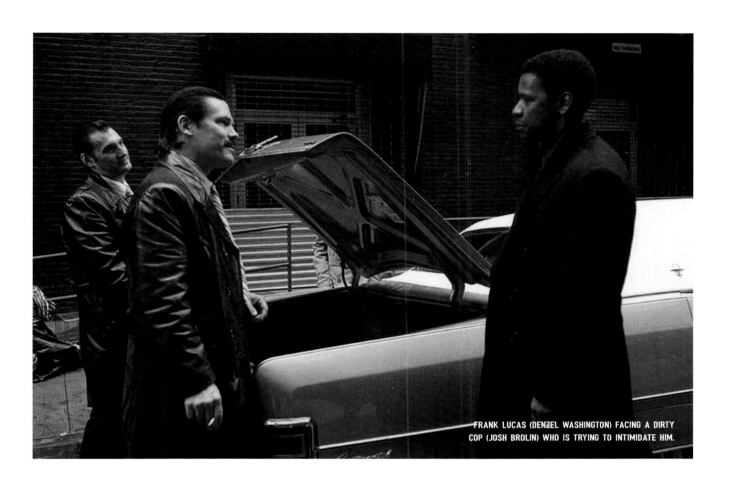

FRANK LUCAS (DENZEL WASHINGTON) FACING A DIRTY
COP (JOSH BROLIN) WHO IS TRYING TO INTIMIDATE HIM.

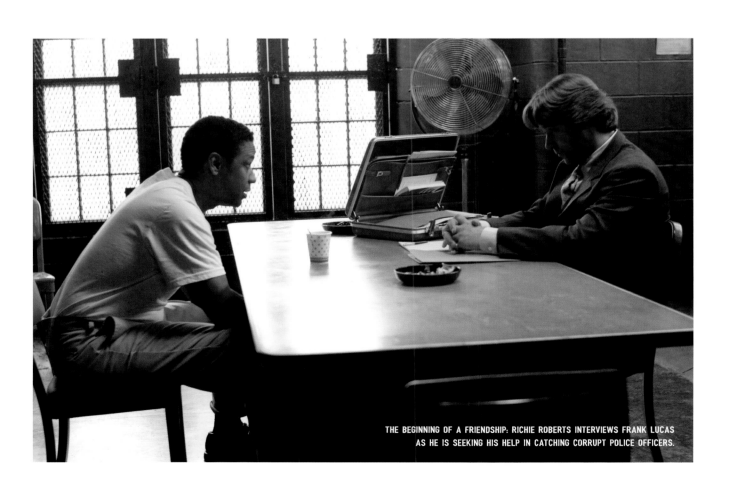

THE BEGINNING OF A FRIENDSHIP: RICHIE ROBERTS INTERVIEWS FRANK LUCAS
AS HE IS SEEKING HIS HELP IN CATCHING CORRUPT POLICE OFFICERS.

ANNA, THE MIDWIFE (NAOMI WATTS), DOES NOT YET KNOW THAT SEMYON (ARMIN MUELLER-STAHL) IS THE BIOLOGICAL FATHER OF THE LITTLE ORPHAN GIRL.

KIRILL (VINCENT CASSEL) AND NIKOLAI (VIGGO MORTENSEN) GET RID OF A RIVAL.

EASTERN PROMISES

CANADA, UNITED KINGDOM, USA, 2007
DIRECTOR: DAVID CRONENBERG

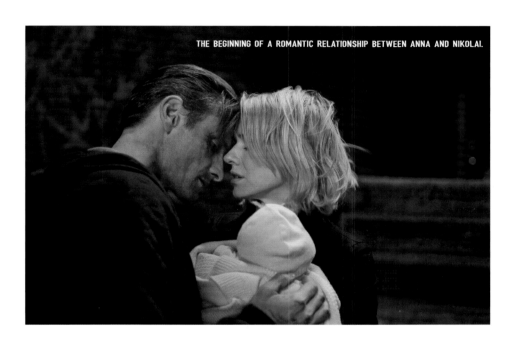

THE BEGINNING OF A ROMANTIC RELATIONSHIP BETWEEN ANNA AND NIKOLAI.

A badly injured Russian teenager dies in a London hospital giving birth to a baby girl. Anna Khitrova (Naomi Watts), a British midwife of Russian origin, who was present at the birth, decides to conduct an investigation and discover the identity of the victim. The dead girl's diary, found in her belongings, leads Anna to a high-end Russian restaurant that serves as a cover for mafia activities. The trio formed by the restaurant's owner, Semyon (Armin Mueller-Stahl), his son Kirill (Vincent Cassel), and their driver Nikolai Loujine (Viggo Mortensen) is at the heart of Russian mobster rings in London and leads a merciless war against Chechen thugs. When Anna understands that the little girl's father

is none other than Semyon, she wonders whether she should cover it up for her own safety or avenge the teenage girl forced into prostitution. With the help of the driver, Nikolai – a secret service agent infiltrated into the family who eventually takes a liking to the beautiful midwife, she will succeed in restoring justice.

The plot takes you into the depths of the Russian mafia, with its extreme brutality, codes of honor, and tattoos. The film leans on some easy clichés – the Russians drink vodka and swear like sailors – but also keeps viewers on the edge of their seats until the end.

LEAD ACTORS: NAOMI WATTS (ANNA "IVANOVNA" KHITROVA), VIGGO MORTENSEN (NIKOLAI LOUJINE), ARMIN MUELLER-STAHL (SEMYON), VINCENT CASSEL (KIRILL) / DIALOGUE: STEVEN KNIGHT / MUSIC: HOWARD SHORE / DURATION: 100 MINUTES / CATEGORY: RUSSIAN MAFIA / TRIVIA: THE FAKE TATTOOS COVERING VIGGO MORTENSEN'S BODY (NIKOLAI THE DRIVER) LOOKED SO AUTHENTIC THAT HE UNWITTINGLY TERRORIZED GUESTS AT A RUSSIAN RESTAURANT IN LONDON WHERE HE HAD GONE AFTER A DAY OF SHOOTING.

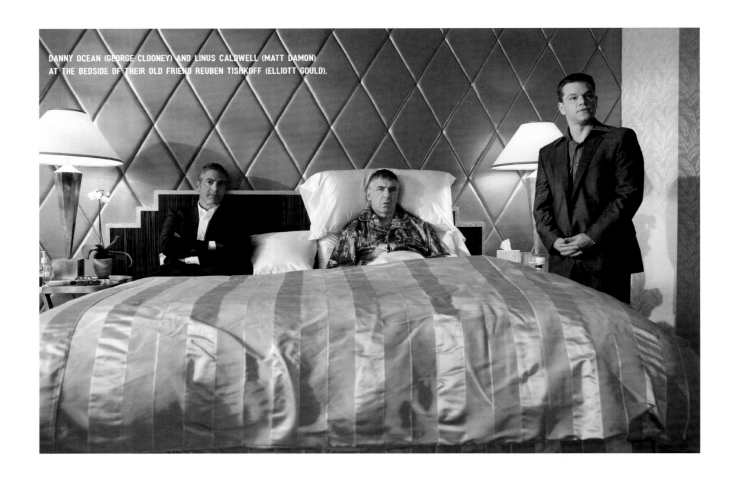

DANNY OCEAN (GEORGE CLOONEY) AND LINUS CALDWELL (MATT DAMON) AT THE BEDSIDE OF THEIR OLD FRIEND REUBEN TISHKOFF (ELLIOTT GOULD).

DANNY OCEAN'S TEAM WILL STOP AT NOTHING TO ACHIEVE HIS GOALS, EVEN IF IT MEANS UNDERMINING THE CASINO'S FOUNDATIONS.

LEAD ACTORS: GEORGE CLOONEY (DANNY OCEAN), BRAD PITT (RUSTY RYAN), MATT DAMON (LINUS CALDWELL), ELLIOTT GOULD (REUBEN TISHKOFF), AL PACINO (WILLY BANK), ANDY GARCÍA (TERRY BENEDICT), VINCENT CASSEL (FRANÇOIS TOULOUR) / DIALOGUE: BRIAN KOPPELMAN, DAVID LEVIEN / MUSIC: DAVID HOLMES / DURATION: 122 MINUTES / CATEGORY: HEIST OF THE CENTURY
TRIVIA: THE WINNING NUMBERS AT ROULETTE ARE 11, 12 AND 13, A NOD TO THE SERIES.

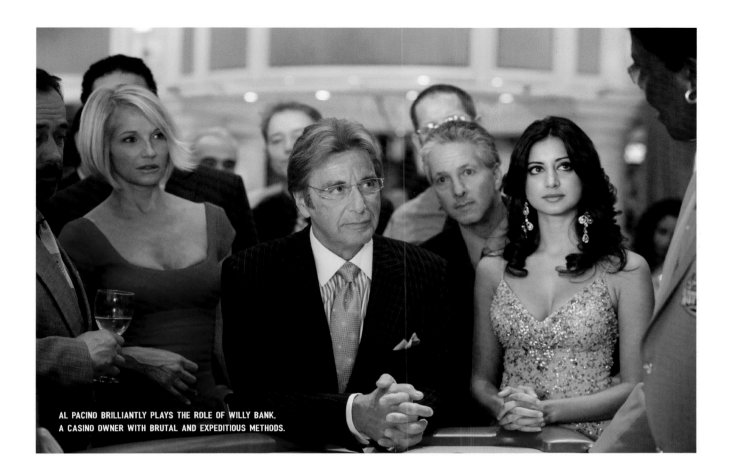

AL PACINO BRILLIANTLY PLAYS THE ROLE OF WILLY BANK,
A CASINO OWNER WITH BRUTAL AND EXPEDITIOUS METHODS.

OCEAN'S THIRTEEN

UNITED STATES, 2007
DIRECTOR: ROBERT DE NIRO

Danny Ocean's gang are back in Las Vegas, this time to avenge their mentor Reuben Tishkoff (Elliott Gould) who was stripped of his shares in a new casino by an unscrupulous competitor, Willy Bank (Al Pacino). As Reuben slowly recovers from a heart attack, Ocean's accomplices come up with a plan to steal the first day's takings, grab a collection of diamonds Bank is particularly proud of and, incidentally, ruin the reputation of his establishment. The challenge is so daunting that they have to team up with their sworn enemy, Terry Benedict (Andy García), to finance this new heist. Danny Ocean and his team will stop at nothing, even if it means creating a mini earthquake or sabotaging a supercomputer.

Faithful to the codes and traditions of the series, this third instalment of the Ocean's adventures takes us even further into the world of Danny Ocean and his gang, although the glamorous touch that Julia Roberts and Catherine Zeta-Jones brought to Ocean's Twelve is missing in this new episode. It is also regrettable that François Toulour (Vincent Cassel), the gang's most astute rival, makes only a brief appearance.

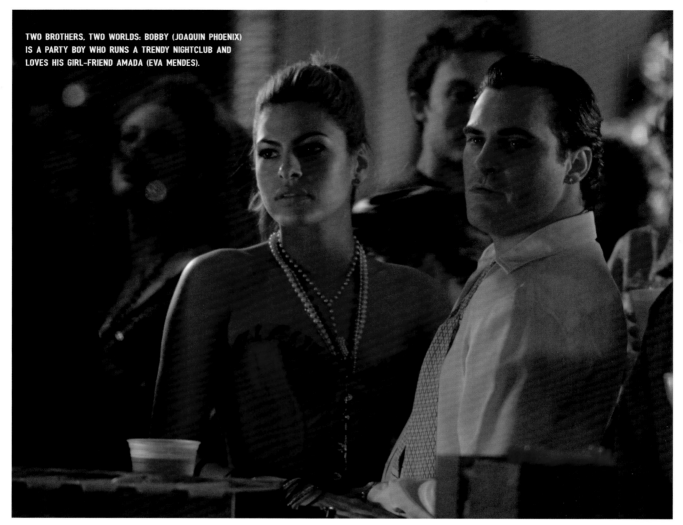

TWO BROTHERS. TWO WORLDS: BOBBY (JOAQUIN PHOENIX) IS A PARTY BOY WHO RUNS A TRENDY NIGHTCLUB AND LOVES HIS GIRL-FRIEND AMADA (EVA MENDES).

THE OTHER, JOE (MARK WAHLBERG), IS A MODEL COP, JUST LIKE THEIR FATHER, BURT GRUSINSKY (ROBERT DUVALL).

WE OWN THE NIGHT

UNITED STATES, 2007
DIRECTOR: JAMES GRAY

Bobby Green (Joaquin Phoenix) leads a dream life; he successfully runs El Caribe, a trendy nightclub; he parties from morning to night with his friends; he is in love with the beautiful Amada (Eva Mendes). His world is the antithesis of his brother Joe's (Mark Wahlberg), an honest policeman who follows in the footsteps of their father Burt (Robert Duvall).

Marat Buzhayev (Moni Moshonov), the powerful Russian businessman who owns the nightclub, asks Bobby to supervise the opening of new nightclubs. However, the latter is caught in a conflict with Buzhayev's own nephew, Vadim Nezhinsky (Alex Veadov), who is using El Caribe as a base for drug trafficking. As his brother Joe is investigating Vadim, Bobby fears that he will be trapped in the crossfire. When Joe launches a police raid on the nightclub, Bobby can't contain his anger against his brother. Shortly afterwards, Joe is shot dead outside his home by hitmen and miraculously survives. Bobby's time has come to make a choice; he agrees to work undercover to find out where Vadim Nezhinsky stores the drugs he sells. But he is discovered and owes his salvation only to the intervention of the police force led by his father.

Now protected day and night as a witness, Bobby watches Amada drift away from him as he languishes. While he is changing hideouts, Vadim's henchmen try to assassinate him and kill his father. Bobby decides to give up his former life to avenge his family.

LEAD ACTORS: JOAQUIN PHOENIX (BOBBY GREEN), EVA MENDES (AMADA JUAREZ), MARK WAHLBERG (JOSEPH GRUSINSKY, BOBBY'S BROTHER), ROBERT DUVALL (BURT GRUSINSKY, BOBBY'S FATHER), ALEX VEADOV (VADIM NEZHINSKY), MONI MOSHONOV (MARAT BUZHAYEV) / DIALOGUE: JAMES GRAY / MUSIC: WOJCIECH KILAR / DURATION: 117 MINUTES / CATEGORY: RUSSIAN MAFIA

TO TRACK DOWN THE FLEEING GANGSTERS, THE POLICE SET FIRE TO A REED FIELD.

GOMORRAH

ITALY, 2008
DIRECTOR: MATTEO GARRONE

Inspired by Roberto Saviano's best-selling eponymous novel about the Camorra, the film retraces the lives of several ordinary people caught up in the mafia's spiral: Totò (Salvatore Abbruzzese), the grocery delivery boy who dreams of becoming a bandit; Roberto (Carmine Paternoster), a young graduate hired by a waste treatment company whose boss, Franco (Toni Servillo), breaks the safety rules without any remorse; Pasquale (Salvatore Cantalupo), a tailor who struggles to make ends meet; Marco and Ciro (Marco Macor and Ciro Petrone), two apprentice gangsters who are increasingly provocative; Don Ciro (Gianfelice Imparato), a discreet and shy man who distributes envelopes of cash to families whose men are in prison. All of them are caught up in the whirlwind of clan rivalries and daily violence with no hope of getting out. The director deliberately shot the scenes as if they were a documentary, adding a chilling touch of realism. Curiously, the Neapolitan mafia, the infamous Camorra, gave the director a free hand to shoot in mafia-controlled building blocks, because the film does not judge the protagonists, it simply shows the daily life of people.

LEAD ACTORS: SALVATORE ABBRUZZESE (TOTÒ), GIANFELICE IMPARATO (DON CIRO), CARMINE PATERNOSTER (ROBERTO), TONI SERVILLO (FRANCO), CIRO PETRONE (CIRO), MARCO MACOR (MARCO), SALVATORE CANTALUPO (PASQUALE) / DIALOGUE: ROBERTO SAVIANO, MATTEO GARRONE, MAURIZIO BRAUCCI, UHO CHITI, GIANNI DI GREGORIO, MASSIMO GAUDIOSO / MUSIC: MASSIVE ATTACK / DURATION: 137 MINUTES / CATEGORY: CAMORRA, MAFIA IN ITALY
AWARDS: JURY'S GRAND PRIZE AT THE CANNES FILM FESTIVAL, A NOMINATION FOR THE GOLDEN GLOBES.

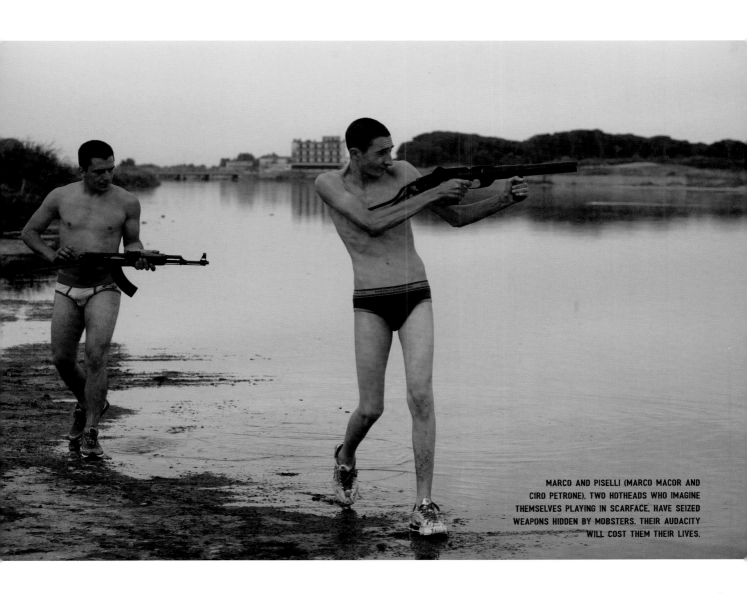

MARCO AND PISELLI (MARCO MACOR AND
CIRO PETRONE), TWO HOTHEADS WHO IMAGINE
THEMSELVES PLAYING IN SCARFACE, HAVE SEIZED
WEAPONS HIDDEN BY MOBSTERS. THEIR AUDACITY
WILL COST THEM THEIR LIVES.

MESRINE PART 1: KILLER INSTINCT
MESRINE PART 2: PUBLIC ENEMY # 1

CANADA, FRANCE, ITALY, 2008
DIRECTOR: JEAN–FRANÇOIS RICHET

More than forty years after his death, Jacques Mesrine remains public enemy number one in the French collective memory. This two-part film retraces the saga of this exceptional gangster whom the press called "the man with a thousand faces" and whose audacity was unequalled.

Upon returning from his military service in Algeria, which was still a French colony, Jacques Mesrine (Vincent Cassel) is looking for his path: he clearly does not want the well-ordered career his parents dreamed of for their only son. His old friend Paul (Gilles Lellouche) introduces him to Guido (Gérard Depardieu), a gangster close to extreme right-wing politicians who hires him for burglaries. Clever and resourceful, Mesrine has only one flaw: violent eruptions when people disrespect him, although he knows how to show incredible composure during robberies. The young thug quickly becomes a gangster, despite his marriage to Sofia (Elena Anaya) when he briefly settles down. But soon he is back to his former criminal life, divorced from Sofia. Mesrine has already become a legendary bank robber and must soon flee to Quebec with his new girlfriend, Jeanne Schneider (Cécile de France). But the kidnapping of a Canadian billionaire goes awry and their escape to the United States ends in an extraordinary chase. Extradited to Canada, Mesrine braves the authorities by joking with journalists and launching a provocative "Vive le Québec libre". Placed in a high-security prison, he cleverly manages to escape. His return to France, where he has become the most wanted man, marks the end of his run when superintendent Robert Broussard (Olivier Gourmet) arrests him for the first time. A fair player, Mesrine surrenders with glasses of champagne in his hands, which he offers to the policemen. If he manages to escape from the Parisian *Prison de la Santé* in the company of his fellow gangster François Besse (Mathieu Amalric), Mesrine still knows that his days are numbered.

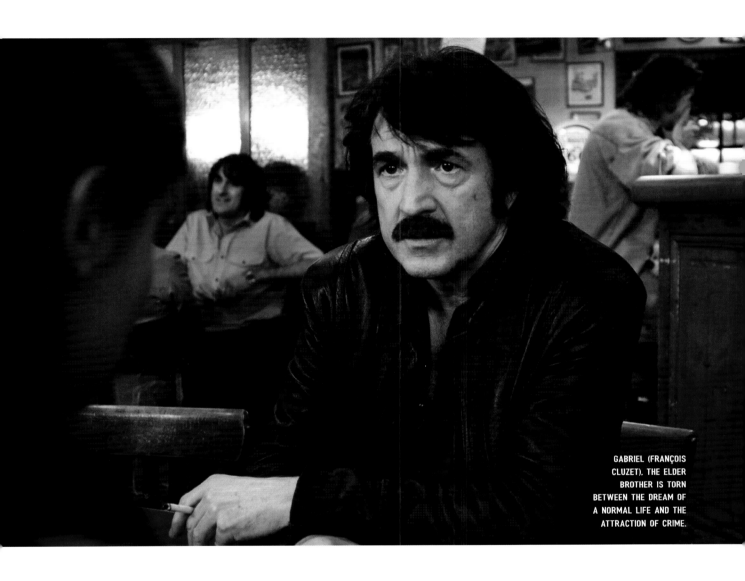

GABRIEL (FRANÇOIS CLUZET), THE ELDER BROTHER IS TORN BETWEEN THE DREAM OF A NORMAL LIFE AND THE ATTRACTION OF CRIME.

LEAD ACTORS: GUILLAUME CANET (FRANÇOIS), FRANÇOIS CLUZET (GABRIEL), OLIVIER PERRIER (HENRI, THE FATHER), MARIE DENARNAUD (NATHALIE), CLOTILDE HESME (CORINNE), CAROLE FRANCK (MONIQUE) /
DIALOGUE: JACQUES MAILLOT, ÉRIC VENIARD, PIERRE CHOSSON / MUSIC: STÉPHAN OLIVA /
DURATION: 103 MINUTES / CATEGORY: STORY INSPIRED BY TRUE EVENTS
TRIVIA: THE PLOT IS INSPIRED BY THE STORY OF BROTHERS MICHEL AND BRUNO PAPET
WHOSE BOOK TELLS THE CROSSED DESTINIES OF MICHEL, THE GANGSTER AND BRUNO, THE COP.

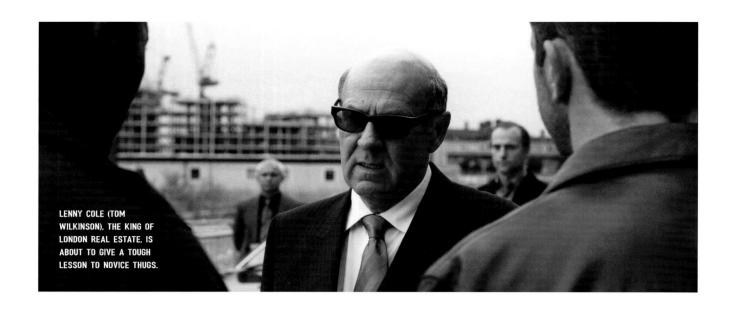

LENNY COLE (TOM WILKINSON), THE KING OF LONDON REAL ESTATE, IS ABOUT TO GIVE A TOUGH LESSON TO NOVICE THUGS.

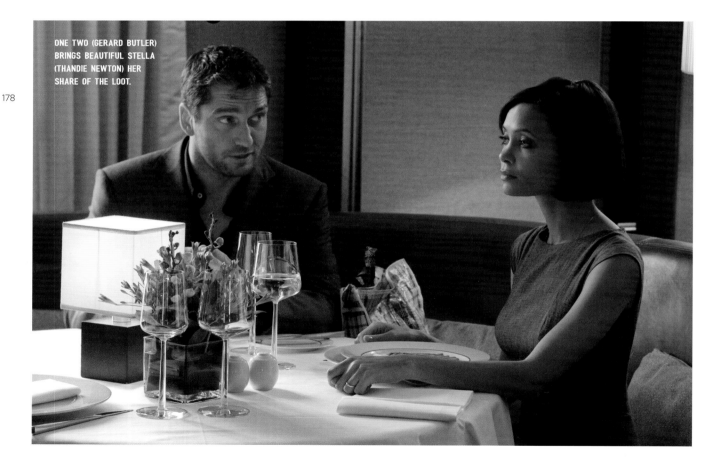

ONE TWO (GERARD BUTLER) BRINGS BEAUTIFUL STELLA (THANDIE NEWTON) HER SHARE OF THE LOOT.

LEAD ACTORS: GERARD BUTLER (ONE TWO), TOM WILKINSON (LENNY COLE), MARK STRONG (ARCHY), THANDIE NEWTON (STELLA), IDRIS ELBA (MUMBLES), TOBY KEBBELL (JOHNNY QUID), TOM HARDY (HANDSOME BOB), KAREL RODEN (URI OMOVICH), CHRIS BRIDGES (MICKEY), JEREMY PIVEN (ROMAN) / DIALOGUE: GUY RITCHIE / MUSIC: STEVE ISLES / DURATION: 114 MINUTES / CATEGORIES: LONDON GANGSTERS, RUSSIAN MAFIA

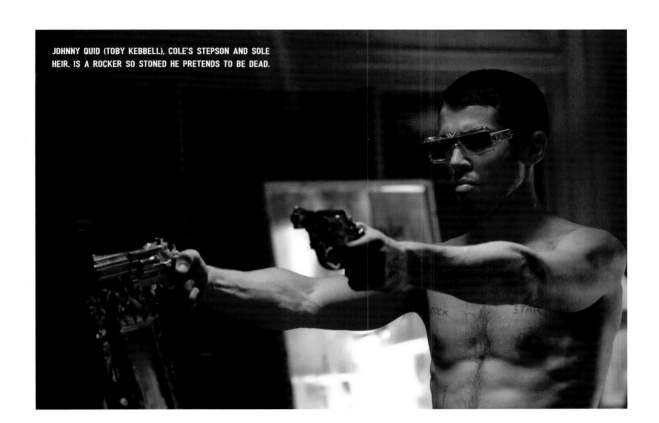

JOHNNY QUID (TOBY KEBBELL), COLE'S STEPSON AND SOLE
HEIR, IS A ROCKER SO STONED HE PRETENDS TO BE DEAD.

ROCKnROLLA

UNITED KINGDOM, 2008
DIRECTOR: GUY RITCHIE

Lenny Cole (Tom Wilkinson) is a major boss of the London underworld. No major real estate project passes him by. The web he has woven among city planners and politicians allows him to get all the authorizations he wants with a simple phone call. Yet Cole has an Achilles' heel: his greed, which leads him to fleece two small-time hoodlums, One Two (Gerard Butler) and Mumbles (Idris Elba), or to act as an intermediary for a Russian oligarch, Uri Omovich (Karel Roden) for huge fee. Omovich agrees to pay him seven million pounds in cash to smooth a real estate deal and lends him his lucky painting as collateral. However, the oligarch's beautiful accountant, Stella (Thandie Newton), who leads a too-tidy life, decides to embezzle the pay-off to alleviate her boredom: she calls on One Two who organizes the heist successfully, and incidentally falls in love with Stella.

Meanwhile, Cole's stepson, a stoned rocker known as Johnny Quid, steal the oligarch's painting from his stepfather's office. When a second cash payment, transported by two Russian gangsters under Omovich's supervision, is attacked again, the oligarch suspects Cole of playing a double game, especially since the Englishman does not seem willing to return his painting. The chase between the rival gangs has only just begun and is set to be violent.

All the ingredients that make Guy Ritchie's films successful are found in this intrigue verging on parody: a big shot who thinks he's invincible, small-time gangsters who are truly amateurs, a bunch of junkies and psychopaths. Thandie Newton adds a touch of glamour to the lively story.

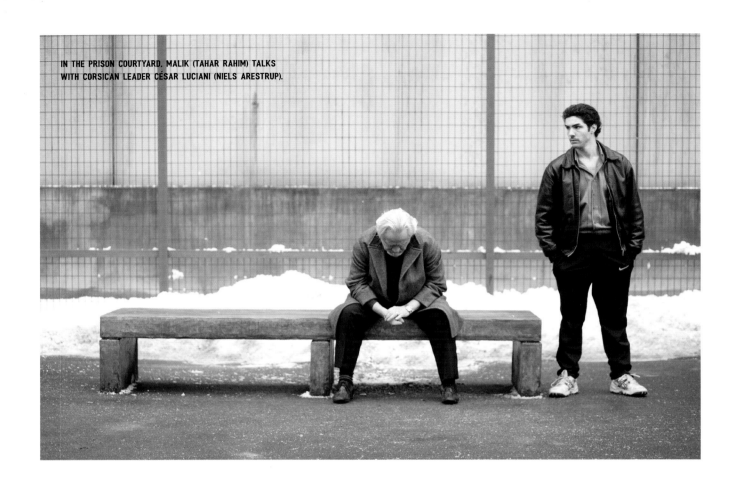

IN THE PRISON COURTYARD, MALIK (TAHAR RAHIM) TALKS
WITH CORSICAN LEADER CÉSAR LUCIANI (NIELS ARESTRUP).

LEAD ACTORS: TAHAR RAHIM (MALIK EL DJEBENA), NIELS ARESTRUP (CÉSAR LUCIANI), HICHEM YACOUBI (REYEB),
ADEL BENCHERIF (RYAD), REDA KATEB (JORDI THE GYPSY), JEAN-PHILIPPE RICCI (VETTORI), LEÏLA BEKHTI (DJAMILA) /
DIALOGUE: JACQUES AUDIARD, THOMAS BIDEGAIN, NICOLAS PEUFAILLIT, ABDEL RAOUF DAFRI /
MUSIC: ALEXANDRE DESPLAT / DURATION: 155 MINUTES / CATEGORY: GANGSTERS IN PRISON

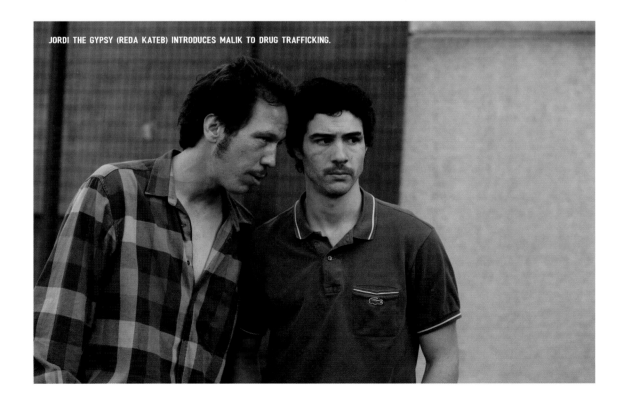

JORDI THE GYPSY (REDA KATEB) INTRODUCES MALIK TO DRUG TRAFFICKING.

A PROPHET

FRANCE, 2009
DIRECTOR: JACQUES AUDIARD

Malik (Tahar Rahim), a 19-year-old delinquent, is incarcerated for six years in a prison near Paris. Without money or protection, he is at first confronted with the prison's petty racketeers, but he is rapidly spotted by the Corsican clan, which runs the prison with the complicity of corrupt prison guards. Malik will soon have the opportunity to show his loyalty to César Luciani (Niels Arestrup), the old Corsican godfather: the latter asks him to kill Reyeb (Hichem Yacoubi), a rival incarcerated in the same prison. Knowing that he has no other choice, Malik carries out the crime, and becomes Luciani's henchman. To allow Malik to circulate freely throughout the prison, Luciani gets him a job as part of the team in charge of distributing food to inmates. Malik can then easily carry Luciani's instructions to other inmates. Meanwhile, Malik takes courses to overcome his near illiteracy. In this way, he becomes friends with

Ryad (Adel Bencherif), a prisoner who intends to rehabilitate himself thanks to his contacts with the "bearded", as the group of Islamist inmates is called. Malik also helps Jordi the Gypsy (Reda Kateb), a drug trafficker, to sell his merchandise throughout the prison, without the knowledge of the Corsicans.

When Malik obtains his first temporary release thanks to Luciani, who entrusts him with the payment of a ransom, the young man sees Ryad again and they join forces to start a drug trade. Without formally freeing himself from the Corsican guardianship, Malik now plays his own game, and joins forces with the bearded men when Luciani's influence begins to decline. Malik goes from being a petty crook to a feared and respected man.

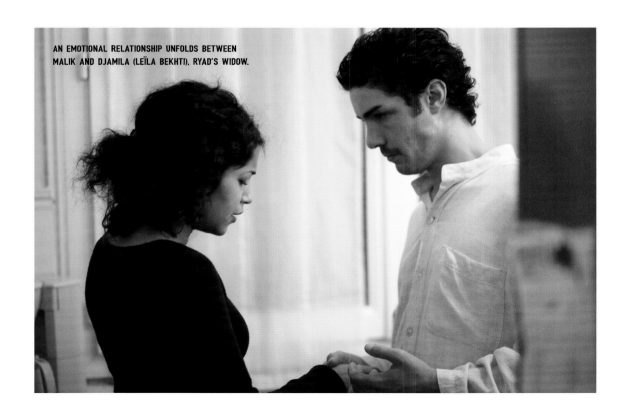

AN EMOTIONAL RELATIONSHIP UNFOLDS BETWEEN MALIK AND DJAMILA (LEÏLA BEKHTI), RYAD'S WIDOW.

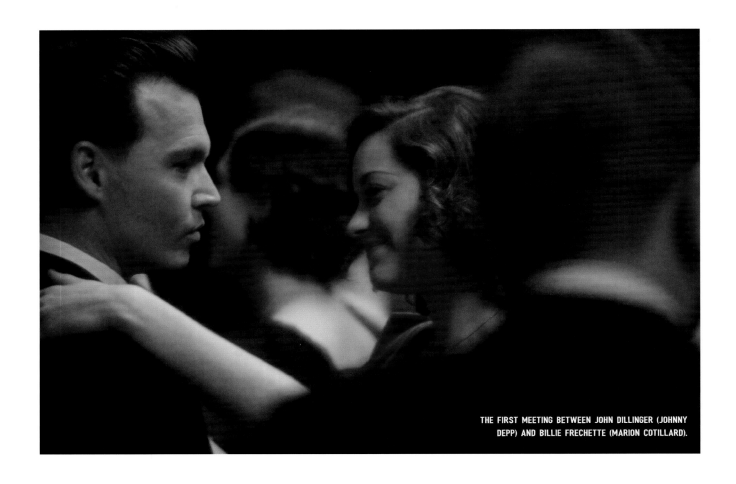

THE FIRST MEETING BETWEEN JOHN DILLINGER (JOHNNY DEPP) AND BILLIE FRECHETTE (MARION COTILLARD).

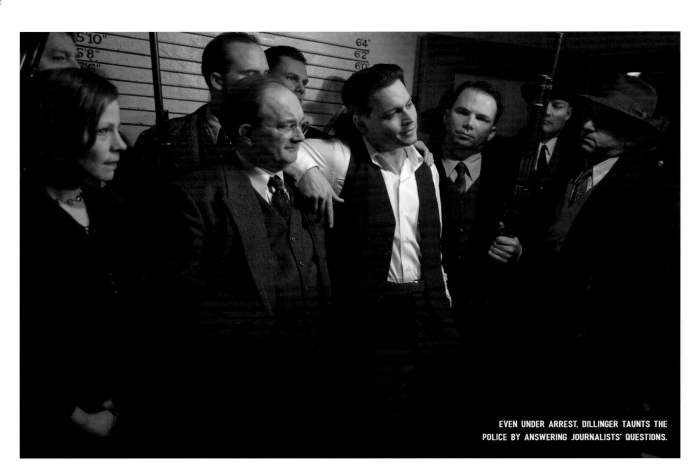

EVEN UNDER ARREST, DILLINGER TAUNTS THE POLICE BY ANSWERING JOURNALISTS' QUESTIONS.

PUBLIC ENEMIES

UNITED STATES, 2009
DIRECTOR: MICHAEL MANN

In the early 1930s, John Dillinger (Johnny Depp) was the most famous and popular bank robber in the United States. His reputation as a lucky and bold gangster gave him an aura worthy of Robin Hood. Michael Mann retraces the last years of Dillinger's life and the hunt organized by Melvin Purvis (Christian Bale), one of the first federal agents recruited by J. Edgar Hoover (Billy Crudup).

After helping accomplices escape from an Indiana penitentiary, Dillinger began a series of spectacular robberies in Chicago, leading the federal government to entrust the search to Melvin Purvis, a police officer who had excelled at manhunts. Between two bank robberies, during an evening out, Dillinger meets the woman who will become his girlfriend, Billie Frechette (Marion Cotillard). Arrested by chance in Indiana, Dillinger again escapes the police and resumes the robberies. Wounded in the arm during a heist, he has to take refuge in an isolated inn with his gang. The inn is soon surrounded, however, by Purvis and his crew who have heard about Dillinger's plans. But here again, luck favors Dillinger: he manages to escape in front of the police. Deprived of his men and hunted down, he tries by all means to see Billie Frechette again, but she is under constant surveillance by the FBI. Their reunion will be short lived...

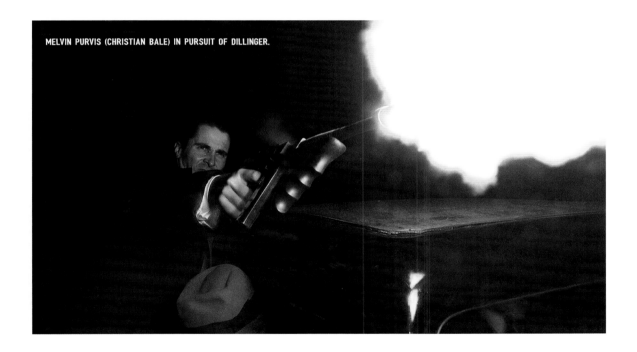

MELVIN PURVIS (CHRISTIAN BALE) IN PURSUIT OF DILLINGER.

LEAD ACTORS: JOHNNY DEPP (JOHN DILLINGER), MARION COTILLARD (BILLIE FRECHETTE), CHRISTIAN BALE (MELVIN PURVIS), BILLY CRUDUP (J. EDGAR HOOVER) / DIALOGUE: RONAN BENNETT, MICHAEL MANN, ANN BIDERMAN, BASED ON A NOVEL BY BRYAN BURROUGH / MUSIC: ELLIOT GOLDENTHAL / DURATION: 134 MINUTES / CATEGORY: LIFE AND DEATH OF A GANGSTER

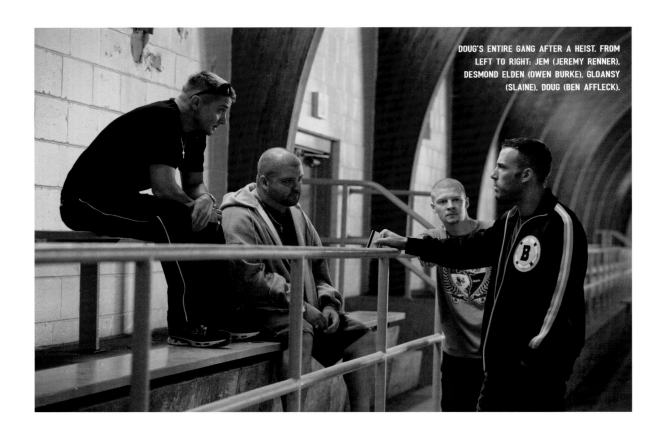

DOUG'S ENTIRE GANG AFTER A HEIST. FROM LEFT TO RIGHT: JEM (JEREMY RENNER), DESMOND ELDEN (OWEN BURKE), GLOANSY (SLAINE), DOUG (BEN AFFLECK).

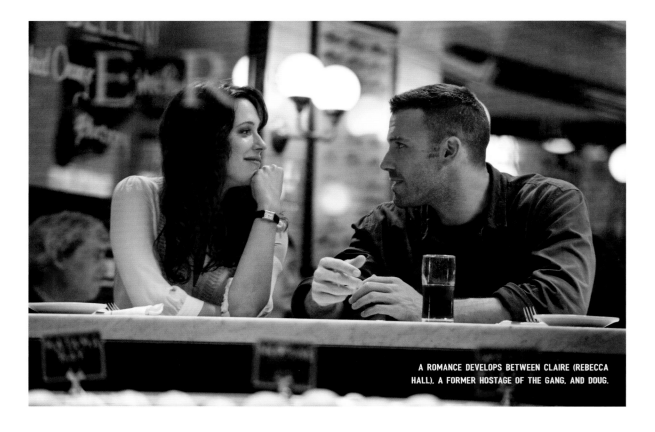

A ROMANCE DEVELOPS BETWEEN CLAIRE (REBECCA HALL), A FORMER HOSTAGE OF THE GANG, AND DOUG.

LEAD ACTORS: BEN AFFLECK (DOUG MACRAY), REBECCA HALL (CLAIRE KEESEY), JEREMY RENNER (JAMES COUGHLIN), JON HAMM (SPECIAL AGENT ADAM FRAWLEY), BLAKE LIVELY (KRISTA COUGHLIN), OWEN BURKE (DESMOND ELDEN), SLAINE (GLOANSY) / DIALOGUE: BEN AFFLECK, PETER CRAIG, AARON STOCKARD, BASED ON CHUCK HOGAN'S NOVEL *PRINCE OF THIEVES* / MUSIC: DAVID BUCKLEY, HARRY GREGSON-WILLAMS / DURATION: 125 MINUTES / CATEGORIES: BANK ROBBERIES, HEIST OF THE CENTURY / AWARDS: AN OSCAR NOMINATION, A GOLDEN GLOBES NOMINATION.

THE TOWN

UNITED STATES, 2010
DIRECTOR: BEN AFFLECK

In Charlestown, an Irish Boston neighborhood, people have been robbing banks for generations. Doug MacRay (Ben Affleck) followed in his father's footsteps and runs a gang that specializes in armored car and bank robberies. Precise and methodical, he tries not to resort to violence, even though he has to compromise with the impulsive temperament of his accomplice and best friend James "Jem" (Jeremy Renner). During a bank heist, Renner brutally hits the branch manager who triggers the alarm. To cover their escape, Doug and his men take the pretty assistant manager, Claire Keesey (Rebecca Hall), hostage. She is freed on a beach, but Jem, who has stolen her driver's license, realizes she lives in Charlestown and worries that she might recognize them. While Jem wants to eliminate this dangerous witness, Doug decides to discreetly contact Claire to see if she poses a threat to the gang. He gains her trust and learns that Claire has seen one of Jem's identifying tattoos, but he convinces her not to tell the police. Meanwhile, Special Agent Adam Frawley (Jon Hamm) is tasked with dismantling the gang: his suspicions quickly turn to Claire, a hostage who was released too quickly and who, moreover, lives in the gangsters' neighborhood. Agent Frawley organizes the hunt for the gang without managing to expose them, and follows Claire. Unaware of the threat, Doug, who is involved in a relationship with Claire, decides to give up his life as a gangster: but first he has to pull off the heist of the century by stealing the proceeds from Fenway Park, the city's baseball stadium.

185

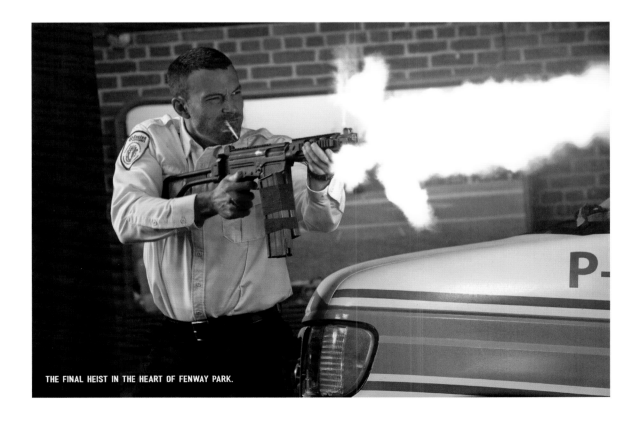

THE FINAL HEIST IN THE HEART OF FENWAY PARK.

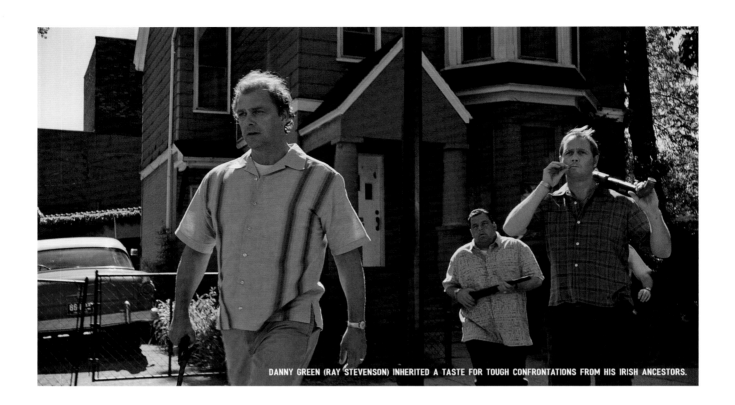

DANNY GREEN (RAY STEVENSON) INHERITED A TASTE FOR TOUGH CONFRONTATIONS FROM HIS IRISH ANCESTORS.

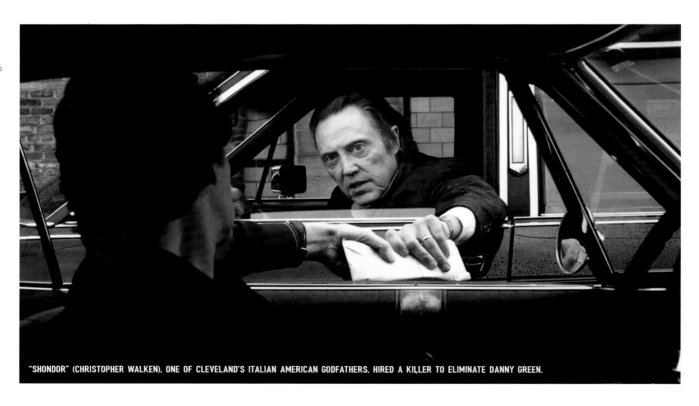

"SHONDOR" (CHRISTOPHER WALKEN), ONE OF CLEVELAND'S ITALIAN AMERICAN GODFATHERS, HIRED A KILLER TO ELIMINATE DANNY GREEN.

LEAD ACTORS: RAY STEVENSON (DANNY GREEN), VINCENT D'ONOFRIO (JOHN NARDI), VAL KILMER (JOE MANDITSKI),
CHRISTOPHER WALKEN (SHONDOR BIRNS), LIND CARDELLINI (JOAN, DANNY GREEN'S FIRST WIFE),
LAURA RAMSEY (ELLIE, DANNY'S NEW PARTNER) / DIALOGUE: JONATHAN HENSLEIGH, JEREMY WALTERS,
BASED ON RICK PORELLO'S NOVEL *TO KILL THE IRISHMAN* / MUSIC: PATRICK CASSIDY / DURATION: 106 MINUTES /
CATEGORIES: BIOPIC, LIFE AND DEATH OF A GANGSTER / TRIVIA: FOR SAFETY AND BUDGETARY REASONS,
ALL THE CAR EXPLOSION SCENES COULD ONLY BE SHOT ONCE.

KILL THE IRISHMAN

UNITED STATES, 2011
DIRECTOR: JONATHAN HENSLEIGH

Danny Green's (Ray Stevenson) life is like an old Irish legend. Raised in a poor neighborhood in Cleveland, Green managed to establish himself as one of the city's godfathers thanks to his imposing stature, his lethal punch and his outspoken temperament. With a touch of irony, the film traces the career of the man who was nicknamed the "Robin Hood of Collinwood" because of his generosity towards the people of his neighborhood. We follow him in his fight against the corrupt bosses of the Dockers' Union, then in his struggle against the almighty Italian American mafia from which he sought to break free. As cautious as he is impulsive, Danny Green managed to escape several assassination attempts that contributed to his reputation as an invincible Celtic warrior. The car bomb explosions that punctuate the plot set the pace for Cleveland's gang warfare in the 1970s. It was one of these car bombs that took out Danny Green in October 1977. But, as the epilogue reminds us, the killer in charge of the execution surrendered to the police and contributed to the downfall of big families of the Italian American mafia.

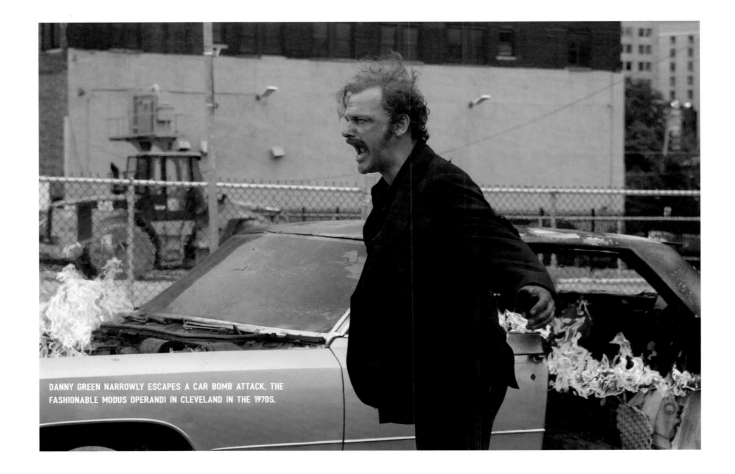

DANNY GREEN NARROWLY ESCAPES A CAR BOMB ATTACK, THE FASHIONABLE MODUS OPERANDI IN CLEVELAND IN THE 1970S.

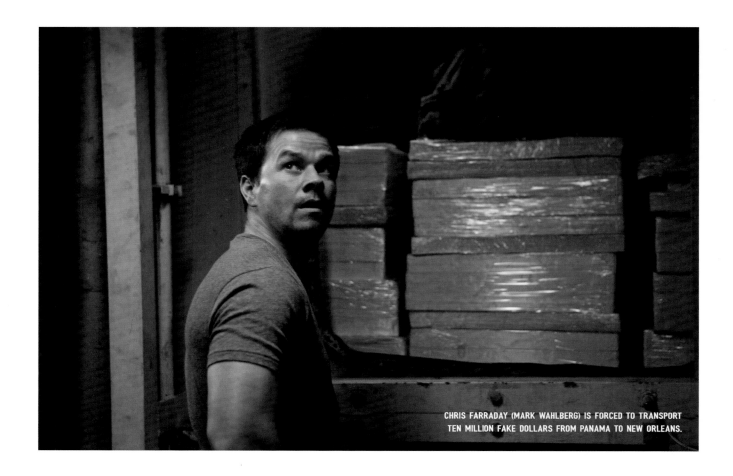

CHRIS FARRADAY (MARK WAHLBERG) IS FORCED TO TRANSPORT TEN MILLION FAKE DOLLARS FROM PANAMA TO NEW ORLEANS.

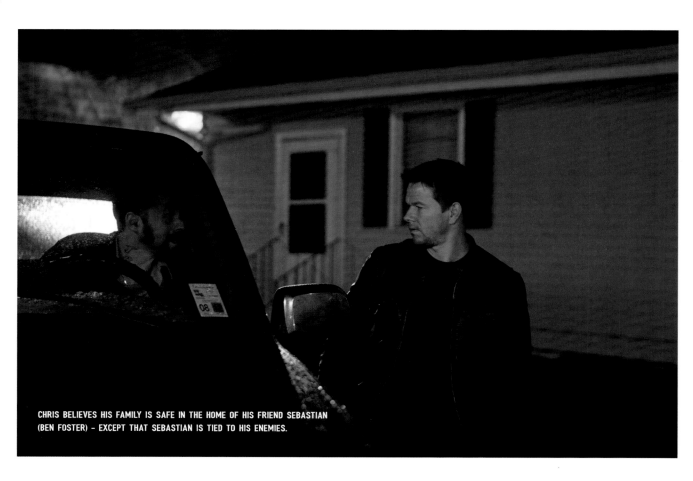

CHRIS BELIEVES HIS FAMILY IS SAFE IN THE HOME OF HIS FRIEND SEBASTIAN (BEN FOSTER) - EXCEPT THAT SEBASTIAN IS TIED TO HIS ENEMIES.

CONTRABAND

FRANCE, UNITED KINGDOM, UNITED STATES, 2012
DIRECTOR: BALTASAR KORMÁKUR

Chris Farraday (Mark Wahlberg), a retired smuggler, lives quietly with his wife and two sons in New Orleans. However, when Andy (Caleb Landry Jones), his naive brother-in-law, narrowly escapes a police raid by getting rid of the drugs he was transporting for Tim Briggs, a local kingpin (Giovanni Ribisi), Chris realizes that he will have to clean up the mess to save himself and his family. With the help of another ex-smuggler, Sebastian Abney (Ben Foster), he agrees to return to service and transport $10 million in counterfeit bills from Panama to New Orleans by taking a job on a cargo ship where he and his father once served. With the complicity of the crew, he sets up an ingenious plan to hide the counterfeit currency. Meanwhile Tim Briggs keeps harassing Chris's family back at home and Sebastian, the faithful friend, plays a double game. When Chris arrives in Panama City, he is only at the beginning of the adventure...

A remake of the Icelandic movie *Reykjavik-Rotterdam* by Óskar Jónasson, the film keeps viewers on the edge of their seats from start to finish.

189

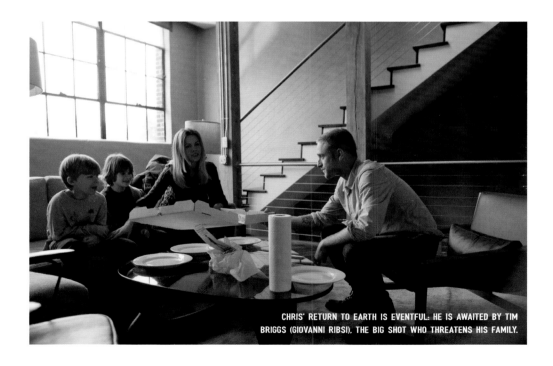

CHRIS' RETURN TO EARTH IS EVENTFUL: HE IS AWAITED BY TIM BRIGGS (GIOVANNI RIBISI), THE BIG SHOT WHO THREATENS HIS FAMILY.

LEAD ACTORS: MARK WAHLBERG (CHRIS FARRADAY), KATE BECKINSALE (KATE FARRADAY), CALEB LANDRY JONES (ANDY), BEN FOSTER (SEBASTIAN ABNEY), GIOVANNI RIBISI (TIM BRIGGS), LUKAS HAAS (DANNY RAYMER) / DIALOGUE: AARON GUZIKOWSKI / MUSIC: CLINTON SHORTER / DURATION: 109 MINUTES / CATEGORY: DRUG TRAFFICKING

LAWLESS

UNITED STATES, 2012
DIRECTOR: JOHN HILLCOAT

During the dark years of Prohibition, the three Bondurant brothers Howard (Jason Clarke), Forrest (Tom Hardy) and Jack (Shia LaBeouf) operate an underground distillery in a remote corner of Virginia while running a gas station and restaurant as a cover. A rift forms between the younger brothers, Forrest and Jack, on which strategy they should follow: Jack thinks big and dreams of fortune while Forrest wants above all to avoid the underworld, and plays the head of the family in the place of Howard who likes nothing more than to drink and fight. With the complicity of the local police, the Bondurant family sells their moonshine in the surrounding area. Everything seems to be working until the state prosecutor, accompanied by a special agent from Chicago, Charlie Rakes (Guy Pearce), comes to interfere in local affairs: Rakes demands an exorbitant sum to turn a blind eye to the traffic and Forrest refuses outright. It is now open war between Rakes and the three brothers, especially since all the other distillers have submitted to the newcomer. In the meantime, Forrest has hired Maggie (Jessica Chastain), a former dancer, to run the bar, and Jack courts Bertha Minnix (Mia Wasikowska), the daughter of a preacher. One winter evening, two drunken customers harass Maggie, but they are severely beaten by Forrest and Howard. However, the drunk men manage to lure Forrest into an ambush and slit his throat, leaving him for dead. He is taken to the hospital at the last minute and miraculously survives. Jack uses this occasion to sell a load of alcohol to the underworld. Together with his best friend, Cricket Pate (Dane DeHaan), he manages to do business with mobster boss Floyd Banner (Gary Oldman), who tells him that Rakes ordered Forrest's unsuccessful assassination. Tension mounts when Rakes discovers the hidden location of the distillery and kills Cricket. Armed confrontation is now inevitable...

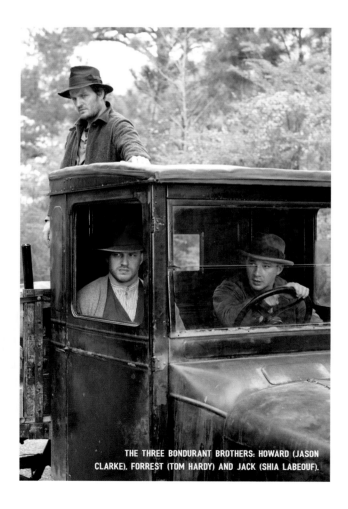

THE THREE BONDURANT BROTHERS: HOWARD (JASON CLARKE), FORREST (TOM HARDY) AND JACK (SHIA LABEOUF).

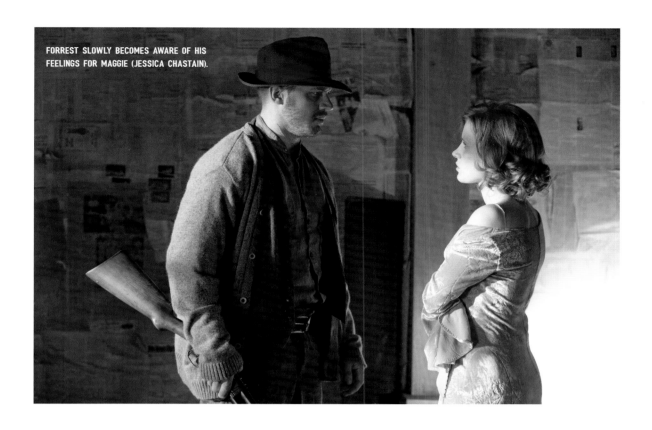

FORREST SLOWLY BECOMES AWARE OF HIS
FEELINGS FOR MAGGIE (JESSICA CHASTAIN).

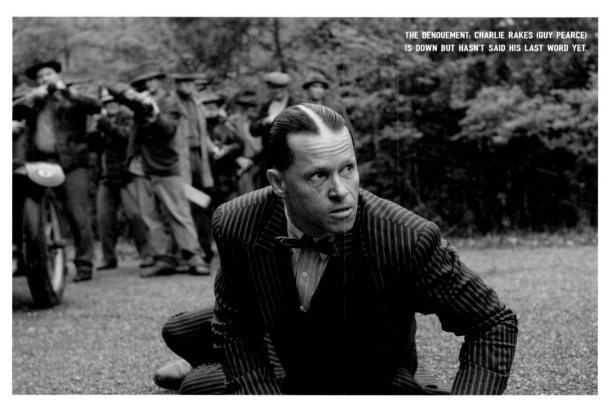

THE DENOUEMENT: CHARLIE RAKES (GUY PEARCE)
IS DOWN BUT HASN'T SAID HIS LAST WORD YET.

LEAD ACTORS: TOM HARDY (FORREST BONDURANT), JASON CLARKE (HOWARD BONDURANT), SHIA LABEOUF
(JACK BONDURANT), JESSICA CHASTAIN (MAGGIE), MIA WASIKOWSKA (BERTHA MINNIX), GUY PEARCE (SPECIAL AGENT
CHARLIE RAKES), DANE DEHAAN (CRICKET PATE) / DIALOGUE: NICK CAVE, BASED ON THE NOVEL BY MATT BONDURANT /
MUSIC: NICK CAVE, WARREN ELLIS / DURATION: 116 MINUTES / CATEGORIES: BIOPIC, FAMILY SAGA, PROHIBITION
AWARD: A NOMINATION FOR THE PALME D'OR AT THE CANNES FILM FESTIVAL.
TRIVIA: THE STORY IS INSPIRED BY THE WETTEST COUNTY IN THE WORLD,
THE BONDURANT FAMILY CHRONICLE WRITTEN BY MATT BONDURANT, JACK'S GRANDSON.

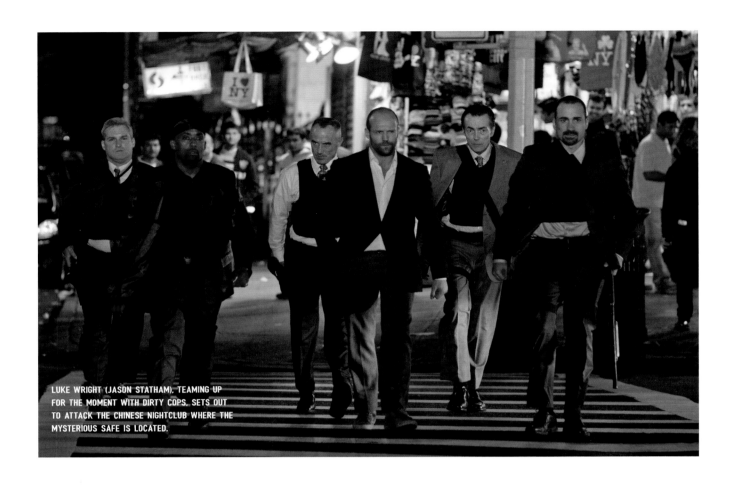

LUKE WRIGHT (JASON STATHAM), TEAMING UP
FOR THE MOMENT WITH DIRTY COPS, SETS OUT
TO ATTACK THE CHINESE NIGHTCLUB WHERE THE
MYSTERIOUS SAFE IS LOCATED.

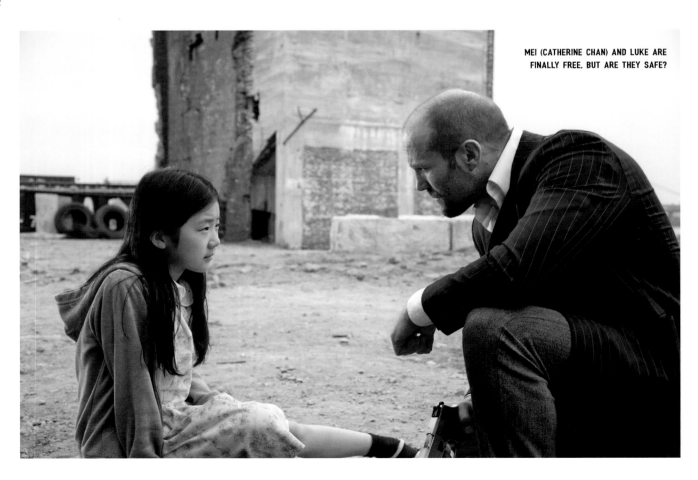

MEI (CATHERINE CHAN) AND LUKE ARE
FINALLY FREE, BUT ARE THEY SAFE?

SAFE

UNITED STATES, 2012
DIRECTOR: BOAZ YAKIN

Luke Wright (Jason Statham), a former secret agent turned wrestler, sees his pregnant wife murdered by the Russian mafia as punishment for winning a rigged fight he should have lost. Vassily Docheski (Joseph Sikora), the son of the Russian godfather in charge of killing Wright's wife decides against all odds to let Wright live, but promises to kill anyone he befriends. Abandoned by everyone, Wright leads the life of a wandering tramp.

At the same time in China, Mei, a little girl with an exceptional memory for numbers, is captured by the leader of a triad, Han Jiao (James Hong), who sends her to the United States to keep track of the triad's financial transactions, which are carried out illegally and without any trace.

One year later, Mei who lives in New York with her triad mentor Quang Chan (Reggie Lee), must learn two combinations of numbers at Han Jiao's request. Shortly afterwards, she is suddenly kidnapped by Russian gangsters who are interested in these mysterious numbers. Mei manages to escape in a moment of inattention and tries to run away from the Russian mafia by hiding in a subway station. Luke Wright, adrift in the same station, sees the little girl hiding and recognizes her pursuers, who are none other than his wife's killers. He manages to free Mei and convinces her to follow him. Pursued by the triad's henchmen, Docheski's gang, and corrupt policemen who smell a bargain, Mei and Luke take refuge in a luxury hotel. When Mei explains the reason why so many gangsters are after her, Luke understands that the coveted combination of numbers is that of a safe. What it contains may be the key to their survival...

193

LEAD ACTORS: JASON STATHAM (LUKE WRIGHT), CATHERINE CHAN (MEI), REGGIE LEE (QUAN CHANG), JAMES HONG (HAN JIAO), ROBERT JOHN BURKE (CAPTAIN WOLF), JOSEPH SIKORA (VASSILY DOCHESKI), SÁNDOR TÉCSY (EMILE DOCHESKI), ANSON MOUNT (ALEX ROSEN) / DIALOGUE: BOAZ YAKIN / MUSIC: MARK MOTHERSBAUGH / DURATION: 94 MINUTES / CATEGORIES: TRIADS, RUSSIAN MAFIA, DIRTY COPS

RICHARD "RICHIE" KUKLINSKI (MICHAEL SHANNON) IS A CONSIDERATE HUSBAND, A LOVING FATHER...

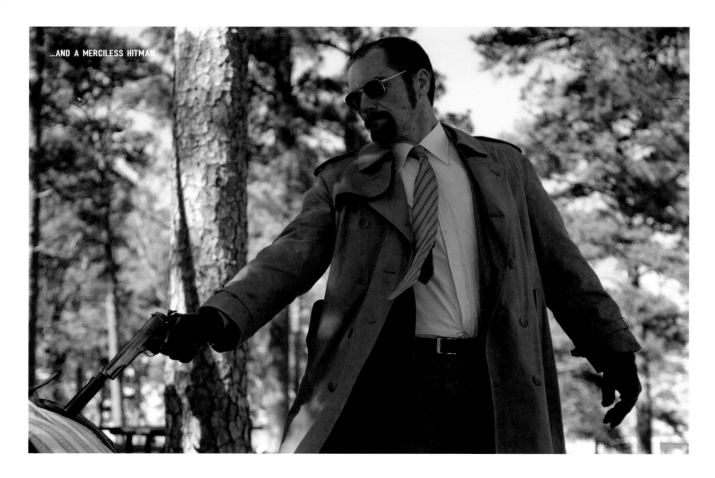

...AND A MERCILESS HITMAN.

AMERICAN HUSTLE

UNITED STATES, 2013
DIRECTOR: DAVID O. RUSSELL

Irving Rosenfeld (Christian Bale) and Sydney Prosser (Amy Adams), a couple of crooks caught with their hands in the cookie jar, agree to serve as bait for a young FBI agent, Richard DiMaso (Bradley Cooper) whose dream is to bring down crooked politicians and their accomplices in the mafia. A project to re-open casinos in Atlantic City, supported by Camden Mayor Carmine Polito (Jeremy Renner), gives them the opportunity to weave their web: Irving Rosenfeld invents a fake sheikh who is ready to invest and to bribe all the influential people he meets. During a party given in his honor by Carmine Polito, the fake sheikh finds himself face-to-face with Victor Tellegio (Robert De Niro), Meyer Lansky's right-hand man,

who seems ready to join in the business. DiMaso, who must constantly fight to obtain further financial and tactical support from his organization, believes his time has come. But his rivalry with Irving, which is further aggravated by DiMaso's feelings for Sydney, will lead him to his downfall.

David O. Russell locates a story full of suspense and glamour in 1970s' New York, with a brilliant Bradley Cooper in the role of an ambitious and crazy young Fed. The film constantly oscillates between comedy and thriller, with funny twists and a very moral ending.

199

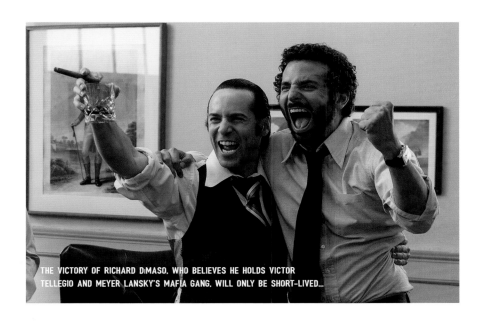

THE VICTORY OF RICHARD DiMASO, WHO BELIEVES HE HOLDS VICTOR TELLEGIO AND MEYER LANSKY'S MAFIA GANG, WILL ONLY BE SHORT-LIVED...

LEAD ACTORS: CHRISTIAN BALE (IRVING ROSENFELD), AMY ADAMS (SYDNEY PROSSER), BRADLEY COOPER (RICHARD "RICHIE" DIMASO), JENNIFER LAWRENCE (ROSALYN ROSENFELD), JEREMY RENNER (CARMINE POLITO) / DIALOGUE: DAVID O. RUSSELL, ERIC WARREN SINGER / MUSIC: DANNY ELFMAN / DURATION: 138 MINUTES / CATEGORY: GAMBLING MAFIA AND CORRUPTION / AWARDS: TEN OSCAR NOMINATIONS, A GOLDEN GLOBE FOR BEST SUPPORTING ACTRESS TO JENNIFER LAWRENCE. / TRIVIA: DUKE ELLINGTON'S "JEEP'S BLUES" IS THE TUNE PLAYING WHEN IRVING AND SYDNEY MEET. IT PUNCTUATES THEIR PASSIONATE RELATIONSHIP THROUGHOUT THE FILM. IT IS ALSO THE MUSIC OF THE FINAL CREDITS.

VICTOR (COLIN FARRELL) AND BEATRICE (NOOMI RAPACE) OBSERVE THE MAN WHO RUINED BEATRICE'S LIFE.

ALPHONSE (TERRENCE HOWARD) LIQUIDATES A DRUG DEALER HE BELIEVES IS INVOLVED IN THE MURDER OF HIS MEN.

DEAD MAN DOWN

UNITED STATES, 2013
DIRECTOR: NIELS ARDEN OPLEV

Victor (Colin Farrell), a taciturn man, works for Alphonse Hoyt (Terrence Howard), a New York mobster involved in shady real estate transactions. Members of Alphonse's gang are regularly killed by a mysterious avenger who sends fragments of photos as the only explanation. One day, Victor sees a female neighbor watching him through the window of her apartment. They wave at each other and end up meeting: Beatrice (Noomi Rapace) is a former beautician of French origin who was partially disfigured in a car accident. She has filmed Victor without his knowledge while he was strangling one of his former colleagues. For the price of her silence, Beatrice asks him to murder the man who caused her accident, an alcoholic who only spent three months in prison. As they develop feelings for each other, Beatrice understands that Victor hides a terrible secret: his three-year-old daughter was killed by Alphonse and his men and his wife by Albanians in their employ. He himself miraculously survived and infiltrated the gang to patiently plot the revenge that would fall on them.

201

THE FINAL SCENE: VICTOR AND BEATRICE CAN FINALLY OVERCOME THE SHADOWS OF THEIR RESPECTIVE PASTS.

LEAD ACTORS: COLIN FARRELL (VICTOR), NOOMI RAPACE (BEATRICE), TERRENCE HOWARD (ALPHONSE HOYT), DOMINIC COOPER (DARCY), ISABELLE HUPPERT (BEATRICE'S MOTHER), JAMES BIBERI (ILIR) / DIALOGUE: J.H. WYMAN / MUSIC: JACOB GROTH / DURATION: 118 MINUTES / CATEGORY: REVENGE

SERGEANT O'MARA (JOSH BROSLIN) AND HIS TEAM PREPARE
A RAID AGAINST A FACILITY HELD BY MICKEY COHEN.

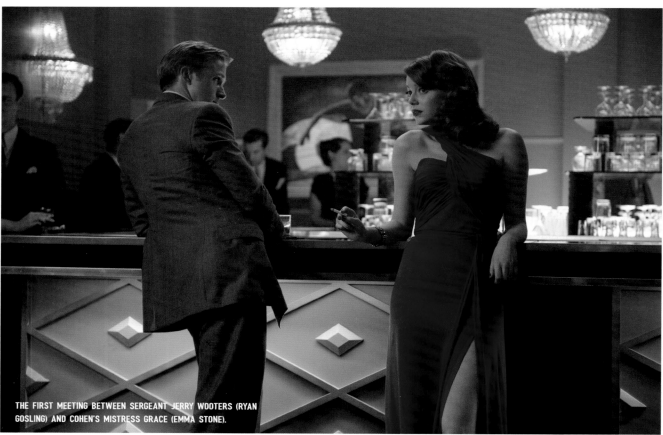

THE FIRST MEETING BETWEEN SERGEANT JERRY WOOTERS (RYAN
GOSLING) AND COHEN'S MISTRESS GRACE (EMMA STONE).

LEAD ACTORS: JOSH BROLIN (SERGEANT JOHN O'MARA), SEAN PENN (MICKEY COHEN), RYAN GOSLING (SERGEANT JERRY WOOTERS), EMMA STONE (GRACE), MIREILLE ENOS (CONNIE O'MARA), GIOVANNI RIBISI (DETECTIVE CONWELL KEELER), NICK NOLTE (BILL PARKER) / DIALOGUE: WILL BEAL, BASED ON PAUL LIEBERMAN'S NOVEL *TALES FROM THE GANGSTER SQUAD* / MUSIC: STEVE JABLONSKI / DURATION: 113 MINUTES / CATEGORIES: GANG BUSTING, LOS ANGELES MAFIA

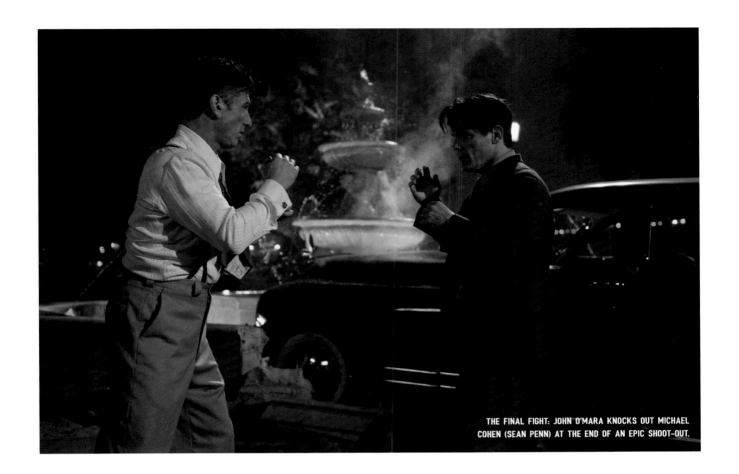

THE FINAL FIGHT: JOHN O'MARA KNOCKS OUT MICHAEL COHEN (SEAN PENN) AT THE END OF AN EPIC SHOOT-OUT.

GANGSTER SQUAD

UNITED STATES, 2013
DIRECTOR: RUBEN FLEISCHER

In the late 1940s, former boxer Mickey Cohen ruled Los Angeles. Politicians, judges and police officers were in his employ, and his extremely brutal methods brought terror to the community. As Cohen plans to take control of all gambling west of Chicago, Police Chief Bill Parker instructs Sergeant John O'Mara (Josh Brolin) to assemble a small team of police officers of absolute integrity whose sole mission will be to bring Cohen down. In spite of the danger, O'Mara and his small team overcome the odds and shake the almighty godfather. However, Cohen is determined to keep his hand in and make them pay a high price for the raids on the establishments he runs.

The power struggle claims victims on both sides. In his vengeful madness, Cohen even tries to target his girlfriend, Grace (Emma Stone), who, unbeknownst to him, is having a secret love affair with one of the brains of O'Mara's team. It is Grace who eventually agrees to testify against Cohen and precipitates his downfall.

All the ingredients which made the success of *The Untouchables* can be found in the movie's breathtaking plot: an ambitious and violent gangster facing a small group of police officers with maverick methods, in an atmosphere worthy of James Ellroy's novels.

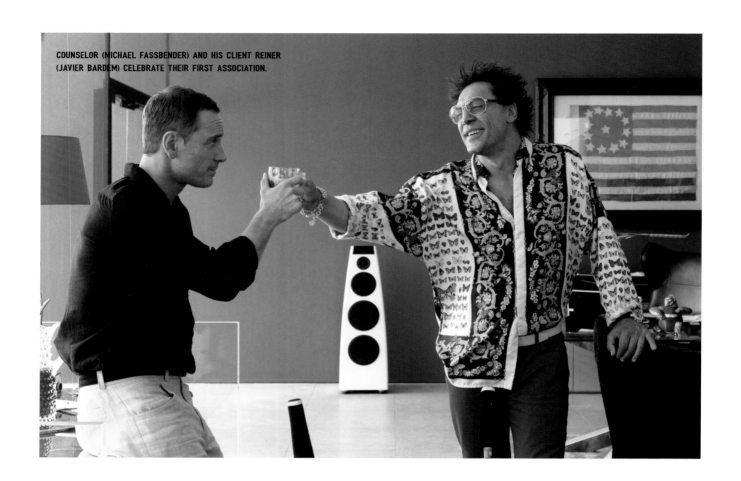

COUNSELOR (MICHAEL FASSBENDER) AND HIS CLIENT REINER (JAVIER BARDEM) CELEBRATE THEIR FIRST ASSOCIATION.

THE COUNSELOR

UNITED STATES, GREAT BRITAIN, 2013
DIRECTOR: RIDLEY SCOTT

The Counselor (his name will never be heard) is a happy man: he does a lucrative business defending drug smugglers and lives with the lovely Laura (Penelope Cruz) whom he wants to marry. One of his clients, Reiner (Javier Bardem), offers him a partnership in the sale of a cocaine shipment that must be delivered soon from Mexico to Chicago. He sends the Counselor to meet Westray (Brad Pitt), one of his accomplices, who warns the novice against the violence of the cartels while promising him a fairytale-like return on his investment. Attracted by easy money, the counselor accepts without thinking twice, but the smoothly running scheme suddenly gets out of control: Malkina (Cameron Diaz), Reiner's girlfriend, has been listening to the conversations and decides to steal the cargo for her own profit. The gangster who carries the key to the truck is killed on her order, and the key stolen. As the Counselor had the same gangster released after being arrested for speeding a few days before, the cartel suspects the lawyer of having arranged the murder. Laura is kidnapped, Reiner is shot, Westray is on the run, and the Counselor finds himself alone in front of the cartel. Meanwhile, Malkina, who got rid of Reiner, manages to gain access to Westray's bank accounts and has him eliminated.

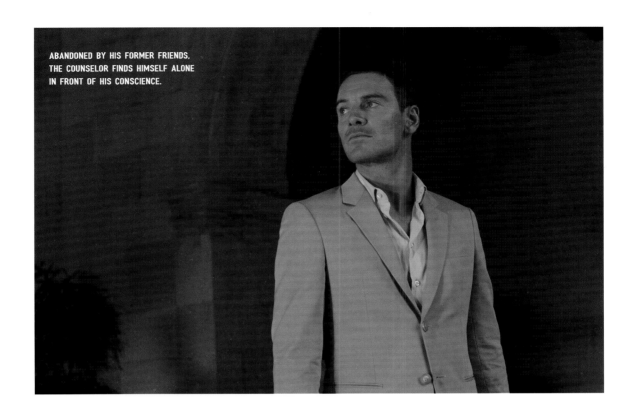

ABANDONED BY HIS FORMER FRIENDS, THE COUNSELOR FINDS HIMSELF ALONE IN FRONT OF HIS CONSCIENCE.

MALKINA (CAMERON DIAZ), REINER'S GIRLFRIEND, WATCHES HER JAGUARS HUNT HARE IN THE DESERT.

LEAD ACTORS: MICHAEL FASSBENDER (THE COUNSELOR), PÉNÉLOPE CRUZ (LAURA), CAMERON DIAZ (MALKINA), JAVIER BARDEM (REINER), BRAD PITT (WESTRAY) / DIALOGUE: CORMAC MCCARTHY / MUSIC: DANIEL PEMBERTON / DURATION: 117 MINUTES / CATEGORIES : DRUG TRAFFICKING, MEXICAN CARTELS

NICK (JOSH HUTCHERSON)
A NAIVE CANADIAN SURFER
ARRIVES WITH HIS BROTHER
IN COLOMBIA.

MARIA (CLAUDIA TRAISAC),
WITH WHOM NICK FALLS IN
LOVE AT FIRST SIGHT.

PABLO ESCOBAR (BENICIO DEL TORO) AS A BENEFACTOR
OF COLOMBIA'S POOR PEOPLE.

ESCOBAR: PARADISE LOST

BELGIUM, FRANCE, PANAMA, SPAIN, 2014
DIRECTOR: ANDREA DI STEFANO

Nick (Josh Hutcherson), a young and slightly idealistic Canadian surfer, accompanies his brother Dylan to Colombia where they dream of opening a surfing school on the Pacific coast. As soon as he settles in, Nick meets Maria (Claudia Traisac), a young woman whose uncle is none other than Pablo Escobar (Benicio del Toro), the powerful godfather of the Medellin cartel. They fall in love, and Maria introduces Nick to her family. However, when small-time thugs who tried to extort the Canadians are burned alive and hanged, Nick realizes what Maria's kinship with Pablo Escobar implies. But it is already too late to escape the grip of the "Boss".

Two destinies from opposite worlds intersect in the plot imagined by Andrea Di Stefano; that of Nick, a carefree, young man caught up in a story that is beyond him, and that of Pablo Escobar as Nick gradually discovers him. A man who is generous and implacable, caring and cynical, simple and megalomaniacal. If Nick's character is purely fictional, Pablo Escobar's real character is portrayed in all its grandeur and madness.

LEAD ACTORS: JOSH HUTCHERSON (NICK "NICO" BRADY), BENICIO DEL TORO (PABLO ESCOBAR), CLAUDIA TRAISAC (MARIA), BRADY CORBET (DYLAN BRADY, NICK'S BROTHER), ANA GIRARDOT (ANNE, NICK'S SISTER-IN-LAW) / DIALOGUE: ANDREA DI STEFANO / MUSIC: MAX RICHTER / DURATION: 120 MINUTES / CATEGORIES: NARCO-BANDITISM, CARTELS
TRIVIA: JOSH HUTCHERSON AND CLAUDIA TRAISAC, WHO MET ON THE SET OF THE FILM WHERE THEY PLAY THE COUPLE NICK-MARIA, HAVE BEEN LIVING TOGETHER SINCE THEN.

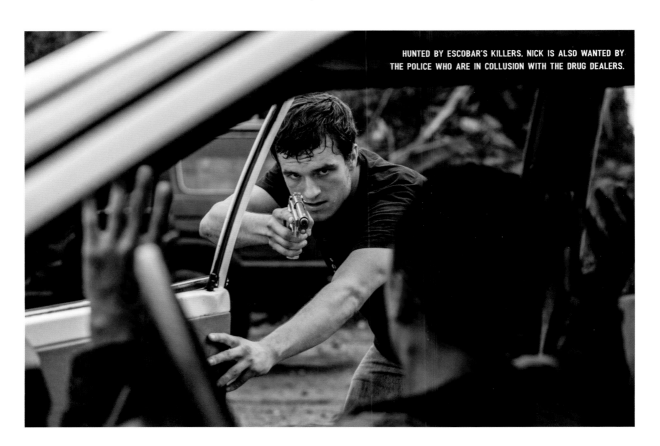

HUNTED BY ESCOBAR'S KILLERS, NICK IS ALSO WANTED BY THE POLICE WHO ARE IN COLLUSION WITH THE DRUG DEALERS.

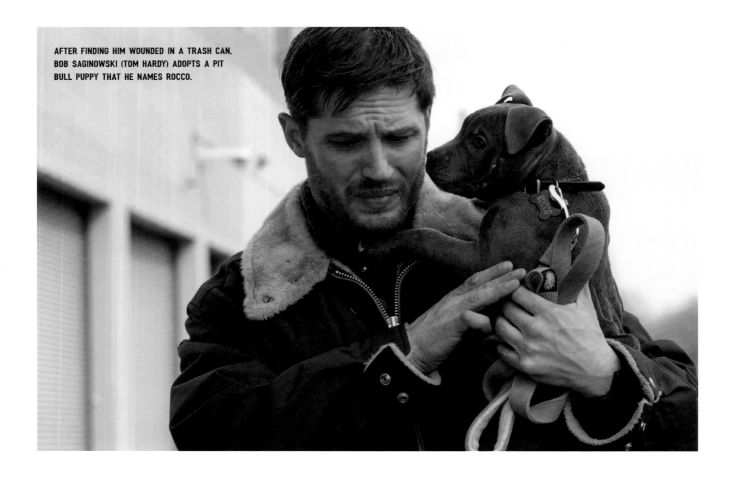

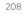

THE DROP

UNITED STATES, 2014
DIRECTOR: MICHAËL R. ROSKAM

Bob Saginowski (Tom Hardy) is a taciturn and apparently quiet young man working in a bar run by his cousin Marv (James Gandolfini). His discovery of a wounded pit bull puppy in a garbage can, his encounter with Nadia (Noomi Rapace) and the raid on the bar by a group of masked bandits break up the peaceful life Bob had built for himself. He suddenly has to face demons from the past and the pressures of the Chechen clan that controls the bar. Tension rises again when the mafia decides to use the bar as a night depository for their illegal takings and his cousin Marv proposes a robbery to get hold of the loot.

Michaël R. Roskam succeeds in transforming small incidents into a breathless intrigue that quickly draws the viewer in. The hero's melancholic character gradually gives way to a firm and determined personality, as if the presence of Rocco, the pit bull he adopted, gives him new self-confidence. A brilliant gallery of supporting roles, including those played by John Ortiz (Detective Torres), Matthias Schoenaerts (Eric Deeds) and Michael Aronov (Chovka the Chechen) add depth to the film. Cousin Marv was James Gandolfini's last role in a movie.

WHAT ANCIENT STORY LINKS BOB TO HIS COUSIN MARV (JAMES GANDOLFINI)?

209

LEAD ACTORS: TOM HARDY (BOB SAGINOWSKI), NOOMI RAPACE (NADIA DUNN), JAMES GANDOLFINI
(COUSIN MARV STIPLER), JOHN ORTIZ (DETECTIVE EVANDRO TORRES), MATTHIAS SCHOENAERTS (ERIC DEEDS),
MICHAEL ARONOV (CHOVKA THE CHECHEN) / DIALOGUE: DENNIS LEHANE / MUSIC: MARCO BELTRAMI /
DURATION: 106 MINUTES / CATEGORY: CHECHEN MAFIA IN AMERICA, HEIST, MONEY LAUNDERING
TRIVIA: THE PLOT WAS LARGELY INSPIRED BY ANIMAL RESCUE, A SHORT STORY BY DENNIS LEHANE.
LEHANE ACTUALLY WROTE THE SCREENPLAY FOR THE FILM.

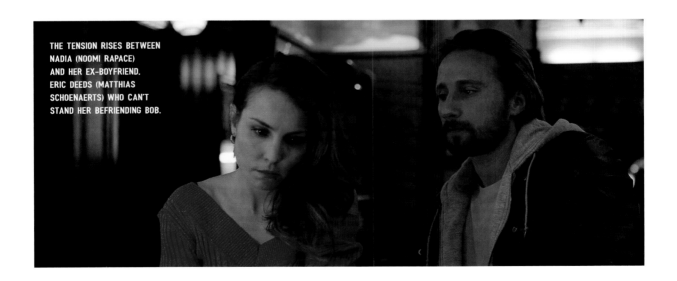

THE TENSION RISES BETWEEN
NADIA (NOOMI RAPACE)
AND HER EX-BOYFRIEND.
ERIC DEEDS (MATTHIAS
SCHOENAERTS) WHO CAN'T
STAND HER BEFRIENDING BOB.

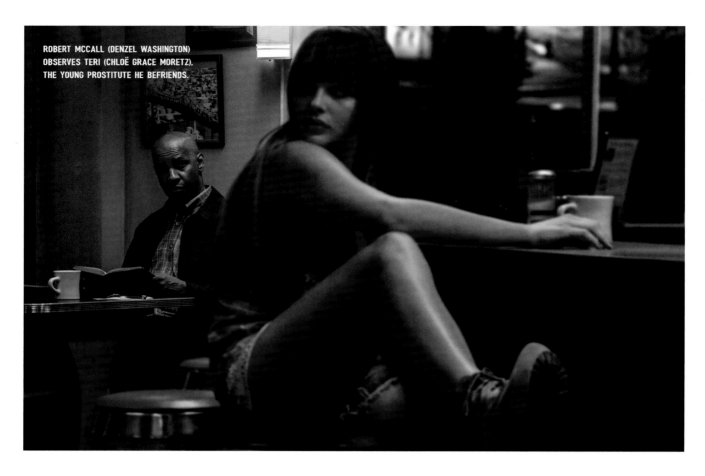

ROBERT MCCALL (DENZEL WASHINGTON)
OBSERVES TERI (CHLOË GRACE MORETZ),
THE YOUNG PROSTITUTE HE BEFRIENDS.

LEAD ACTORS: DENZEL WASHINGTON (ROBERT MCCALL), CHLOË GRACE MORETZ (TERI/ALINA), DAVID MEUNIER (SLAVI), JOHNNY SKOURTIS (RALPHIE), MARTON CSOKAS (TEDDY RENSEN/NIKOLAI ITCHENKO) / DIALOGUE: RICHARD WENK, LOOSELY BASED ON THE 1980S SERIES OF THE SAME NAME WRITTEN BY RICHARD LINDHEIM AND MICHAEL SLOAN / MUSIC: HARRY GREGSON-WILLIAMS / DURATION: 132 MINUTES / CATEGORIES: VIGILANTE, RUSSIAN MAFIA, DIRTY COPS

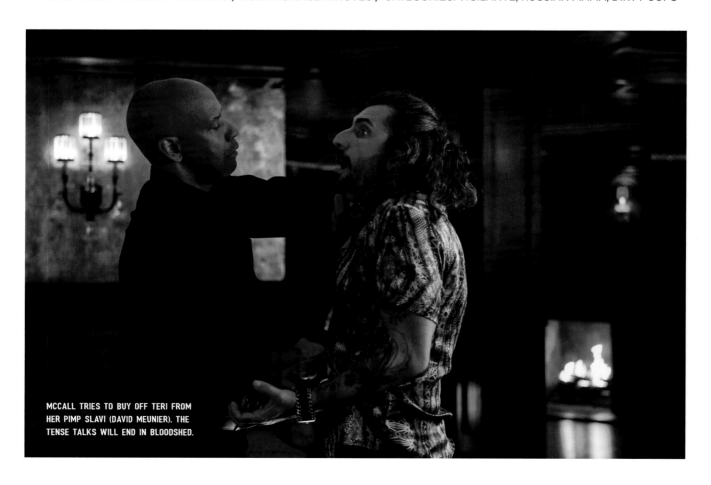

MCCALL TRIES TO BUY OFF TERI FROM
HER PIMP SLAVI (DAVID MEUNIER). THE
TENSE TALKS WILL END IN BLOODSHED.

THE EQUALIZER

UNITED STATES, 2014
DIRECTOR: ANTOINE FUQUA

Robert McCall (Denzel Washington) is a quiet and amiable man who works a low-level job at a building supply store. An insomniac widower, he spends his nights reading novels at a diner near his home to escape memories from his past life as a Secret Service agent. His meeting with a young Russian prostitute, Teri (Chloë Grace Moretz), who is controlled by a violent pimp, will lead him to return to service. Following his instincts to track down the exploiter he kills Slavi (David Meunier), the pimp who had badly beaten Teri. McCall goes on to kill the mafia thugs on his heels one after the other, including a prominent Russian godfather whom he manages to electrocute while the latter is taking a bath in a sumptuous residence near Moscow. At the same time, McCall helps one of his young colleagues, Ralphie, pass the security guard exam while knocking out dirty cops who were trying to extort money from Ralphie's mother, the owner of a pizzeria. Having regained a taste for action, and despite the promise he made to his late wife to leave his former life forever, McCall places a small ad in the local newspaper inviting all victims of injustice to contact him as a vigilante. He signs it as "the Equalizer".

211

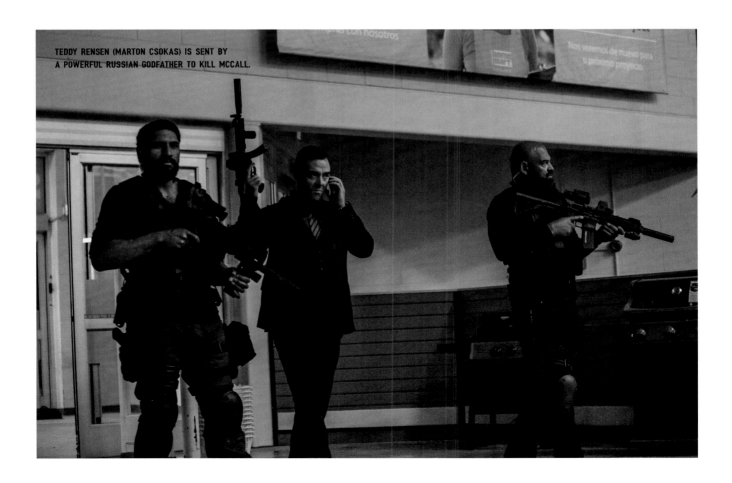

TEDDY RENSEN (MARTON CSOKAS) IS SENT BY A POWERFUL RUSSIAN GODFATHER TO KILL MCCALL.

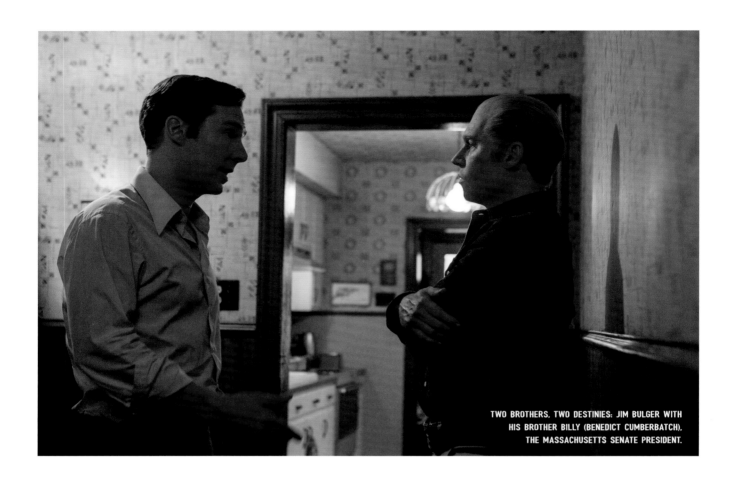

TWO BROTHERS, TWO DESTINIES: JIM BULGER WITH HIS BROTHER BILLY (BENEDICT CUMBERBATCH), THE MASSACHUSETTS SENATE PRESIDENT.

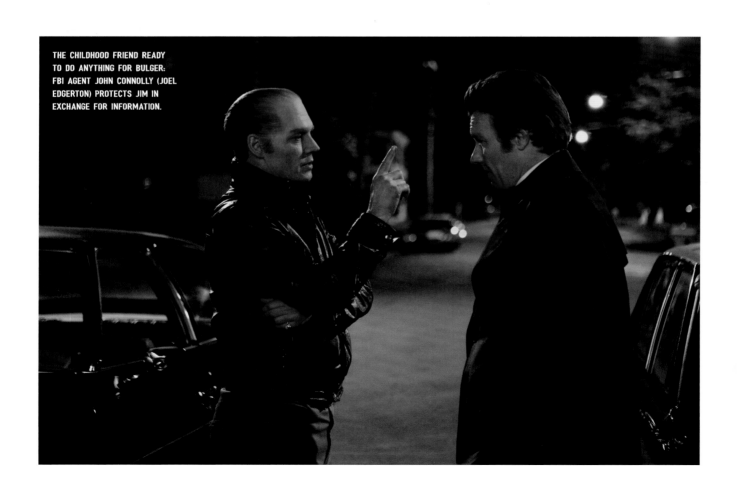

THE CHILDHOOD FRIEND READY TO DO ANYTHING FOR BULGER: FBI AGENT JOHN CONNOLLY (JOEL EDGERTON) PROTECTS JIM IN EXCHANGE FOR INFORMATION.

BLACK MASS

UNITED STATES, 2014
DIRECTOR: SCOTT COOPER

In the mid-1970s, James "Whitey" Bulger (Johnny Depp) was the undisputed godfather of South Boston, the city's Irish neighborhood. But the FBI's attention was focussed on another criminal gang, the Angiulo Brothers, a gang affiliated with the powerful East Coast Italian American mafia, who were actively trying to encroach on Bulger's territory. Bulger's childhood friend and police officer, John Connolly (Joel Edgerton), took advantage of the situation to propose an alliance to Bulger: if he agreed to provide information that could be used against the Angiulo brothers, the FBI would turn a blind eye to his activities. This unnatural alliance was tacitly supported by Billy Bulger (Benedict Cumberbatch), Jim's brother, who was the Massachusetts Senate President. Although initially reluctant to be used as a rat, Jim Bulger saw an opportunity to get the drop on his rivals and he helped to arrest them. Shocked by this success, which benefited his career, John Connolly agreed, in the name of their friendship, to cover up all the crimes committed by Bulger and his men. Thanks to this protection, and with the help of corrupt police officers, Connolly extended his grip on the city until a new assistant prosecutor known for his toughness, Fred Wyshak (Corey Stoll), came to restore order in the city. The seizure of an arms shipment destined for the

IRA by a customs patrol was the first step leading to the downfall of Bulger and those who had naively supported him.

Inspired by real events, the film plunges the reader into the heydays of the Irish mafia. Johnny Depp, unrecognizable in the guise of Jim Bulger, brilliantly plays the role of a gangster who is as relentless as he is ambitious.

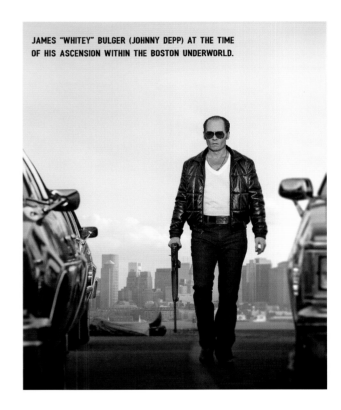

JAMES "WHITEY" BULGER (JOHNNY DEPP) AT THE TIME OF HIS ASCENSION WITHIN THE BOSTON UNDERWORLD.

213

LEAD ACTORS: JOHNNY DEPP (JAMES J. "WHITEY" BULGER), BENEDICT CUMBERBATCH (BILLY BULGER), JOEL EDGERTON (JOHN CONNOLLY), KEVIN BACON (AGENT CHARLES MCGUIRE), COREY STOLL (FRED WYSHAK), JESS PLEMONS (KEVIN WEEKS), RORY COCHRANE (STEPHEN FLEMMI) / DIALOGUE: MARK MALLOUK, JEZ BUTTERWORTH BASED ON THE NOVEL *BLACK MASS: THE TRUE STORY OF AN UNHOLY ALLIANCE BETWEEN THE FBI AND THE IRISH MOB* BY DICK LEHR AND GERARD O'NEILL / MUSIC: JUNKIE XL (TOM HOLKENBORG) / DURATION: 123 MINUTES / CATEGORIES: BIOPIC, HISTORICAL NARRATIVE, IRISH MAFIA IN BOSTON, LINKS BETWEEN POLICE AND MAFIA

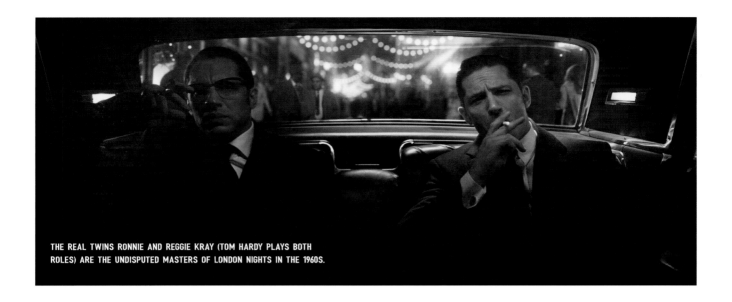

THE REAL TWINS RONNIE AND REGGIE KRAY (TOM HARDY PLAYS BOTH
ROLES) ARE THE UNDISPUTED MASTERS OF LONDON NIGHTS IN THE 1960S.

214

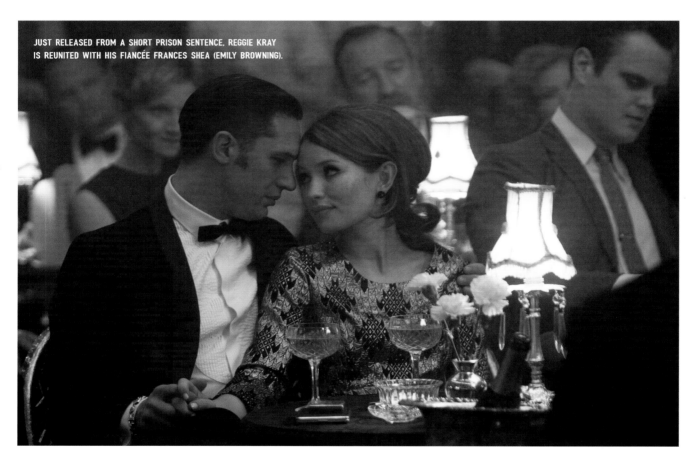

JUST RELEASED FROM A SHORT PRISON SENTENCE, REGGIE KRAY
IS REUNITED WITH HIS FIANCÉE FRANCES SHEA (EMILY BROWNING).

LEAD ACTORS: TOM HARDY (RONALD "RONNIE" AND REGINALD "REGGIE" KRAY), EMILY BROWNING
(FRANCES SHEA-KRAY), DAVID THEWLIS (LESLIE PAYNE), CHAZZ PALMINTERI (ANGELO BRUNO), PAUL ANDERSON
(ALBERT DONOGHUE), CHRISTOPHER ECCLESTON (DETECTIVE LEONARD "NIPPER" READ) /
DIALOGUE: BRIAN HELGELAND BASED ON JOHN PEARSON'S BOOK *THE PROFESSION OF VIOLENCE* /
MUSIC: CARTER BURWELL / DURATION: 132 MINUTES / CATEGORIES: BIOPIC, HISTORICAL ACCOUNT

LEGEND

FRANCE, UNITED KINGDOM, UNITED STATES, 2015
DIRECTOR: BRIAN HELGELAND

Ronnie and Reggie Kray (both played by Tom Hardy) are two legends of the sixties. The real twins from London's working-class East End reigned unchallenged from the late 1950s to 1968. These legendary gangsters received celebrities in their nightclubs who came to mingle with the underworld and built up an empire of casinos and discos with methods as brutal as they were effective, to the point that they were even admired by the American mafia. The film traces their rise and fall as seen by Frances Shea (Emily Browning), Reggie Kray's girlfriend whom he married in 1965. The inseparable Kray brothers will gradually grow apart from each other: Ronnie, unstable and subject to murderous outbursts of

rage, does not understand that Reggie is trying to settle with the outside world. Blood ties are stretched to the limit when Ronnie decides to eliminate Leslie Payne (David Thewlis), the business lawyer who has taken care of their fortune. It's the one conflict too many that will lead to their downfall.

Tom Hardy brilliantly plays two opposite personalities: Ronnie, the fragile psychopath, and Reggie, the charmer who is torn between his affection for his brother and his sense of reality.

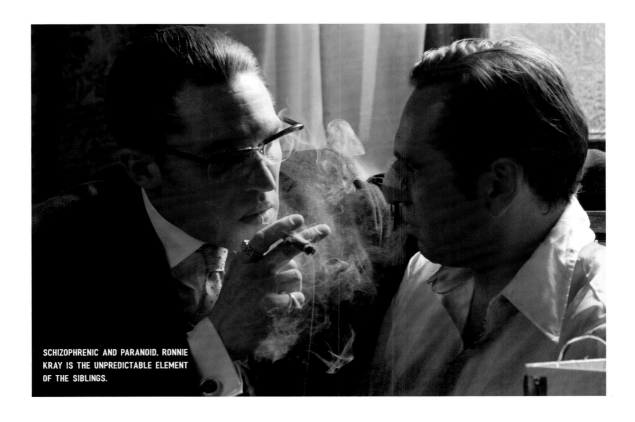

SCHIZOPHRENIC AND PARANOID, RONNIE KRAY IS THE UNPREDICTABLE ELEMENT OF THE SIBLINGS.

A MACABRE DISCOVERY: CORPSES WALLED UP BY DRUG DEALERS.

IN A SECRET TUNNEL THAT SERVES AS A PASSAGE FOR DRUGS BETWEEN MEXICO AND THE UNITED STATES.

LEAD ACTORS: EMILY BLUNT (KATE MACER), BENICIO DEL TORO (ALEJANDRO GILLICK), JOSH BROLIN (MATT GRAVER),
DANIEL KALUUYA (REGGIE WAYNE), MAXIMILIANO HERNÁNDEZ (SILVIO) / DIALOGUE: TAYLOR SHERIDAN /
MUSIC: JÓHANN JÓHANNSSON / DURATION: 121 MINUTES / CATEGORIES: DRUG TRAFFICKING, MEXICAN CARTELS
AWARDS: THREE OSCAR NOMINATIONS, ONE FOR THE PALME D'OR AT THE CANNES FILM FESTIVAL.

SICARIO

MEXICO, UNITED STATES, 2015
DIRECTOR: DENIS VILLENEUVE

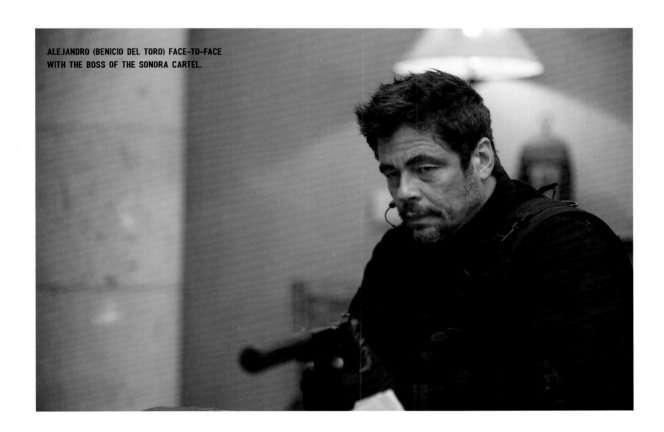

ALEJANDRO (BENICIO DEL TORO) FACE-TO-FACE
WITH THE BOSS OF THE SONORA CARTEL.

As a young FBI recruit, Kate Macer (Emily Blunt) takes part in a raid on a hideout used by Mexican drug dealers in Chandler, southern Arizona. Kate and her colleague Reggie Wayne (Daniel Kaluuya) make a macabre discovery: dozens of decomposing corpses are walled up, all victims of the war between the cartels. The operation is interrupted, however, by the explosion of a booby-trapped device abandoned by the dealers, killing several of the agents.

Shortly afterwards, Kate is offered a new secret mission to dismantle the Sonora cartel. She brings together a group of CIA agents and former soldiers to go and find one of the cartel's barons across the border, a high-risk expedition that results in the death of several thugs. Kate begins to question the legality of the methods employed by the team's coordinator, Matt Graver (Josh Brolin), and by the mysterious consultant leading the operation, Alejandro (Benicio del Toro). When they let another drug baron get away after a money laundering attempt, Kate must choose between her principles and the goal of the mission: the gangster will lead them to the cartel boss, with whom Alejandro has an old score to settle. The assault on a tunnel used by drug traffickers will bring even more surprises...

SUBURRA

FRANCE, ITALY, 2015
DIRECTOR: STEFANO SOLLIMA

During the first days of November 2011, Rome is in a state of turmoil: the pope is thinking of retiring, the IMF announces that Italy is in a critical financial situation and the government is going through a major political crisis. All this, however, does not prevent politicians from getting involved in the most dubious shenanigans, nor does it prevent the mafia from considering transforming the Ostia waterfront into a replica of Las Vegas with the discreet financial support of the Vatican.

A member of parliament above suspicion, Filippo Malgradi (Pierfrancesco Favino) has sex in a hotel with two prostitutes, but one of them, a minor, dies of an overdose in the room. The second call girl, Sabrina (Giulia Elettra Gorietti) calls a young gangster from the Anacleti family, Alberto "Spadino" (Giacomo Ferrara) to get rid of the corpse. Spadino recognizes the politician who was exiting the room, and tries shortly afterwards to blackmail him. Worried about the consequences, Malgradi asks a friend to find the gangster and

teach him a lesson: unfortunately, the task is given to the fiery boss of a rival clan, Aureliano "Number 8", who kills Alberto. A war between rival gangs seems inevitable. Only the intervention of the highly respected Samurai, a gangster boss representing the interests of the major Roman families, succeeds in restoring peace and saving the real estate project.

Meanwhile, Sabrina the call girl has found refuge with a friend, Sebastiano (Elio Germano) who has had a falling out with the Anacleti clan, unaware that Manfredi Anacleti, the clan's boss, is working on a plan to avenge the death of his little brother.

Stefano Sollima takes us to the heart of Rome's underworld where alliances between the city's masters are made and broken. He offers a dark, but lucid vision of the corrupt Roman elite.

LEAD ACTORS: PIERFRANCESCO FAVINO (MEMBER OF PARLIAMENT FILIPPO MALGRADI), CLAUDIO ARMENDOLA (SAMURAI), ALESSANDRO BORGHI (AURELIANO "NUMBER 8"), GRETA SCARANO (VIOLA, AURELIANO'S GIRLFRIEND), GIULIA ELETTRA GORIETTI (SABRINA, THE CALL GIRL), ADAMO DIONISI (MANFREDI ANACLETI), GIACOMO FERRARA (ALBERTO "SPADINO" ANACLETI), ELIO GERMANO (SEBASTIANO) / DIALOGUE: GIANCARLO DE CATALDO, SANDRO PETRAGLIA, STEFANO RULLI, BASED ON THE DETECTIVE NOVEL OF THE SAME NAME BY CARLO BONINI / MUSIC: PASQUALE CATALANO / DURATION: 130 MINUTES / CATEGORIES: MAFIA AND POLITICS, ROMAN MAFIA

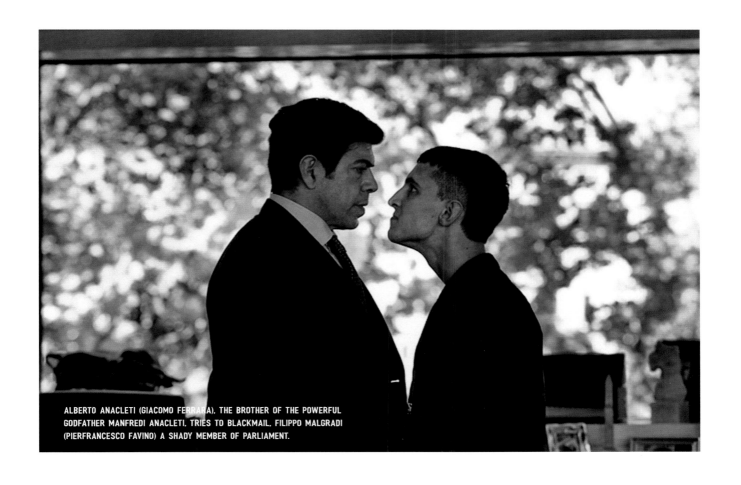

ALBERTO ANACLETI (GIACOMO FERRARA), THE BROTHER OF THE POWERFUL GODFATHER MANFREDI ANACLETI, TRIES TO BLACKMAIL, FILIPPO MALGRADI (PIERFRANCESCO FAVINO) A SHADY MEMBER OF PARLIAMENT.

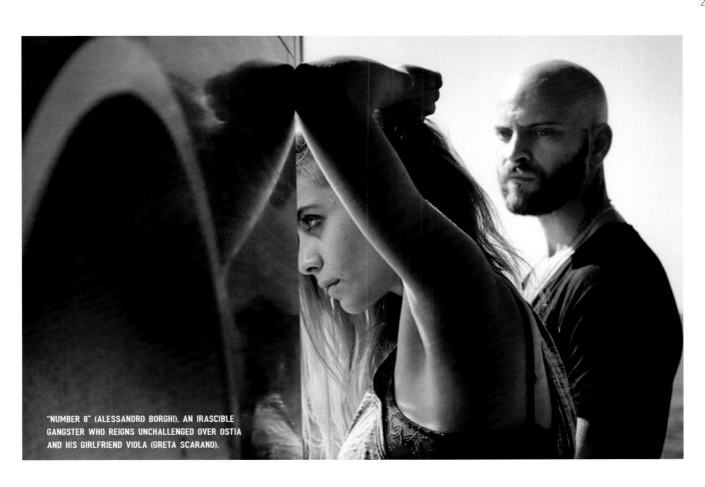

"NUMBER 8" (ALESSANDRO BORGHI), AN IRASCIBLE GANGSTER WHO REIGNS UNCHALLENGED OVER OSTIA AND HIS GIRLFRIEND VIOLA (GRETA SCARANO).

LIVE BY NIGHT

UNITED STATES, 2016
DIRECTOR: BEN AFFLECK

Haunted by his memories of the First World War, Joe Coughlin (Ben Affleck) decides he will never obey anyone again. He leads the life of an outlaw in 1920s Boston, much to the annoyance of his father, who is a deputy chief of police. With the help of his accomplice Dion Bartolo (Chris Messina), Coughlin organizes hold-ups, and raids the establishments run by Albert White (Robert Glenister), one of Boston's barons of the underworld. Worse still, Coughlin seduces White's mistress, Emma (Sienna Miller). Rumors of their affair reach the ears of Maso Pescatore (Remo Girone), the godfather of the Italian mafia. Pescatore tries to blackmail Coughlin and force him to kill White. Joe and Emma decide to flee to California, but White also gets wind of their affair: he lures Coughlin into a trap set with the complicity of Emma and delivers him to the police who are hunting him for the murder of three policemen during a car chase: the death penalty seems certain. Joe's father nevertheless manages to use his influence and the sentence is reduced: three years in prison and twenty years suspended.

After serving his sentence, Joe Coughlin agrees to join forces with Maso Pescatore to get revenge against White. He is sent to Florida, where White has settled, to supervise illegal rum production, and develop Pescatore's business there. As soon as he disembarks from the train, he meets Graciella Suarez (Zoe Saldana), a Cuban woman who, along with her brother, manages the supply of raw materials to the clandestine distilleries. Love at first sight is mutual and business flourishes. But White, still at war with Pescatore, sends Klu Klux Klan members to attack Coughlin's hidden bars. In spite of his growing disgust for violence, Coughlin must quickly get rid of these new enemies by force, all the more so as a gigantic casino project is capturing his and Pescatore's full attention. Nothing seems to stand in the way of Coughlin's plans any longer, but trouble is about to erupt unexpectedly...

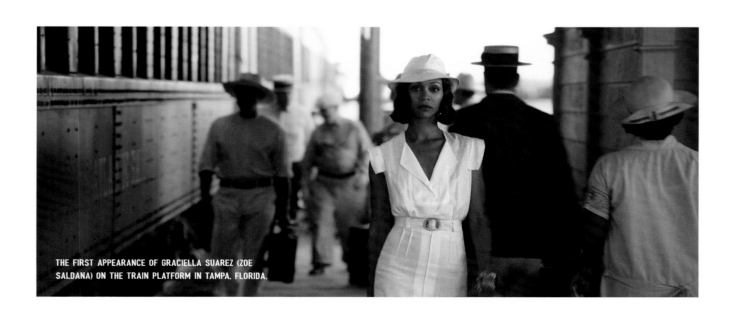

THE FIRST APPEARANCE OF GRACIELLA SUAREZ (ZOE SALDANA) ON THE TRAIN PLATFORM IN TAMPA, FLORIDA.

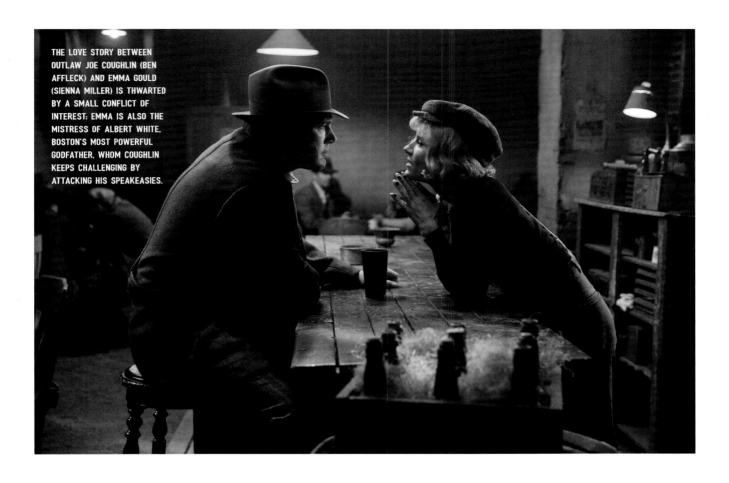

THE LOVE STORY BETWEEN OUTLAW JOE COUGHLIN (BEN AFFLECK) AND EMMA GOULD (SIENNA MILLER) IS THWARTED BY A SMALL CONFLICT OF INTEREST: EMMA IS ALSO THE MISTRESS OF ALBERT WHITE, BOSTON'S MOST POWERFUL GODFATHER, WHOM COUGHLIN KEEPS CHALLENGING BY ATTACKING HIS SPEAKEASIES.

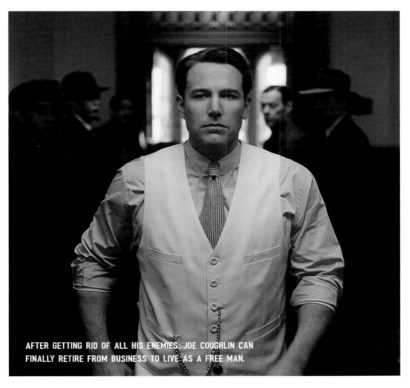

AFTER GETTING RID OF ALL HIS ENEMIES, JOE COUGHLIN CAN FINALLY RETIRE FROM BUSINESS TO LIVE AS A FREE MAN.

LEAD ACTORS: BEN AFFLECK (JOE COUGHLIN), CHRIS MESSINA (DION BARTOLO), ZOE SALDANA (GRACIELLA SUAREZ-COUGHLIN), SIENNA MILLER (EMMA GOULD), CHRIS COOPER (SHERIFF IRVING FIGGIS), ELLE FANNING (LORETTA FIGGIS), REMO GIRONE (MASO PESCATORE), ROBERT GLENISTER (ALBERT WHITE), MATTHEW MAHER (RD PRUITT), BRENDAN GLEESON (THOMAS COUGHLIN) / DIALOGUE: BEN AFFLECK, BASED ON THE NOVEL OF THE SAME NAME BY DENNIS LEHANNE / MUSIC: HARRY GREGSON-WILLIAMS / DURATION: 129 MINUTES / CATEGORIES: BOSTON MAFIA, PROHIBITION IN FLORIDA, SMUGGLING, REVENGE

THE CONNECTION

BELGIUM, FRANCE, 2016
DIRECTOR: CÉDRIC JIMENEZ

The Connection offers a highly fictionalized, but nevertheless thrilling, account of the merciless struggle at the end of the 1970s that pitted a former juvenile court judge Pierre Michel (Jean Dujardin) against Gaëtan Zampa (Gilles Lellouche), the Marseilles godfather of the French Connection.

A juvenile court judge from eastern France, Pierre Michel was promoted in Marseilles to fight drug traffickers who controlled the entire underground economy. Tenacious and intrepid, supported by a team that he led with intelligence, Pierre Michel quickly adapted to the reality of Marseilles. He delivered blow after blow to the underworld and shook up the untouchable mafia. This atypical magistrate worried not only Gaëtan Zampa and his lieutenants, but also the political establishment of the city as Michel's investigations questioned the links between mafia and local politics. From a tracker of criminals, Pierre Michel became a hunted man.

Despite some anachronisms noted by critics, the film skillfully recreates the atmosphere of Marseilles in the 1970s, with its clandestine laboratories, nightclubs and prostitution networks controlled by the French. Jean Dujardin and Gilles Lellouche perfectly embody the rivalry between two dominant and implacable men. *The Connection* is a classic and breath-taking gangster film. It avoids clichés about the lonely judge while raising the question of the links between politics and organized crime.

LEAD ACTORS: JEAN DUJARDIN (PIERRE MICHEL), GILLES LELLOUCHE (GAËTAN ZAMPA), BENOÎT MAGIMEL (LE FOU), CÉLINE SALLETTE (JACQUELINE MICHEL) / DIALOGUE: AUDREY DIWAN, CÉDRIC JIMENEZ / MUSIC: GUILLAUME ROUSSEL / DURATION: 135 MINUTES / CATEGORIES: BIOPIC, MARSEILLES MAFIA

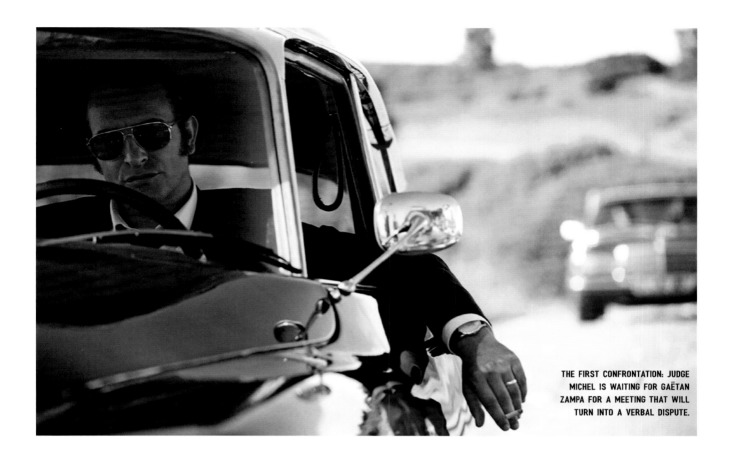

THE FIRST CONFRONTATION: JUDGE MICHEL IS WAITING FOR GAËTAN ZAMPA FOR A MEETING THAT WILL TURN INTO A VERBAL DISPUTE.

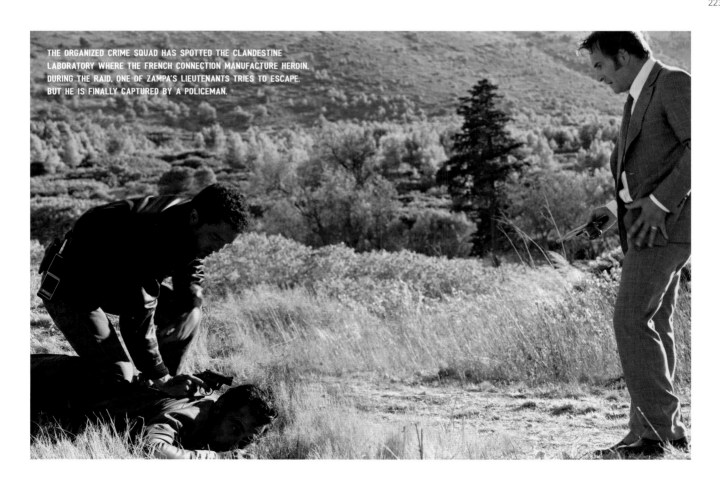

THE ORGANIZED CRIME SQUAD HAS SPOTTED THE CLANDESTINE LABORATORY WHERE THE FRENCH CONNECTION MANUFACTURE HEROIN. DURING THE RAID, ONE OF ZAMPA'S LIEUTENANTS TRIES TO ESCAPE. BUT HE IS FINALLY CAPTURED BY A POLICEMAN.

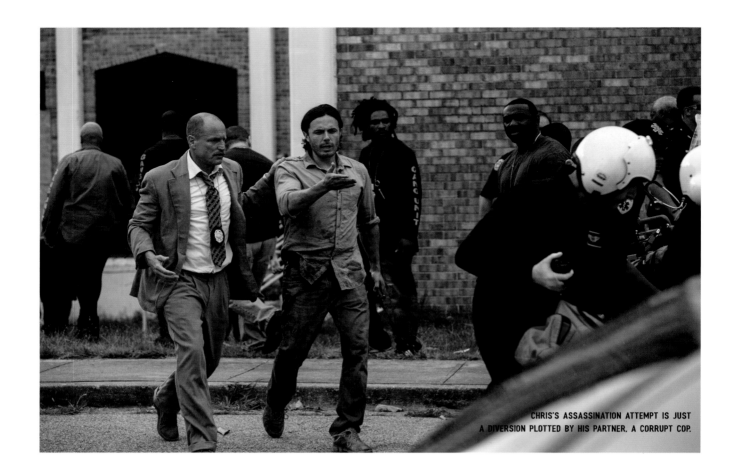

CHRIS'S ASSASSINATION ATTEMPT IS JUST
A DIVERSION PLOTTED BY HIS PARTNER. A CORRUPT COP.

TRIPLE 9

UNITED STATES, 2016
DIRECTOR: JOHN HILLCOAT

A group of veterans from the Special Forces recruited by the Atlanta Police Department commit several hold-ups on behalf of the Russian-Israeli mafia with whom one of them, Michael Atwood (Chiwetel Ejiofor), has family links. When the wife of the imprisoned mafia boss, Irina Vlaslov (Kate Winslet), demands an impossible mission from them, they know they have no choice but to try and steal sensitive documents from a hyper-secure Homeland Security bunker. The only way to achieve this would be to activate the 9-9-9 signal, which sends a message that a policeman is down. The signal mobilizes all the units present, and their hope is that entire police force will be distracted enough not to respond to the heist

alarm. The police officer they select to shoot to activate triple 9 seems to be a perfect match: a young policeman with integrity, Chris Allen (Casey Affleck) who has just joined Atwood's brigade. But officer Allen proves to be too smart, and he enjoys the protection of his uncle, Jeff (Woody Harrelson), an experienced policeman who knows the underbelly of the city like the back of his hand. While the entire department comes to Chris's rescue as he is being hunted by a drug dealer, the dirty cops are on the run. But success is still a long way off, and Chris hasn't had his last word yet.

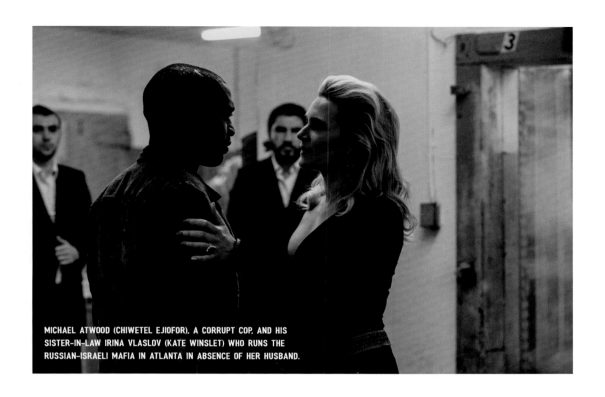

MICHAEL ATWOOD (CHIWETEL EJIOFOR), A CORRUPT COP, AND HIS
SISTER-IN-LAW IRINA VLASLOV (KATE WINSLET) WHO RUNS THE
RUSSIAN-ISRAELI MAFIA IN ATLANTA IN ABSENCE OF HER HUSBAND.

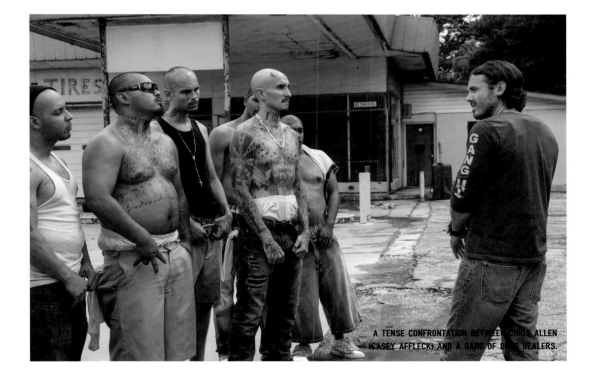

A TENSE CONFRONTATION BETWEEN CHRIS ALLEN
(CASEY AFFLECK) AND A GANG OF DRUG DEALERS.

LEAD ACTORS: CASEY AFFLECK (CHRIS ALLEN), CHIWETEL EJIOFOR (MICHAEL ATWOOD), ANTHONY MACKIE
(MARCUS BELMONT), KATE WINSLET (IRINA VLASLOV), NORMAN REEDUS (RUSSELL WELCH), WOODY HARRELSON
(JEFF ALLEN), CLIFTON COLLINS JR. (FRANCO RODRIGUEZ) / DIALOGUE: MATT COOK / MUSIC: BOBBY KRLIC, ATTICUS
ROSS, LEOPOLD ROSS, CLAUDIA SARNE / DURATION: 115 MINUTES / CATEGORIES: RUSSIAN-ISRAELI MAFIA, DIRTY COPS

BABY DRIVER

UNITED KINGDOM, UNITED STATES, 2017
DIRECTOR: EDGAR WRIGHT

Ever since a car accident killed his parents and damaged his eardrums as a child, Baby (Ansel Elgort) has lived with music in his ears. He divides his life between caring for his adoptive father Joseph (CJ Jones), a paraplegic, and acting as a driver for a gang of robbers led by Doc (Kevin Spacey). Although he is a driving genius, Baby only takes on this role to pay off a debt to Doc. When he has almost satisfied his debt, Baby meets Debora (Lily James), a young waitress who is also crazy about music and with whom he falls in love. They both have dreams of running away, but are thwarted by Doc's hold on Baby: the gang leader forces him to go back on duty for a last heist in the company of a crazy crew that includes Bats (Jamie Foxx), a violent psychopath, Buddy (Jon Hamm) a former Wall Street banker and his girlfriend Darling (Eiza González), a top-notch shot caller. Baby is aware that Doc won't hesitate to take out Debora if he doesn't accept the task, however the young man still tries to run away. Caught in extremis by his accomplices, Baby is given a hard time, especially since the accomplices discover that he is used to recording their conversations and remixing them. Knowing that he's on probation, Baby devises a plan to get rid of the rest of the gang and take off with Debora.

226

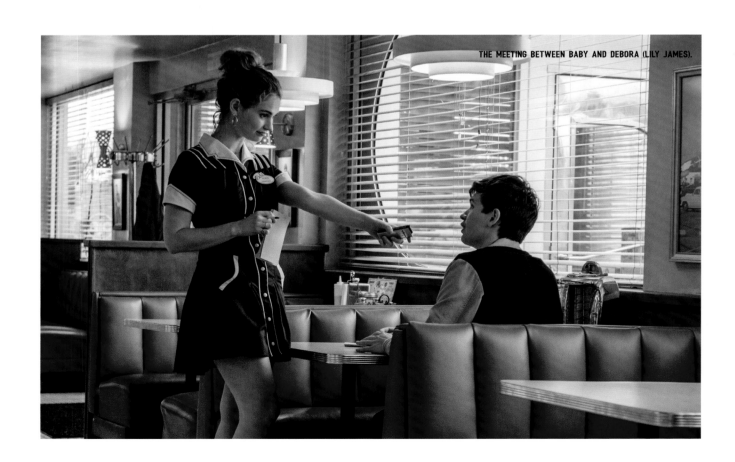

THE MEETING BETWEEN BABY AND DEBORA (LILY JAMES).

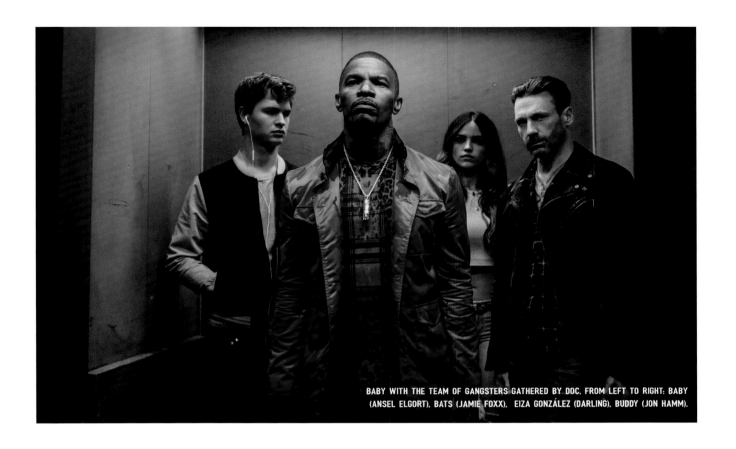

BABY WITH THE TEAM OF GANGSTERS GATHERED BY DOC, FROM LEFT TO RIGHT: BABY (ANSEL ELGORT), BATS (JAMIE FOXX), EIZA GONZÁLEZ (DARLING), BUDDY (JON HAMM).

LEAD ACTORS: ANSEL ELGORT (BABY), LILY JAMES (DEBORA), KEVIN SPACEY (DOC), JON HAMM (BUDDY), EIZA GONZÁLEZ (DARLING), JAMIE FOXX (BATS), CJ JONES (JOSEPH) / DIALOGUE: EDGAR WRIGHT / MUSIC: STEVEN PRICE / DURATION: 113 MINUTES / CATEGORIES: CRAZY GANGSTERS, ESCAPE

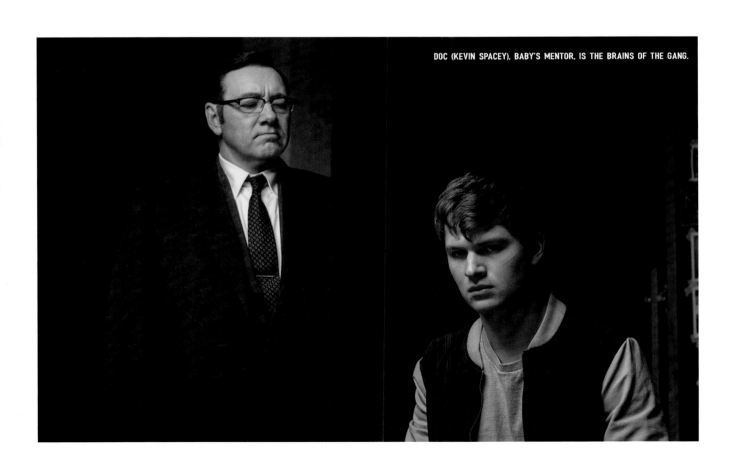

DOC (KEVIN SPACEY), BABY'S MENTOR, IS THE BRAINS OF THE GANG.

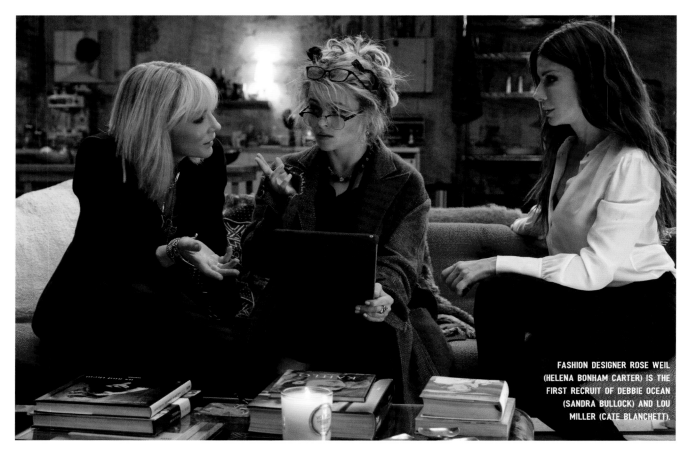

FASHION DESIGNER ROSE WEIL
(HELENA BONHAM CARTER) IS THE
FIRST RECRUIT OF DEBBIE OCEAN
(SANDRA BULLOCK) AND LOU
MILLER (CATE BLANCHETT).

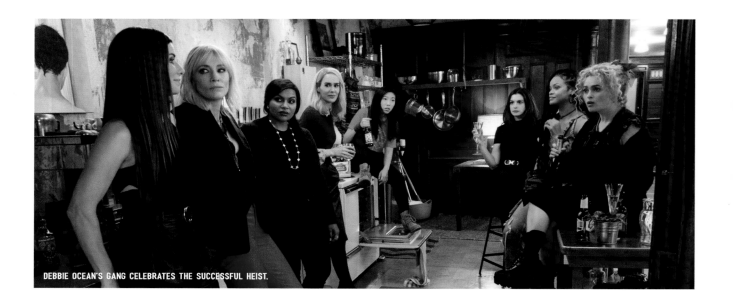

DEBBIE OCEAN'S GANG CELEBRATES THE SUCCESSFUL HEIST.

OCEAN'S EIGHT

UNITED STATES, 2018
DIRECTOR: GARY ROSS

Ratted out by her former male accomplice, Debbie Ocean (Sandra Bullock) has just been released on parole after spending five years in prison. She uses these years to devise a totally impossible heist worthy of her brother Danny Ocean, who has just died: it is nothing less than stealing a jewel from the Cartier collection, the *Toussaint*, a diamond necklace so precious that it is never on display. Debbie Ocean's plan is anything but simple: she has to arrange to have the guest of honor at the Metropolitan Museum's annual gala wear it and then steal it on this occasion. To do this, she must first recruit the fashion designer who will dress the star guest Daphne Kluger (Anne Hathaway), a genius hacker (Rihanna), a diamond dealer (Mindy Kaling), a seasoned pickpocket (Awkwafina) and the indispensable Tammy, an outstanding fence (Sarah Poulson). Debbie can count on the unfailing support of her old friend Lou Miller (Cate Blanchett) and of another accomplice above all suspicion. This impossible heist could, however, be only a small part of Debbie's diabolical plan...

THE TOUSSAINT, A DIAMOND NECKLACE VALUED AT $160 MILLION, AROUND DAPHNE KUGLER'S NECK (ANNE HATHAWAY).

LEAD ACTRESSES: SANDRA BULLOCK (DEBBIE OCEAN), CATE BLANCHETT (LOU MILLER), ANNE HATHAWAY (DAPHNE KLUGER), RIHANNA (NINE BALL), SARAH PAULSON (TAMMY), HELENA BONHAM CARTER (ROSE WEIL), MINDY KALING (AMITA), AWKWAFINA (CONSTANCE), WITH THE PARTICIPATION OF ANNA WINTOUR, KIM KARDASHIAN, KATIE HOLMES, SERENA WILLIAMS, HEIDI KLUM AND OTHER CELEBRITIES PLAYING THEMSELVES / DIALOGUE: GARY ROSS / MUSIC: DANIEL PEMBERTON / DURATION: 110 MINUTES / CATEGORIES: MUSEUM BREAKDOWN, REVENGE

THE CONVOY LED BY MATT GRAVER (JOSH BROLIN) IS ATTACKED BY MEXICAN POLICE OFFICERS BRIBED BY THE CARTELS.

LEAD ACTORS: BENICIO DEL TORO (ALEJANDRO GILLICK), JOSH BROLIN (MATT GRAVER), ISABELA MONER (ISABEL REYES), JEFFREY DONOVAN (STEVE FORSING), BRUNO BICHIR (ANGEL) / DIALOGUE: TAYLOR SHERIDAN / MUSIC: HILDUR GUÐNADÓTTIR / DURATION: 122 MINUTES / CATEGORIES: HUMAN TRAFFICKING, KIDNAPPING, MEXICAN CARTELS

ALEJANDRO (BENICIO DEL TORO) AND ISABEL REYES (ISABELA MONER) WANDER IN THE DESERT IN SEARCH OF HELP.

SICARIO: DAY OF THE SOLDADO

UNITED STATES, 2018
DIRECTOR: STEFANO SOLLIMA

At the border between Mexico and the United States, human trafficking is on the way to dethroning drugs: it is now human smugglers who add to the fortunes of the cartels. When a group of Yemeni Islamists who had entered the United States illegally carries out a suicide bombing in a Kansas City supermarket, the CIA urgently recalls Matt Graver (Josh Brolin), on a mission to the Arabian Peninsula, and give him carte blanche to act. He finds Alejandro (Benicio del Toro) the mysterious Colombian avenger who offers him a diabolical plan of action: to kidnap the daughter of a cartel godfather and hand her over to a rival gang to provoke a war that will disrupt the criminal activities. Matt Graver's team succeeds in kidnapping Isabel Reyes (Isabela Moner), the daughter of Carlos Reyes, while Alejandro

assassinates the lawyer of a rival cartel, the Matamoros, making his crime look like an order from Reyes. Reyes' daughter is still to be handed over to the Matamoros, but the convoy is attacked by Mexican policemen and the case turns into a diplomatic fiasco. Alejandro finds himself alone, in enemy territory, with Isabel Reyes. Together, they try to escape from the gangsters on their heels.

The breathless atmosphere and all the elements that made the success of the first film can be found in this new instalment: The same mixture of geopolitical imbroglio, raw violence and personal grudges strengthens the plot. Benicio del Toro plays a character who is as mysterious and unstoppable as ever.

231

UNMASKED, ALEJANDRO IS GIVEN A HARD
TIME BY THE CARTEL GANGSTERS.

FRANK SHEERAN (ROBERT DE NIRO) IS THE CONFIDANT OF DETROIT'S
ITALIAN AMERICAN GODFATHER, RUSS BUFALINO (JOE PESCI).

LEAD ACTORS: ROBERT DE NIRO (FRANK SHEERAN), JOE PESCI (RUSS BUFALINO), AL PACINO (JIMMY HOFFA),
ANNA PAQUIN (ADULT PEGGY SHEERAN) / DIALOGUE: STEVAN ZAILLIAN, BASED ON CHARLES BRANDT'S BOOK
I HEARD YOU PAINT HOUSES / MUSIC: ROBBIE ROBERTSON / DURATION: 209 MINUTES /
CATEGORIES: LIFE AND DEATH OF A GANGSTER, ITALIAN- AMERICAN MAFIA, LINKS BETWEEN MAFIA AND UNIONS

THE IRISHMAN

UNITED STATES, 2019
DIRECTOR: MARTIN SCORSESE

Through the life of Frank Sheeran (Robert De Niro), an Irish gangster linked to the Bufalino clan, Martin Scorsese traces the turbulent history of the Italian American mafia from the 1950s to the present day. The old gangster, confined to a wheelchair in an old people's residence, recalls the milestones in his rise to prominence in organized crime. The film traces Frank's path from a simple truck driver who started doing menial favors to right-hand man and executor of the dirty work on behalf of Russ Bufalino (Joe Pesci), the powerful godfather of Philadelphia. Eventually, Sheeran is sent by the mafia to assist Jimmy Hoffa (Al Pacino), the charismatic president of the Truckers' Union, one of the great purveyors of funds for all the projects controlled by the criminal world. Jimmy Hoffa and Frank became friends despite the ups and downs of Jimmy's career. However, when Hoffa broke free from his mafia ties, Frank had no choice but to abide by the decisions of the Bufalino clan.

The story, despite some lengthy scenes, brilliantly completes the vast fresco on the history of the Italian American mafia that has characterized Martin Scorsese's oeuvre since *Mean Streets*.

233

FRANK AS THE BODYGUARD AND MENTOR OF JIMMY HOFFA (AL PACINO), THE POWERFUL BOSS OF THE TRUCKERS UNION.

PICTURE CREDITS

234

236

RatPac-Dune Entertainment / Warner Bros. / iMint Media / MovieStillsDB

THE CONNECTION: © 2014 Gaumont / Légende Films / France 2 Cinéma / Canal + / Ciné + / France Télévisions / Scope Pictures / RTBF / La Wallonie / Région PACA / MovieStillsDB

TRIPLE 9: © 2016 Worldview Entertainment / Anonymous Content / MadRiver Pictures / Mars Distribution / MovieStillsDB

BABY DRIVER: © 2017 TriStar Pictures / MRC / Working Title Films / Big Talk Productions / Sony Pictures / MovieStillsDB

OCEAN'S EIGHT: © 2018 Warner Bros. / Village Roadshow Pictures / Rahway Road Productions / Smokehouse Pictures / MovieStillsDB

SICARIO: THE DAY OF THE SOLDADO: © 2018 Columbia Pictures / Black Label Media / Thunder Road Pictures / MovieStillsDB

THE IRISHMAN: © 2019 Tribeca Productions / Sikelia Productions / Winkler Films / Netflix / MovieStillsDB

ACKNOWLEDGMENTS

Our thanks go to the team at Gingko Press for their precious advice, endless patience and careful proofreading of the manuscript.

Thanks also to all our interlocutors in the different image banks we contacted.

Special thanks to Lee Ripley for proof-reading this book, and for enjoying the reading.

We have made every reasonable effort to identify and credit the production and distribution companies with films featured in this book. Any omissions are strictly accidental and will be corrected in future editions. We thank you for reporting any errors to the following e-mail address: fancybookspackaging@gmail.com.

The contents of some of the works included in this book may not be suitable for minors because of violent or sexually explicit scenes, or because of some inappropriate language. The films selected in this work are intended for adult audiences and do not in any way promote organized crime. The authors' positive assessment of a particular script does not in any way imply his approval, or support of any form of violence.

IMPRINT PAGE

First Published in the United States of
America, February 2021 under license
from Fancy Books

First Edition

Gingko Press, Inc.
2332 4th Street, Suite E
Berkeley, CA 94710, USA
www.gingkopress.com

ISBN: 978-3-943330-73-1
Printed in China